Van Gogh

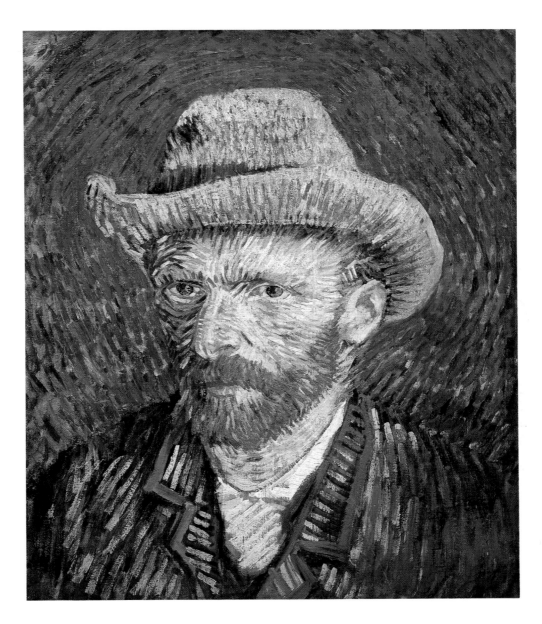

Van Gogh

KEITH WHELDON

Published by Gallery Books
A Division of W H Smith Publishers Inc.
112 Madison Avenue
New York, New York 10016

Produced by
Brompton Books Corp.
15 Sherwood Place
Greenwich, CT 06830

ISBN 0-8317-9124-1

Printed in Spain

10 9 8 7 6 5 4 3 2 1

Page 1: *Self Portrait in a Gray Felt Hat* 1887

Page 2: *The Café Terrace, Arles at Night* (detail) 1888

Introduction

The myth of Van Gogh as the struggling, suffering, isolated artist, whose paintings are the unmediated outpouring of an ecstatic but anguished psyche in confrontation with nature is gradually losing currency. At best it only represented one aspect of his production. The survival of his letters to Theo, his younger brother, continues to stimulate popular interpretations of his work which see his paintings exclusively in the light of his own statements. The fact that these existed in a context, and for all their apparent frankness are codes determined by that context is ignored. No matter how faithfully a painting ostensibly represents psychological authenticity in the artist's response to what he considered to be nature and society, they are more than the sum of these factors. The value of the paintings for both the artist and the viewer is that they are representations with a sense of otherness

embodied in their construction, which constitutes their active role in society. It is this making of something other than the subjective response to the world that makes Van Gogh's art so rich.

In spite of Van Gogh's extended four-year stay in France from February 1886 to his death at Auvers-sur-Oise on the 29th July 1890, many of his attitudes toward society, aesthetics, and the practice of art, were formulated in the context of his Dutch upbringing. Even his understanding of the French avant-garde in literature and painting was initially formulated within a specifically Dutch context. He was clearly aware of this when he wrote to his painter friend Anton van Rappard on the 15th October 1881:

. . . in Holland . . . we are ourselves, there we feel at home, there we are in our element. The more we know of what is happening abroad,

the better, but we must never forget that we have our roots in Dutch soil.

Van Gogh's 'roots' were not just generically Dutch but highly specific, determined by his regional background, class, and family circumstances. He was born on the 30th March 1853 at the parsonage of the small north Brabant village of Groot Zundert in the southern part of Holland. Although by any standards this was a rural backwater, he was not from a humble background. His father Theodorus Van Gogh came from an eminent, old bourgeois family as did his mother, Anna Maria Carbentus. Both the Van Goghs and the Carbentus's were closely associated with the administrative, religious, and cultural establishments of late nineteenth-century Holland. Van Gogh's father followed in the family tradition of theologians and pastors; it was only his rather limited abilities as a

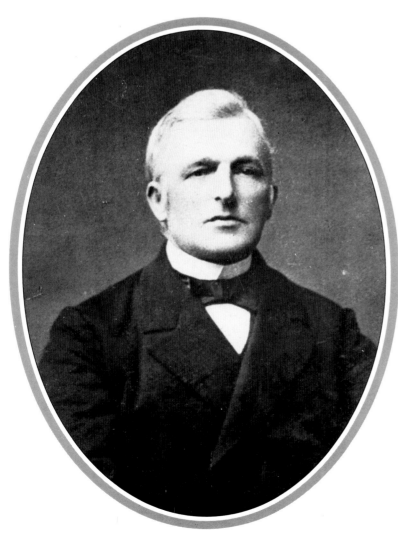 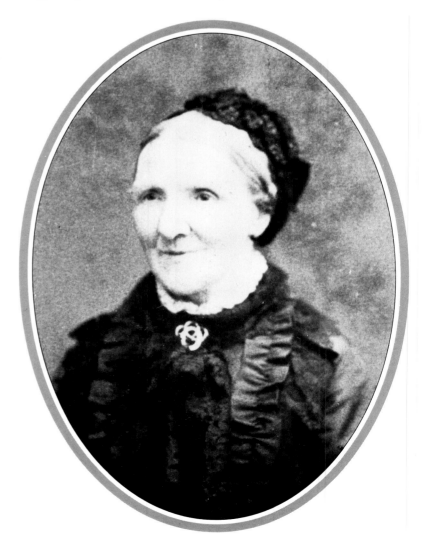

public speaker that blighted his career in the Church and led him to the rural insignificance of Groot Zundert. The pastor's role in a small village where most of the population consisted of the poor peasantry was clearly defined, combining a sense of vocation, service, authority, and compassion. All these traits were later to be exhibited in Van Gogh's construction of his role as artist.

Van Gogh's involvement with art both as a picture dealer and as a painter was also determined by the context of family tradition. Three of his uncles, Hendrik Vincent, known familiarly as Hein, Cornelius Marinus, and Vincent were art dealers and in various ways did their best to help their brother's eldest son at the outset of his career. His mother's family were also intimately connected through marriage with the visual arts. His aunt Jet married Anton Mauve, an eminent member of The Hague school. Later in Van Gogh's life Mauve would provide his young relative with his first formal painting lessons. Another maternal aunt, Cordelia Carbentus, married Van Gogh's uncle Vincent, the art dealer. In the context of this educated,

prosperous, and sophisticated family group, Van Gogh identified himself and constructed and reinterpreted his social, philosophical, and aesthetic values.

In his short 37-year life span he never abandoned this context of family life. His relationship with his brother Theo is the most obvious example of this. Their correspondence, dating from August 1872 and continuing with occasional short breaks until 1890, was the one consistent relationship he constructed. It survived because it was a mediated relationship in which the artist's violent changes of mood were moderated by the premeditation and distance necessitated by writing. When the two brothers lived together in Paris between 1886 and 1888 considerable strain was placed on their friendship.

The framework of bourgeois family values was particularly clear in the relationship between the two brothers. Vincent failed in his career as an art dealer, and became an art producer. The younger brother Theo followed in the same profession with some success. The younger brother earned money and the older one did not. In his later years the artist was

exclusively dependent on the art dealer's financial support. In her memoir of Van Gogh, Theo's wife, Johanna van Gogh-Bonger, made it clear that this inversion of the normal bourgeois equation of masculinity with money and family power and primogeniture caused Vincent to lose status, and to some extent rights. This is revealed in her disparaging comments about Van Gogh's attempts to 'adopt' a family when he was living in The Hague in 1881. The fact that the family consisted of a prostitute and her illegitimate offspring is only alluded to, although it is clear that Van Gogh's 'choice' was deemed totally unacceptable on moral, social, and class grounds – compassion had its limits. What is stated openly is the unacceptability of such a liaison on financial grounds: 'taking upon himself the cares of a family – and such a family! . . . while he was financially dependent on his younger brother.'

Van Gogh's inability to provide lowered his status within his family to that of supplicant, and as such he could not assume the role of protector and head of a family. As an artist and individual Van Gogh was both protected and constrained by family

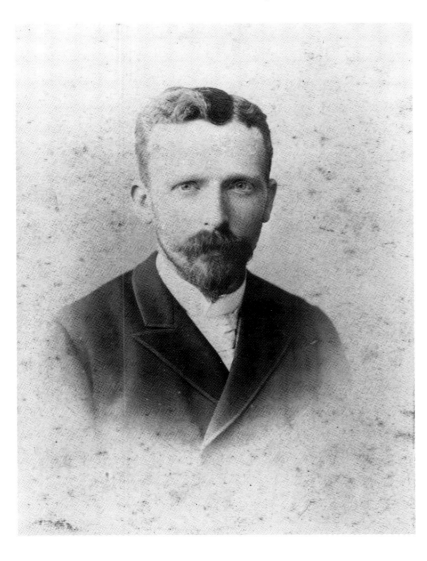

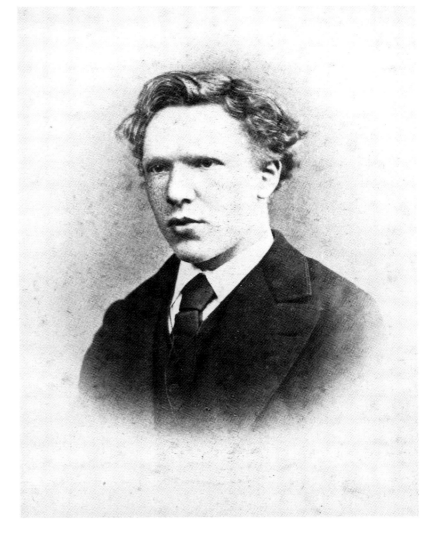

relationships, especially with his father. In this context it is easy to see why Van Gogh adopted diverse strategies to undermine these power structures. The most notable was the self-defeating ploy of undermining the value of Theo's position as an art dealer.

In the village of Groot Zundert the young Van Goghs were isolated within the family group. The local school was considered to be too rough for the young Vincent and he was given private tuition until he was twelve years old when he left home to attend boarding school at Zevenbergen. If his social circle and contact with the peasant class was limited, his acquaintance with the surrounding heathland was not. His childhood walks in the countryside were to play an important part in his identification with traditional patterns of Dutch rural life, which occupied such a significant position in the works of his early maturity in Drenthe and Nuenen. In his early years Van Gogh observed nature and what in the mid 1850s were still relatively stable patterns of country life but he participated in both from within the language, culture, and values of his class.

The family were instrumental in obtaining his first employment as a junior employee in The Hague branch of the art dealers Goupil et Cie, at the age of sixteen in July 1869. This position was obtained for him by his uncle Vincent who after establishing his own art gallery in The Hague had been offered a partnership in Adolphe Goupil's Paris-based firm of international art dealers. As the youngest employee of the firm, Van Gogh was placed under the direction of the manager of The Hague branch, H C Tersteeg. Tersteeg was to remain a friend and advisor to Van Gogh after he left art dealing to become a painter and only broke with him in January 1881 after the affair of the adopted family. In a reference for Van Gogh he wrote that he was 'diligent' and 'studious' indicating that at this stage Van Gogh was content with the prevailing values and taste of his family, family friends, and employers in The Hague. The business was mainly concerned with a trade in prints and reproductions with an increasingly large number of original works also being sold. This early acquaintance with reproductions established a pattern in Van Gogh's life and he

became an avid collector of prints, illustrations taken from magazines, photographic reproductions and, at a later date, fine art prints, especially the fashionable Japanese wood-block prints.

By developing a museum of the imagination through an extensive collection of reproductions, Van Gogh was participating in a culture which was dramatically expanding its visual terms of reference and was significantly altering the status of the original work of art. It allowed for an altogether unprecedented scale of 'collecting' presenting the enthusiast with a massive range of imagery to draw upon in which different aspects of the same original could be developed in the hands of different craftsmen and as a result of the qualities of different reproductive media. Van Gogh was to utilize both of these aspects of the reproduction in his own visual culture. The latter was of less importance for him before he became an artist himself, but the former revealed itself in the almost encyclopedic range of his taste. By the time he had been promoted to the London branch of Goupils in June 1873, he had formed a taste for fashionably modern but

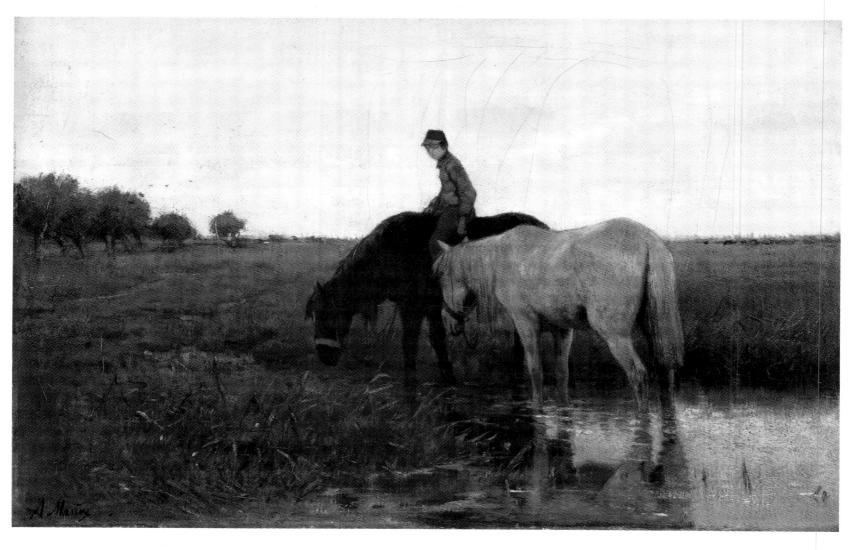

Below: *Sandpit, Dekkersduin near The Hague,* 1883. Van Gogh made many more finished drawings of figures engaged in various types of labor (see pages 36, 38-39, and 43).

not radically avant-garde painting based on the French, Dutch, Belgian, and British schools. In January 1874 he could write to Theo listing in one letter the names of 59 contemporary and seventeenth-century artists in admiring terms. The culture of reproductions allowed him to assimilate and value so much more than would have been possible in any other context. The vast range of reproductions and original works of art available to him did not stun his critical faculties as many critics have suggested but they did allow him to approach and appreciate the values to which he was committed in as many modes of representation as possible. As he wrote in the same letter to Theo: 'Admire as much as you can; *most people do not admire enough.*'

Goupil et Cie specialized in selling works of the French Barbizon School, many of whom were included in Van Gogh's 1874 list of favorites. These included Théodore Rousseau, Constant Troyon, Jules Dupré, Charles-François Daubigny, and Narcisse-Virgile Diaz. He also admired works by artists associated with the group whose work he had seen through the medium of reproductions, especially Jean-François Millet, whose images were of great significance to Van Gogh throughout his life. The academic painter of peasant scenes Jules Breton was another hero exciting Van Gogh's critical admiration. Goupils also specialized in

selling works by contemporary Dutch artists, especially those by members of The Hague school who included Johannes Bosboom, Jozef Israels, Thijs and Jacob Maris, Van Gogh's relative Anton Mauve, H W Mesdag, and H J Weissenbruch. Once again Van Gogh admired their works which had many themes in common with those of the French, especially rural labor set in open landscapes in either somber or idyllic moods. They stressed apparent objectivity and compassion on the part of the artist, and perseverance, dignity, harmony, and continuity on the part of the depicted peasants.

In addition to the art he saw through his work for Goupils, Van Gogh also became acquainted with the works of such Dutch seventeenth-century artists as a result of assiduous museum visiting, especially Hals, Rembrandt, and Jacob van Ruisdael. The impact of the Dutch tradition of painting with its emphasis on religious and moral themes and Dutch identity was to remain with Van Gogh until the end of his life. It also exerted an equally pervasive and diverse influence on his thought, perception, and production as did that of Millet, Breton, and the French painters. The richness and variety of the visual culture of these early years was not forgotten. In a long and melancholy letter to Theo from Cuesmes in Belgium written in July 1880, Van Gogh noted with sadness the lack of

art in the coalmining district of the Borinage where he was teaching and evangelizing. It caused him to be intensely homesick 'for the land of pictures.'

Homesickness also characterized his stay in London after the passing of the initial euphoria of living in a great city with more money in his pocket than he had ever had before. He worked in the London branch of Goupils from June 1874 to May 1875, and during this time he changed from being a promising and industrious member of the firm to a sullen and insular individual developing something approaching religious mania. Van Gogh's rejected declaration of love at the hands of his landlady's daughter, Ursula Loyer, played a significant part in this change. Although he visited his home in Holland for a short recuperative holiday, he did not survive the rebuff unscathed. It marked the first of a series of unsuccessful attempts to encounter middle-class women within the context of a caring and compassionate relationship. It also produced the first of a series of attempted displacements which functioned as consolations for his sense of loss and rejection, and as sublimation for a frustrated libido. In this case the displacement activity was religious enthusiasm. Later, especially in his Arles period, it took the form of intense painting activity. Art also developed the role of constant companion in times of intense loneliness.

Although Van Gogh was less inspired by contemporary English art than he had expected, he expressed interest in the works of J E Millais and G H Boughton when he saw them in Goupil's Galerie Photographique. Both artists were admired for their choice of themes rather than any specific formal or technical merit. In a letter of July 1873 he specifically identifies their works with puritan subjects – Millais' *The Huguenot* and Boughton's *Early Puritan of New England Going to Worship* – which suggests that he saw value in pictures if they reflected his own concerns. The lonely Calvinist Pastor's son clearly found consolation in heroic and comforting images of the Puritan way of life.

Van Gogh's interest in the narrative content of pictures at this time partially accounts for his growing interest in the work of contemporary English graphic artists. He had started collecting pictures from magazines like *The Graphic* and *The Illustrated London News* as early as March 1875. Illustrators like Frank Holl, Hubert Herkomer, Luke Fildes, Percy Macquoid, William Small, and Fred Walker were to provide him with the themes of urban and rural working life which informed his own activities as a draftsman in his Hague, Drenthe, and Nuenen periods from 1881 to 1885. Occasionally he adopted the format of the illustrated magazines for the pages of his own sketchbooks. The illustrators shared many concerns with those of contemporary English novelists. They illustrated scenes from their novels when they were serialized in magazines and as a result they applied themselves to broadly similar social issues.

Van Gogh read Dickens, George Eliot, Bulwer Lytton, and Thomas Carlyle with great enthusiasm. In George Eliot and Dickens he found vivid realizations of social and moral issues conveyed with sentiment and compassion, especially those associated with the conflict between town and country. They contributed to forming his own views on the role of the concerned middle classes when confronted with the plight of the poor, underprivileged, and displaced members of society. Sentiment made these representations of potentially dangerous classes attractive, and showed them to be deserving of the good works of the controlling bourgeoisie. Van Gogh's works inspired by the example of English illustrators and novelists avoid the sentimentality to be found in Dickens, but he does use his position as a member of a class other than those represented to observe and evoke compassion in the viewer. Like many of the English illustrators he makes an alien class accessible to an affluent and powerful audience. Unlike his English examplars he was unable to address that audience on any significant scale, because of the private nature of his early works such as The Hague series of charcoal

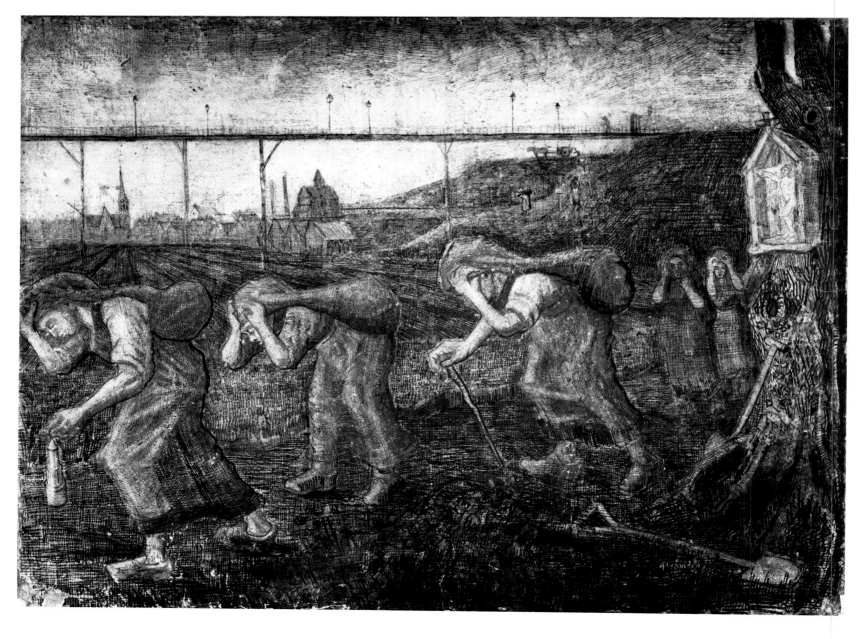

Below: Millet's *Gleaners* inspired a whole generation of artists by its depiction of rural labor. Van Gogh's vision was, however, harsher and unidealized.

sketches of the soup kitchens set up for the urban poor in 1882-83.

After the trauma caused by Ursula Loyer, Van Gogh became increasingly obsessed with religion. This phase of his life lasted until early 1880. Based on his reading of the Bible and contemporary authors like Jules Michelet, E Renan, Victor Hugo, Harriet Beecher-Stowe, and Charles Dickens, he saw Christ as a model for social reform who, through compassion and self-sacrifice could heal the ills of society. He became increasingly committed to a vocation in Evangelism which would at once help the poor and dispossessed and provide him with redemption and nobility through self-discipline and self-sacrifice. This self-mortification led him to what he called a 'still sadness' which he used to justify his profound sense of isolation and social and sexual inadequacy.

His growing concern with religion, sacrifice, and service led him to become totally disillusioned and created a profound distaste for the art trade. He became so insular and unstable in his work in London that he was transferred to the Paris branch of Goupils in May 1875. His disaffection increased and his only relief seems to have been his friendship with a young Englishman Charles Gladwell who also worked at Goupils. They read the Bible together in Van Gogh's room in Montmartre. Eventually after an unauthorized visit to his family at Christmas time in 1875, the unwilling employee was given the sack which took effect on the 1st of April 1876.

His earlier stay in England led him to formulate a comfortable vision of English Methodism. It was this vision which stimulated his return to England as a teaching assistant, first at a school in Ramsgate in Kent and then in Isleworth on the outskirts of London. One of his employers was greatly impressed by his efforts. Mr Jones, the headmaster at Isleworth, supported Van Gogh's pastoral leanings by encouraging him to write and deliver a sermon. Later he assisted his protegé's father in obtaining a place for the young Dutchman in the School of Evangelism in Laeken, on the outskirts of Brussels.

Van Gogh returned to Holland at the end of 1876, increasingly determined to become an evangelist, and after a false start as a bookseller in Dordrecht, his family assisted him in pursuing his new vocation in every way they could. He was twenty-four years old. He wanted to study Theology in Amsterdam but in order to do this he had to acquire a knowledge of Classical languages. One of his uncles found a teacher for him, another provided him with food and lodging. In spite of all this the stay in Amsterdam from May 1877 to May 1878 was unsuccessful. He was impatient with academic study as it seemed to have nothing to do with the urgency of

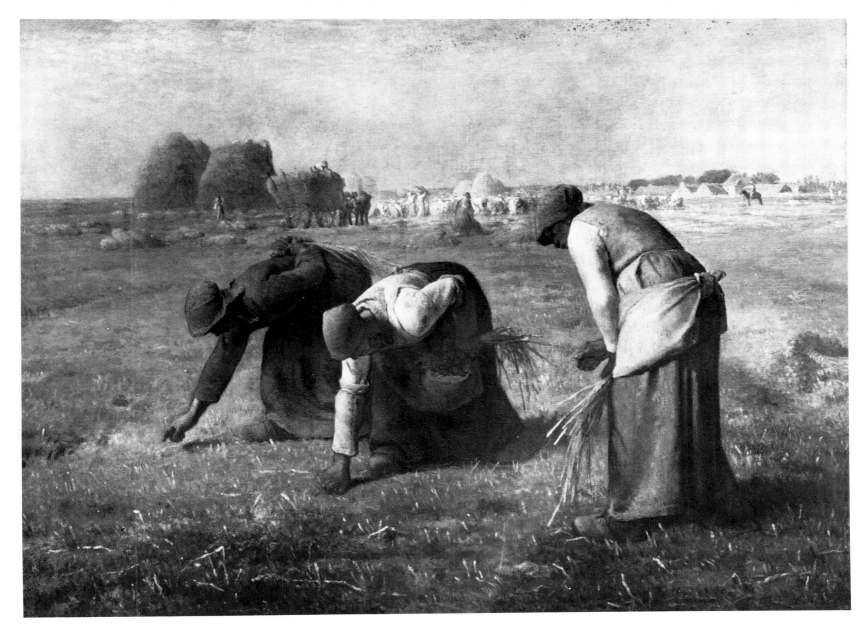

Van Gogh's confused notions of compassionate identification and authority led him to lose his position at Masmes, and as a result he experienced a period of intense alienation, isolation, and misery in the winter of 1879-80. He was separated from the poor, his family, his class, his vocation and he seemed to have no direction. It was at this time that he made his abortive visit to the studio of Jules Breton at Courrières in northern France. This miserable journey undertaken on foot with virtually no money did not result in a meeting with his idol but it did stimulate him to resume his drawing studies. When he returned to the Borinage, this time to the village of Cuesmes, he set up a small studio in his lodging house; here he started to develop his representations of the work of the mining community around him. In a letter to Theo of July 1880 he saw this as a return to lucidity after an excess of visionary absent-mindedness. This distrust of abstraction and dreams which in the Borinage had nearly caused him to lose his 'voice,' remained with him. It became a cornerstone of his aesthetic theory and was at the heart of the disputes with Paul Gaugain and Emile Bernard in 1889.

With characteristic intensity and application Van Gogh set about learning to be a draftsman. He received very little formal training in art academies and relied on family, friends, copybooks, and prints for his education. In Cuesmes he worked from two books that were to be of great importance to him, Charles Bargue's *Cours de Dessin* and *Exercises au fusain, pour préparer à l'étude de l'académie d'après nature*, both published by Goupil. When he went to Brussels in October 1880 he did not study at the Academy but continued to use these primers together with Lavater and Gall's *Physiognomy and Phrenology*. He also took informal lessons in elementary perspective and anatomy. Through his brother Theo he met the painter Anton Ridder van Rappard, who was studying at the Brussels Academy. Bargue's emphasis on the importance of firm outline, Lavater's stress on characterization through emphasis and distortion, the belief in the expressive control of space embodied in perspective systems, and van Rappard's insistence on study after nature were all of the greatest importance in forming his chosen language of representation.

When he moved to the new family home at Etten in April 1881, he continued his studies and generated a correspondence

catering to the needs of the sick and the poor. Consequently he did not gain admittance to the Faculty of Theology at the University of Amsterdam, and it was decided that he should study at the new School for Evangelists at Laeken. This only required three months training and a further six months probationary period of field work. Initially this new course was successful. It was only after he left for his probationary period at Masmes in the Borinage late in 1878 that his intensely personal construction of Evangelism caused him to clash with his teachers. Following his literary models, renouncing all worldly goods, and in effect acting as a model of compassionate identification with the poor, he ended up living in utter squalor. This destabilized

what was then seen as the necessary pattern of paternal authority essential to evangelistic work. His position was held to be inconsistent.

Living with the coal miners of southwest Belgium was his first experience of poverty and it is clear that he found it hard to accommodate to this in anything other than the terms of his own class. He had to resort to consulting 'a little handbook of geography' to define 'a special Borinage type.' He was in a strange land in more ways than one and he needed a guidebook, presenting the unfamiliar in terms of familiar middle-class values. It presented the object of his empathy in terms of otherness. He never ceased to use these terms in the Borinage or at any period of his life.

Right: Van Gogh sketched this perspective frame in a letter of August 1882: 'In the meadows one can look through it like a window . . . practice enables one to draw like lightning.'

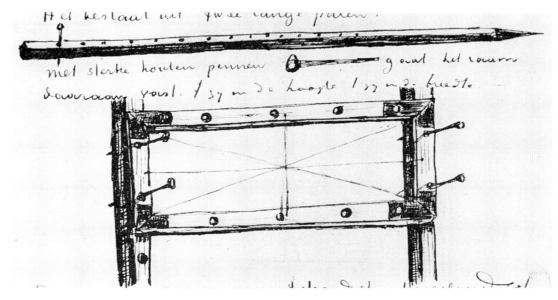

Below: Sketch of a fishing smack arriving at Scheveningen.

with van Rappard. Throughout this period he fostered his skills by copying prints after Dutch seventeenth-century masters and Jean-François Millet. In these studies he was not only developing manual dexterity and skill but also formulating a vocabulary which would represent a particular ideology of the relationship between land and labor. These were further re-inforced by his contact with Anton Mauve, who

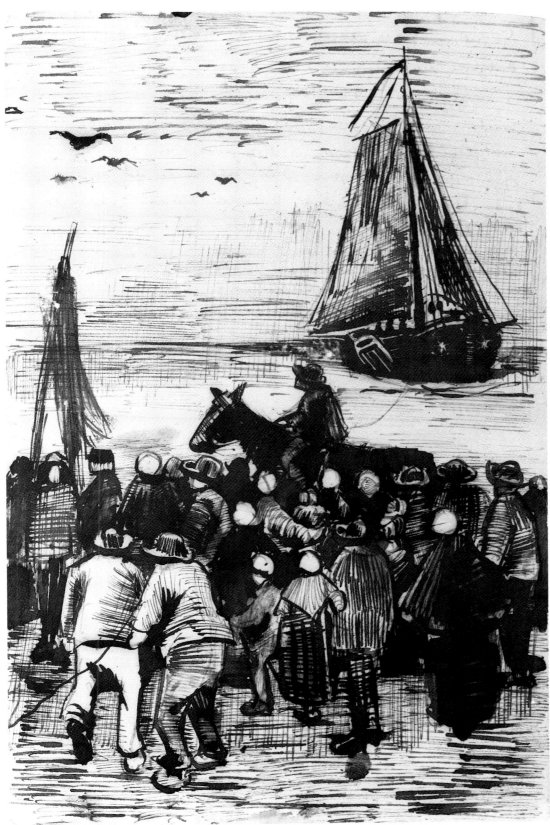

encouraged him to make his first studies in oils, develop his watercolor drawing technique, and symbolically presented him with a color box. His value and identity as an artist had been established.

The relatively calm and happy period of his life at Etten was curtailed by a violent disagreement between Van Gogh and his father over his unsuccessful attempts to form a relationship with his widowed cousin Kee Vos. Once again he had misjudged the ethical boundaries of his own class, and once again he failed to develop a viable relationship with a bourgeois female. As a result he was sent to The Hague in December 1881 where he continued his studies with Mauve. In The Hague the practice of art was developed within the context of sexual and social disappointment and disorientation. Within a couple of months of his abortive relationship with Kee he had set up with Classina Maria Hoornik, a prostitute, and established a 'shadow' family. Within this ménage it was possible to exercise compassion and power simultaneously and to continue to work without fear of serious intellectual disagreement. In spite of nearly losing the support of his family because of this liaison he was never abandoned, his alienation was never complete. His father and brother rescued him from a hospital for the poor when he was suffering from venereal disease on the condition that he ceased to co-habit with Classina (Sien). They then financed his move in September 1883 to the province of Drenthe in the northeast of Holland.

During his sojourn in The Hague from January 1882 to September 1883 Van Gogh became increasingly interested in the theme of modern urban life. He sketched in the streets, the soup kitchens and suburbs stressing the immediacy of his involvement with his subject. When he sketched in the open air he wanted to give the sense of 'catching things in the act.' As he wrote to Theo about some of his early Hague street scenes: 'that was done . . . in a

Right: Van Gogh's father's house at Nuenen.

Below: *La Place de Clichy,* 1887, by Louis Anquetin, whom Van Gogh had met in Paris in 1884, and, like Bernard, a leading Cloisonnist.

Right: Van Gogh's father's house at Nuenen.

street where I was standing in the mud, amid all the noise and confusion.' He clearly wanted to stress the immediacy of his sensations in his representations of The Hague. He was in the crowd sharing in its movement, but as an observer.

In his images of the poor he links sentiment and pathos with an awareness of social reality which once again reveals the impact of the modern French novel on his thinking, especially the de Goncourt brothers, Zola, and Michelet, and also his growing awareness of the graphic arts tradition. In two outstanding series of drawings, *Views of The Hague*, commissioned by his uncle, the art dealer C M Van Gogh, the artist partially rejected the traditions of

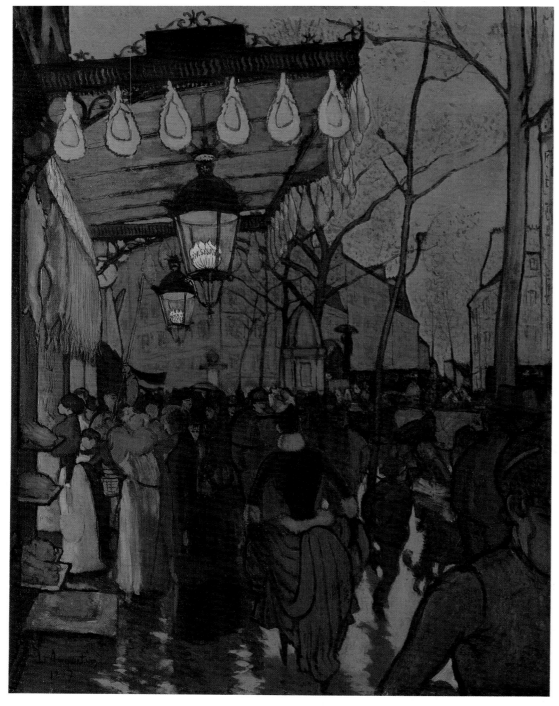

The Hague School, with whom he was increasingly familiar. His understanding of the tentative and changing relationships between city and country, between industrialization and genteel suburbanization, and his consequent understanding of the political reality of modern urban expansion he goes beyond anything produced by his Hague contemporaries. Equally, his images of the urban poor were unprecedented in their directness.

The problematic nature of Van Gogh's Hague drawing, which explored the tensions between the growth of urban capitalism and the role of the urban working classes in this expansion, together with an increasingly difficult private life, contributed to Van Gogh's retreat to the heathlands of Drenthe in early September 1883. The open spaces, somber moods and the cyclical nature of its rural labor were completely at odds with the dislocated and fragmentary nature of the social and political geography of the modern city in The Hague. As a result Van Gogh moved from exploring the casual relations which created the lot of the urban proletariat in a modern, expanding capitalist society and resorted to more 'universal' symbols of the cycle of life and labor among the rural peasantry. He could return to the familiar models of perception in Millet and English graphics for structures with which to represent the peasantry and their value to a middle-class audience. In spite of intense loneliness Van Gogh used his time in Drenthe to good effect by developing his technical abilities, particularly in the representation of space, atmosphere, and color organization.

Van Gogh's concern with the life of peasants continued during his stay in the

village of Nuenen (where his father had taken up a new living) from December 1883 to October 1885, and culminated in his painting *The Potato Eaters*, produced in April and May of 1885. The projected, but incomplete, series of peasant portraits that led to the *Potato Eaters* was a major factor in Van Gogh's determination to become an artist as opposed to an illustrator and led to a system of sponsorship financed by his brother, that alleviated the necessity for him to compete in the 'open' market.

The association of the peasant with traditional values marks both *The Potato Eaters* and the *Weavers* series also produced in Nuenen. These values were based on closeness to the land, hand craft, the family, and a homogeneous sense of community, as opposed to the modern values of urbanization and industrialization. As such these pictures were a reaction against the world view presented in the *Views of The Hague*. Family and religion played an important part in this myth of a homogeneous community and both were under strain; the community/family as a result of changes in the pattern of rural labor, and the family/religion as a consequence of the artist's personal crisis of faith which led to

a decisive break with his father, who up to the early part of Van Gogh's Nuenen period had done everything he could to assist his son in his ambition to be a painter. Van Gogh's sense of the impermanence of religious institutions and the survival of faith emerges in his many images of the old graveyard and church tower at Nuenen. Personal and social change were interwoven in these pictures.

Most of the Nuenen paintings pose a central problem for Van Gogh's work as a whole; the co-ordination of the study of Nature (signs) with the need to create an effective contemporary symbolism based on modern life and broadly understood existing symbols. Van Gogh adopted Christian symbols to highly personal ends creating a para-mythic function for his work. This can be seen in his memorial to

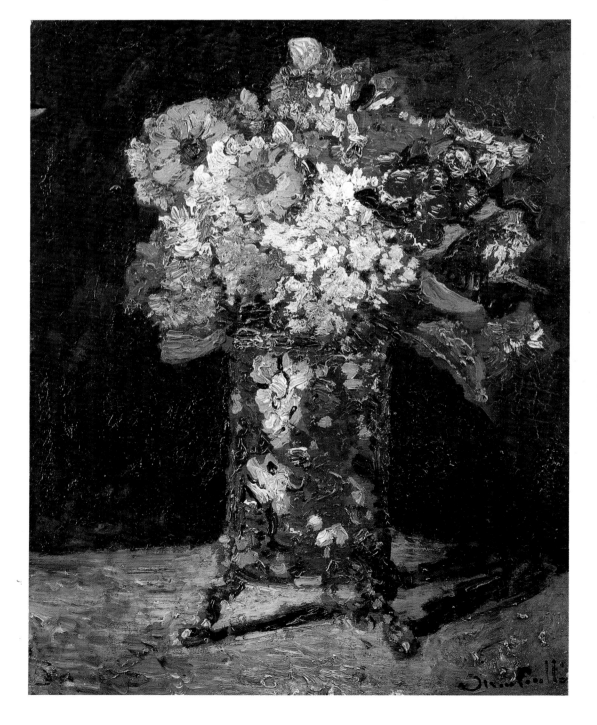

Right: *Gas Tanks at Clichy,* 1886, by Paul Signac. Van Gogh briefly experimented with the Neo-impressionists' techniques (see page 66).

Below: *Vase with Flowers* by Monticelli, an artist venerated by Van Gogh.

his father, *Still Life with Open Bible, Candle, and Zola's 'Joie de Vivre.'* The Nuenen pictures create and exploit a tension between immediate sensation and broader meaning, between experience and history.

Van Gogh's decision to become an artist in Nuenen led him to a, by now, familiar position, the need to go back to basics, to obtain formal training. In November 1885 he moved to the City of Antwerp and stayed there until February 1886. During this time he enroled in the Antwerp Academy. This period has usually been presented as one of academic insensitivity to the needs of the young artist. This was not the case. It merely revealed a highly inconsistent attitude towards institutions and academic authority. Van Gogh's rela-

tive lack of academic skill was precisely the reason he enroled in Verlats' academy. He wanted to learn to draw from something other than a copybook. He made basic blunders like offering landscapes to the head of the figure-drawing class, and in the end did not succeed in jumping the academic hurdles that he had set for himself. His overwhelming commitment to rendering his own sensations through his means of expression and his awareness of mid-century Franco-Dutch avant-garde practice had blighted his relationship with academe, yet because of his lack of formal training he still felt the need to underpin his activities with solid academic precepts, no matter how inappropriate it might be for his temperament.

Antwerp was attractive to Van Gogh as a training center for another reason. It was the city of Rubens, the seventeenth-century Flemish master of color. Color was another area of artistic practice where Van Gogh felt inadequate. His largely monochromatic pictures to date indicate that there was some basis for his uncertainty. At

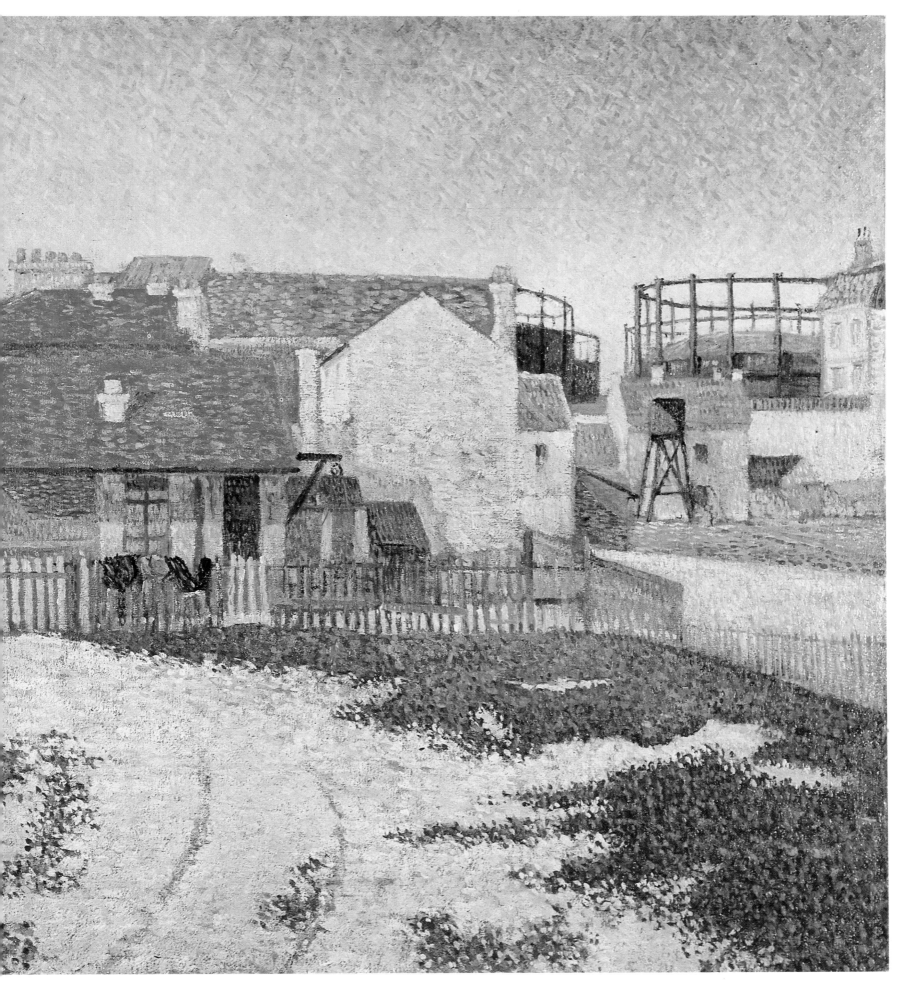

the same time as admiring Rubens he started to develop an admiration for the greatest modern master of color, Delacroix, whom he probably knew of at this time through the writing of the French critic and art historian Charles Blanc. This admiration for Delacroix grew into adulation and remained with him for the rest of his life, and was one of the reasons behind his departure for Paris.

Furthermore, Van Gogh's brother Theo lived there and through his work with Goupil's Montmartre gallery had contacts with some of the most innovative artists of the day. Van Gogh's sudden decision to leave Antwerp and live in Paris (he arrived on 20th February 1888) was a logical solution to his problem. He could study Delacroix at first hand, see the Millet retrospective at the Ecole des Beaux-Arts and he could develop his painting in one of the most innovative intellectual and artistic environments in Europe. He may have intended to continue his academic training

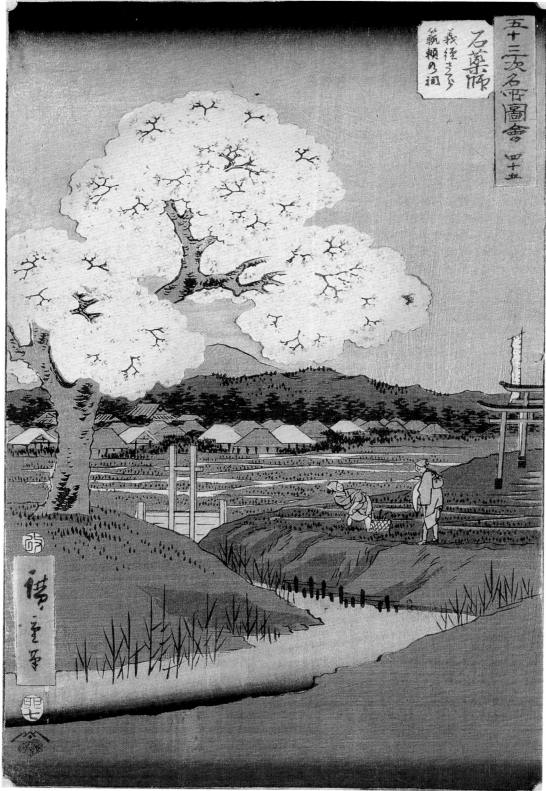

Left: *Plum Tree* by Hiroshige. Japanese prints were avidly collected by many artists in the 1880s, and Van Gogh painted several Japanese-style pictures, including some based directly on Hiroshige prints (see page 82).

generation of painters who had established their reputations in the galleries of the 'grands boulevards' in the center of Paris's right bank.

The technical and formal innovations of the Impressionnists, Neo-Impressionists, and Cloisonnists were not the only aspects of their work to exert an influence on Van Gogh. Their themes and motifs were also of great importance to him. The radical landscape themes of the industrial suburbs, the urbanizing of rural Montmartre, and the modern pastoral of the city parks, all occur in his works. In the Paris of the mid 1880s these were associated with the concept of modernity and anarchism that were so influential on the thinking of Neo-Impressionists like his friend Signac and the Symbolists, like Bernard. Gradually Van Gogh moved from the use of French artistic models who evoked his Dutch background to a radical combination of Realist, Impressionist, Neo-Impressionist, and Symbolist pictorial structures.

Van Gogh's passion for Japanese prints was a fashionable passion, especially in the Paris of the mid 1880s, and yet it was an outgrowth of his well established interest in the graphic arts. Having first discovered the woodblock prints of the Ukiyo-e in Antwerp, Van Gogh and his brother proceeded to form a large collection in the years 1886-90. This stimulated further innovations in Van Gogh's works. He incorporated both Japonaiserie (Japanese motifs) and Japonisme (Japanese formal devices) in his works. He was particularly struck by the Japanese use of flat, intense color and firm expressive outline forming strong decorative patterns and silhouettes which were echoed in the pictures of Cloisonnists such as Bernard. He also felt that the Japanese artists used black and white as colors, something he was to develop in his own work at Arles. The motifs used in Japanese prints frequently occur in Van Gogh's paintings in 1887 and 1888 in the form of free copies of the originals or fusions of details taken from several different prints. Occasionally Ukiyo-e prints are found as motifs within paintings, where they are intended to evoke a vision of Japan contrasted with their context of representations of modern Paris.

Japanese prints were not only a source of formal devices to be plundered, they also offered a model for a harmonious society, sophisticated and yet also close to nature. He constructed this model on his own terms and, for this reason they remained an

as well; for a short time in early 1884 in Paris he enroled in the 'atelier libre' of the painter Fernand Cormon, where, although he seems to have gained little experience, he did meet some of the most radical painters in Paris, including Louis Anquetin, Emile Bernard, and Henri de Toulouse-Lautrec. These artists were the founders of the movement known as Cloisonnisme. They used flat, unmodulated areas of color and strong, decorative outlines to convey a synthetic, intuitive understanding of the idea underlying the diverse phenomena of visual experience.

This movement focussed the growing disparity between observation and imagination, between the various Symbolist movements and the Impressionists. Van Gogh found himself in the middle of this. Being an outsider he did not ally himself exclusively with any one of the many competing factions in the Parisian avant-garde. As well as older French artists influenced by Dutch seventeenth-century painting like Georges Michel and Charles-François Daubigny, Delacroix, Millet, and Breton, he also admired Monet and Pissarro among the Impressionists, the independents Ziem and Monticelli, and the Neo-Impressionists Seurat and Signac. His work in Paris reflects his attempts to integrate their ideas with his already existing pictorial concerns. He and Theo were associated with the radical artists of the 'petits boulevards' around Montmartre but at the same time they could also accommodate the previous

important source of inspiration for his later work in Arles and St Rémy.

The pressures of artistic life in the metropolis proved to be too much for Van Gogh. He found the sophisticated, knowing, and competitive atmosphere of the coteries did not suit his identification with the primitive and harmonious, the slower, rougher qualities of rural life. At least in part he needed to identify himself against the avant-garde in Paris (as Gauguin did later in the 1890s). By going to Arles in February 1888 Van Gogh was both resisting modern urban values and asserting his belief in harmonious society and values of another culture, that of Provence, which he identified with both Holland and Japan.

Provence did not immediately prove to be the appealing mixture of regionalism, rural social harmony, gentle climate, bright light, color, and earthiness, that he had at first expected. The growing literary and artistic fashion for Provence inspired by Alphonse Daudet's *Letters from my Windmill* and *Tartarin of Tarascon*, Cézanne's growing reputation, and the increasingly frequent visits to the south made by Impressionists like Monet and Renoir had not prepared him for the snow which greeted him when he arrived in Arles on the 21st February. In spite of this throughout the spring and summer of 1888 Arles and the artist changed and accommodated each others needs.

It is immediately noticeable that Van Gogh rejected a tourist's view of the city and its environs, ignoring its picturesque Roman ruins. He did eventually fall for the commonplace of the legendary beauty of the Arlésiennes, but even then it was in the context of wider concerns. He painted the outskirts of the city including the symbol of modernity, the railway. He painted the orchards, market gardens, and canals of the Plain of Le Crau in the spring, the wheatfields in the summer. Working at an extraordinary pace, alone, and studying nature with intensely heightened emotion, Van Gogh's works until the fall of 1888 elaborate and develop ideas that he had formulated in both Holland and Paris.

Van Gogh's attitude to the relation between painting and nature was extremely complex. The confrontation with nature and its representation in the mind and on the canvas were problems that constantly taxed him, and his attitudes were constantly subject to revision, especially in the fall of 1888 and after. Although his stay in Paris had provided him with a pictorial

vocabulary which he developed in a highly original manner during the months from February to October 1888, nevertheless, his basic theories about the relationship between art, nature, and truth of representation seem to have been formed in the latter part of his stay in Nuenen. He wrote to Theo in early November 1885:

I study nature, so as not to do foolish things, to remain reasonable: however, I don't care so

much whether my color is exactly the same, as long as it looks beautiful on my canvas, as beautiful as it does in nature.

The representation on canvas was an equivalent of what was seen, not a transcription. This was a habitual mode of seeing by the time he was at Arles. His letters make constant reference to what he had seen in terms of the language of his pictorial vocabulary. The same representation

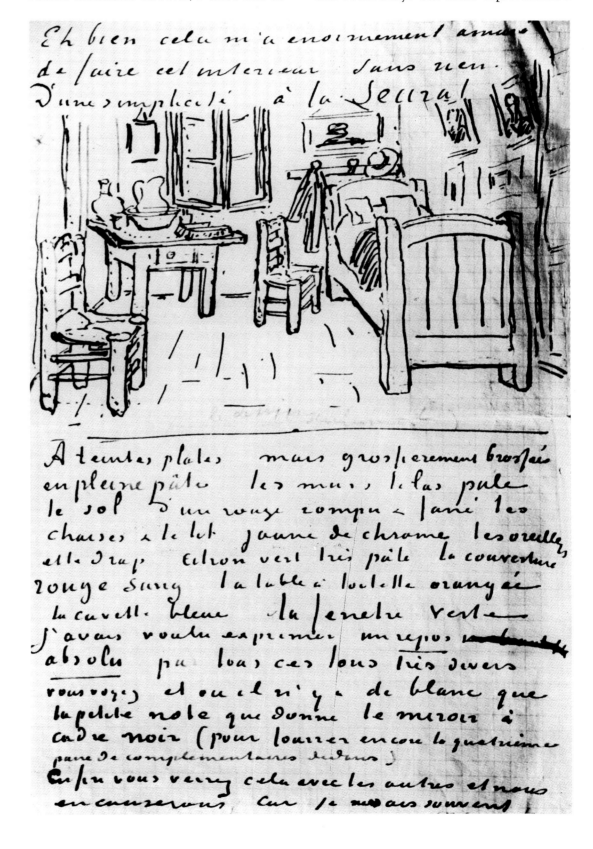

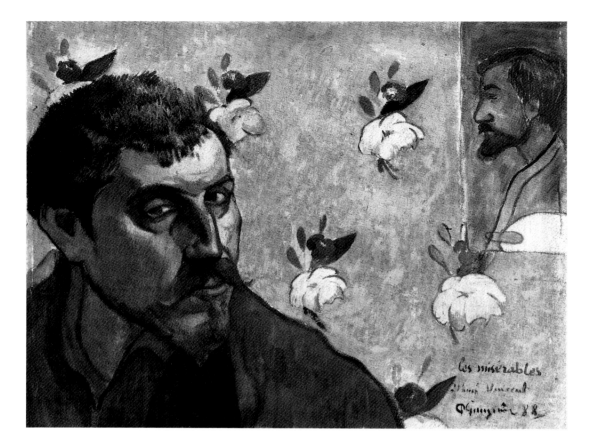

was also an equivalent of the heightened emotion engendered by total immersion, the exclusive concern with, the intensified perception of nature as color, form, and symbol. The intensity of this experience informs his comment to Emile Bernard in October 1888, 'I suffer from vertigo.'

The kind of experiences that stimulated this vertigo were frequently alluded to in his letters to Theo in the Summer of 1888 and seem to have been especially strong when he worked at Saintes-Maries-de-la-Mer in late May and early June of 1888, and in his midsummer series of Wheatfield pictures. The south of France with its stronger sensations of light, color, shadow, and definition affected him physically and he had to find an equivalent for these new stimuli. As he wrote to Theo about his Saintes-Maries pictures:

Now that I have seen the sea here, I am absolutely convinced of the importance of studying in the Midi and positively piling it on, exaggerating the color.

Although the technical control of his pictorial means, especially color, still preoccupied him as it had in Nuenen, and the balancing of what he considered to be essential colors in a composition (in the summer of 1888 these were red-blue, yellow-orange, lilac-green) was to remain central to his art, it is clear that by the time he was in Arles his concerns were far wider than in the earlier period. Color was intended to be suggestive as well as harmonious. He looked to Delacroix and Monticelli, both of whom had painted subjects in the south, as models for this.

Van Gogh also brought value and meaning to what he saw, and embodied this in his representations. His paintings were clearly a mixture of spontaneity and calculation. The motifs he chose were intended to have symbolic value, either to evoke something existing in memory or to gain access to an abstraction, to an idea. In a letter to Theo of early September 1888 he makes this clear:

To express hope by some star, the eagerness of a soul by a sunset radiance. Certainly there is no delusive realism in that, but isn't it something that actually exists?

The imitation of 'delusive realism' ignores the multiplicity of cognitive and representational processes that constitute our comprehension of the world and is as a consequence inadequate. Van Gogh had to depart from realism in order to represent those processes.

The Wheatfield and Market Garden pictures with their associated themes of sowing and reaping elaborated several of the major thematic concerns in Van Gogh's work of the Arles period. These included the cyclicality of harmonious labor and its relation to the life cycle. The problem of the work ethic in both a primitive and modern society had preoccupied major symbolist artists like Gauguin. Van Gogh developed his own imagery in the light of their ideas and also those of fashionable social philosophers like Thomas Carlyle.

The idea that the artist was also a worker in society, even if by their example rejecting bourgeois values, was widely held in the Symbolist and Neo-Impressionist circles. Van Gogh, like his contemporaries, formed clear ideas about the social function of the artist. The artist could bring consolation and solace to a disturbed

society by providing images of harmony and order against anarchy. In Van Gogh's terms this meant opting for conservative, rural models for society, based on a mixture of secularized Christian and Syndico-Anarchist values. Artists' colonies and the works they produced could also act as models for new social and moral values – the artist and his special perception could become a model for society. With these aims in mind Van Gogh wanted to found a School of the South in Arles. He hoped to use Theo as co-ordinator, which in reality he already was, and expected to found the new school on the co-operative efforts of Gauguin, Emile Bernard, and himself. He also hoped to found a school of the North in the Borinage to contrast the values of industrial and rural society, the Mediterranean, and Northern Europe. This attempt to found a new school based upon a particular regional grouping was not unique, although its grandiose aims did distinguish it from many contemporary artists' colonies. When Gauguin joined Van Gogh on October 20th he arrived from Pont-Aven in Brittany where he had assumed the leadership of a group of Symbolist artists. He clearly expected to assume a similar role in Arles. Van Gogh deliberately ignored Gauguin's grudging compliance with his requests to come to the south and went to great lengths to prepare his studio in the Yellow House for the foundation of the new School of the South. He had considerable grounds for optimism: the co-operation between Gauguin, himself, and Bernard had reached the point where they were exchanging self-portraits, apparently a move towards group identity.

If Van Gogh had looked more closely at Gauguin's self portrait *Les Miserables* he might have been less optimistic. He might have realized that his temperament and Gauguin's were not compatible. He might also have realized that his position on epistemology, nature, and expression were in many ways strikingly different from Gauguin's by the end of the summer of 1888. By the time he had completed the series of Wheatfields, the Sunflowers, and the quill pen drawings of Le Crau he had become concerned with a form of heightened and perpetuated immediacy of sensation which revealed the truth and authenticity of experience – 'The real character of things' – and reflects his understanding of Thomas Carlyle's theory that the whole of Nature is composed of symbols which allude to the presence of Divinity (In Van Gogh's case

this did not, by 1888, imply a Christian God). This had been something he had been preoccupied with since his Nuenen period. The means by which this was to be achieved assumed great importance in his work as meaning could not be divorced from the language of representation.

It has already been indicated that Van Gogh had experimented with the heightening and deforming of color, seeing it as both 'invoking' abstractions and as a symbol. He also realized that pictorial space construction could express 'the character of things.' In *The Night Café* of September 1888, and in the two versions of *The Sower* of November 1888, dramatic perspectives serve to isolate and destabilize figures and were expressive rather than descriptive devices, especially when measured against Van Gogh's increasing emphasis on the surface value of paint on the canvas.

Gauguin immediately set about pushing Van Gogh away from his practices of the summer. His paintings in Arles were frequently a critique of Van Gogh's methods, especially the latter's stress on the direct confrontation with nature. For Gauguin memory and imagination were essential to the expression of the idea and that fall he engaged in developing a wide range of anti-naturalistic devices to facilitate this in terms of representation. This should be seen in the context of his discovery of Bernard's Cloisonnism in the summer of 1888 and his development of this style into his far more abstract and esoteric synthetism. Van Gogh was a perfect sounding-board, although not always a willing one, and tried to modify this method in line with Gauguin's teaching. Gauguin's stress on esoteric symbolism, arbitrary color, and flat, decorative surfaces all found echoes in Van Gogh's work, especially in pictures like *Memory of the Garden at Etten* of November 1888.

An essential factor in Gauguin's development of Cloisonnism and Van Gogh's use of heightened color and expressive line, was the emphasis on the decorative qualities of painting. The stress on the functions of decoration was an important part of Parisian Symbolist theory and practice from the mid-1880s to the end of the century. Its anti-naturalistic qualities were seen as means of expressing the artist's subjectivity. The idea underlying the object depicted, and articulating concepts such as synthesis (synthèse), mystery (mystère), and dream (rêve), were all

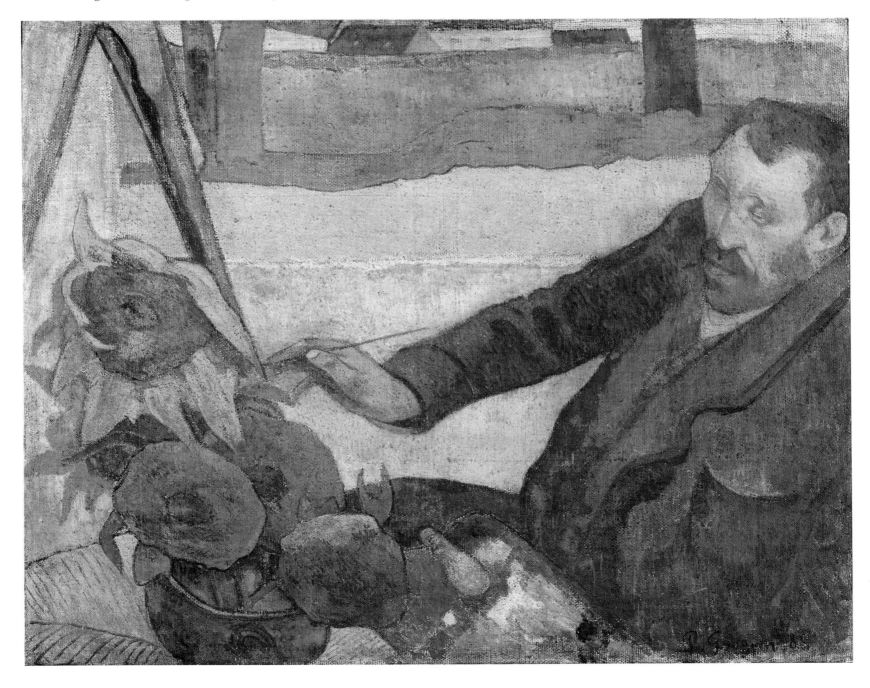

Below: In April 1888 Van Gogh sketched out this project for an *Orchards in Blossom* triptych (see page 92).

essential formulae for the Symbolist aesthetic. Each in their own way provided a means by which allusions could be made to the underlying structure or meaning of reality. As the critic Julius Meier-Graefe wrote in an early biography of Van Gogh:

'An artist of today can make good his endeavor to find in chaos rhythmic order . . .'

thus indicating that decorative harmony in painting also contained value; in this case, of social harmony.

Van Gogh saw decoration as a means by which a great new school of art would be born and when Gauguin eventually arrived in Arles on the 20th October he made sure that their lodgings at the Yellow House were appropriately decked out with decorative schemes. From the beginning of the year he had been interested in arranging his paintings in the form of triptychs. In April he had sketched out a project for an *Orchards in Blossom* triptych and in late May the following year he planned another

consisting of two *Sunflowers* paintings on either side of *La Berceuse*. The format, essentially decorative in terms of carefully contrived related harmonies of color across the pictures, lent a quasi-religious significance to what were apparently secular subjects. The decorative arrangement of the pictures indicated to the viewer the way in which the image should be read. The conception of a vast series of decorative paintings dominated Van Gogh's whole production in 1888. On the 16th June he wrote to Theo about the relationship between the various subjects he was attempting to paint. In the spring he had painted the *Orchards* in the color harmonies of white and pink, in the summer he had painted the yellow *Wheatfields* and the blue seascapes (*Marines*) and in the fall he wanted to paint vinyards with what turned out to be predominantly yellow and red harmonies. The seasons and labors of the year were harmonized by a vast scheme of decorative color organization. Decoration on this scale provided a symbol for cosmic

harmony. As he said in his letter it 'will give the whole scale of the lyre.'

Many of his works of late 1888 and early 1889 reveal an increasingly emphatic use of anti-naturalistic decoration. This is especially clear in the *Alyscamps* series of November 1888, and the portraits of Mme Augustine Roulin (*La Berceuse*) and Joseph Roulin of January-February 1889.

Van Gogh's portraiture in Arles was still coming to terms with the consequences of a proposal made by Baudelaire in *The Painter of Modern Life*, where he stated that the ephemeral world of appearance should reveal something of the eternal through means of 'correspondences.' His *Portrait of the Poet Eugène Boch* of September 1888 attempted to show something of the visionary quality of the poet's 'calling,' a theme of great importance to Van Gogh in Arles, by contrasting his highly characterized features with a heavenly blue speckled with stars, which evoke the haloes in medieval and early Renaissance images of saints. The decorative background

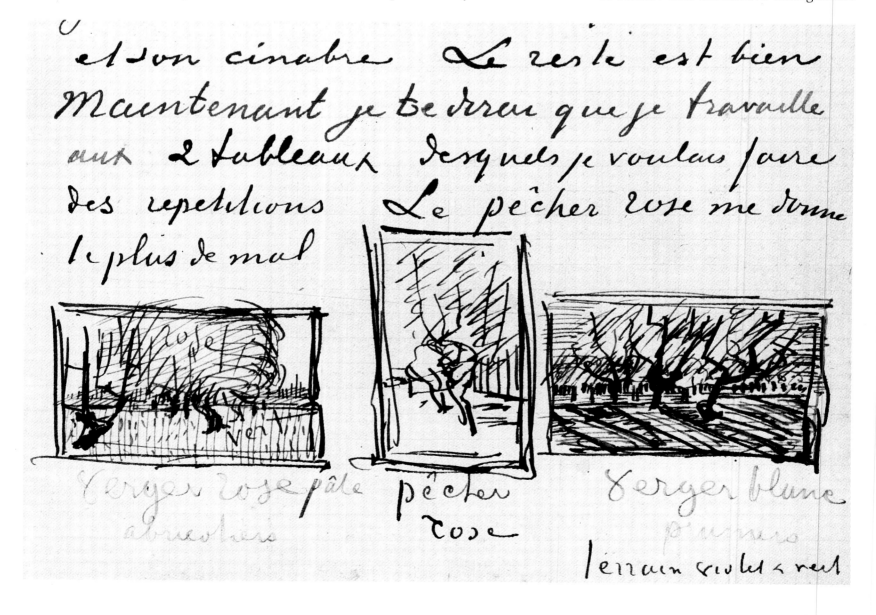

Right: A scheme of May 1889 for *La Berceuse* flanked by *Sunflowers* lends the central figure a quasi-religious air (see pages 118-120).

confronted Van Gogh's subjective deformation of the poet's features (he was not as gaunt as depicted). This process is taken farther in the Roulin portraits of January 1889 where the decorative pattern of flowers is elaborated and intensified. The decorative harmony of the floreate background together with the stress in the Mme Roulin *La Berceuse* portraits on her maternal qualities was intended to convey a sense of consolation to the viewer. Her maternal function also approximated the functions of the Virgin Mary in religious imagery. As the centerpiece of a projected triptych the decorative patterns of flowers, color, and lines would have dominated the para-mythic triptych and would have evoked meaning, almost subliminally, rather than stating it overtly, which would have reduced the range of meaning.

Like many artists in the 1880s Van Gogh saw a parallel between the decorative aspects of the new painting and music. Musicality was an important element in Arles and subsequent periods of his activity. Painting like music should evoke emotions by the rhythmic use of line and color, and like music it could achieve a culminative effect by orchestrating the related harmonies of series of pictures.

The major inspiration for the Symbolists ideas on musicality was Richard Wagner. Van Gogh had first been introduced to his work in Nuenen but his interest was quickened in Paris, where magazines like *La Revue Wagnérienne* exerted a major influence on the Impressionists and Symbolists. The Wagnerian theory of the total work of art, the 'Gesammtkunstwerk,' derived from his development of the music-drama, was seen by Van Gogh and many other Symbolist painters in the mid 1880s, to have considerable application to the visual arts. The joint studio in the Yellow House at Arles was to be decorated with, among other works, a series of twelve panels of *Sunflowers* which Van Gogh described in a letter to Theo of late August 1888:

the whole thing will be a symphony of blue and yellow.

This symphony of color was intended to heighten and suggest emotions to the viewer in much the same way as music did to the listener. The repetition of the theme would create a pervasive mood in the same way that Wagner's music was associated with specific qualities – comfort, consolation and love – and it was these qualities that the artist evoked in paintings like *La*

Berceuse and *The Poet*. Underlying this theory of a Wagnerian total work of art is the belief in the power of synesthesia, the registration of one sense phenomenon in terms of another. Van Gogh seems to have experienced this before he had encountered Wagner's theories – he constantly described both line and color in terms of musical analogies. In a letter to Theo written on New Year's Eve 1881-82, from The Hague, he described the drawing techniques of artists he admired in the following terms:

Some artists have a nervous hand at drawing, which gives their technique something of the sound peculiar to a violin, for instance, Lemud, Daumier, Lancon – others, for example, Gavarni and Bodmer, remind one more of piano playing. Do you feel this too? Millet is perhaps a stately organ.

It has already been suggested that Van Gogh was constantly structuring his identity in direct response to his changing relationship with his family. The concern with the family was a theme in both his Nuenen and Arles periods. In Nuenen the peasant and weaver families were seen as signs of a social order under threat. The theme of the family as a model for social coherence also emerged as an important element in late nineteenth-century French avant-garde art. Thus when Van Gogh returned to the subject in the Arles Roulin pictures and later at St Rémy in March and April of 1890 in the series of drawings associated with 'the reminiscences of the North' paintings, he was able to integrate both private and more broadly social concerns for consolation and harmony. It also provided a symbol for a natural, cosmic

order and continuous birth, growth, decay, and death.

The woman's role in the family was of central importance to his organic view of society. In the company of Symbolist artists like Maurice Denis and successful salon painters like Eugène Carrière, he stressed the role of woman as mother, and when they were not peasants, as in the portraits of Mme Ginoux of October-November 1888, their respectability for his profoundly misanthropic view of human nature is not genteel, as his painting *The Night Café* reveals. Here Mme Ginoux, wife of the bar owner depicted in Van Gogh's *The Night Café*, is shown as arch and knowing in a similarly hellish atmosphere to that of Van Gogh's painting. No pious respectability here. Van Gogh did not restrict himself to the two formulations of the woman mentioned above: he went out of his way to show the value of the rural proletarian as well as the bourgeois female; the former, if only because of her status, was closer to the earth. In spite of this he frequently conformed to the same gender stereotypes. The family and the woman in her various roles underpinned an organic continuum which resisted an increasingly anarchic and fragmented society.

On the 23rd December 1888 Van Gogh threw a glass at Gauguin and then pursued him with a knife. The following night he cut off the lobe of his left ear and sent it to a prostitute in the local brothel. He was admitted to hospital in Arles and remained there until the 7th January. Gauguin left almost immediately after the incident and the hopes for a School of the South were destroyed. The cause of Van Gogh's illness is still obscure, although alcoholism and

schizophrenia seem to have contributed a great deal to it. From an early age he had been emotionally unstable, a factor particularly noticeable in his impulsive relationships with women, his aggressive, overemphatic statements of his views, and in his constant sense of being an inferior outsider in all matters concerning the visual arts. He was difficult to live with, humble, charming, resentful, and angry by turns. Even his brother found living with him a strain, and it is thus no surprise that the tensions of living with Gauguin brought matters to a head. The tension created by a mixture of humility and resentment was virtually unavoidable given Gauguin's abrasive character and Van Gogh's preconceptions about himself and Gauguin.

The initial attack was not taken too seriously by the local population, but after having suffered for some time from insomnia and hallucinations he had a second serious attack on the 9th February 1889. He sought both medical help from Dr Felix Rey and spiritual guidance from the Protestant pastor in Arles, Pastor Salles. The local council demanded Van Gogh's incarceration in a hospital for the insane, on account of his continuing unstable condition. Eventually, under the guidance of Pastor Salles, he voluntarily committed himself to the asylum of Saint-Paul-de-Mausole, Saint-Rémy, a few miles from the town of Arles.

The petition and the voluntary commitment reveal the conflict between society's definitions of acceptable behavior and madness and the isolated behavior of an individual who had constructed his value system within the ambiguous alliance of bourgeois Christian values and the existential freedoms claimed by the artistic avant-garde of the intelligentsia. As such, the conflict reveals that social and institutional norms of bourgeois culture in the late nineteenth century were *creating* categories of opposition by the process of exclusion. In Van Gogh's case this process of exclusion is particularly ironic because of his emphasis on social and spiritual harmony in his art. He was providing a model for a society that could overcome what he saw as loss of coherence, order, and direction, and yet he was seen by the bourgeois as an agent of disruption.

Conditions in the asylum of Saint-Paul-de-Mausole were not of the best, especially with regard to the treatment regime. Most of the day inmates were allowed to vegetate, no therapeutic labor being provided. Van Gogh commented on their brutalized state and found it hard to consider their inactivity, trivial pleasures, and gluttony as anything more than bestial.

Even in the world of the institutionally ostracized he found no sense of belonging. This psychological alienation was remarked upon by the artist himself. One

Right: In 1890 Van Gogh had a major revival of interest in scenes of rural labor, an interest reflected by these Jacques Lavieille wood engravings after Millet.

Below: Van Gogh voluntarily committed himself to the asylum at Saint-Rémy, after recurrent bouts of mental illness. He stayed for nearly a year.

also sees a sick member of the intellectual middle classes confronted with sick members of the lower orders and not even finding a sense of community in shared misfortune and distress.

Initially his illness was so severe that he was not allowed to paint, although later when he was somewhat recovered and experiencing long periods of calm and lucidity he was allowed to set up a studio in an unoccupied room next to his own. Van Gogh's painting during the period of his voluntary incarceration at St-Rémy falls into distinct categories and reveals his characteristic vigor in his manipulation of both means of expression and the themes he chose. He never painted when laid low by his illness. His paintings are never out of control. The works conform to a pictorial order which has been defined as a characteristic of Expressionism; the deliberate accentuation of intense emotion which has to conform to the ordering and articulating norms of a language of representation. This creates works of art which utilize controled formal devices to create the sense of spontaneous and emotional outpouring communicated with great intensity to the viewer and demanding an equally intense response. At St-Rémy Van Gogh's paintings of motifs, as opposed to copies, are conflations of intense immediate experience (not unlike that suggested by Gauguin in his advice to Paul Sérusier when painting *The Talisman* in the fall of 1888), memory (frequently of disturbed states) and rational control of the means of expression. In the light of this it is unsatisfactory to consider Van Gogh's art at St-Rémy and later at Auvers-sur-Oise as being crudely defined psycho-biography. His paintings are not simply symptoms of neurosis or schizophrenia. If they are, the disturbance is on a far longer and more profound scale than the acute, localized traumas of late 1888 and early 1889, when he was in Arles.

Psychoanalytic method can most effectively be applied to Van Gogh's work as a model for understanding the structures of his whole production. Even then it cannot be safely isolated from other factors like the self-consciousness of art-making which dominates his correspondence, conscious and unconscious social, ethical, and historical factors, and the particularities of the languages he employed at any one time and place. It has already been suggested that many aspects of his work were part of an elaborate system of compensation and

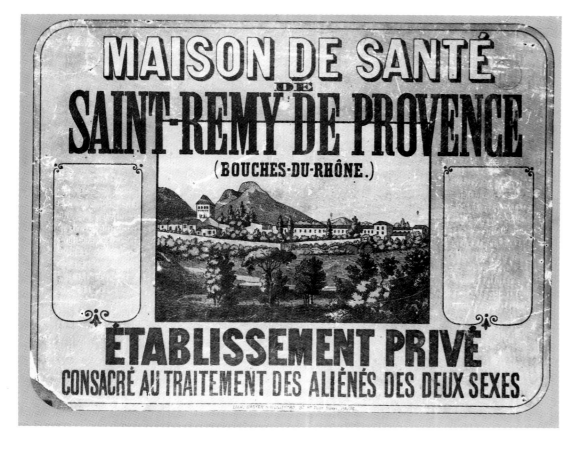

MAISON DE SANTÉ
DE
SAINT-REMY DE PROVENCE
(BOUCHES-DU-RHÔNE.)

ÉTABLISSEMENT PRIVÉ
CONSACRÉ AU TRAITEMENT DES ALIÉNÉS DES DEUX SEXES.

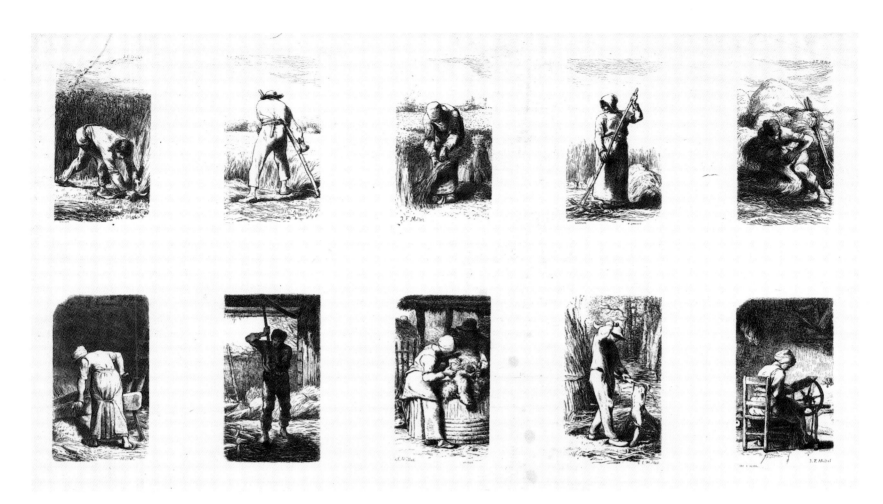

displacement. This is particularly evident in his use of subject matter, Mme Roulin as the mother he has lost, Gauguin's chair as the compromised authority of his father, and so on. This would imply suppression but at the same time an attempt to come to terms with the world of his psyche. Painting can be seen as a form of healing and adjustment to the realities of the world, not simply as the Freudian concepts of symptom and wish fulfilment.

It has also been convincingly argued by Meyer Schapiro that Van Gogh's painting was a form of catharsis, conforming in part to an expressionist theory of spontaneous release. Schapiro uses this method to illuminate the difference between the unstable space in *The Artist's Bedroom* painted in Arles in October 1888 and his statement in a letter to his brother that it was an expression of 'absolute repose.' In Schapiro's argument repose comes after the act of painting, the expression is therefore achieved as a conseqence of the process of representation. It can be argued, on the other hand, that Van Gogh's paintings are a field of tensions more or less successfully held in equilibrium. The characteristics of these tensions frequently display the features of a creative personality with a strong manic-depressive element in it. Some of the copies of the artist's work done at St-Rémy are particularly revealing in this light where elements of aggression are displayed in the markings on the canvas and the themes are of gentleness and consolation. The *Pietà after Delacroix* of 1889 is an eloquent example of this.

Another suggestion that Van Gogh's 'intensity' of expressive vocabulary – the need to make paintings appear spontaneous outpourings – is a form of modified sexual activity, particularly masturbation, may well be correct within its own terms, but it does not mean that Van Gogh's art is simply a private means of channeling neurotic, masturbatory behavior. The apparent freedom of brushwork owes at least as much to the artist's knowledge of the Impressionists' artifice creating apparent spontaneity, as it does to any symptoms of neurosis. His 'messing' with heavy and elaborate textures of oil paint may also suggest an anal component in his work but as such it tells us nothing of intrinsically greater importance than other systems of knowledge. Its excessively normative approach may well reduce our understanding to a level of generality which makes it unilluminating.

Initially Van Gogh was too ill to paint at St-Rémy and it was only gradually that he started to work again. Views of the asylum and its garden, landscapes of olive groves, enclosed wheatfields, and the mountains of Les Alpilles, copies of Millet, Delacroix, Doré and of his own works, and finally drawings of peasants and cottages related to Northern themes dominated his work at this time.

The copies occupy an ambiguous place in Van Gogh's work and thinking at this time. On one level they appear to contradict his insistence upon direct experience of nature, and were clearly a substitute for having no models or motifs to work from. On the other hand they assumed a positive value in that the process of working proved to be consoling as did the selection of themes which were taken from prints after the works of artists he had admired throughout his working life. As such they represented the reworking of old values. They had the consoling function of reiterating 'constant' spiritual and social values derived from masters whose status and value were beyond reproach. They also reaffirmed Van Gogh's status as artist, an essential factor in his identity since 1885.

Van Gogh's copies were not crude reproductions of originals, crude plagiarism, although the artist had occasional qualms of conscience on this count. They acknowledged a tradition and provided a base for innovation. From the outset they involved a creative choice in the transformation of medium from black and white prints to oil painting. He considered them to be interpretations in the sense that a musician interprets a score. This musical analogy is further alluded to when he wrote to Theo that ' . . . I improvise color' Like a musical performance the contribution to the work of art is shared, that in this case the sharing is uncompromisingly on Van Gogh's terms. The color evokes the artist's feeling and emotion when confronting the prints. As he wrote to Theo in November 1889 of his copies of Millet's *The Sower*, after an etching by Paul Edme La Rat: 'It seems to me that working from these drawings of Millet's is much more *translating them into another tongue* than copying them.'

25

These translations and memories with their consonance of emotion and formal qualities had a tangible starting point, and it is clear that the issue of tangibility, grasp, and the substantiality of the world were of the greatest importance to the arist by late 1889 and remained so until his death at Auvers-sur-Oise in late July 1890. Although this is evident in copies like *The Sheaf Binder* of early 1889, it is even more noticeable in the landscapes produced in the period from June 1889 to March 1890.

The fear of 'abstraction' is at the heart of the issue of tangibility and came to a head in his correspondence with Theo and Emile Bernard, over pictures that Bernard and Gauguin were painting in the fall of 1889. (Any suggestion that Van Gogh was a 'madman' incapable of anything other than purely subjective and irrational modes of understanding and therapeutic painting is clearly invalid in the face of this highly sophisticated response to the aspect of current Symbolist practice). In a letter to Theo of mid-November he took issue with their *Christ in the Garden* on the grounds that they were not properly observed. As such they had the intangibility of a 'dream or nightmare.' This was opposed to the more healthy, a term he frequently used in aesthetic debate, process of thought which was based on experience and sensation. He commented in a letter to Bernard that he found his erudite archaisms, derived from the study of Early Renaissance and Medieval art the product of an intangible and inauthentic emotion, and esoteric and artificial culture. For him immersion in nature was a necessary starting point, not in terms of the crude rendering of experience of an exclusively Impressionist subjective response to light on form, but as a necessary broadly comprehensible source of themes which would embody in representation the moral and spiritual aspirations of modern humanity and as such they would function both as 'real' and as symbols. The representation would also reveal the character of things, embodying a distinctive meaning in themselves. As he wrote to Theo in mid-November 1889 with reference to his painting of olive and cypress trees:

The olive is as mutable as our willow or pollarded osier in the north, you know the willows are very striking, in spite of them seeming monotonous, it is the tree in character with the country. Not what the willow is at home, that is just what the olive and the cypress signify here. What I have done is rather hard and coarse realism beside their abstractions (Bernard's and Gauguin's work) but it will give the feeling of the country and will smell of the soil.

Confrontation with nature represented vitality and immediacy and would produce thought, which was the painter's duty as opposed to the treacherous, intangible and incomprehensible world of dreams. This association of Nature, thought, virility and the artist's duty reveals another important factor. Nature is something which is taken as the irreducible base of experience and as such is the ultimate frame of reference representing the base for the artist's value system. At the same time it is something to be fought with revealing the artist's power to see it and its meaning more clearly. This process reveals strength and consequently health (as opposed to the unhealthy dreams produced by abstractions). This masculine, Herculean view of the artist's struggle with Nature gives him the ability to discern both the permanent and fleeting but often characteristic qualities of things. It is also a struggle to represent the world in the form of thought, the essential ordering function of the mind. The artist is not simply a passive observing subject, but through the cognitive structures of his subjectivity which are stimulated in the presence of the motif he achieves a creative understanding of the object. This greater understanding engenders an urgent need for expression which is articulated

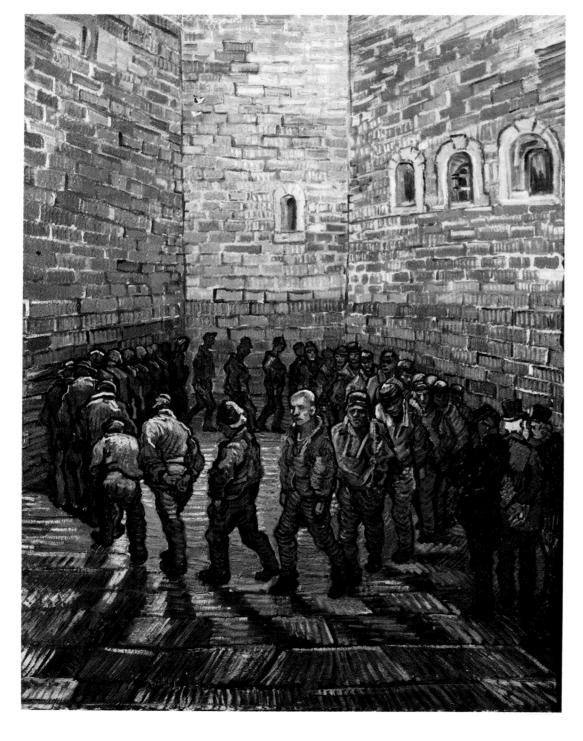

through the pictorial 'means' which simultaneously articulate the language understood as 'painting,' the language which is a sign for expression, the emotion engendered by the perception of the motif, the signs which render the seeing (in the fullest sense) of the motif, and a recognizable equivalent of the motif.

In addition to this, many of Van Gogh's landscape subjects, like the olive groves and cypresses, evoke responses based upon literary and historical culture. The olive trees are both characteristic of Provence and indirect references to the Biblical theme of Christ's Agony in the Garden. The cypresses are traditionally associated with death. Van Gogh's virile struggle with nature and coarse realism was not as antithetical to the construction of metaphors with an historical and symbolic content as he would have had his

correspondents believe. By stressing the material and health base for thought he is trying to align his production with the broadest possible range of comprehension, overcoming his own alienation by means of communication, even where that theme is the major idea behind his work, as in the enclosed Wheatfields and the most dramatically distorted views of Les Alpilles. The degree to which Van Gogh's rendering of the intensity of perception was intentional as opposed to being unreflexive and spontaneous is shown by his very obvious choices of language of expression. This has already been indicated with regard to his choices of color in his 'copies' at St-Rémy. It is also clear in a letter he wrote to Theo, from St-Rémy on 9th June 1889:

When the thing represented is, in point of character, absolutely in agreement and one

with the manner of representing it, isn't just that which gives a work of art its quality.

The omnipotence of the artist's control implicit in this statement anticipates Matisse's theories of expression as presented in *The Notes of a Painter* of 1908. For Van Gogh form and idea must be in total harmony for a work of art to be successful. It was therefore impossible for him to work at times of intense emotional disturbance. When he felt calmer, work was frequently a means of objectification, supporting him, and keeping the most intensely destructive forces at bay.

Living in the South, isolated in the asylum of St-Rémy, Van Gogh felt a long way from everything he had once known. He was disdainful of the maneuverings of the Parisian art world, especially of Gauguin's 'Groupe Impressionniste et Synthetiste'

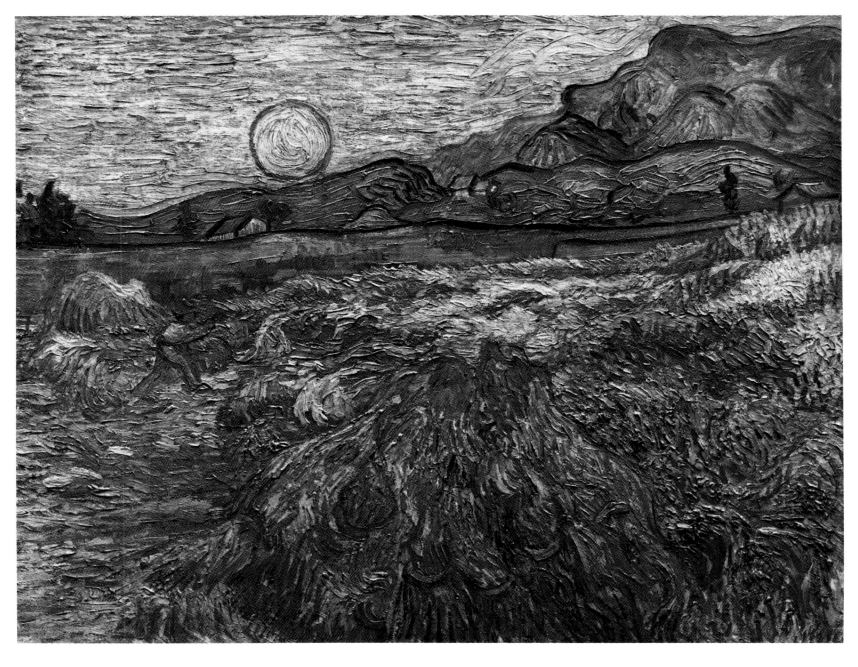

Right: *Green Wheatfields, Auvers* was painted in July 1890, the month of Van Gogh's death.

Below: A photograph of the 1930s showing the room in which Van Gogh died in Auvers.

exhibition at the Café des Arts, known as the Volpini exhibition after the owner of the Café. Above all he felt intense nostalgia for Holland and the Brabant countryside in particular. The landscape around St-Rémy may have reminded him of a 'Ruysdael but without laborers,' but it could not compensate for the intense longing he felt for the north. In an extensive series of drawings and paintings of March and April 1890 he recalls Dutch rural life, occasionally in winter scenes, populated with peasants, working in the fields or at home at their cottages, echoing his concerns of the Nuenen period. These were done, exceptionally in his career, at a time of extreme mental distress.

When he recovered, the two brothers decided that it would be better for him to return to the north. He left St-Rémy and arrived in Paris on 17 May 1890. Three days

later he left for Auvers-sur-Oise where he stayed, under the supervision of Dr Paul Gachet, at a local inn. Gachet was an eccentric homeopath with a passion for the visual arts and a talent for etching. The doctor and the artist were not particularly close. Van Gogh felt that Gachet did not value the works in his collection sufficiently; but they did attempt to co-operate on a series of etchings after paintings by Van Gogh.

The village of Auvers had many artistic associations and these played an important part in Van Gogh's own production. Cézanne and Pissarro had both stayed with Gachet, but more important for Van Gogh, Daubigny had lived in the village, and his widow still did. Daubigny represented the enduring value of the older generation of French artists that the Dutchman had always admired. He stood on the same

level of achievement as the other great artists of the 1850s and 1860s, such as Théodore Rousseau, Jules Dupré, and especially J F Millet. Van Gogh felt that their achievements and those of the great Romantics like Delacroix would outlast those of the younger Impressionist generation. In one of his earliest letters from St-Rémy he had seen these artists, especially Daubigny and Rousseau, as:

expressing all that it (the vastness of the landscape before dawn) has of intimacy, all that vast peace and majesty, but adding as well a feeling so individual, so heartbreaking.

He added: 'I have no aversion to that sort of emotion.'

The intimacy of Auvers and the vastness of the surrounding wheatfields would once again 'evoke that sort of emotion.' He was also aware that the village was a changing

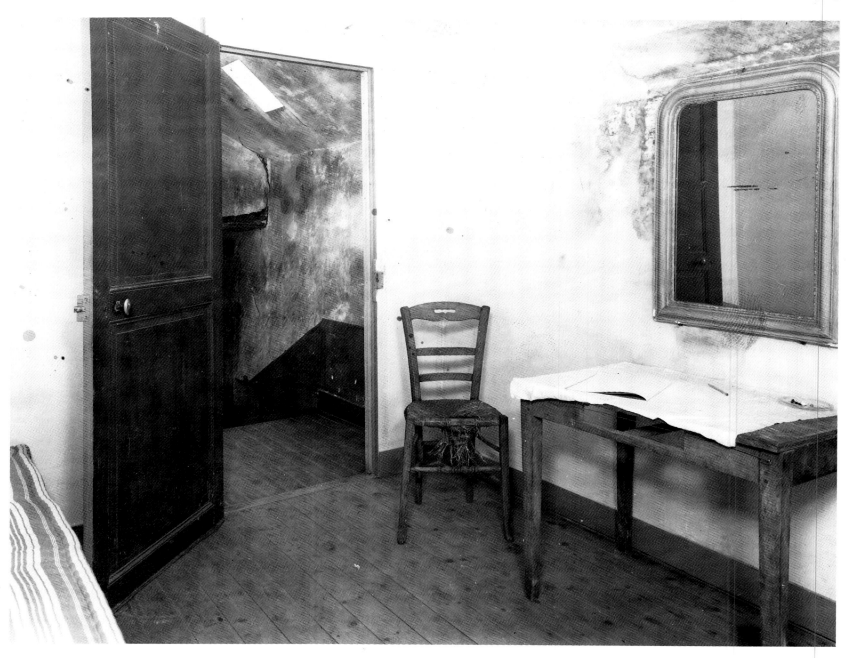

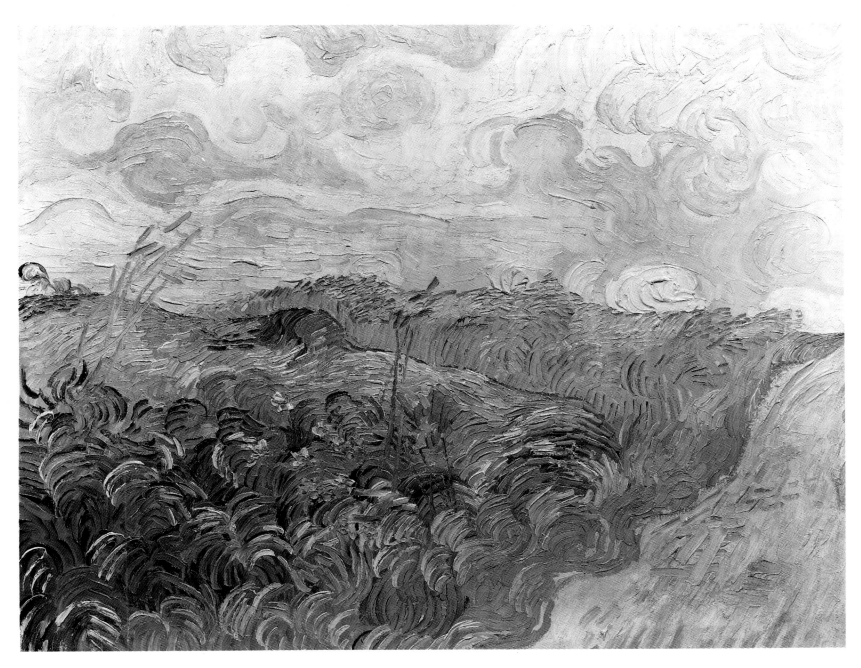

society. He wrote to Theo and Jo in late May, that it was 'real country,' but had changed since Daubigny's time. He continued:

This is an almost lush country, just at the moment when a new society is developing in the old, is not at all unpleasing; there is much well being in the air. I see or think I see in it a quiet like that of Puvis de Chavannes, no factories, but lovely greenery in abundance.

He could see abundance and rest in the village through his understanding of the art he associated with it. Similarly, he could associate the landscape with works by Dutch seventeenth-century masters. He chose to see the village as an intimate community in the midst of a majestic plane. This helps to account for his choice of subjects – open fields, tightly-knit village scenes, intimate and domestic portraits, and detailed studies of the smallest details of nature, in a painting such as *The Ears of Wheat* of June 1890.

In examining the full range of his subjects in Auvers it becomes clear that Van Gogh was profoundly concerned with the relationship of two qualities, the vastness

of space and the minuteness of the objects in it. This had also played an important part in the St-Rémy 'Northern' paintings (it is less obvious in the drawings). It was not a theme that was exclusively a product of his late period; space had always had expressive potential. In 1883 he wrote to Theo from the province of Drenthe:

When one has walked through that country for hours and hours, one feels that there is nothing but that infinite earth – the green mold of corn or heather, that infinite sky. However, in one's quality as a little speck noticing other little specks – leaving the infinite apart – one finds every little speck to be a Millet.

The artist and the rest of humanity are nothing but specks in this majestic, peaceful vastness of earth and sky, this could evoke an emotion which Van Gogh had characterized as 'individual' and 'heartbreaking.' In pictures like the famous *Crows over a Wheatfield* or the less well known *Roots and Trunks of Trees*, both of July 1890, the individual is totally obliterated. The artist articulates the loss of control of space, stability and the control of the elements. In Schapiro's terms the artist/

viewer becomes the vanishing point. It was the realization of the utter impossibility of resolving the paradoxical nature of the miniscule insignificance of the intimate life of individuals and the ordering of the vastness of creation that determines the character of all of Van Gogh's last works. It had tragic ramifications on all levels of creation and consciousness. The artist was fully aware of the psychic dangers of struggling with these themes. In a letter written but not sent to Theo of 23/24 July 1890, he states the theme in the following terms: 'Well, my own work, I am risking my life for it and my reason has half floundered because of it – that's all right . . .'

Three days later he left his lodgings with his painting equipment and a revolver. He shot himself, either in the chest or the stomach, exact details are not known. Early in the morning of 29th July 1890, he died with Theo by his side. He was only 37 years old. Just before his brother's death, Theo had written to his wife:

. . . poor fellow, very little happiness fell to his share, and no illusions are left. The burden grows too heavy at times, he feels so alone.

Etten, The Hague, Drenthe

The practice of copying the works of artists he admired was firmly established at the beginning of Van Gogh's career. This was, at least in part, due to the fact that he was predominantly self-taught or picked up tuition in an informal manner. *The Angelus (After Millet)* and *Worn Out* show how even the apprentice draftsman was capable of turning such didactic exercises to expressive ends.

Van Gogh placed Millet in the highest rank of modern artists. When he was in Paris in 1875 he had been to the sale of 95 pastels by Millet in the collection of Emile Gavet at the Hotel Drouot (Millet died earlier that year). He was so impressed by what he saw that, he reported to Theo, he felt like saying to the other visitors 'Take off your shoes, for this place where you are standing is Holy Ground.' Later, when he decided to go to Paris earlier than expected in early 1887, he may have been stimulated in his unexpected move by the need to see a major retrospective exhibition of Millet's work at the Ecole des Beaux-Arts.

The subject of 'The Angelus' had always had a special appeal to Van Gogh. Writing from London in January 1874, he characterized the qualities of a print after the original in the following terms: ' . . . that is it – that is beauty, that is poetry.' In both his Etten and Drenthe periods the same sense of the poetic beauty of rural labor in expressive landscapes, dominates Van Gogh's drawings and paintings. The *Two Women working in the Peat* shows this quality very clearly and also indicates how he was trying to achieve an effect of expressive contour and silhouette, a formal element that he greatly admired in the old master's work. The rhetoric of isolated figures against the vastness of space made the lot of the rural poor both resigned and heroic. This was part of a deeply nostalgic and conservative view of rural society formed by Van Gogh in the light of his own experience of rural life as a child, and his awareness of the changes taking place in contemporary society. This was given form by means of a complex fusion of the study of nature in the context a deep respect for the works of artists such as Millet and Breton, Dupré and Rousseau, and in the case of drawings like *Views of Landscape and Figures, Nieuw Amsterdam* an awareness of English popular graphics like W B Murray's *Market Gardening – A Winter's Journey to Covent Garden*, from *The Graphic* of 12 February 1876 (see page 12).

The nostalgic view of land and labor was based upon the need to retrieve certainties in a changing world and in images like *The Angelus*, those qualities were firmly present. The labors of the seasons are presented in the context of the 'timeless' rituals of religious belief providing a spiritual and temporal structure for existence. It is clear that Van Gogh was aware of these qualities in the work. He saw Millet's work as simultaneously real and symbolic. Symbols were not vague abstractions but embodiments in the material world. In *Worn Out* similar qualities are present without the direct reference to Millet. The theme alludes to the process of the life cycle and the ages of man, and yet remains firmly anchored in the study of nature. The despair at the end of life is also one old man's pathetic fatigue.

The need to study nature closely was a major concern while he was working on *Worn Out* in September 1881. He was taking informal lessons from his friend Anton van Rappard by means of letters and occasional meetings. One of the criticisms the young teacher had of his pupil's work was that he did not study nature closely enough. This pen drawing was one of a series of studies after the model that Van Gogh produced in order to rectify this shortcoming. Both the line drawing and watercolor technique are still hesitant and in his letters of this time Van Gogh is clearly aware that his facility in different media is extremely limited.

The combination of technical exercise and a concern for establishing a relationship between meaning and the means of expression characterizes one of his most important sets of early drawings, produced during the spring of 1882 at The Hague. *Sorrow* was considered by Van Gogh to be one of his best figure drawings to date. It utilizes to great effect the lithographic medium, like black chalk, a powerful means of expression. It was based on the direct study of nature, the model being Sien, the prostitute with whom he had set up home. It also reveals the impact of his use of drawing manuals, as a means of teaching himself an acceptable and current language of pictorial representation. The stark outline and angular forms of the body, especially clear in the drawing of the breasts, all speak of a manner derived from Charles Bargue's *Exercises au fusain, pour préparer à l'étude de l'académie d'après nature*, with its emphasis on the need for a clear and expressive outline. Van Gogh has clearly negotiated this hurdle with a considerable degree of success as he has created a powerful, technically competent, and accessible image.

The theme 'sorrow' shows how Van Gogh could utilize the means of expression in relation to the close observation of nature to create a symbol of a more general idea. Not only did his schooled drawing style enable him to see nature (the model) more clearly, it also allowed him to embody the broad categories of human experience. Clearly Van Gogh was not certain about how successful he had been in communicating this by the graphic means at his disposal. In both this and in the earlier *Worn Out* he provides a clue for the viewer by including the title on the page. The fact that in both cases these are in English would indicate that he had the example of English book illustrators at the back of his mind. This determination to make the meaning of the drawing explicit was taken even further in a 'worked up' version of the drawing which he gave to his brother Theo; this was accompanied by a quotation from the French writer Jules Michelet, 'How can it be that there is on this earth a woman so alone, forsaken!' This compassionate concern for the dispossessed was developed in a letter describing landscapes of

tree roots that he had done at this time, and which he specifically associates with 'Sorrow,' revealing that he considered all forms to be expressive of the human condition, not just the figure. In both sets of pictures he suggests that the theme is of a 'struggle for life,' which is expressed by means of the tenacity by which the roots and, by implication, the figure, maintain a firm grasp of the earth. This concern to maintain a hold on the tangible world as a necessary condition for continued existence returns in different forms throughout his career, and becomes a central theme in a large part of his oeuvre in Arles, St-Rémy, and Auvers, as can be seen from the *Enclosed Wheatfields, Olive Groves, Les Alpilles,* and *Open Wheatfields* series.

A firm hold on the earth and the relation between things and their representation in pictorial form, was an important factor underlying Van Gogh's interest in perspective. During his stay in The Hague he repeatedly worked on themes that allowed him to develop a firmer control of this difficult technical device: *The Road at Loosduinen* is an example. By improving his technical ability Van Gogh was also taking hold of the language of commercial and critical acceptability. He was making his works credible and saleable. His family and friends were pushing him in this direction. There was a profitable market for highly finished landscape drawings as picture dealers like Theo and Tersteeg, the manager of the Hague branch of Goupils, who were two of the artist's advisors at the time, were well aware. To aid him in the mastery of the techniques Van Gogh once again resorted to primers and copybooks, in this case Armand Cassagne's *Le dessin pour tous.* Cassagne stressed the use of the perspective frame as an aid in constructing a coherent relation of proportions between objects in a picture; he called it the 'cadre rectificateur.' Once more technical exercises were a means of 'seeing' nature more clearly, providing recipes which aided the eye, in the complex business of constructing representations of the ever-elusive reality. Van Gogh employed a variety of different perspective frames throughout his career, including the particularly complex one to be used on the dunes at Scheveningen, a fishing port just outside The Hague, and illustrated in a letter to Theo in August 1882.

The complexity of the relationships between forms in space is a major element in a drawing like *The Road at Loosduinen.* It is also clear that it provided the artist with an expressive device that goes beyond the norms of proportional relationships and the measuring of space. Here the road sweeps into space with a dynamism that completely belies the distances represented. The perspective of the road makes it go too far in too short a distance. It also serves to isolate the lone, walking figure. The device that is meant to make the world stable is engaged in subverting its own premises by destabilizing the relationship between the figure (which in Drenthe he called 'specks') and its environment. This characteristic remains a major factor in Van Gogh's pictorial language.

The perspective frame was used to make large-scale charcoal drawings which would later be worked up into oil paintings. Van Gogh clearly made a distinction, commonplace at the time, between studies or sketches and finished works. He kept sketchbooks in which to record preliminary notions. As he wrote in a letter of 1882: 'My sketchbook shows that I try to catch things in the act' and by doing this he was 'able to catch the impression.' These and larger studies in charcoal, crayon, or pencil, all done in the open air functioned to 'analyze a bit of nature,' and by so doing, get an established idea right or formulate a new one. On the other hand, in a picture which was to be put before the public, 'the painter gives a personal idea,' he adds something of his own. The idea was not, however, the equivalent of unmediated autobiography. Van Gogh was clearly aware of his public, and this imposed a need for pictorial decorum. The artist should objectify his thought, not simply pour out his emotions. As he wrote in one of his letters to Theo in the first weeks of his stay in The Hague:

'It has always seemed to me that when an artist shows his work to the public, he has the right to keep the inner struggle of his private life to himself (which is directly and inevitably connected with the peculiar difficulties involved in producing a work of art) . . .'

This balance was to change in Arles and St-Rémy, but it was never ignored. Van Gogh was concerned with making mediated statements within the parameters of value which he understood to define the work of art.

In The Hague Van Gogh produced some of the most innovative drawings of his career, the two sets of six views of The Hague (see page 9) commissioned by his uncle, the picture dealer C M Van Gogh. They were remarkable because, as Griselda Pollock has pointed out, they resist the acceptable and saleable categories of urban and rural landscape being developed in The Hague at the time. They are uncompromising both in the nature of their suburban themes and their rejection of established strategies for the representation of the city as in Mesdag's famous panorama of the port of Scheveningen.

The large-scale charcoal drawings Van Gogh made of the poorest quarters of The Hague and its inhabitants, *Orphan Man with Top Hat and Stick seen from the Back, Man Digging seen from the Back,* and *Woman with Child on her Knee* are equally remarkable. These were intended to be studies, concerned with nature and the study of individuals. As he said of his drawing of early May 1882, they are 'the work of my model and me.' These individuals were, nevertheless, seen from a distant viewpoint which had both aesthetic and social connotations to it. On the one hand, Van Gogh repeatedly writes of the poor as 'types,' thus part of a class of beings other than oneself, individuals and yet from the point of view of the artist/viewer, not individuated. The middle classes encounter the poor as something other than themselves. This concern for types could also 'transcend' the individuals who created it, a type as a transcendent quality that went beyond nature to express its essential qualities, rather than merely its appearance.

Van Gogh made this clear when he wrote about it to Theo on 3 January 1883:

. . . something quite different should finally result from the many studies, namely the *type* distilled from many *individuals.*

That's the highest thing in art, and *theme* sometimes rises above nature – in Millet's 'Sower' for instance, there is more *soul* than in an ordinary sower in the field.

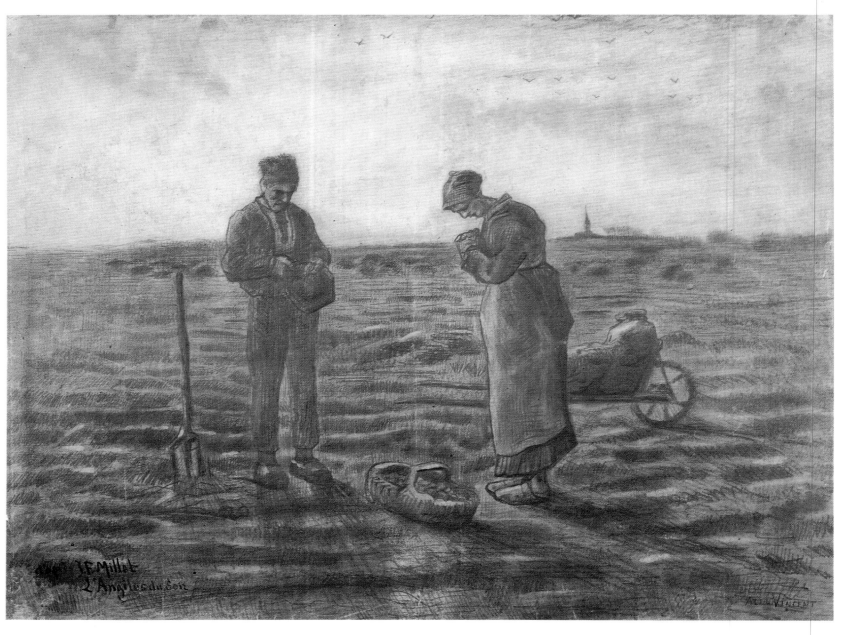

The Angelus (after Millet) October 1880
Pen and wash heightened with green and white
19×14½in (48×36.5cm)
Rijksmuseum Vincent van Gogh, Amsterdam

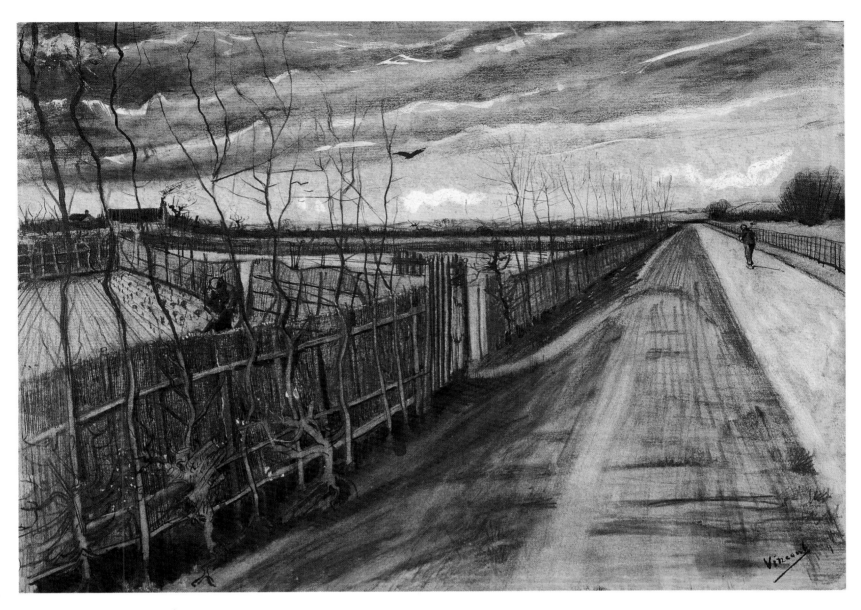

Road at Loosduinen March 1882
Black chalk and pen heightened in white
10¼×14in (26×35.5cm)
Rijksmuseum Vincent van Gogh, Amsterdam

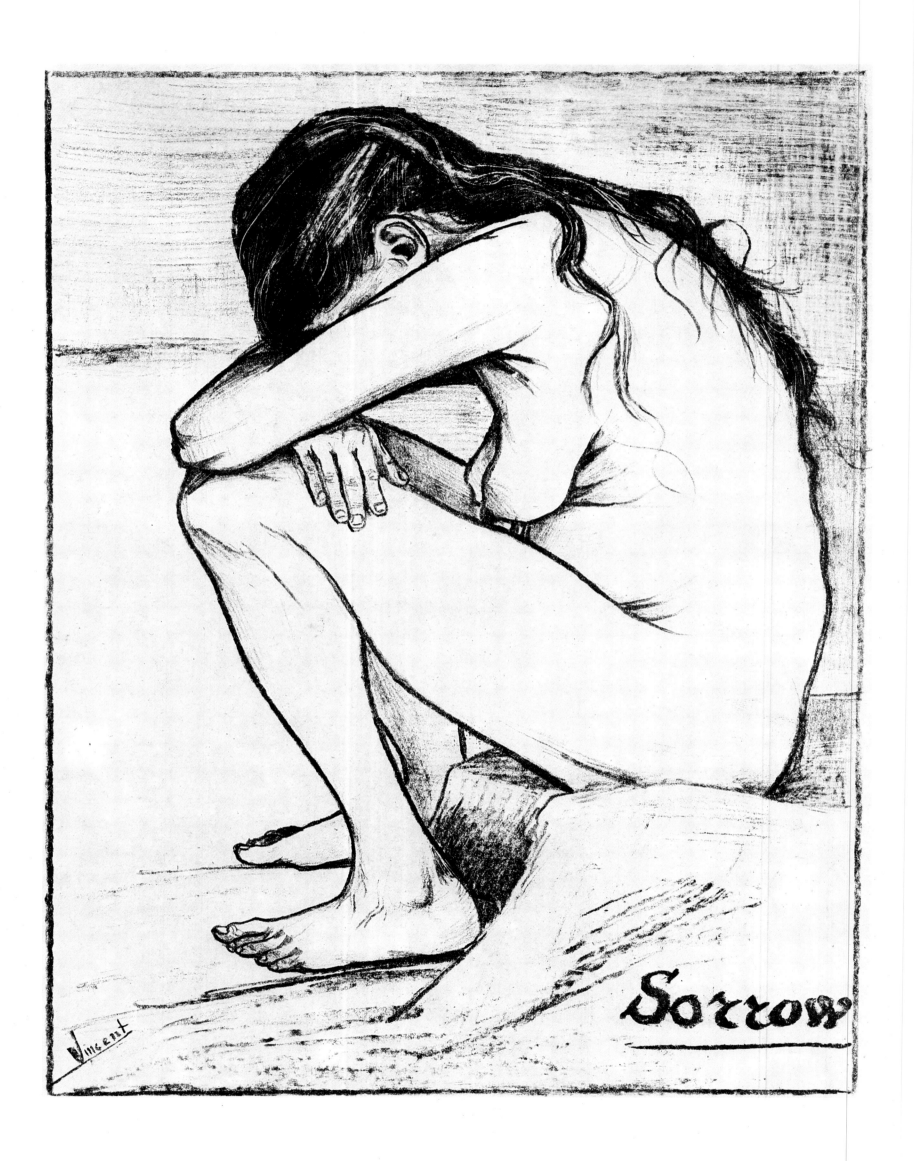

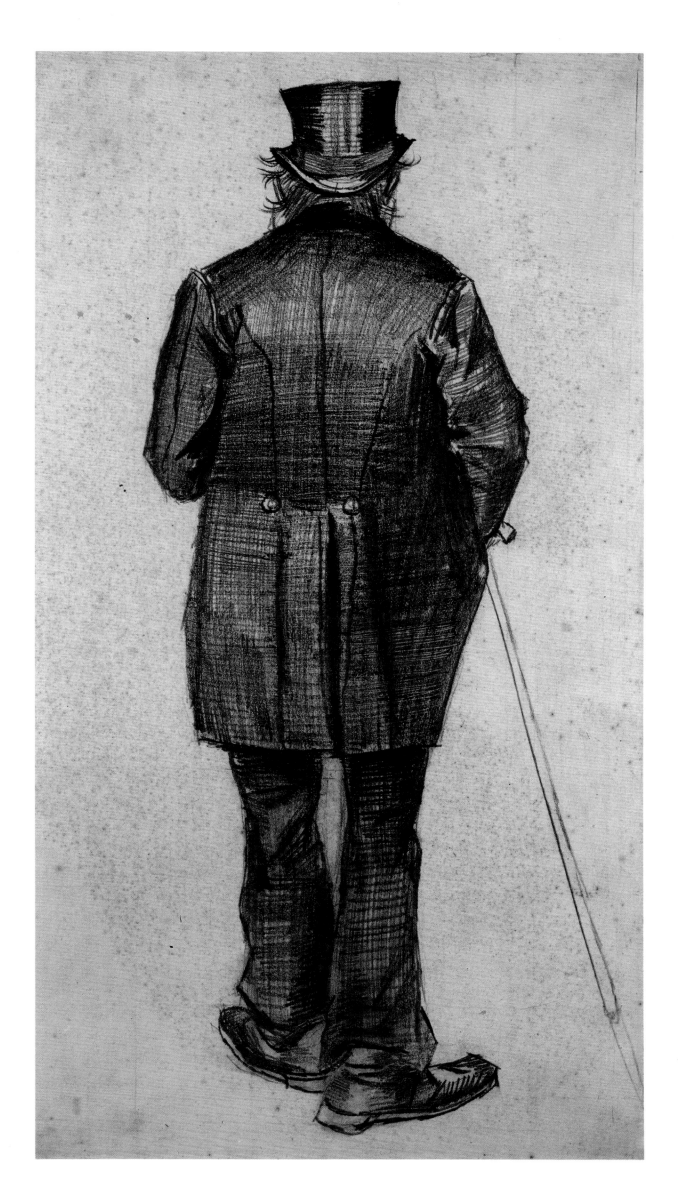

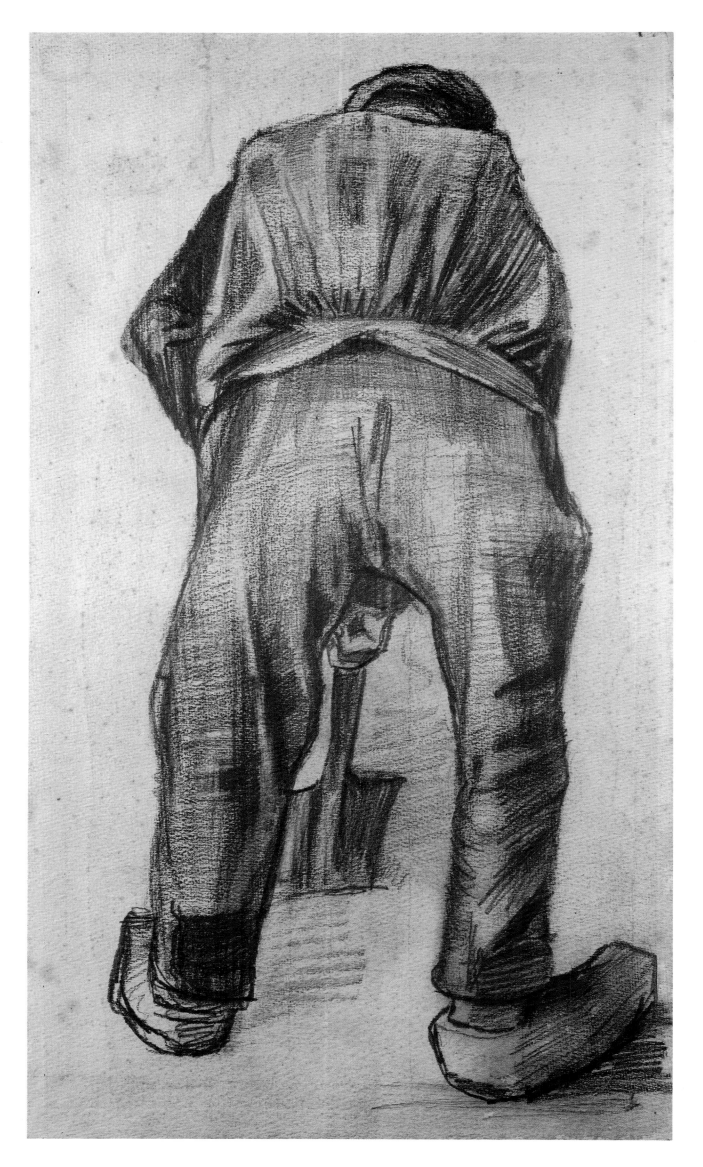

Left:
Man Digging
November 1882
Pen and pencil on paper
19½×11¼in
(49.5×28.5cm)
Rijksmuseum Vincent
van Gogh, Amsterdam

Right:
**Woman with Child on
her Knee** Spring 1883
Black chalk and wash,
heightened with white
16¼×10½in (41×27cm)
Rijksmuseum Kröller-
Müller, Otterlo

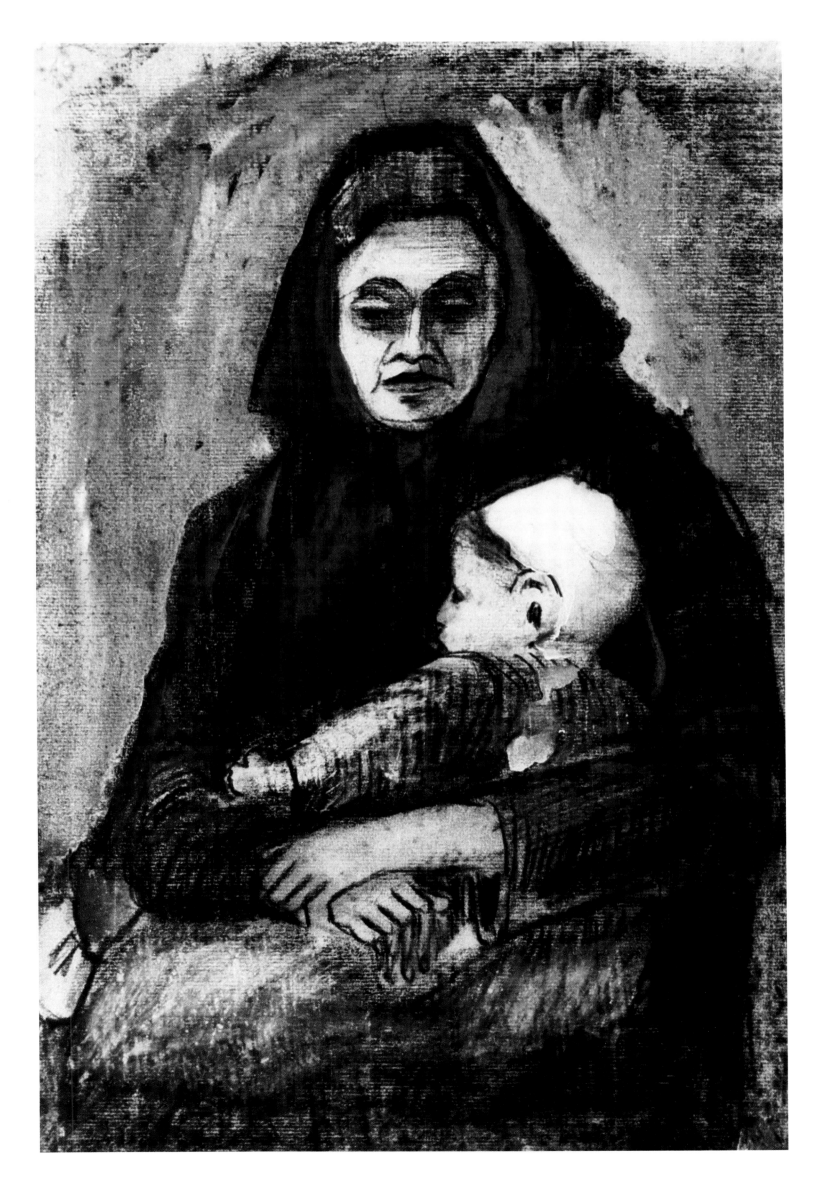

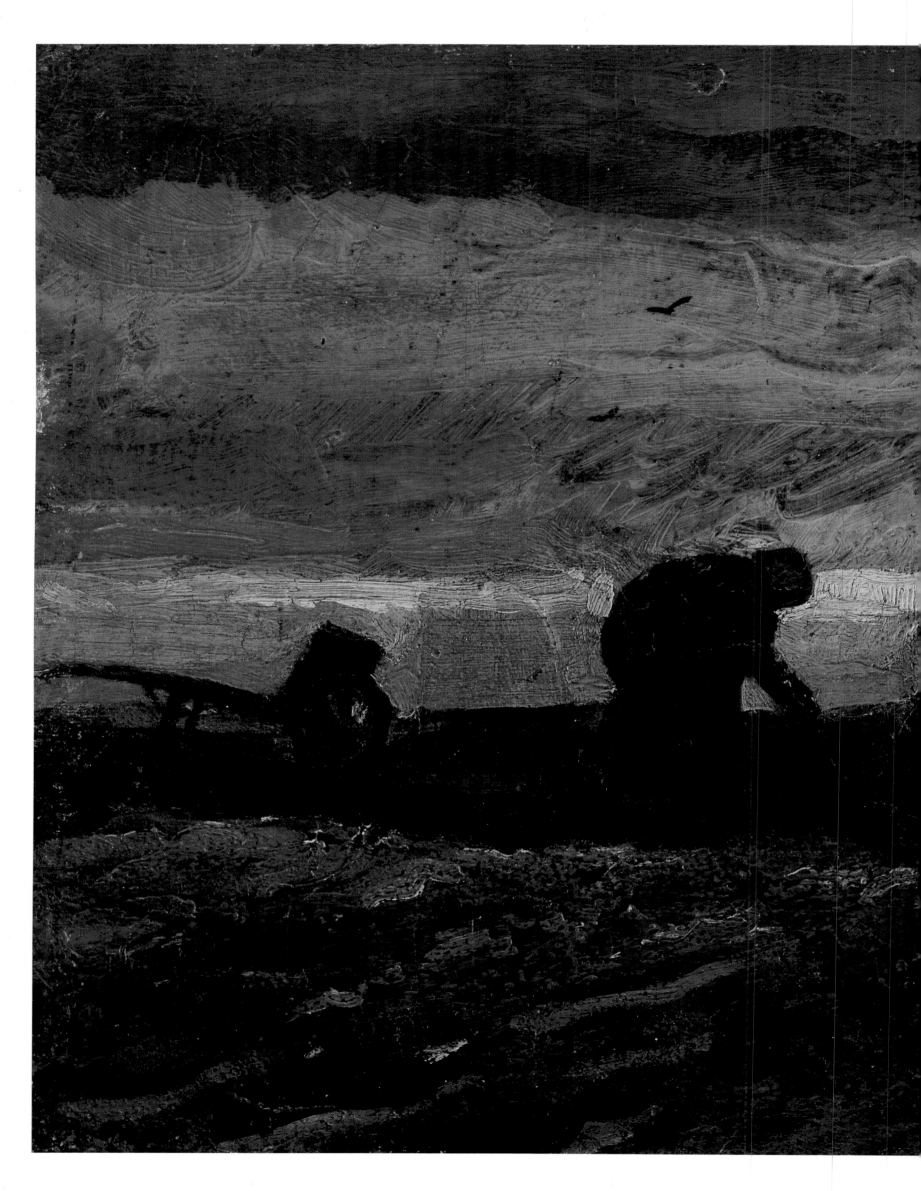

Two Women Working in the Peat
October 1883
Oil on canvas
10½×14in (27×35.5cm)
Rijksmuseum Vincent van Gogh,
Amsterdam

Nuenen

Van Gogh's return to the family home, this time the parsonage at Nuenen, was not without difficulties. He felt excluded, disapproved of; in his letters he likens himself to a dog and a beast. His family were civil in their dealings with him, a fact that he acknowledged, but it was this very gentility of parsonage life that alienated him from them.

The propriety of his family and class were stifling him and he wanted to break out, as he wrote to Theo in June 1885:

And I was sick of the *boredom* of civilization.

This was incomprehensible to his family. They did all they could to assist him, attempting to provide him with what they thought an artist's studio should be. His father made the disused laundry Van Gogh chose to use as a studio as comfortable as possible, installing a stove, covering the stone floor with boards, placing his bed on a dais to protect him from damp.

This was precisely what he didn't want; his family's definition of the appropriate context for art was not his. His father suggested that a large window should be installed, a common requirement in artists' studios, but Van Gogh argued that the original small windows should be maintained, this brought his studio closer to the reality of the peasant dwellings he constantly visited throughout his stay in Nuenen. It is possible to see this as the grown-up son taking revenge on his father and his values, the father who removed him from the society of rough local boys in the village school of Groot Zundert, and placed him within the genteel confines of the Parsonage.

In pictures like *The Presbytery Garden at Nuenen* painted early in his stay at Nuenen, Van Gogh reveals his awareness of the values of established religion in rural life. A middle-class woman is placed in the foreground of the ordered and enclosed garden, the freedom of space embodied in the perspective of the path being literally cut off by the fence. Beyond, and central to the picture, is the tower of the old church, an important symbol for Van Gogh. It was both sign and symbol of established religion, it was central to the experience of country people and the inhabitants of the presbytery including the artist himself.

The theme of order and its disruption underlies the various subjects Van Gogh explored in his works at Nuenen. In the pen and ink drawing *Willowgrove and Shepherd* of March-April 1884, an ordered countryside, represented by the regular lines of trees, and quiet, trudging but harmonious labor is indicated by the presence of the peasants within that structure. The pen and ink drawing style also stresses the ordering of the world by means of the regular, curved and straight hatched lines. This style was admired by one of Van Gogh's mentors, van Rappard. It was seen by both the artist and his family and friends as a move towards an acceptably skilful and polished mode of representation that would make the depiction of rural life acceptable to the art-consuming audience.

Van Gogh's conflict with his parents' values increasingly led him to distinguish between established religon as an institution and more 'permanent' values. These he constructed in the forms of 'the peasant' a class with whom he developed an intense empathy at this time, and a generalized concept of God. In *The Tower of the Old Church at Nuenen* and *The Sale of the Crosses of the Old Cemetery, Nuenen*, both of May 1885 and thus painted after The Weavers series, the Peasant Heads and *The Potato Eaters*, these themes are developed in the broadest terms and at the same time they are based on the closest observation of aspects of village life. *The Tower of the Old Church at Nuenen* shows the tower, having recently lost its spire, in a state of crumbling decrepitude. In spite of its bricked-up arches and massive buttresses Van Gogh has stressed the monumentality of the tower allowing it to dominate both the picture and the landscape. It is a symbol of heroic mutability. In a letter to Theo of late May/early June 1885 he makes its purpose clear:

And now these ruins tell me how faith and religion moldered away – strongly founded though they were – but how the life and death of the peasants remain forever the same, budding and withering regularly, like the grass and the flowers growing there in that churchyard.
Les réligions passent, Dieu demeure (religions pass, but God remains) is a saying of Victor Hugo's . . .

The theme of the peasants introduced in this letter is important and helps to explain the background to *The Sale of the Crosses of the Old Cemetery, Nuenen*.

Van Gogh presents them as an eternal, recurring, and organic entity, like the life cycle of plants, part of the earth. This sense of peasants being part of the earth and the natural cycle of life permeates pictures like *Cottage at Nightfall* of May 1885 where their peat-roofed dwellings seem to be concretions of the raw earth, and their labor and rest part of the times of the day. *The Sale of the Crosses of the Old Cemetery, Nuenen* reveals this view to be a deliberated construction rather than the recording of fact. The old pattern of village life was changing, even the eternal cycle of life and death came under the auctioneer's hammer as the old graveyard crosses were sold. Far from being an eternal, unchanging, mythically organic class, the peasants were under threat as the forces of modernization uprooted traditional ways of life.

In one of his earliest series of the Nuenen period, The Weavers, the threat of modern, urban industrial practices, instigated by the bourgeoisie, to the traditional rural patterns of skilled, home-based hand labor is made explicit if the full social context of the imagery is understood. In the *Weaver with a view of the Old Church Tower at Nuenen through an open window* of June-July 1884, Van Gogh depicts a harmonious relationship between traditional patterns of faith, represented by the Old Church tower, the labor of the fields, and the home industry of the weavers. The family relationships which cemented stable rural societies are also implicit in the representation as the artist links the man and woman to the institutions of the home and church. Social and domestic harmony prevail, the picture seems to be an extension of Millet's conception of rural life as depicted in the series 'Travaux des Champs' engraved by Jacques Lavieille, which Van Gogh had in his collection of prints and reproductions. By the mid-1880s the rural home-weavers of southern Holland were disappearing as weaving became a centralized activity taking place in urban factories. The dwindling number that remained lived in poverty, condemned to ever more crushing burdens of work as the profits on their production diminished. That

Van Gogh thought of this situation in terms of class conflict is indicated by his request to Theo to send him an engraving after Paul Renouard of striking weavers in the city of Lyons which had appeared in the French magazine *L'Illustration*. Further evidence for Van Gogh's conception of this as a conflict of class-based values is revealed by his criticism of Theo in a letter of September 1884 that he, the art dealer, had never entered the cottages of the poor as Van Gogh, the artist, had done.

Van Gogh was aware that he was not of the peasant class he empathized with, but he was equally aware that he was substantially alienated from many of the values of his own class. He took the view, based upon Thomas Carlyle and Jules Michelet's social philosophies, that the artist through 'the truth' of representations of the underprivileged would change the ideology of the bourgeoisie, the intended market for his pictures. In Michelet's view this would create a non-violent revolution and produce a society based on the principles of compassion and love. Van Gogh's position in 1884 was more militant. He saw a parallel between the years 1884 and 1848, the year of revolutions, and identified himself with the revolutionaries of that year. Theo, the representative of his family's values, was cast in the role of a government soldier on the side of Louis Philippe. When the artist mistakenly identified Delacroix's *Liberty Leading the People* with the Revolution of 1848, he saw painting as having revolutionary social content.

In Van Gogh's view it was not only the subject matter of paintings that was socially radical but the means of expression. When he embarked on his project to paint a series of 50 portraits of peasants, 'Les paysans chez eux,' based, in part, on a series he had seen in the English magazine *The Graphic* called 'Heads of the People' in the winter of 1884-85, and in the preliminary sketches for 'The Potato Eaters' of early Spring 1885 set about rendering the features of his sitters in the most uncompromising manner. The echoes of Rembrandt's later manner in the cream, ocher, and brown color range are used as a starting point against which he identifies his own pictorial devices. The impastos have none of the finely worked textures of the old masters, the features of the sitters deliberately reject beautifying conventions, and the brutal portrait bust format leaves the viewer in harsh confrontation with peasants. The peasants are not smoothed out and made acceptable for their intended audience.

All the factors mentioned above characterize the most ambitious of his works of the Nuenen period, *The Potato Eaters* of April/May 1885, although Van Gogh's consciousness of producing a major work pushed him into more conventional means of production. He followed all the academic processes in constructing the picture, producing sketches, oil sketches, individual figure sketches, groupings, and notations of tone and color. Griselda Pollock has pointed out that the subject of the Peasant Meal was well established in late nineteenth-century Dutch painting. Van Gogh identifies his own radical position against that tradition. Instead of the expected sentimental image of peasant life, he provides a tense, uncompromising interplay of pictorial elements, throwing each other into high relief. The viewer is presented with the dark interior of a peasant cottage derived from the artist's own observation of one family's dwelling, not a generalized 'stage set' interior. The toughness of the features and coarseness of their hands is stressed by his use of harsh light and shadow represented by alternating light and dark tones, roughly brushed in. He also exaggerates their lumpen joints and coarse features in order to stress the quality of the figures not their literal likenesses. He acknowledged Millet, Daumier, and Doré as sources for this approach to realism. For Van Gogh, realism was not a matter of holding a mirror to reality (a favorite metaphor used in mid-nineteenth century French realist criticism), but rather using the pictorial means at the artist's disposal to represent the character of things seen in nature, hence the necessity to depart from 'literal truth.' Realism was also a matter of choice of subject matter, it should be of simple and common things, like peasants eating and drinking basic food in their humble dwellings at the end of a day's work. The use of color in *The Potato Eaters*, with the predominant use of earthy hues and dull yellows and creams, acknowledges the tradition of Rembrandt, expresses the earthy quality of the peasants, and also conforms to Van Gogh's aesthetic criteria that '*color expresses something in itself*' (Van Gogh to Theo early November 1885), and that '*much, everything* depends on my perception of the infinite variety of tones of one *same family*.' The beauty of the picture in terms of color, paint handling, and subject matter is one that deliberately espouses what the artist's contemporaries would consider to be ugly, crude, and technically incompetent. As such it was intended as a revealing, radical, and revolutionary picture (in a general rather than political sense). The contemporary theme is also intended to allude to the more eternal values, as Van Gogh wrote to Theo in January 1885, painting should reveal 'ce qui ne passe pas dans ce qui passe,' the permanent in the fleeting. A vital means of achieving this in *The Potato Eaters* is by the interplay between the peasant subject and religious imagery.

The peasants' supper has a great sense of ritual about it. Van Gogh draws a parallel between it and the Last Supper. Thus the potatoes and coffee are the equivalent of the bread and wine, and the lamp alludes to traditional representations of the Holy Spirit. On the wall the image of the Crucifixion with its theme of suffering and redemption makes the analogy between the peasants and 'eternal' religious values explicit.

A similar concern with the perception of the eternal in the ephemeral is found in Van Gogh's memorial to his father, *Still Life with Open Bible, Extinguished Candle, and Zola's 'Joie de Vivre'* of October 1885, where the Dutch tradition of 'vanitas' still life is reinterpreted in the light of the artist's own experience. Death is present in the symbol of the extinguished candle. Van Gogh's father's values dominate the picture in the form of the great Bible open at the Book of Isaiah, against which the joys of life, the ephemeral things, are embodied in the dog-eared diminutive copy of Zola's novel, with its modern-life subject.

Returning to *The Potato Eaters*, the artist presents the viewer with a myth of eternal value in a threatened class. That in itself made the choice of the peasant subject modern, but hardly modern in the sense of Manet's urbane, urban images of Parisian life and culture. Painting and drawing peasants was modern in another sense. Van Gogh was constantly assessing his own production in the context of the value he attached to Dutch seventeenth-century masters. In one significant aspect he found them and other old masters lacking: they did not address the theme of people working. When they depicted laborers in the field Van Gogh felt that they were too concerned with posing figures within the conventions established in the art academies. To be modern one had to break with these conventions. He wrote in July 1885:

To draw *a peasant's figure in action,* I repeat,
that's an essentially modern image, the very heart of modern art.

Van Gogh cultivated the ugliness in *The Potato Eaters* because he felt this was modern. Similarly, in a series of drawings of the summer of 1885, including *Peasant Woman Stooping* of July/August and *Peasant Reaping* of August, he stresses the lumpen character of his figures. Although based on sound drawing practice it did not matter if the anatomy was strictly correct by academic standards. Van Gogh felt that would be both inappropriate and immodest in the context of representations of peasants. What did matter was:

there must be character in a digger, I circumscribe it by saying: that peasant *must* be a peasant, that digger *must* dig, and then there will be something essentially modern in them.

This modernity led works like *The Potato Eaters* to be roundly criticized. As always Van Gogh returned to the authority of academic models to counteract his insecurity and decided to develop his studies in the Antwerp Academy.

Above:
The Presbytery Garden at Nuenen
April 1884
Oil on card
10½×22½in (27×57cm)
Groninger Museum, Groningen

Below:
Willowgrove and Shepherd
March-April 1884
Pencil and pen on paper
15½×21½in (39.5×54.5cm)
Rijksmuseum Vincent van Gogh,
Amsterdam

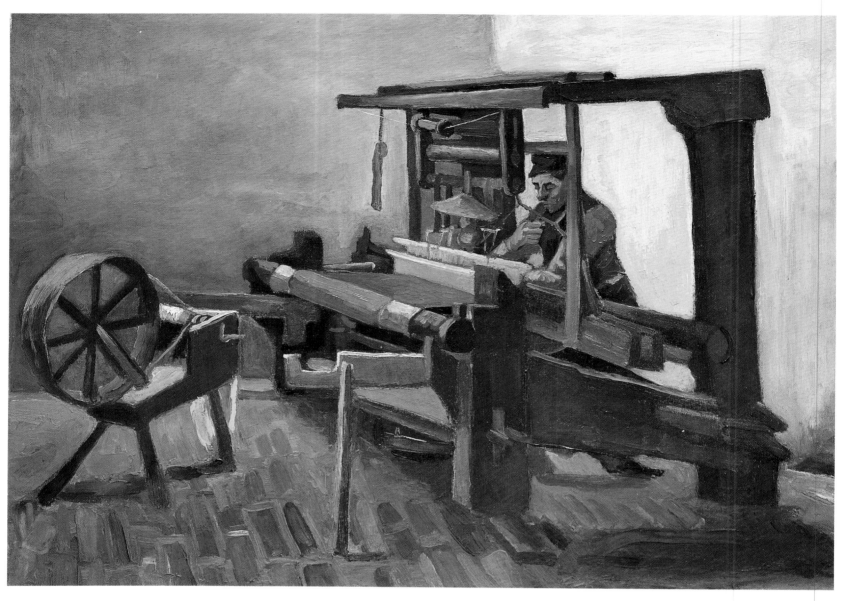

Weaver 1884
Oil on canvas
24⅝×33¼in (62.5×84.4cm)
Museum of Fine Arts, Boston

Weaver with a View of the Old Church June-July 1884
Oil on canvas on paste board
27½×33½in (70×85cm)
Neue Pinakothek, Munich

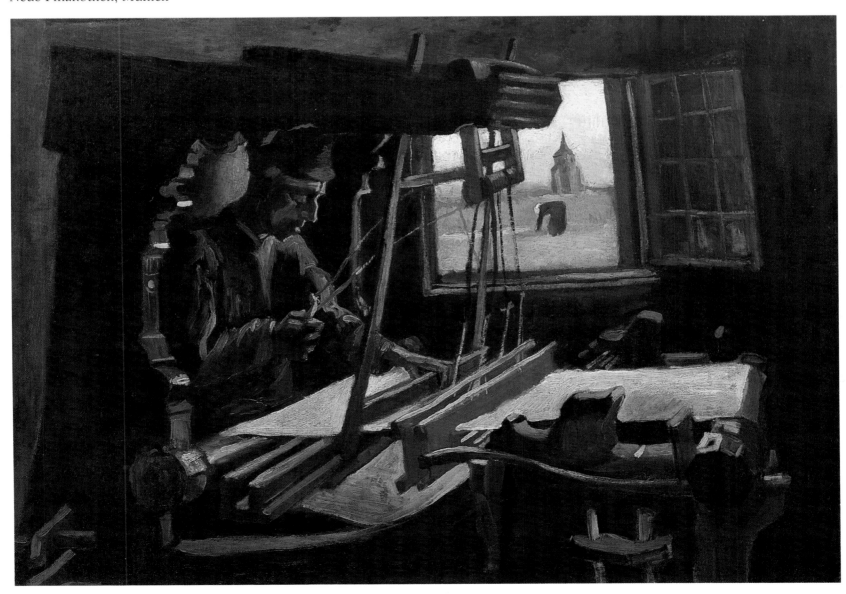

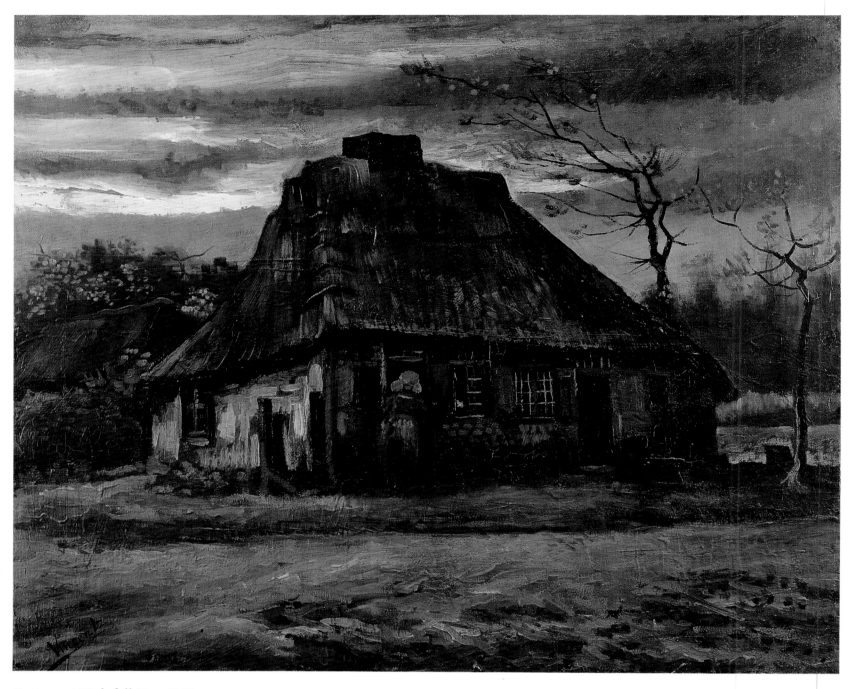

Cottage at Nightfall May 1885
Oil on canvas
25¼×30¾in (64×78cm)
Rijksmuseum Vincent van Gogh, Amsterdam

The Sale of the Crosses May 1885
Oil on canvas
14¾×25½in (37.5×65cm)
Rijksmuseum Vincent van Gogh, Amsterdam

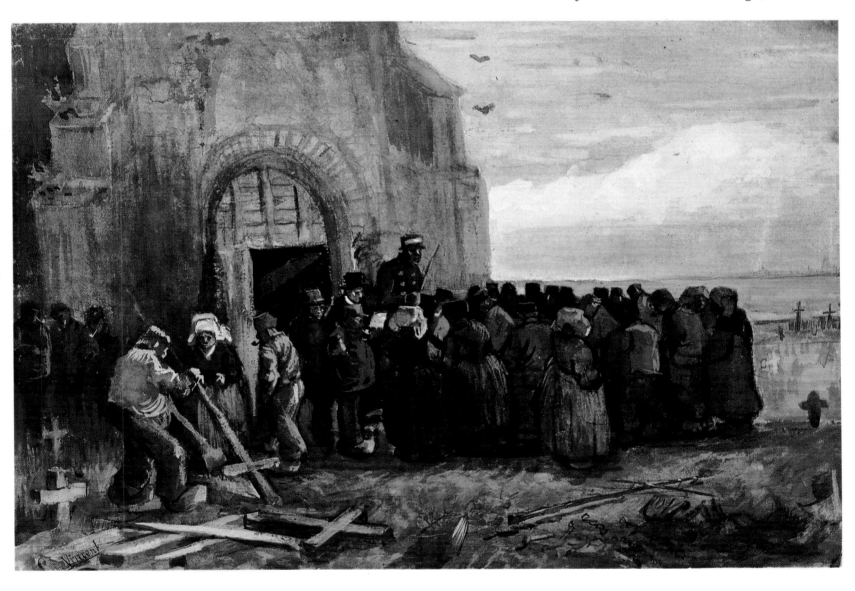

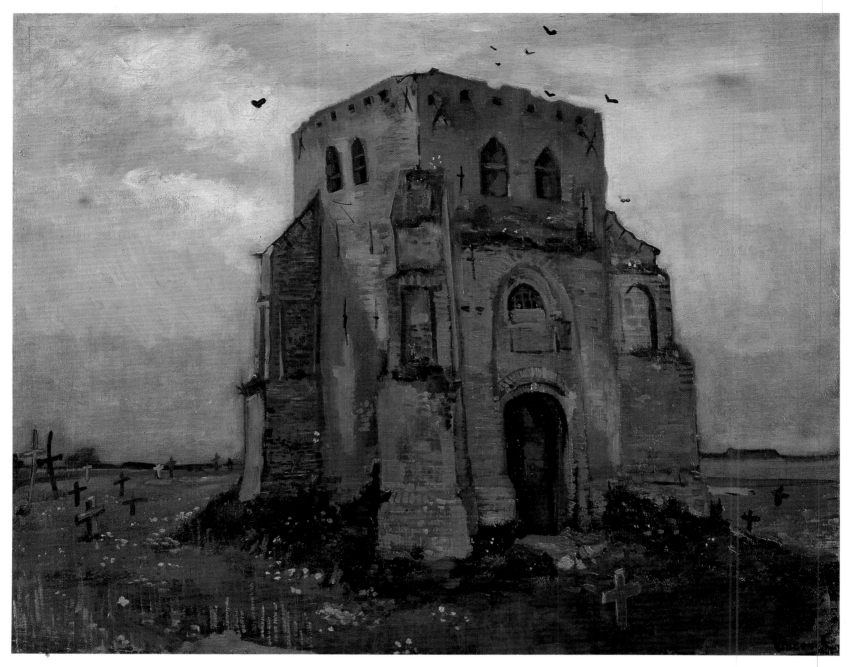

The Tower of the Old Church at Nuenen
May 1885
Oil on canvas
24¾×31in (63×79cm)
Rijksmuseum Vincent van Gogh, Amsterdam

Head of a Peasant Woman
December 1884-January 1885
Oil on canvas
16½×13¾in (42×35cm)
Rijksmuseum Vincent van Gogh, Amsterdam

Peasant Woman Early 1885
Pencil on paper
13½×8½in (34.5×21.5cm)
Rijksmuseum Vincent van Gogh, Amsterdam

Right:
Bust of a Peasant with Hat May 1885
Oil on canvas
15¼×12in (39×30.5cm)
Musée d'Art Moderne, Brussels

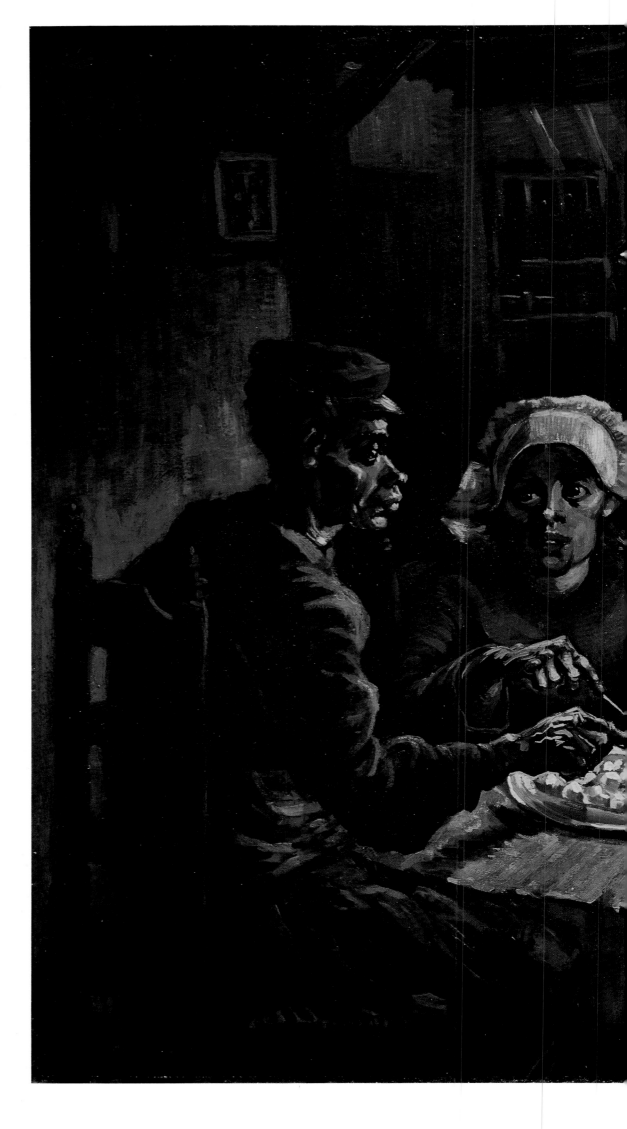

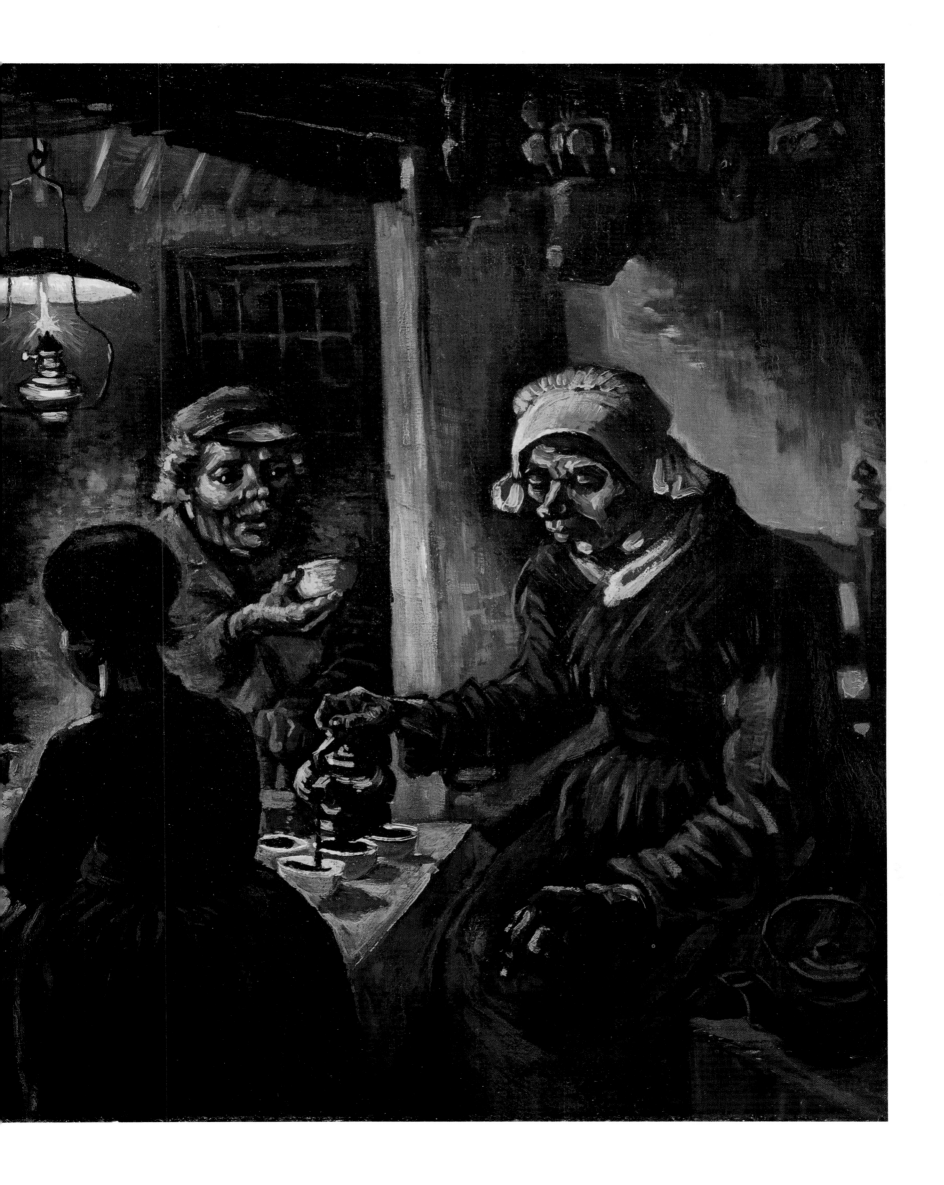

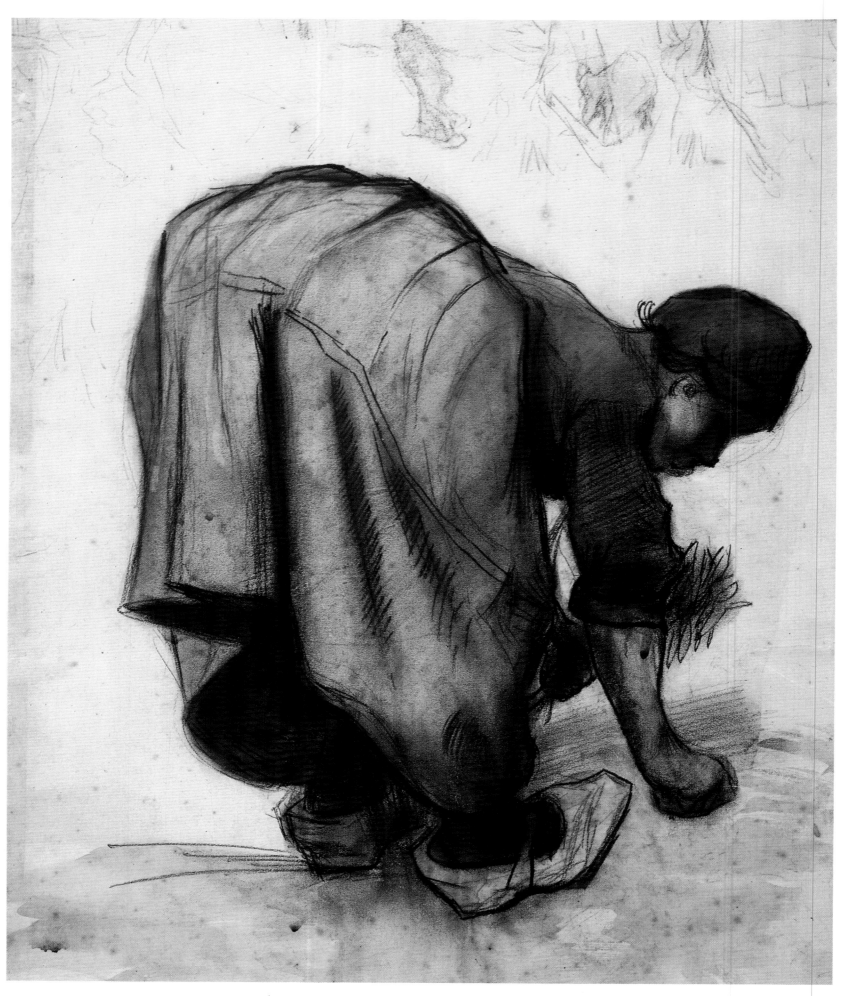

Peasant Woman Stooping
July/August 1885
Black chalk and wash on paper
20¾×17in (52.5×43.5cm)
Rijksmuseum Kröller-Müller, Otterlo

Peasant Reaping August 1885
Black chalk on paper
16¼×22¾in (41.5×58cm)
Rijksmuseum Kröller-Müller, Otterlo

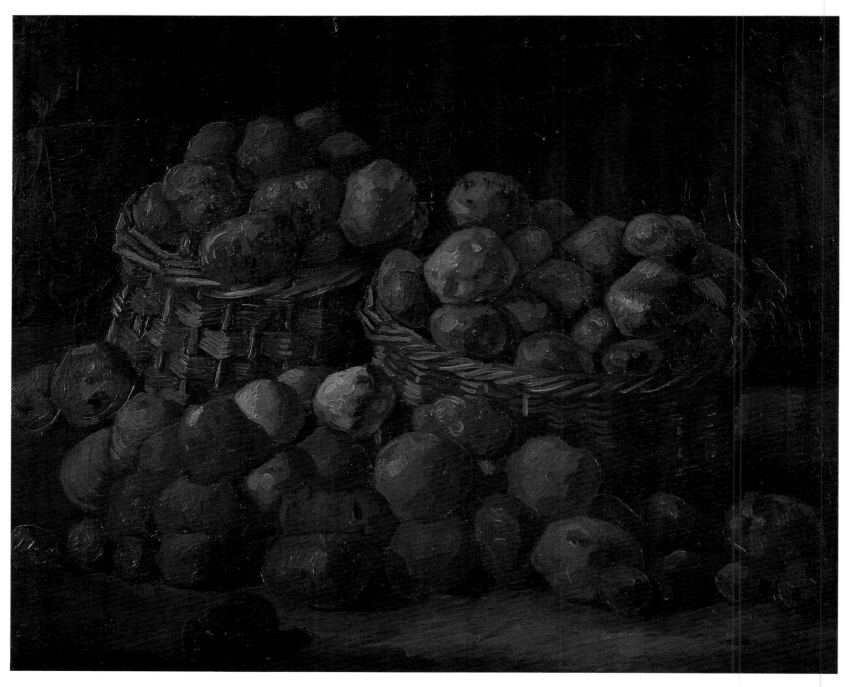

Two Baskets of Potatoes September 1885
Oil on canvas
26×31in (66×79cm)
Rijksmuseum Vincent van Gogh, Amsterdam

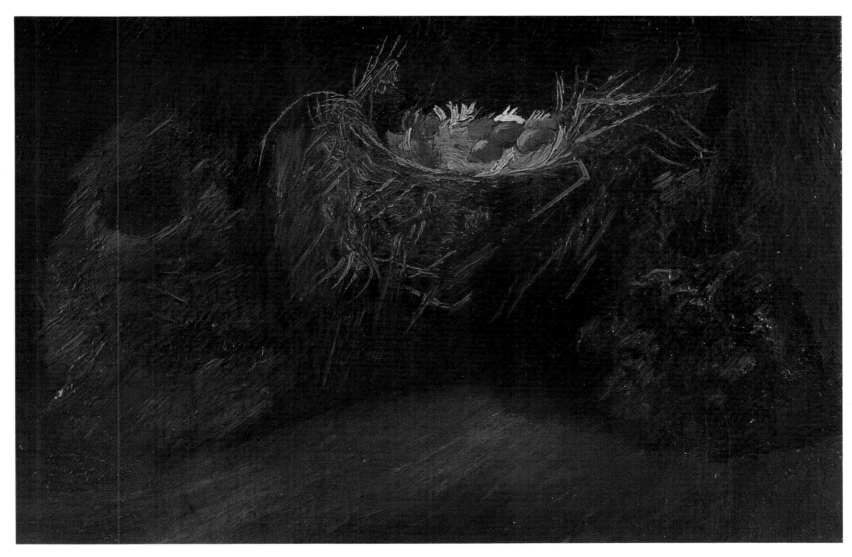

Birds' Nests September 1885
Oil on canvas
13¼×20in (33.5×50.5cm)
Rijksmuseum Kröller-Müller, Otterlo

*Still Life with Open Bible, Extinguished
Candle, and Zola's 'Joie de Vivre'*
October 1885
Oil on canvas
25½×30¾in (65×78cm)
Rijksmuseum Vincent van Gogh, Amsterdam

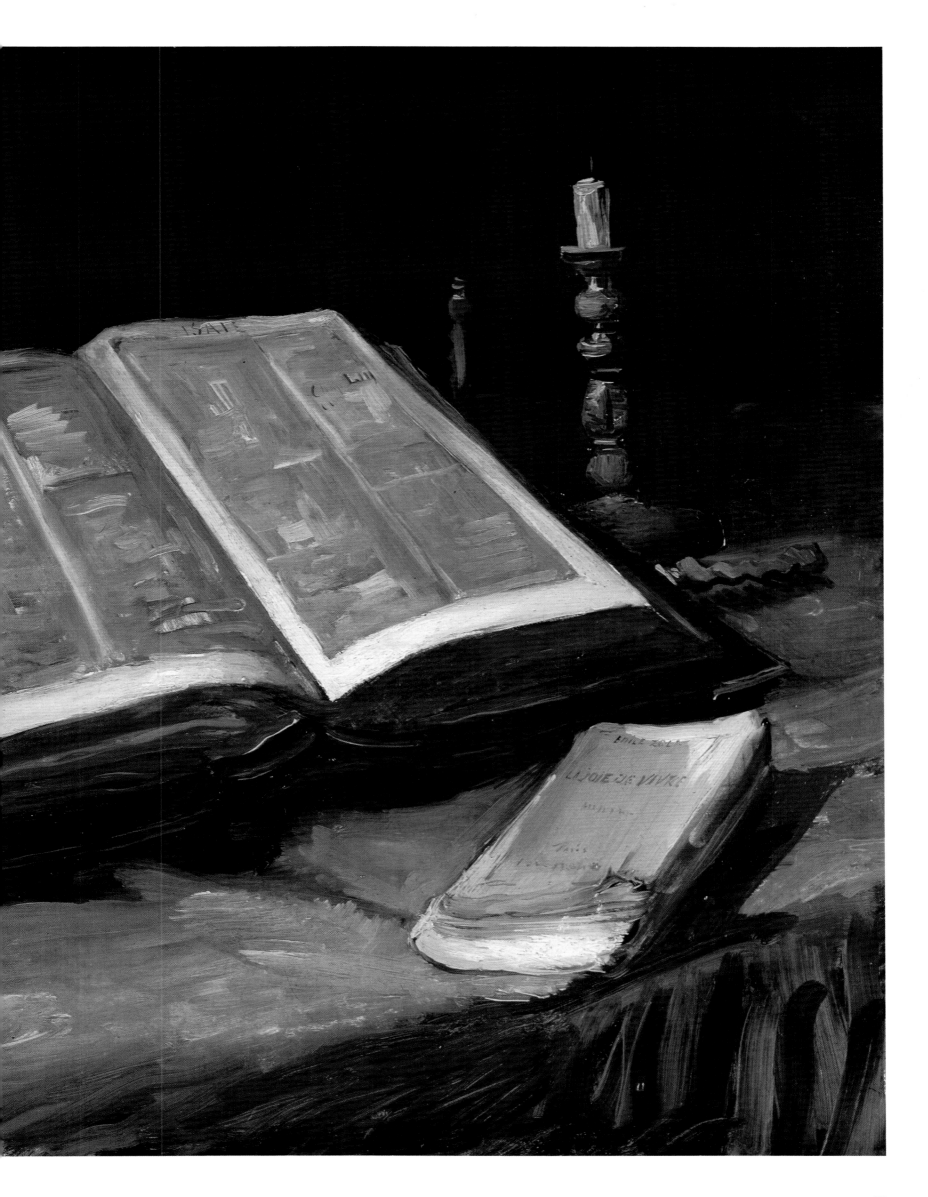

Antwerp, Paris

Obtaining models was always a problem for Van Gogh as he never had enough money to pay them. This economic constraint influenced aspects of his work both in Antwerp and Paris. At the Antwerp Academy he was schooled in the use of expressive outline, mainly drawing from the male nude. Modeling and color were not given priority in the teaching program of Van Gogh's elementary class, although the artist wanted to practice these skills. As a consequence he became impatient with climbing the ladder of academic attainment. When he did have money to pay for private study from the model he produced portraits of working-class models. In these oil studies he used freely flowing patterns of brushwork to create richly modeled effects to balance profiles and silhouettes. Van Gogh stated his aims in the Antwerp portraits in a letter to Theo at the end of December:

One considers the form as the means of depicting impression and sentiment, . . . one models for the sake of modeling, because it is so infinitely beautiful in itself.

He considered these to be characteristics of high art.

When he joined his brother in Paris he clearly aimed to further his skills in order to produce high art. Although the three months he spent in Cormon's atelier were 'not as useful as I had expected it to be' (Letter to Horace Mann Livens), Van Gogh found the friendships he made there and through Theo to be immensely productive. It was some of these friends that provided him with some of his free models – not human beings, but gifts of bunches of flowers. These provided the material for still life studies in tone, color, and brushwork textures, in which he also manifested his admiration for both Delacroix and Monticelli. In *Vase of Flowers with Physostegia, Gladiolus, and Lynchnis* of late summer 1886, the varied brushwork, rich impasto, and the sonorous colors created by the contrast of light and dark tones all reveal Van Gogh putting his understanding of Monticelli and Delacroix to his own ends. He associated the qualities of color like this with both 'passion' and 'the eternal,' indicating the Romantic roots of his early experiments with color in Paris. He also felt that both his mentors provided an equivalent of the warm colors of the south in their works. He had extensive first-hand experience of Monticelli's work through his brother's business and private collection. On the other hand his understanding of Delacroix's color organization was formed as much by the writings and theories of Charles Blanc as it was by first-hand knowledge of the paintings.

In the still lifes with plants of the following spring, such as the *Still Life with Vase, Flowers, Coffee Pot, and Fruit,* the format, composition, color, and brushwork acknowledge his awareness of Impressionism, especially Monet's work. Theo sold several works by Monet during Van Gogh's stay in Paris, notably from the series of paintings done at Belle-Ile. Van Gogh was also aware of Monet's flower pieces. The bright, intense hues and the extended vocabulary of brush markings in *Still Life with Vase, Flowers, Coffee Pot, and Fruit* all acknowledge Van Gogh's assimilation of the formal vocabulary which dominated Monet's work in the first half of the 1880s.

Van Gogh's work in Paris was not that of a naive provincial; he was never subject to the art that impressed him. As in Holland he worked in series and themes, each with a clear functon, sometimes working on two or more simultaneously. In *The Hill of Montmartre* there are many echoes of Holland – the windmills, the interest in the uncertain ground between city and country, not quite suburban but gradually urbanized, which had characterized his Hague drawings. There are also clearly 'Parisian' characteristics. In terms of color and clarity of light and atmosphere, Van Gogh was experimenting with a pictorial language derived from Corot. In terms of subject matter he reveals an interest in the sights of bohemian life that characterized much of modern-life subject matter in Parisian painting of the 1870s and 1880s. The windmills, with the notable exception of *La Moulin à Poivre,* were no longer working in industrial context but functioned as picturesque settings for restaurants, dance-halls, and open-air drinking establishments. They were places of assignation attracting bohemian middle-class and working-class males and working class females. Van Gogh ignores the undercurrent of sexual licence that attracted Renoir and Toulouse-Lautrec in these institutions.

In the early spring of 1887 Van Gogh painted a different aspect of the city of Paris. The *View from Van Gogh's Room, rue Lepic* is one of two versions of the same theme, a view from the high ground around Montmartre over the city towards the Left Bank, with the two towers of Notre-Dame-de-Paris in the distance. The juxtaposition of the church and the secular buildings has none of the symbolic weight of the Nuenen pictures. They are located in a tradition of views of the city over rooftops found in the works of Corot, Daubigny, Manet, Monet, Luce, and Camille and Lucien Pissarro. In this developing tradition it is the experience of urban living that is the central factor. Van Gogh knew of the work of these artists and in the fall of 1887 was to meet both Pissarros. In 1887 their works were strongly influenced by divisionist theory and practice. This is also true of Van Gogh's view from his room in the rue Lepic. It is not purely coincidental that his adoption of this manner in the spring of 1887 happened at the time he met Paul Signac, one of the two leading figures in the Neo-Impressionist group together with Seurat, whom Van Gogh also knew. He experimented with their divisions of tones in a highly individual manner, using irregular dots and hatching which are sufficiently separated to allow the white of the underpainting to show through creating a high value but cool and delicate web of color organization. The colors themselves are based on the complementary and adjacent relationships of blue-red and green-yellow. This indicates that Van Gogh was not only taking the practice of Seurat, Signac, and the two Pissarros into account, but also applying his understanding of the theories of the graduated colors derived from his readings of Charles Blanc and Michel-Eugène Chevreul.

In his view of *The Voyer-d'Argenson Park, Asnières* of May 1887, Van Gogh revealed his highly independent approach to contemporary Parisian theory and practice. In terms of subject matter he acknowledges a tradition of urban park and private garden to be found in Monet and Renoir. The location of this park at Asnières, a suburb to the north west of Paris, indicates his interest in the Neo-Impressionist's use of radical images of modernity, in their representations of the anti-picturesque of the city. The picture has an

implicit proletarian subject. The dress of genteel lovers indicates that they are members of the working classes. This not only continues Van Gogh's concerns with painting the lower classes but also shows his knowledge of Signac's images of working-class environments which were intended to reveal to bourgeois viewers the class characteristics of society. Other works like *Factories at Asnières* of this time reveal even closer links with this aspect of Signac's work. In terms of color and paint application, Van Gogh reveals that he is capable of appropriating several different manners without any apparent inconsistency and creating something entirely individual. He utilizes red-green, blue-yellow color harmonies with pink, violet, and orange counterpoints throughout, with the darkest colors created from touches of pure hue unmixed with white. He moves between hatching and dot marking and dynamic parallel brush strokes in the sky, which acknowledges a debt to Renoir's manner of the early 1880s. The impact of Renoir's work also accounts for the idyllic theme of a modern 'garden of love.' In the *Crows over a Wheatfield* of July 1890. Here the paths unite to create a sense of intimacy which echoes the human emotions revealed in the figures. Later it created a sense of insignificance and isolation which is even hinted at in the contrast between the isolated figure and the dynamic perspective of *Road along the Seine at Asnières*.

Van Gogh's awareness of modern Paris was not simply the product of his observation and knowledge of the works of contemporary painters as different as Signac and Raffaelli. His choice of subject matter was selective and his understanding of the connotations of representations of Paris was formed by the values embodied in his interpretation of the modern French naturalist novel. Writers like Zola and de Maupassant, particularly the latter in *Bel-Ami*, had depicted the suburban pleasures of Asnières, and Van Gogh's representations of this part of the environs of Paris are constructed in relation to the mythologies and values of these novels. In *The Ramparts with Horse Tram* of July-September 1887, Van Gogh depicts a suburban scene at the Porte de Clichy with strollers and idlers in groups or alone. The presence of the telegraph pole and tenement block indicate the interplay between city and open space. The theme of pleasure on the edge of the city at the ramparts was not simply chosen at random. It once again derives from his reading of naturalist novels, in this case de Maupassant and Edmond and Jules de Goncourts' *Germinie Lacerteux*. The de Goncourts' novel is particularly close to Van Gogh's picture in suggesting the varied pleasures of this part of Paris. In *Still Life with Plaster Statuette and Two Novels* of late fall 1887, the 'vanitas' structure of the Nuenen *Still Life with Open Bible, Extinguished Candle and Zola's 'Joie de Vivre'* is re-interpreted, indicating the moral value inherent in Van Gogh's reading of the naturalist novel which he characterized as 'the need we all feel to be told the truth.' It juxtaposes de Maupassant's *Bel-Ami* with the de Goncourts' *Germinie Lacerteux*, a plaster statuette of a female torso, and a rose. Like many of Van Gogh's still-life allegories it admits of several readings, one of which contrasts the ephemeral qualities of love in a cynical society with enduring love (the contrasting themes of the two books juxtaposed with the rose), and the 'eternal feminine' of the statuette. On another level it is an allegory of the relation between life and art.

The *Still Life with Plaster Statuette and Two Novels* is also an exercise in contrasting intense hue and related light tones, a formal device that was later to be used in the Arles harvest scenes and Sunflowers. The interest in the closely related tones of yellow is an important factor in several of Van Gogh's paintings of the fall of 1887, like the *Still Life with Apples, Pears, Grapes, Lemons, and an Orange*. The extension of the color harmonies of yellow over the frame of this picture reveal his knowledge of the latest experiments with colored frames by Pissarro and Seurat. The picture also indicates his growing awareness of the expressive power of areas of intense flat hue. This suggests that by the end of his stay in Paris he knew of the early experiments with Cloisonnism carried out by Louis Anquetin and Emile Bernard in the fall of 1887. It is also doubtful if he would have accepted without reservation the uncompromising Idealist theory underpinning the manner as announced by Edouard Dujardin in his article 'Aux XX et aux Indépendants: Le Cloisonisme?':

The point of departure is a symbolic conception of art. In painting as well as in literature, the representation of nature is a chimera . . . On the contrary, the aim of painting and literature is to give the sensation of things; according to the special means of painting and literature.

What Van Gogh did accept without any hesitation was the importance of Japanese prints as a source for the use of rich flat colors and expressive outlines, which were also an important element in the development of the Cloisonnist manner. Van Gogh had been aware of Japanese prints since his stay in Antwerp and had developed his taste in Paris. He had organized an exhibition of his and Theo's collection at the Café du Tambourin in the spring of 1887 which made a considerable impression on both Bernard and Anquetin. In the background of *Woman at the Café du Tambourin* of February 1887, a portrait of the owner Agostina Segatori, a figure of a geisha as represented in a print can be seen on the right of the picture. The Van Goghs' enthusiasm for Japanese prints was stimulated by both the possibility of acquiring large numbers of them cheaply and the growing critical enthusiasm for these exotic pieces which occupied a half-way stage between the primitivism of Images d'Epinal and works of fine art. Théodore Duret's book *L'Art japonais* of 1884 was of particular importance in developing their understanding of these works. Van Gogh produced a series of three free copies after Japanese prints in September of 1887. *Japonaiserie: The Flowering Plum Tree* is based on a print by Hiroshige, but also acknowledges Monet's images of orchards in blossom. He utilizes Hiroshige's color scheme, but renders it in richly painterly textures. The close attention to detail seen in the foreground was understood as a sign of closeness to nature on the part of Japanese artists, something Van Gogh felt that the sophisticated art of Paris had lost. In the *Japonaiserie: Oiran (after Kesai Yeisen)*, he combined elements from several different prints, even taking the central figure after Yeisen from the cover illustration of *Paris Illustré* of May 1886. In this act of combination he appropriates Japanese prints to his own ends.

Japanese prints form the background to the two versions of his portrait of *Père Tanguy* of late fall/winter 1887. The color merchant and picture seller is situated in an uncompromisingly frontal pose in a picture space created in a manner derived from his Japanese sources by the superimposition of his bulky silhouette against the flat brightly colored plane of prints. In places, particularly at the bottom of the painting, the construction of space is entirely eliminated and separate bands and patterns of unmodulated color are substituted. Tanguy is surrounded by a poetic world of nature, actors, and courtesans and yet Van Gogh has characterized him as a dignified but naive old man, especially in his features and the rather stiff pose of the clasped hands, naive, knowledgeable, and earthy. A similar sense of peasant-like earthiness and vitality is found in his portrait *Italian Woman with Carnations (La Segatori)* of late 1887. The paint-handling of the pattern of her dress echoes that to be found on the right-hand side of the Père Tanguy portrait. Like the picture dealer she is surrounded by areas of flat brilliant color, her chair has an air of crude rusticity about its construction, and the modeling of her features is deliberately crude and heavy. Its color and the asymmetrical patterns of the border indicate a further debt to Japanese prints. Contrast these portraits with the well dressed individual in the *Self Portrait with a Gray Felt Hat* of late summer 1887 and it becomes clear that in his most Japanese portraits he creates something earthy, authentic, and intense in the bohemian types of Paris by associating them with the values and forms he found in Japanese wood-block prints. This search for harmony, authenticity, and sense of closeness to the earth foreshadows many of the concerns of the Arles period.

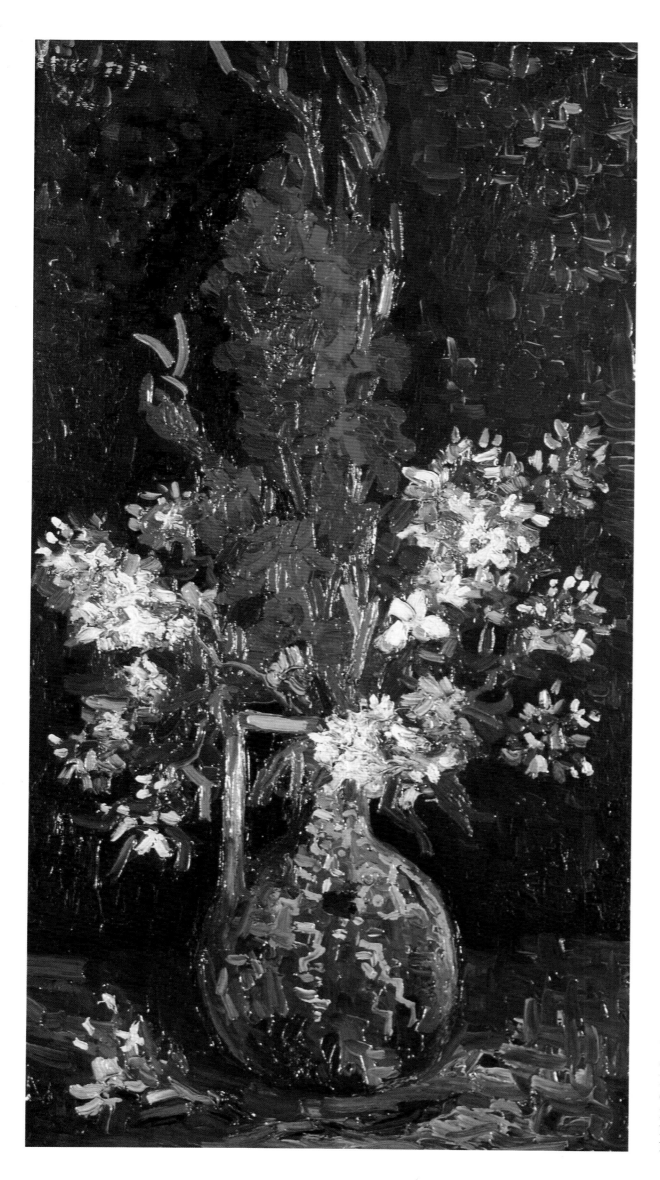

Vase with Physostegia,
Gladiolus, and Lychnis
Late summer 1886
Oil on canvas
25¾×13¾in (65.5×35cm)
Museum Boymans-van
Beuningen, Rotterdam

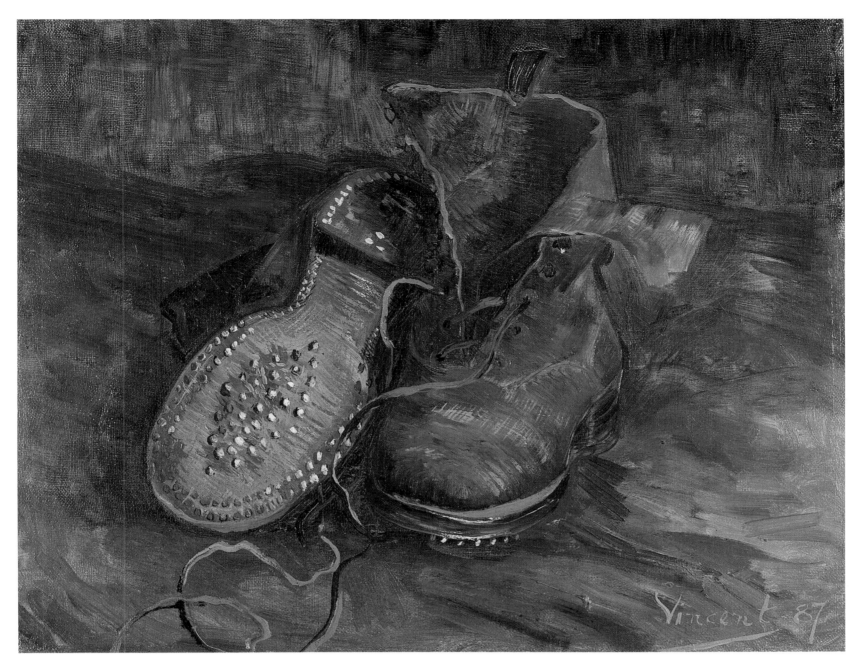

Boots Early 1887
Oil on canvas
13½×16¼in (34×41.5cm)
Baltimore Museum of Art,
Baltimore, Maryland

Overleaf
The Hill of Montmartre Fall 1886
Oil on canvas
14¼×24in (36×61cm)
Rijksmuseum Kröller-Müller, Otterlo

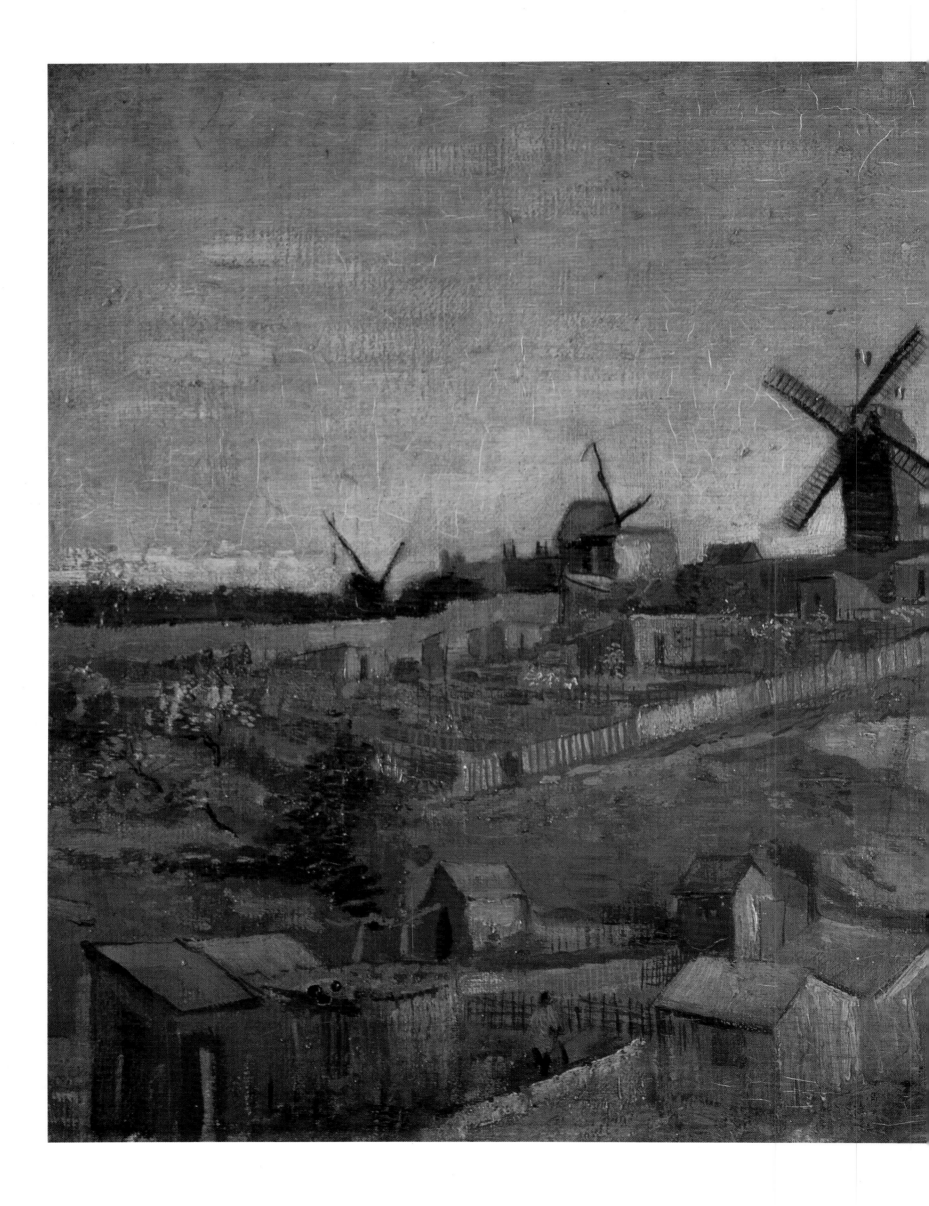

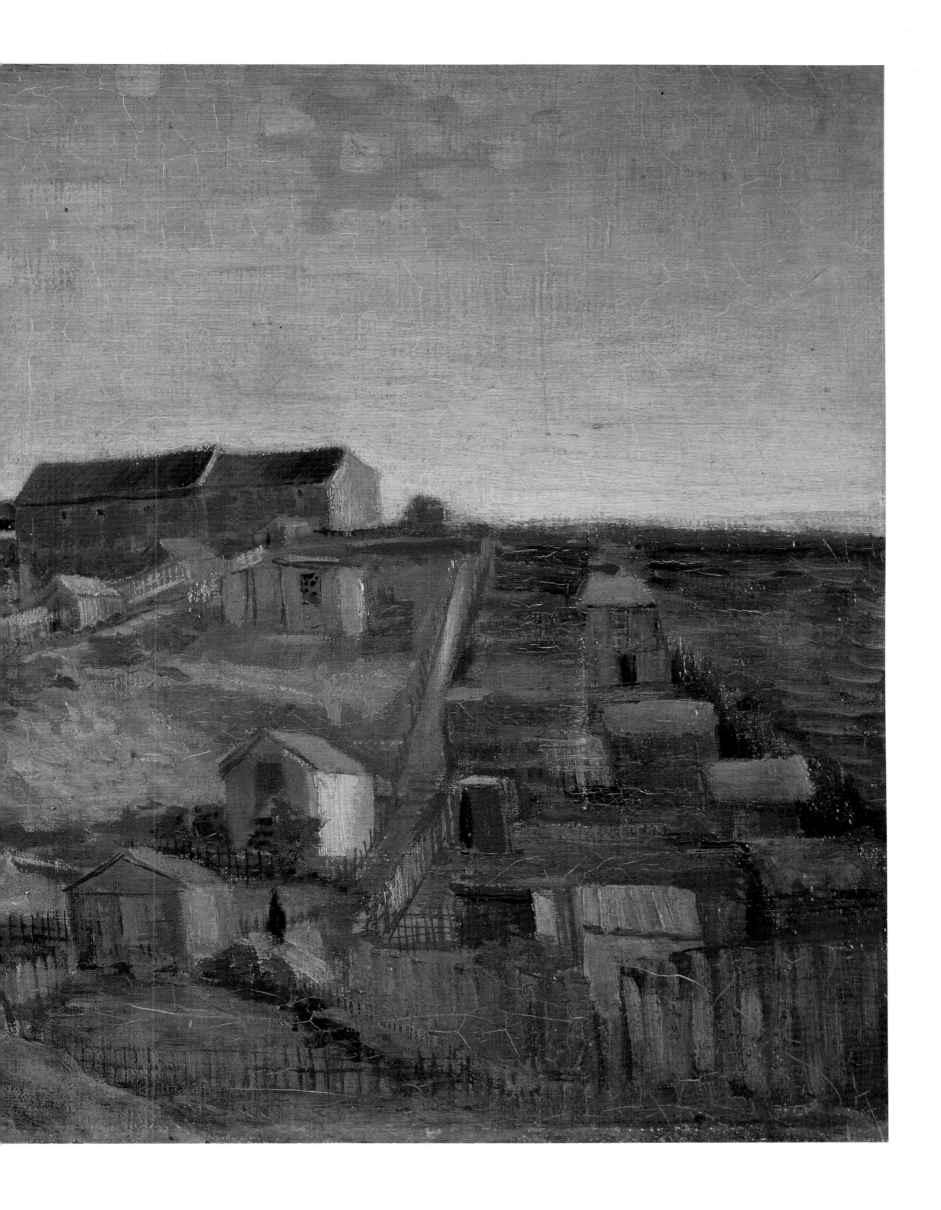

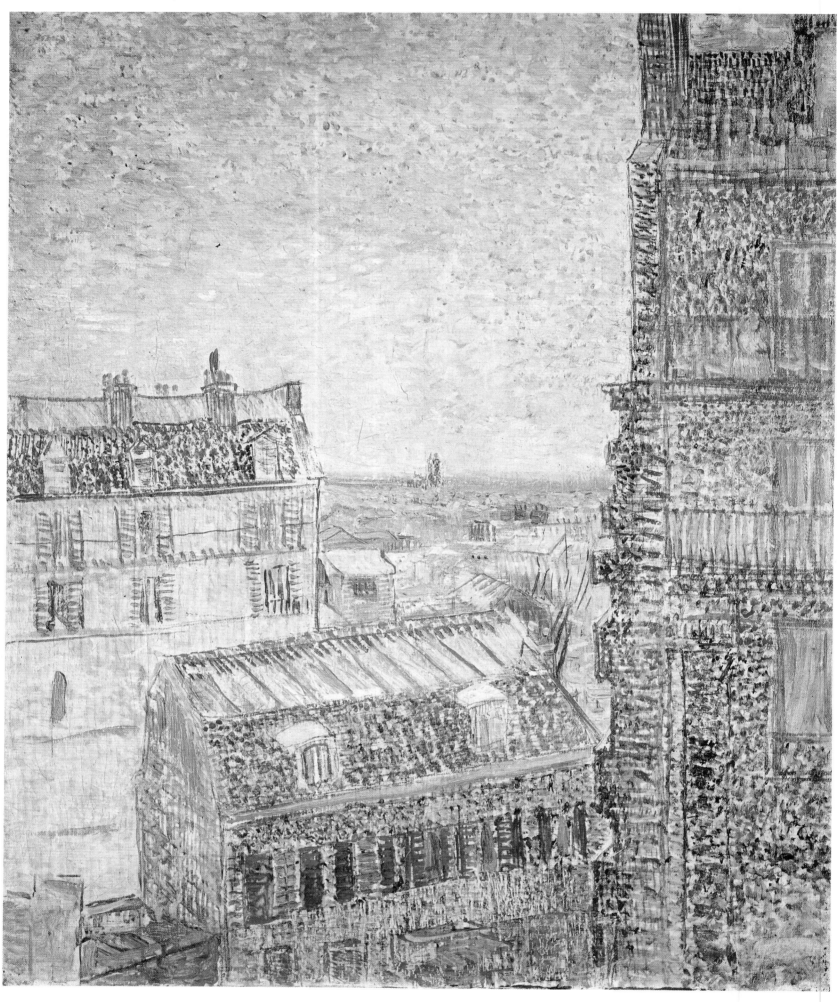

View from Van Gogh's Room, Rue Lepic, Paris Spring 1887
Oil on canvas
18×15in (46×38cm)
Rijksmuseum Vincent van Gogh, Amsterdam

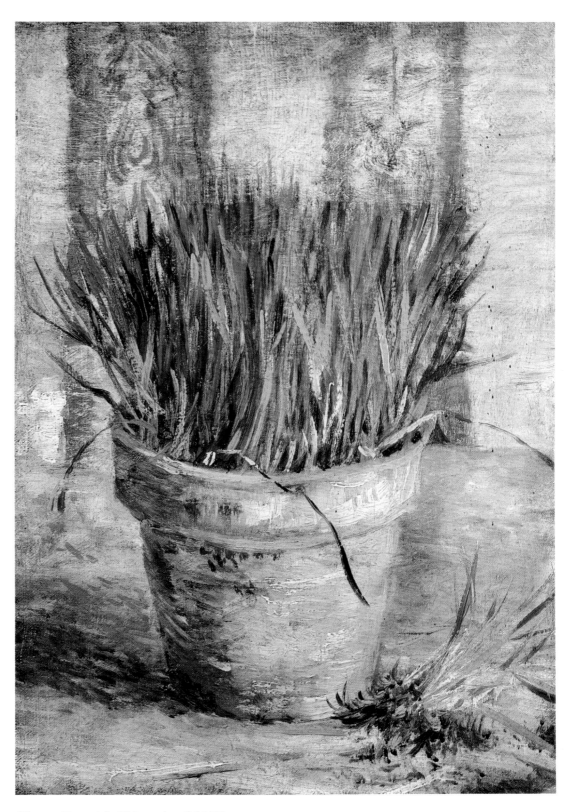

Flower Pot with Chives April 1887
Oil on canvas
12½×8¾in (32×22cm)
Rijksmuseum Vincent van Gogh,
Amsterdam

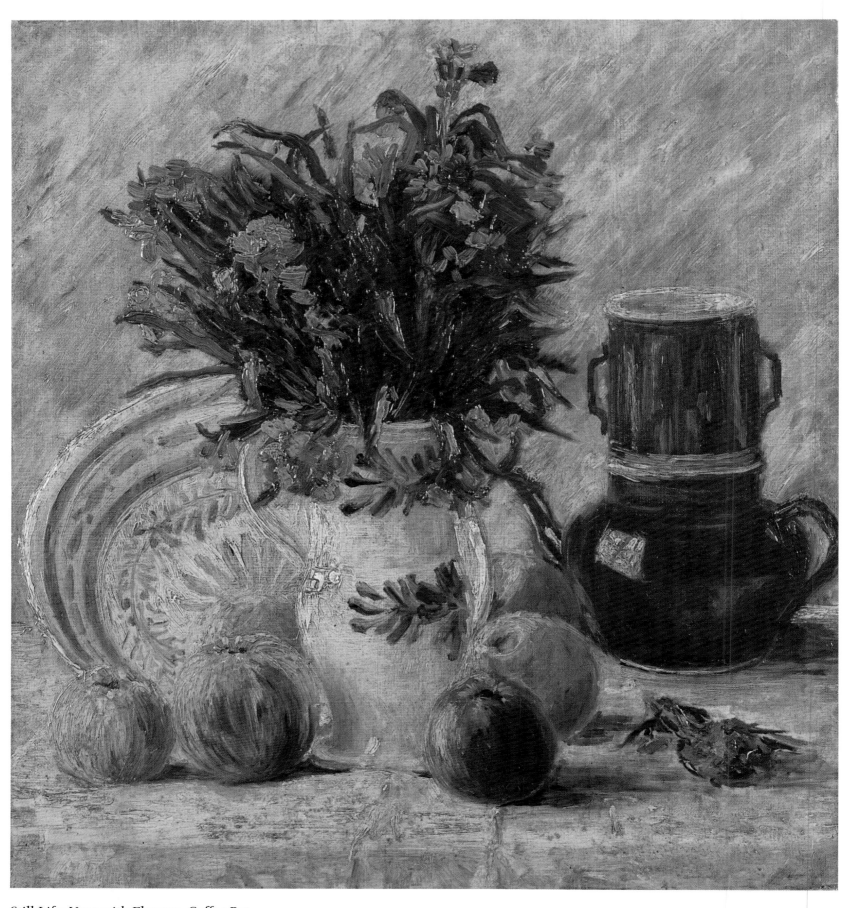

Still Life: Vase with Flowers, Coffee Pot,
and Fruit April, 1887
Oil on canvas
16¼×15in (41×38cm)
Von der Heydt-Museum, Wuppertal

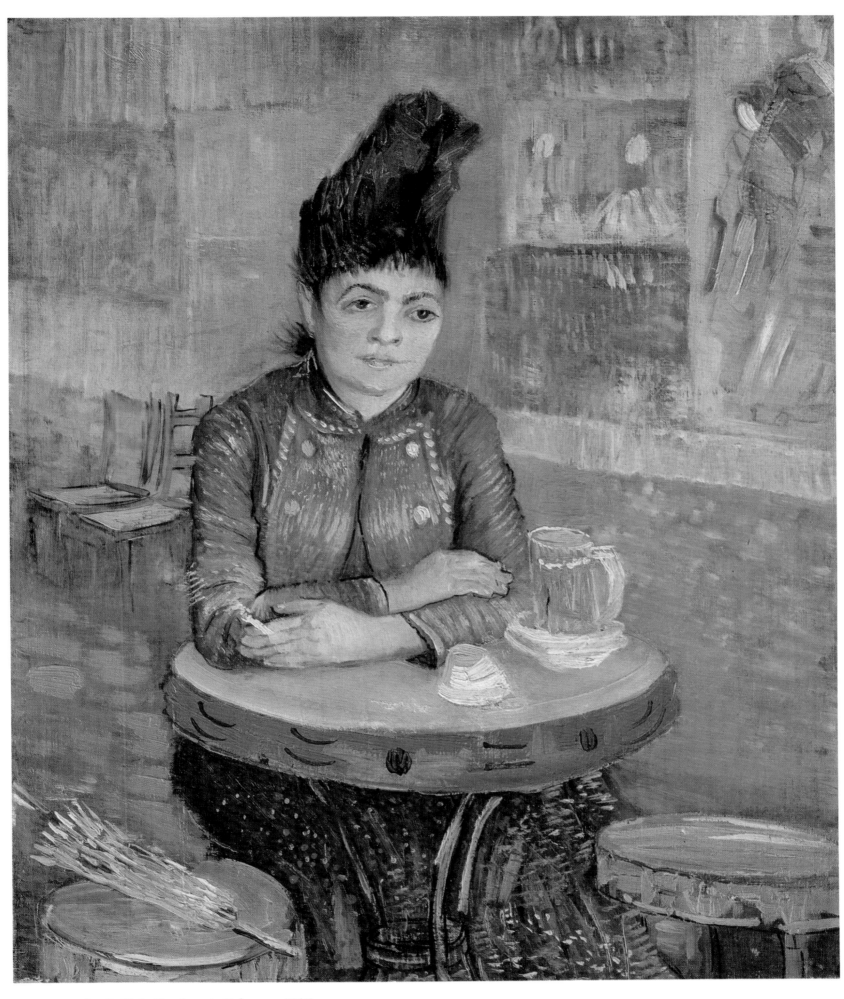

Woman at the Café du Tambourin February 1887
Oil on canvas
21¾×18¼in (55.5×46.5cm)
Rijksmuseum Vincent van Gogh, Amsterdam

Road along the Seine at Asnières
April-June 1887
Oil on canvas
19¼×26in (49×66cm)
Rijksmuseum Vincent van Gogh,
Amsterdam

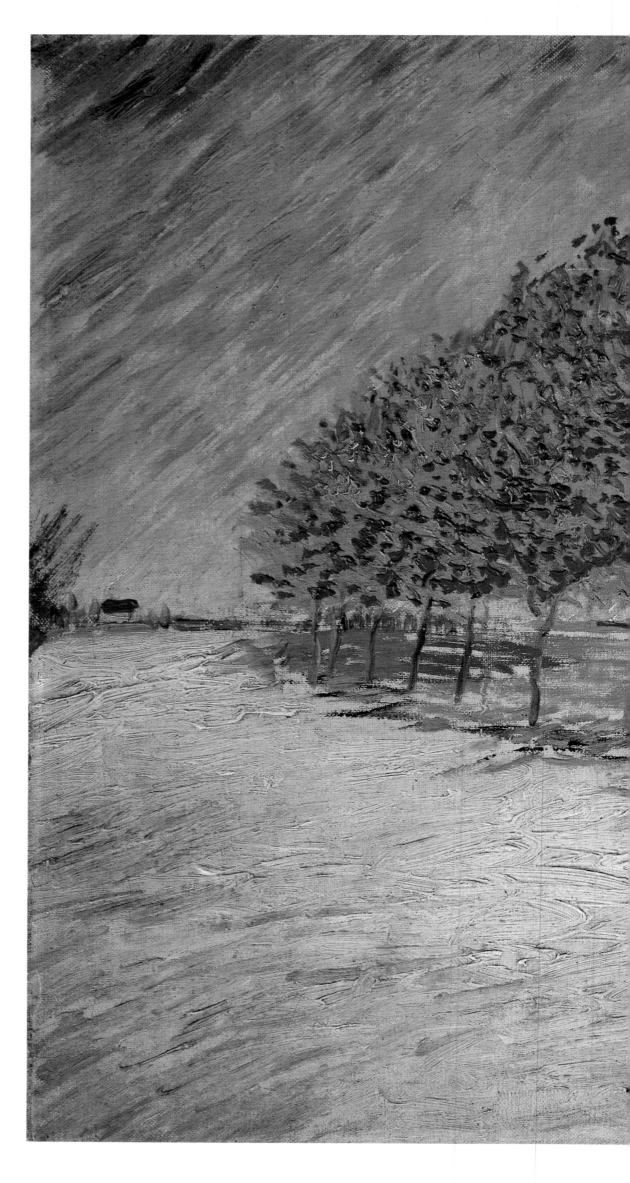

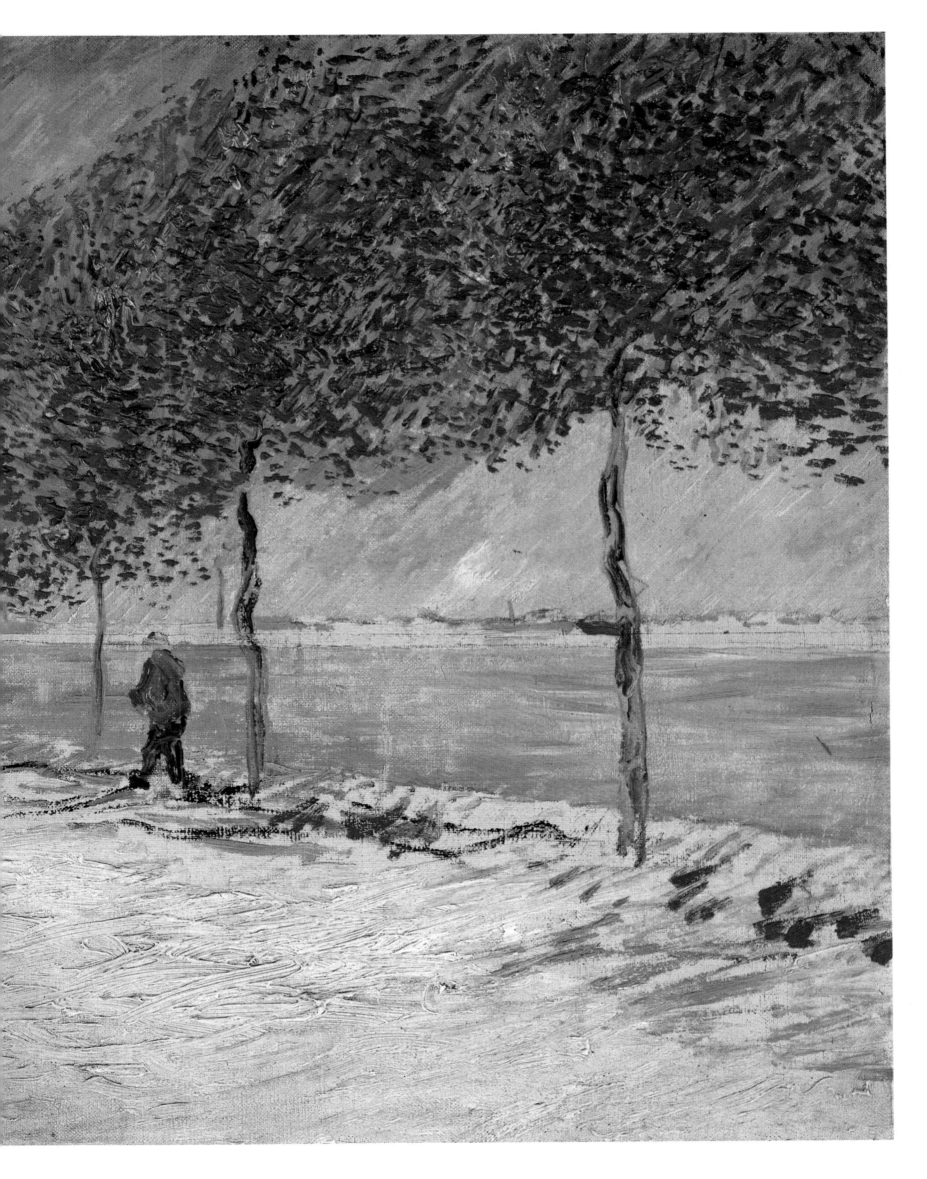

Voyer-d'Argenson Park, Asnières
May 1887
29¾×44½in (75.5×113cm)
Rijksmuseum Vincent van Gogh, Amsterdam

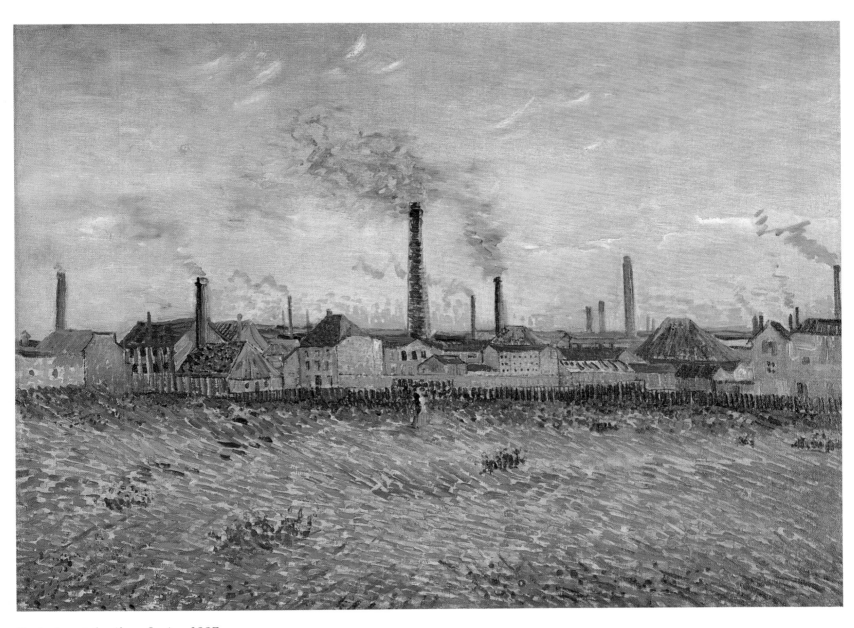

Factories at Asnières Spring 1887
Oil on canvas
21¼×28¹⁄₁₆in (54×72cm)
The Saint Louis Art Museum, Saint Louis, Missouri

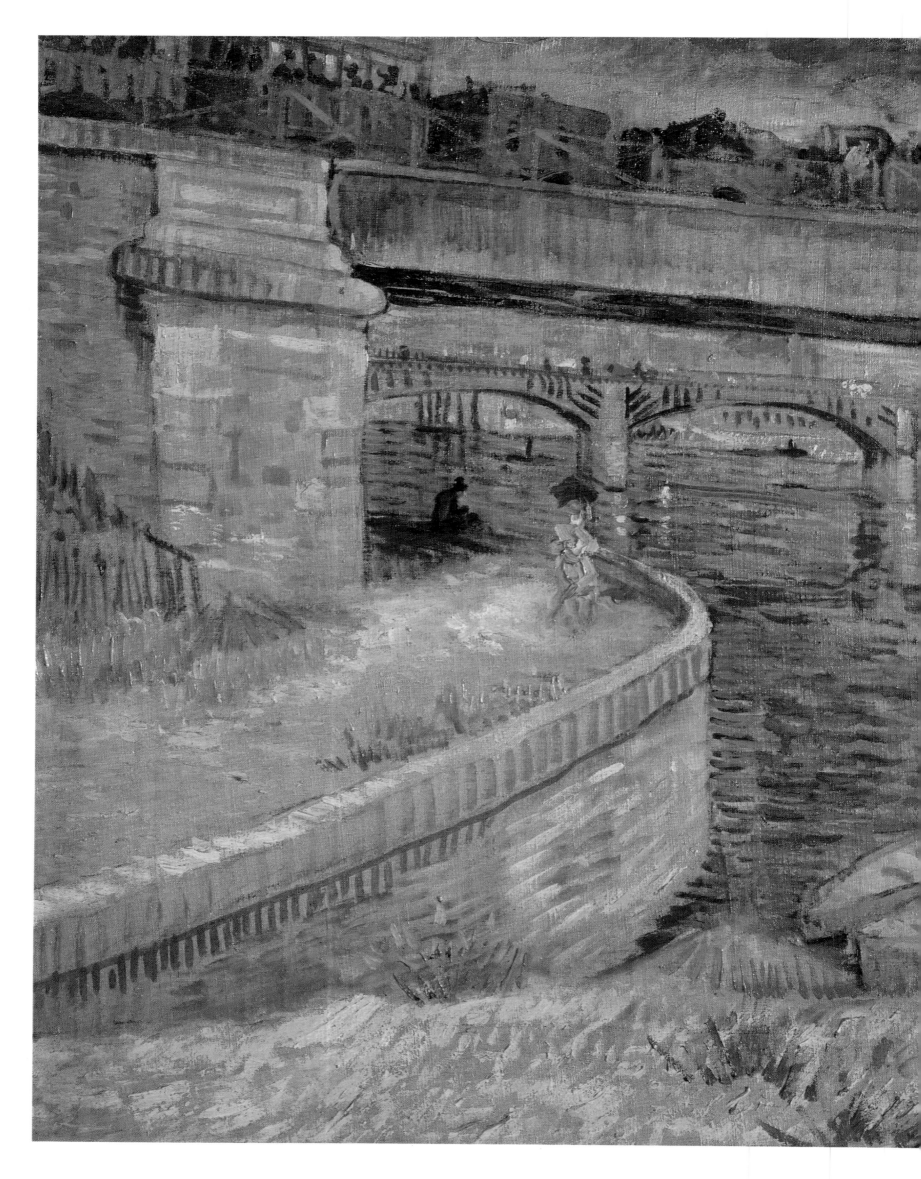

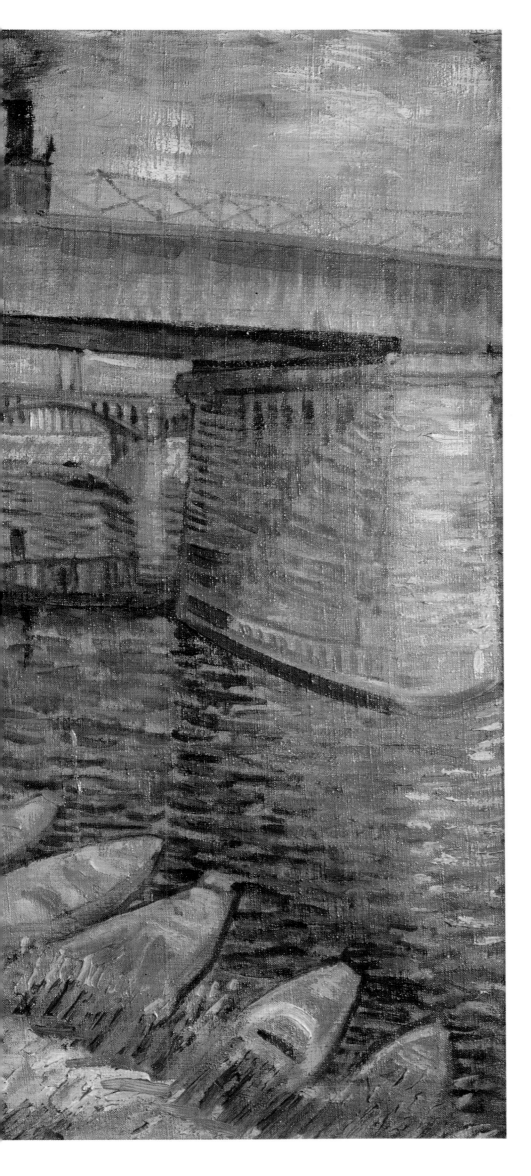

Bridge at Asnières July-September 1887
Oil on canvas
20½×25½in (52×65cm)
Stiftung Sammlung E G Bührle, Zurich

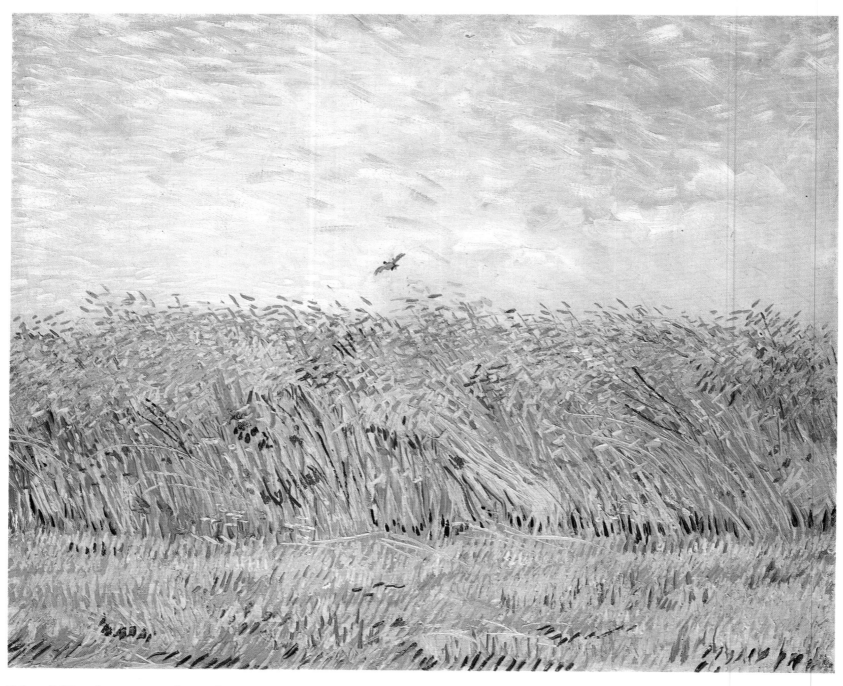

Wheatfield with Poppies and a Lark
Early summer 1887
Oil on canvas
21¼×25½in (54×64.5cm)
Rijksmuseum Vincent van Gogh, Amsterdam

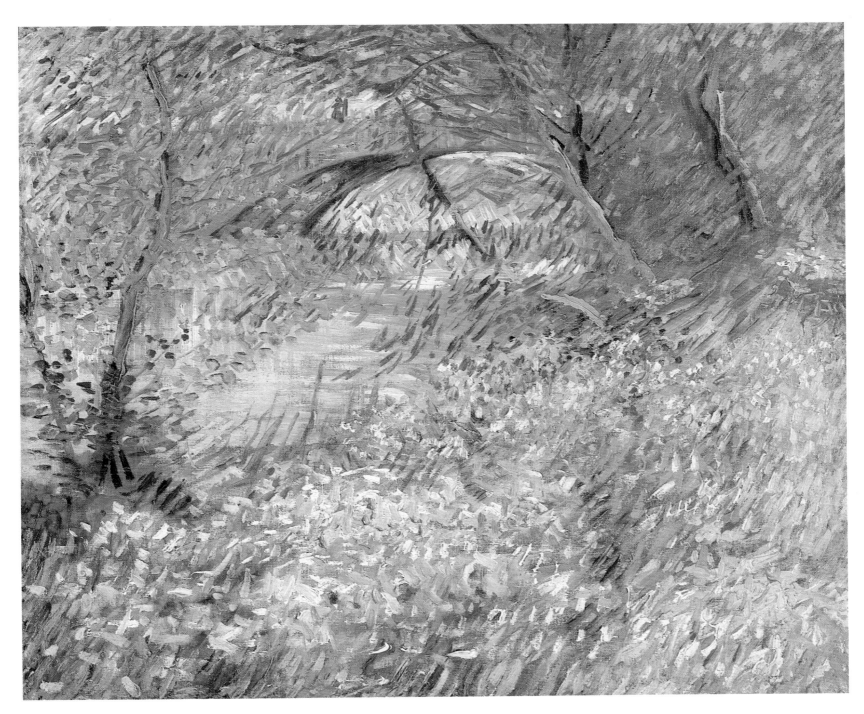

Riverbank in Springtime
Summer 1887
Oil on canvas
19×22½in (50×60cm)
Dallas Museum of Arts

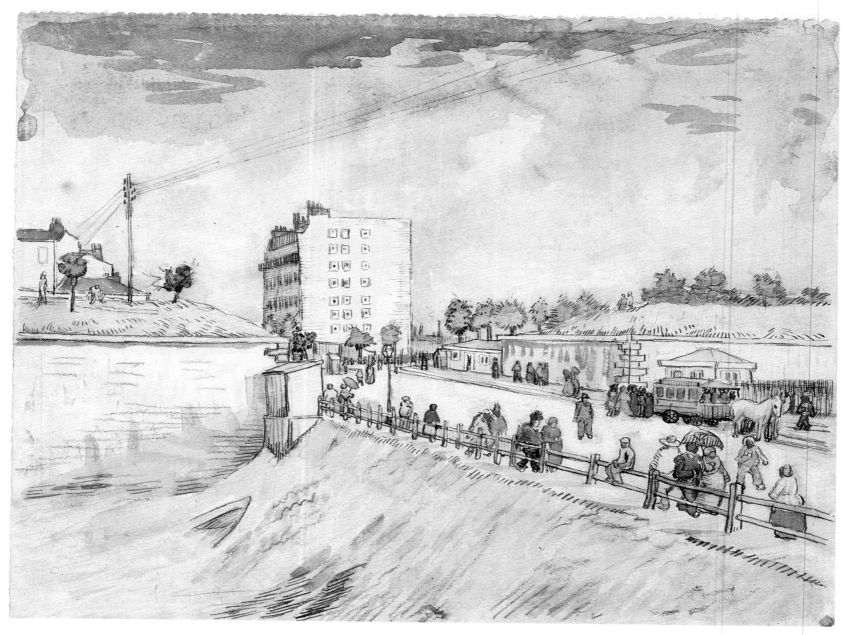

The Ramparts with Horse Tram
July-September 1887
Watercolour on paper
9½×12½in (24×31.5cm)
Rijksmuseum Vincent van Gogh, Amsterdam

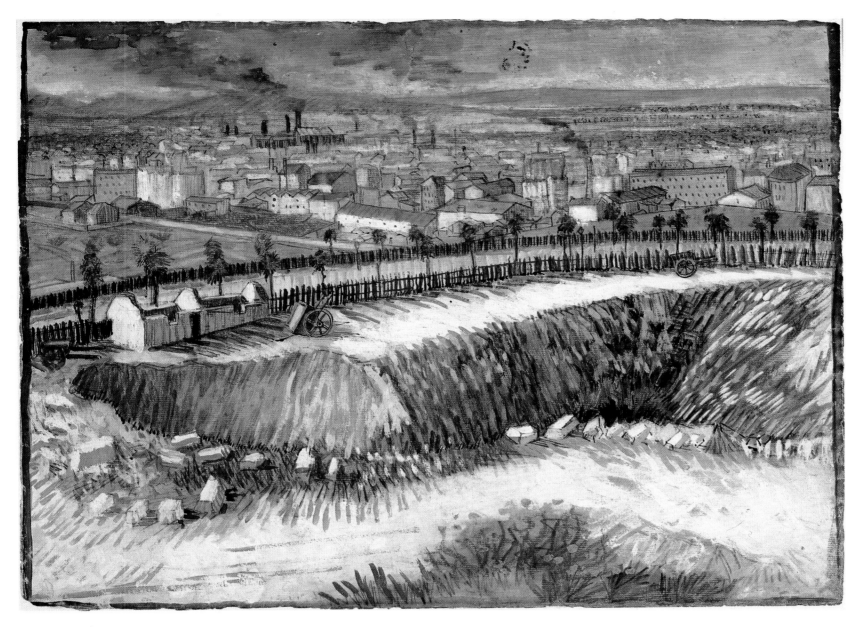

Outskirts of Paris near Montmartre 1887
Oil on canvas
15½×21in (39.5×53.6cm)
Rijksmuseum Vincent van Gogh, Amsterdam

Still Life with Four Sunflowers
July-September 1887
Oil on canvas
23⅝×39⅜in (60×100cm)
Rijksmuseum Kröller-Müller, Otterlo

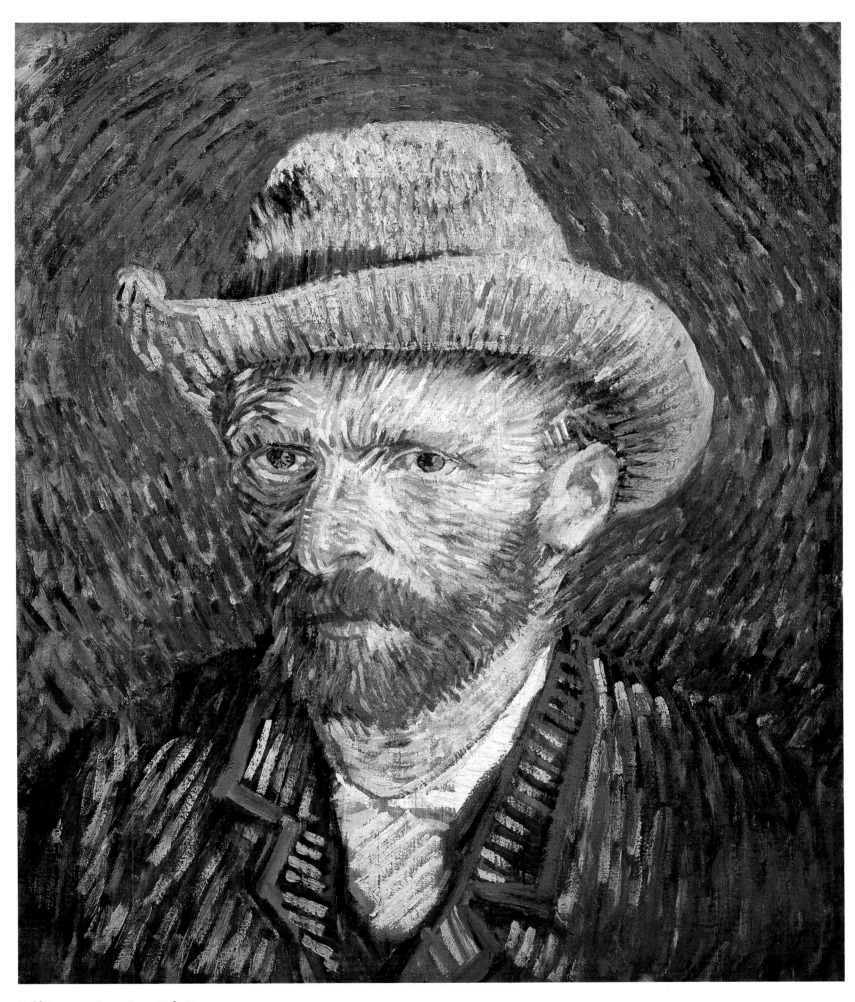

Self Portrait in a Gray Felt Hat
Late summer 1887
Oil on canvas
17⅜×14¾in (44×37.5cm)
Rijksmuseum Vincent van Gogh, Amsterdam

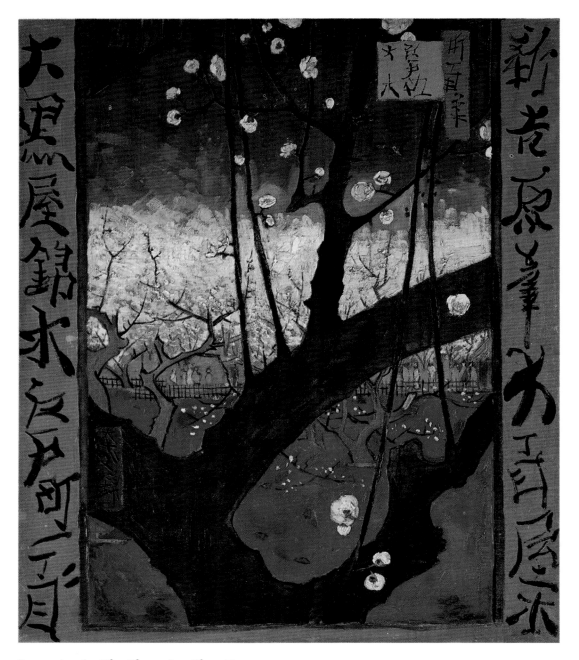

Japonaiserie: The Flowering Plum Tree
Summer 1887
Oil on canvas
21¾×18in (55×46cm)
Rijksmuseum Vincent van Gogh, Amsterdam

Right:
Japonaiserie: Oiran (after Kesai Yeisen)
Summer 1887
41¼×24in (105×61cm)
Rijksmuseum Vincent van Gogh,
Amsterdam

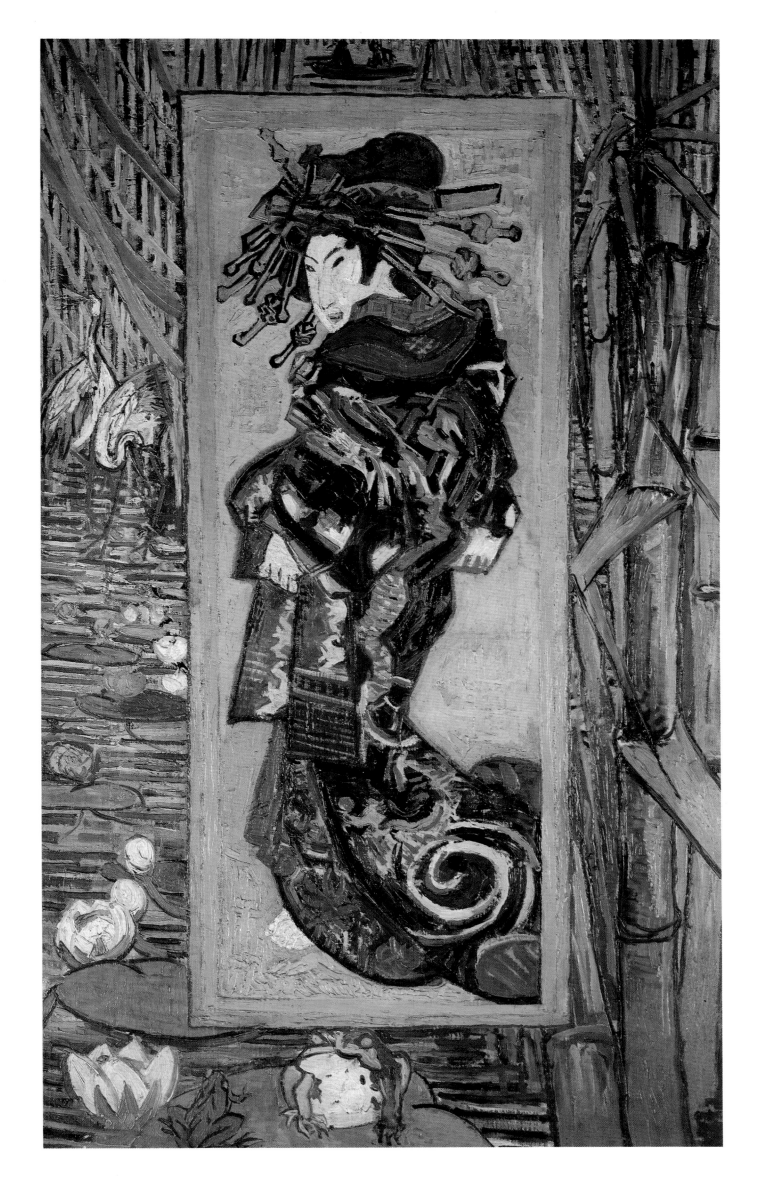

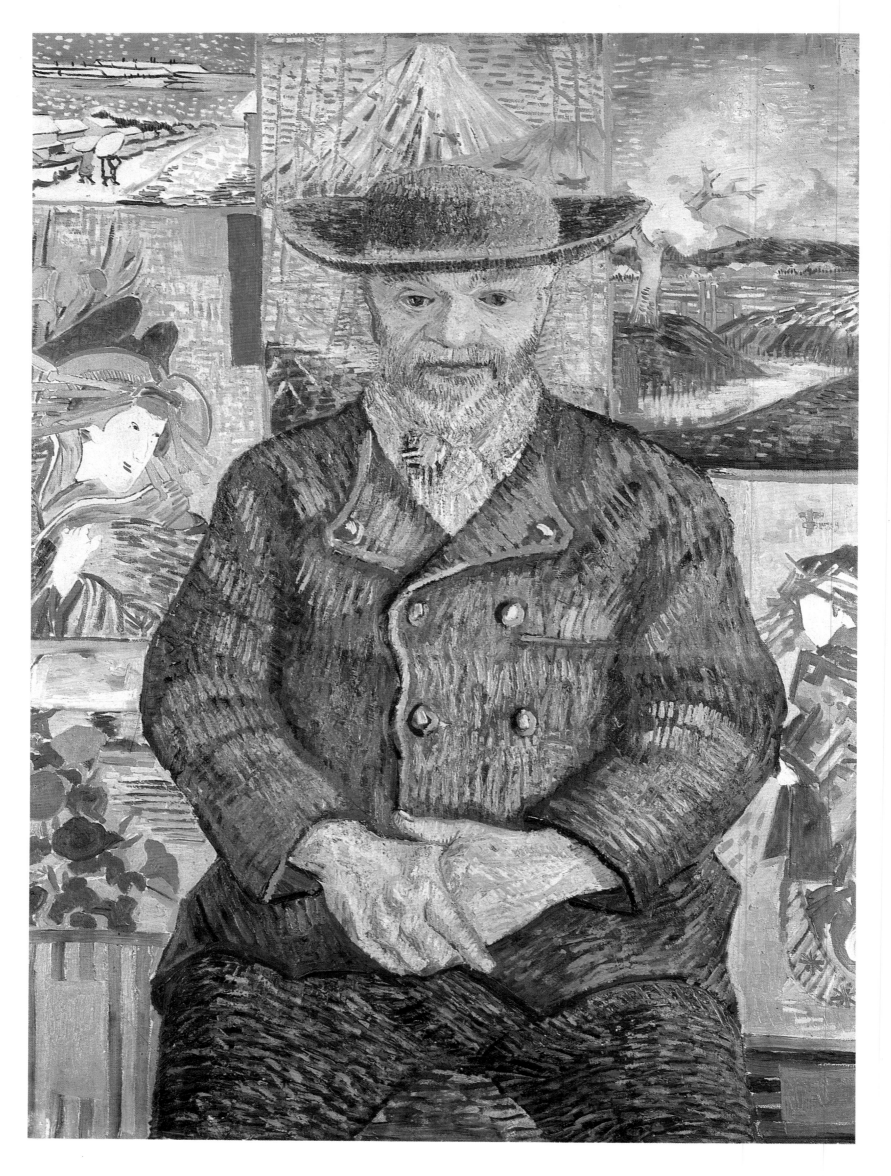

Left:
Portrait of Père Tanguy 1887
Oil on canvas
25×19in (63×48cm)
Musée Rodin, Paris

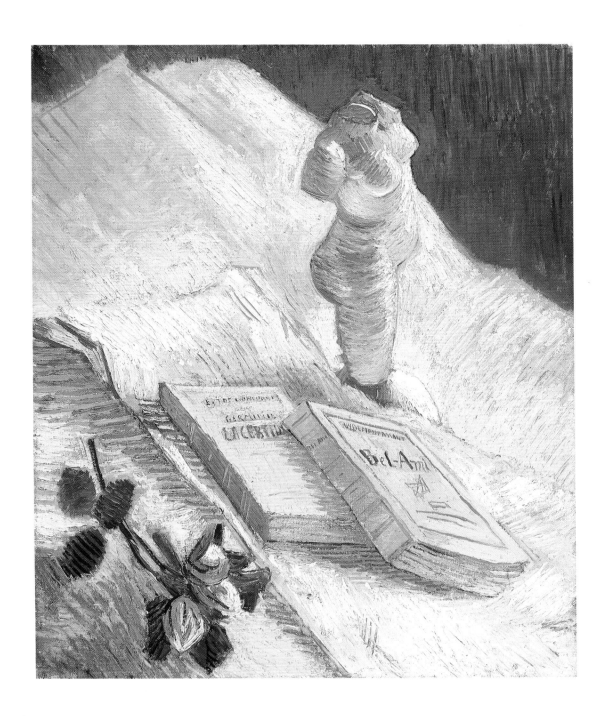

Right:
**Still Life with Plaster Statuette and
Two Novels** Autumn 1887
Oil on canvas
21¾×18¼in (55×46.5cm)
Rijksmuseum Kröller-Müller, Otterlo

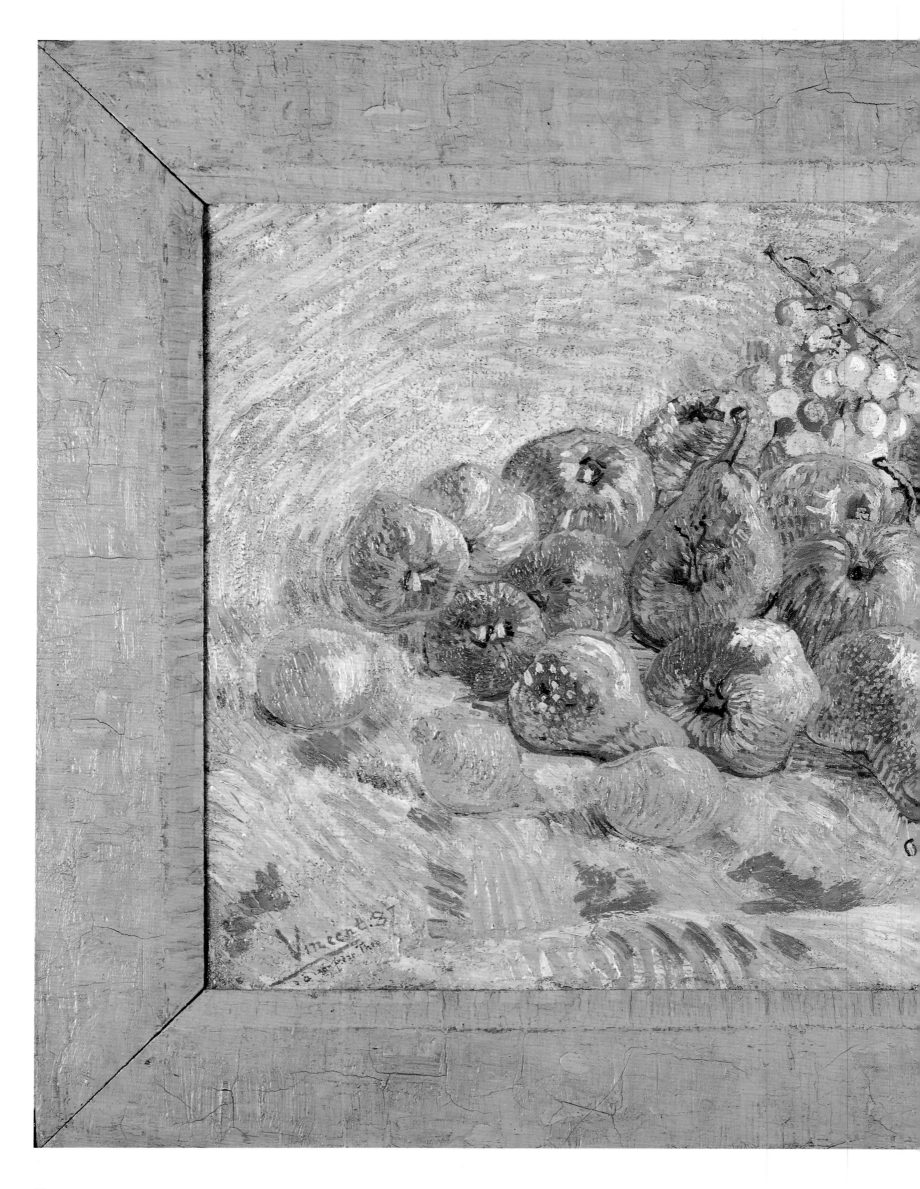

Still Life with Apples, Pears, Grapes, Lemons,
and an Orange Fall 1887
Oil on canvas
19×26⅛in (48.5×65cm)
Rijksmuseum Vincent van Gogh, Amsterdam

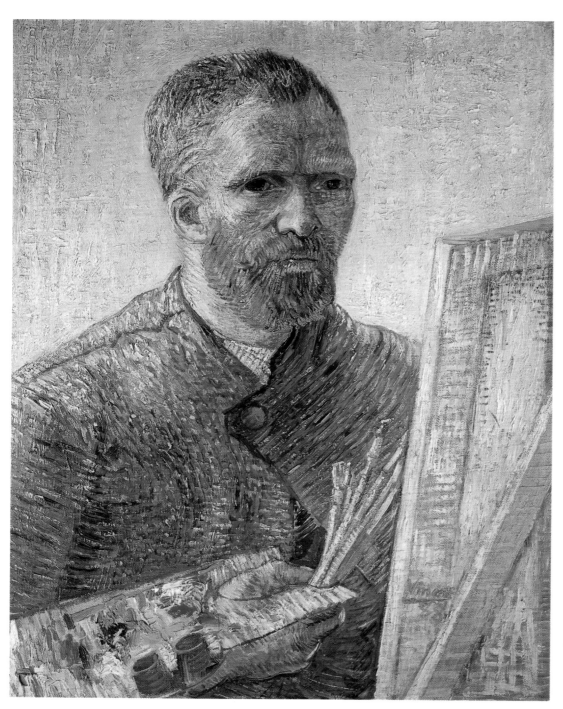

Self Portrait with Easel Early 1888
Oil on canvas
25½×20in (65×50.5cm)
Rijksmuseum Vincent van Gogh, Amsterdam

Right:
Italian Woman with Carnations (La Segatori)
Winter 1887-88
Oil on canvas
31¾×23½in (81×60cm)
Musée d'Orsay, Paris

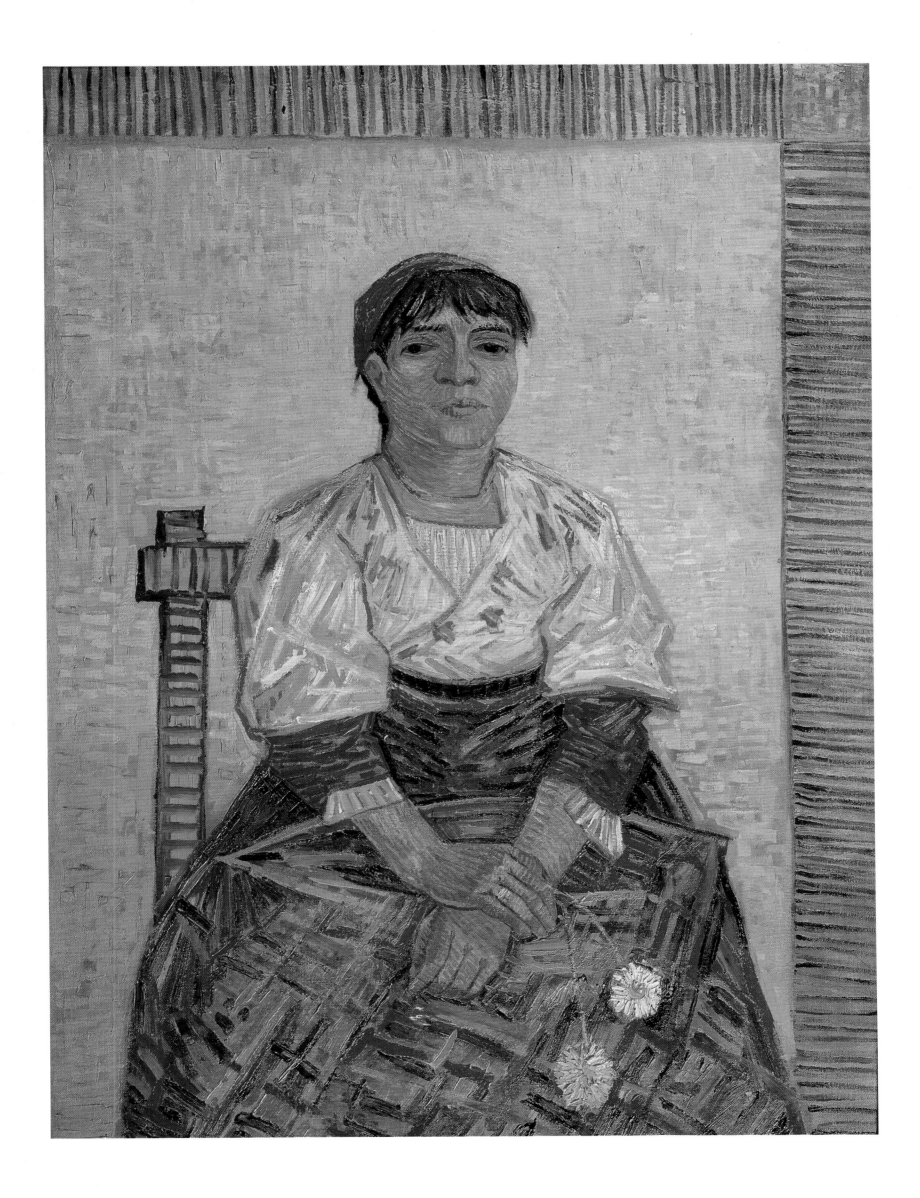

Arles

After visiting Seurat's studio with his brother Theo on 19 February 1888, Van Gogh left for Arles, and arrived on the following day. The work he was to produce during the next year, until he left for Saint-Rémy-de-Provence on 8 May 1889, was to be marked by range and depth and most reveals the ambition that underpinned his project to paint in the south and eventually establish a new school of painting there. Rapid sketches, ambitious drawings independent of paintings, drawings after paintings, studies in oils, finished works executed in front of nature and in the studio, and cycles of paintings were all produced in a period of isolation, and later, conflict. He identified his production by relation and reaction to the procedures and theories he had developed in Holland and Paris. That he could talk of paintings like *Landscape with Irises and View of Arles* of May 1888 in relatively slighting terms, as 'this study . . . the subject was very beautiful, and I had some difficulty in getting the composition.' (letter to Theo, 12 May 1888) indicates the exacting standards he was setting himself.

He saw the natural, earthy, and joyous qualities of Arles and its surrounding landscapes as being opposed to Paris. It had a quality of crudeness about it which he associated with Monticelli. He wrote of this quality as being like earthenware, the earth-given form. In pictures such as *Fruit Trees in Blossom with Cypress Trees* of April 1888, he experimented with this crudeness, by means of simplification of tonal relations and 'savageries' of color application. By Parisian academic standards pictures like this not only lacked 'finish,' they were not even acceptable as rough sketches. The characteristics of this crudeness which he felt that Monticelli had also captured were thus embodied in the means of expression. He saw this as both departing from Impressionism and allowing the viewer to see things properly. The quality of seeing was not limited to the purely visual, the means of representation being used to indicate the feelings engendered by the qualities of things. Thus the color quality he admired in Monticelli and applied to his own work gave

something passionate and eternal – the rich color and rich sun of the glorious south in a true colorist way parallel with Delacroix' conception of the south. Vis that the south be represented now by *contrasts simultanés* of color and their derivations and harmonies and not by forms and lines in themselves . . .

(Van Gogh to John Russell, April 1888)

This contrast of colors which had none of the broken tones of Impressionism is found in works of the Harvest series painted in June of 1888 such as *Haystacks in Provence*. By October, when he painted *Van Gogh's Bedroom, Maison Jaune*, he specifically associated the areas of flat color in the painting with both simplicity and virility. It can be seen from this that the formal devices he used were far from value-free, and that when he wrote to Theo in the same month, of '. . . a new School of *colorists* . . .' emerging in the south, based on, '. . . the desire to express something by color itself,' he was stressing the power of the means of expression to convey the emotion engendered by the qualities of the object depicted. In a letter to Emile Bernard of April 1888 he wrote of one of the two versions of *Fruit Trees in Blossom, with Cypress Trees* that drawing also mattered to this process and that the line was also associated with grasping the

essential qualities of objects as perceived through his subjectivity:

Working directly on the spot all the time, I try to grasp what is essential in the drawing – later I fill in the spaces which are bounded by the contours – either expressed or not, but in any case *felt* – . . .

This indicates that for all he felt he had broken with the effete qualities of Parisian avant-garde art in his work, his aesthetic debate was shaped by the criteria of synthesis as developed in the theory and practice of the Cloisonnists like Bernard and Anquetin.

Van Gogh likened the bright colors of the south to those found in Japanese prints, and in this context constructed his experience of Arles as the Japan of the south. This helped him to overcome his initial disillusionment with the faded glories of the folkloric aspects of the city:

I think that the town of Arles has been infinitely more glorious once as to the beauty of its women and the beauty of its costumes. Now everything has a battered and sickly look about it.

(Van Gogh to Theo, September 1888)

It may have been the closest thing to his dream of Japan but it was also a city under the pressure of change and modernization and for all that Van Gogh strove for poetry in his themes as in *The Garden of the Poets* of August/September 1888, he did not ignore these intrusions. *The Railway Viaduct, Avenue de Montmajour* of October 1888 stresses the urban aspect of his environment and presents the poetic aspect of the view – the distant gardens of the Place Lamartine where the artist lived – as a faint and distant vision, calm, beyond the dramatic crossed axes of the clashing and exaggerated perspective schemes of the foreground.

Japanese prints and ink paintings exerted a considerable influence on Van Gogh's drawing techniques in Arles and as early as April he was planning a series of drawings, 'in the manner of Japanese prints.' As in Paris he admired the expressive quality of their use of outline and strove to incorporate this in the series of drawings which he began in May 1888 and developed in the works executed with a reed pen at Saintes-Maries-de-la-Mer in early June. *Seascape: Boats at Sea* and *Street at Saintes-Maries* both reveal the artist creating an extremely rich and varied vocabulary of markings with the reed pen. These were to be developed in even more ambitious series of drawings throughout the summer. The artist felt that the south and Saintes-Maries in particular lent itself to the development of the Japanese, expressive, and spontaneous qualities in his work. He wrote to Theo in early June:

I wish you could spend some time here, you would feel it after a while, one's sight changes: you see things with an eye more Japanese, you feel color differently. The Japanese draw quickly, very quickly, like a lightning flash, because their nerves are finer, their feeling simpler. I am convinced that I shall set my individuality free . . . here.

This passage also makes it clear that Van Gogh was constructing his image of the Japanese artist as the model for the cognitive processes underlying the new art he hoped to develop in the south. Fine nerves and simple feeling were at the heart of this. He developed this reasoning in September when in a letter to Theo he contrasted

the mechanistic knowledge of the West with the deeper, mystical knowledge which is at once organic and more religious to be found in Japanese art:

[The Japanese artist] . . . studies a single blade of grass. But this blade of grass leads him to draw every plant and then the seasons, the wide aspect of the countryside, then animals, then the human figure. . . . Come now, isn't it almost a . . . religion which these simple Japanese teach us, who live in nature as though they themselves were flowers? And you cannot study Japanese art, it seems to me, without becoming much gayer and happier, and we must return to nature in spite of our education and our work in a world of convention.

The themes of a wise and philosophic artist in harmony with nature play an important role in the complex significations of the *Self Portrait: à mon ami Paul Gauguin* of September 1888. It develops Parisian prototypes like the *Portrait of Père Tanguy*, which stress the principle of the naive philosopher. On the other hand it reveals the artist with his shaved head and harsh features rejecting the norms of Western elegance. He has exaggerated rather than caricatured his own features, but he has also alluded to several persona which indicate the artist's construction of character in the representation. In his letters to Theo he likened himself to the mad Flemish artist Hugo van der Goes, as depicted by the nineteenth-century painter Emile Wauters, but at the same time suggested that the portrait had something of the calm features of the priest in the same picture. In later letters he saw himself as Japanese and more specifically as 'a simple bonze worshipping the eternal Buddha.' Simplicity and 'timeless' knowledge again, but here they are the product of Western constructions of these qualities in the Japanese, this time derived from his reading of Pierre Loti's novel *Madame Chrysanthème*. This picture was part of a group of self-portraits to be exchanged with Gauguin, Bernard, and Laval. Gauguin's contribution, *Self portrait: Les Miserables* in which he presents himself as Zola's hero Jean Valjean, also utilized persona to indicate particular characteristics the artist wanted to stress.

The artist or sage in the modern 'age of iron' could either be mad outcast or at one with nature. The models for the more positive construction of these two realities did not have to be Japanese. As in the earlier portrait of Tanguy it could allude to the Golden Age of Greek philosophy and mythology, even if the figures remained modern in their dress. In a letter to Emile Bernard, Van Gogh wrote of his *Portrait of Joseph Roulin* of July/August 1888 as representing 'A Socratic Type, none the less socratic for being somewhat addicted to liquor . . .' Both Roulin and Tanguy were nonconformists, radical republicans, and approximated the stance of opposition that Van Gogh had constructed for the modern artist in bourgeois society. Both of the old men were 'sages' not intellectuals, and as such could be associated with natural as opposed to sophisticated means of accessing knowledge. They could inhabit the world of Socrates and Daumier simultaneously.

The principle of portraiture by means of persona and association was taken to new lengths in a pair of pictures where objects are used as displacement images of people. *Van Gogh's Chair* and its pendant *Gauguin's Chair*, both of December 1888, represent the qualities of the two artists as seen by Van Gogh. The 'self portrait' is naive, simple, natural, full of daylight; and the Gauguin, overbearing, more artificial with the modern characteristics of Parisian novels; a night scene but with characteristics of leadership in the symbol of the lighted candle. These two symbolic displacement portraits attempt to unite two proundly different worlds of experience within the 'simple' symbolic function of two intimate objects, chairs. This is reminiscent of the kind of intimate knowledge to be gained from the study of the blade of grass by Van Gogh's Japanese artist, the microcosm revealing the macrocosm.

The Café Terrace on the Place du Forum, Arles at Night and *The Night Café* of September 1888, develop the formal concerns of creating color harmonies which effectively represent artificial light and the rich hues of starlit nights. They also explore the themes of existential despair in *The Night Café* and the intimation of a life beyond death in *The Café Terrace*. As early as July 1888 Van Gogh's thoughts had been focussed on death and the possibility of an afterlife by the death of one of his uncles, a preoccupation that was to continue in the following two months. In a letter to Theo of mid-July 1888, he specifically associates stars with the infinity of life beyond death:

This brings up again the eternal question: is the whole of life visible to us, or is it rather that this side of death we see one hemisphere only. . . . For my own part, I declare I know nothing whatever about it, but to look at the stars always makes me dream *as simply* as I dream over the black dots of a map representing towns and villages . . . if we take a train to Tarascon or Rouen, we take death to reach a star.

Later, in August, he wrote to Theo about starting a picture of a Night Café, in which he denies the possibility of the afterlife, or at least of knowing of it:

I always feel that I am a traveler, going somewhere and to some destination. If I tell myself that the somewhere and the destination do not exist, that seems to me very reasonable and likely enough. . . . And in the same way a child in the cradle, if you watch it at leisure, has the infinite in its eyes. In short I know *nothing* about it, but it is just this feeling of *not knowing* that makes the real life we are actually living now like a one-way journey on a train. You go fast, but you cannot distinguish any object very clearly, and above all you do not see the engine.

The two passages reveal the anxiety created by alternating intuitions of hope for infinity and acceptance of the existential condition of humanity. The two café scenes are symbols of his fluctuating state and uncertainty. *The Night Café* reveals the consequences of existential despair and alienation. The artist felt that he was trying to 'express the idea' of the café as 'a place where one can ruin oneself, go mad, or commit a crime.' In more general terms he was expressing 'the powers of darkness.' This was masked by 'an appearance of Japanese gaiety, and the good nature of Tartarin,' Alphonse Daudet's Provençal hero, the Tartarin of Tarascon. The importance of the structure of the painting as described by Van Gogh is shattering. He employs a deliberate disjunction of signifiers – the atmosphere of hell, the vertiginous perspective on the one hand and gaiety and good nature on the other – to create an equivalent of, or an expression of, the state of dislocated perception and anxiety that also underlies his description of life in the simile of the trian journey in the passage from the August 1888 letter to Theo quoted above.

The disjunction of metaphor plays a significant role in his painting at this time. In *The Mowers, Arles in the Background* of June 1888, strikingly different in every pictorial mechanism from the painting by Anquetin of a similar theme, country, city, and rural labor in harmony with the cycle of the seasons is deliberately separated from the image of the city by a speeding train, which in the context of the passages from the letters quoted above is given a greater metaphorical value than that of a sign of modernity. It is a metaphor of life and existential uncertainty, deliberately clashing with the harmony and cosmic order represented by the cyclic metaphor of life in the fields and the harvest and also seen in themes like *The Sower*. The essential point of disjuncture occurs in the clash of two metaphorical representations of time, one linear (train) and the other cyclic (labors of the seasons). The grand decorative cycle that underlay Van Gogh's work at Arles has already been commented upon. In the largest sense this was the consoling musical quality of his work. At the same time this constructed continuity was undermined by a profoundly disturbing and destabilizing metaphor of time and existence. This creates immense tensions in even his most joyous paintings of the Arles period and makes the seismic disturbances of some of his Saint-Rémy works less unexpected.

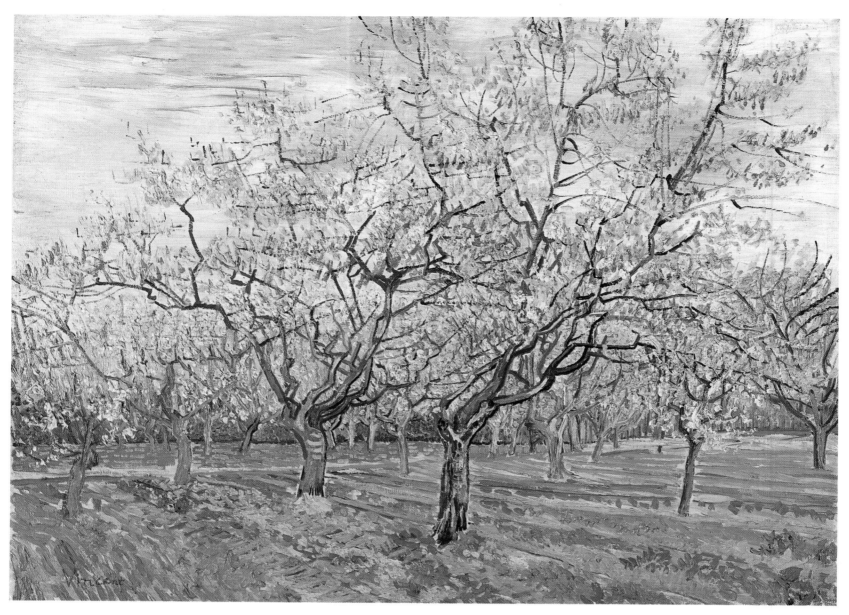

The White Orchard April 1888
Oil on canvas
23½×31½in (60×80cm)
Rijksmuseum Vincent van Gogh, Amsterdam

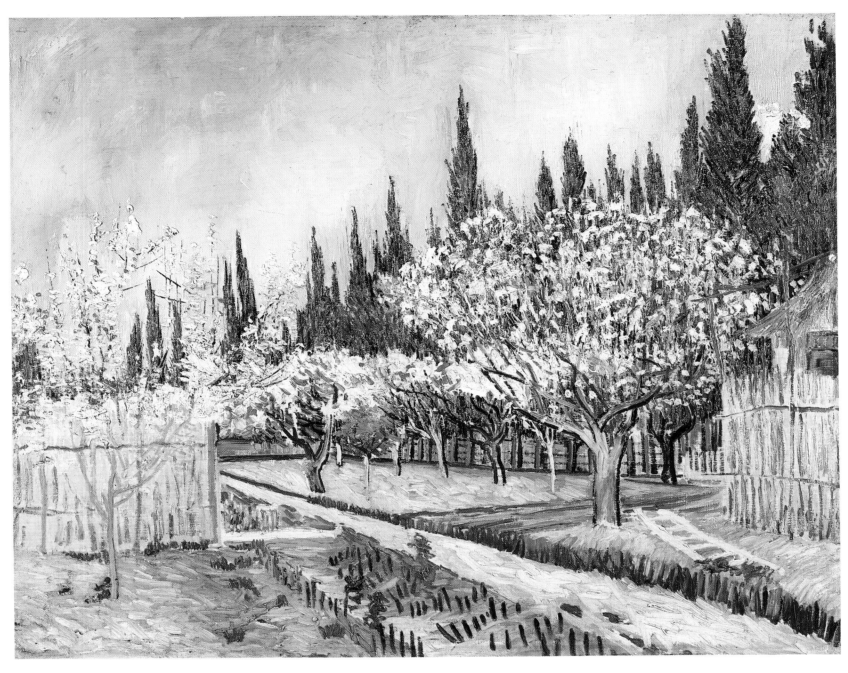

Fruit Trees in Blossom, with Cypress Trees
April 1888
Oil on canvas
25½×31¾in (65×81cm)
Rijksmuseum Kröller-Müller, Otterlo

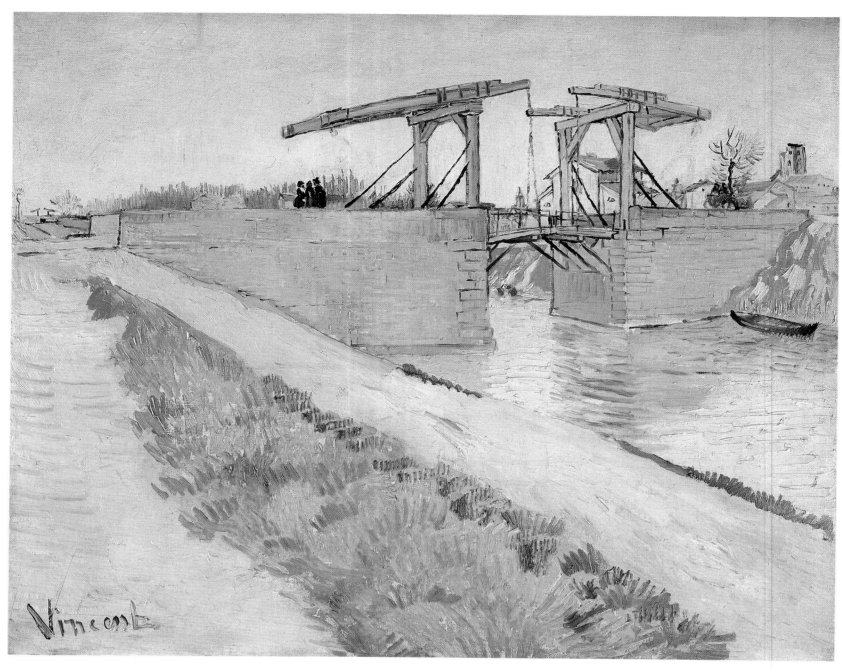

The Bridge of Langlois March 1888
Oil on canvas
23×28¾in (58.5×73cm)
Rijksmuseum Vincent van Gogh, Amsterdam

Landscape with Irises and View of Arles
May 1888
Oil on canvas
21¼×25½in (54×65cm)
Rijksmuseum Vincent van Gogh, Amsterdam

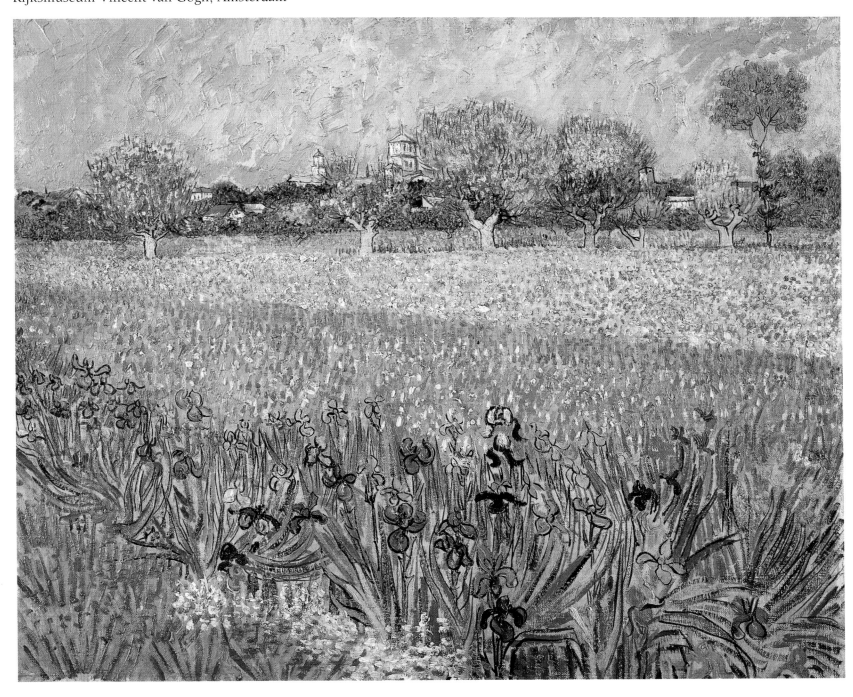

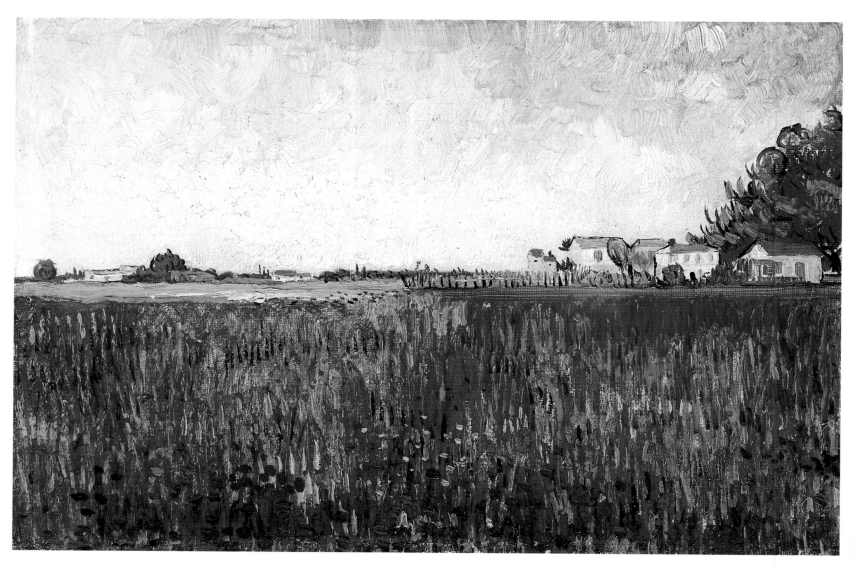

Meadow with Poppies May 1888
Oil on canvas
9×13⅜in (23×34cm)
Rijksmuseum Vincent van Gogh, Amsterdam

Right:
The Mowers, Arles in the Background June 1888
Oil on canvas
28¾×21¼in (73×54cm)
Musée Rodin, Paris

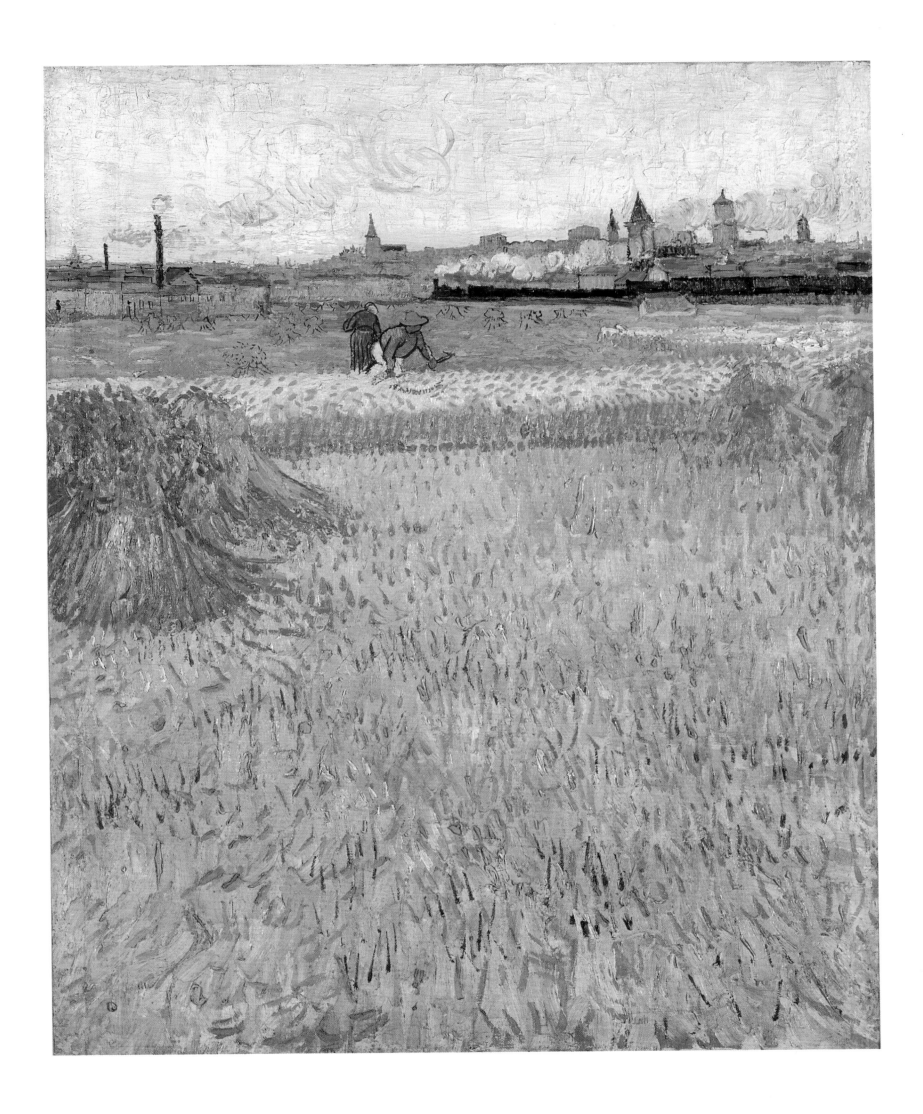

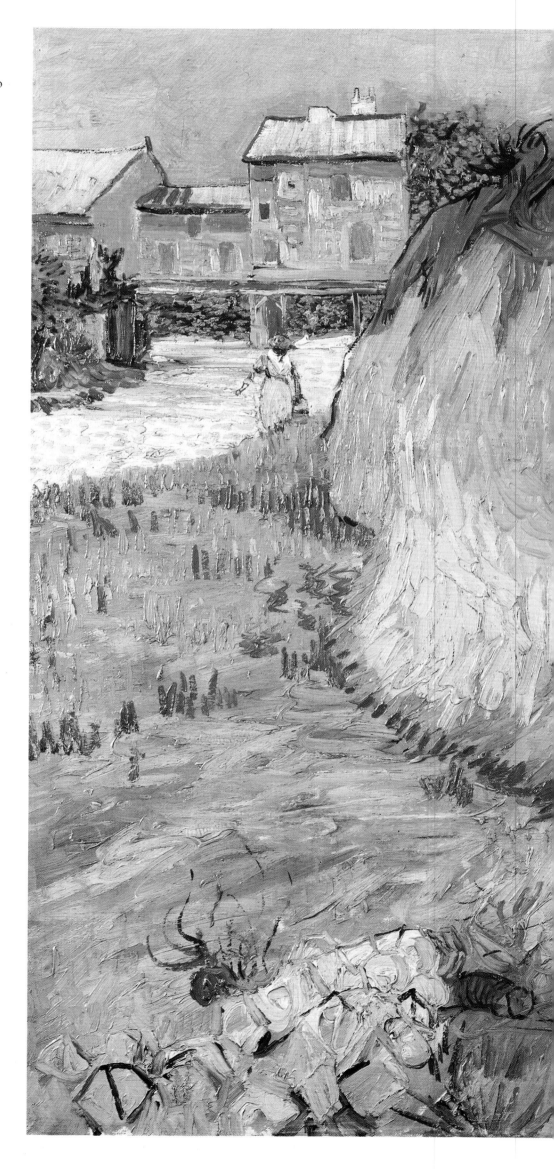

Haystacks in Provence June 1888
Oil on canvas
28¾×36in (73×92.5cm)
Rijksmuseum Kröller-Müller, Otterlo

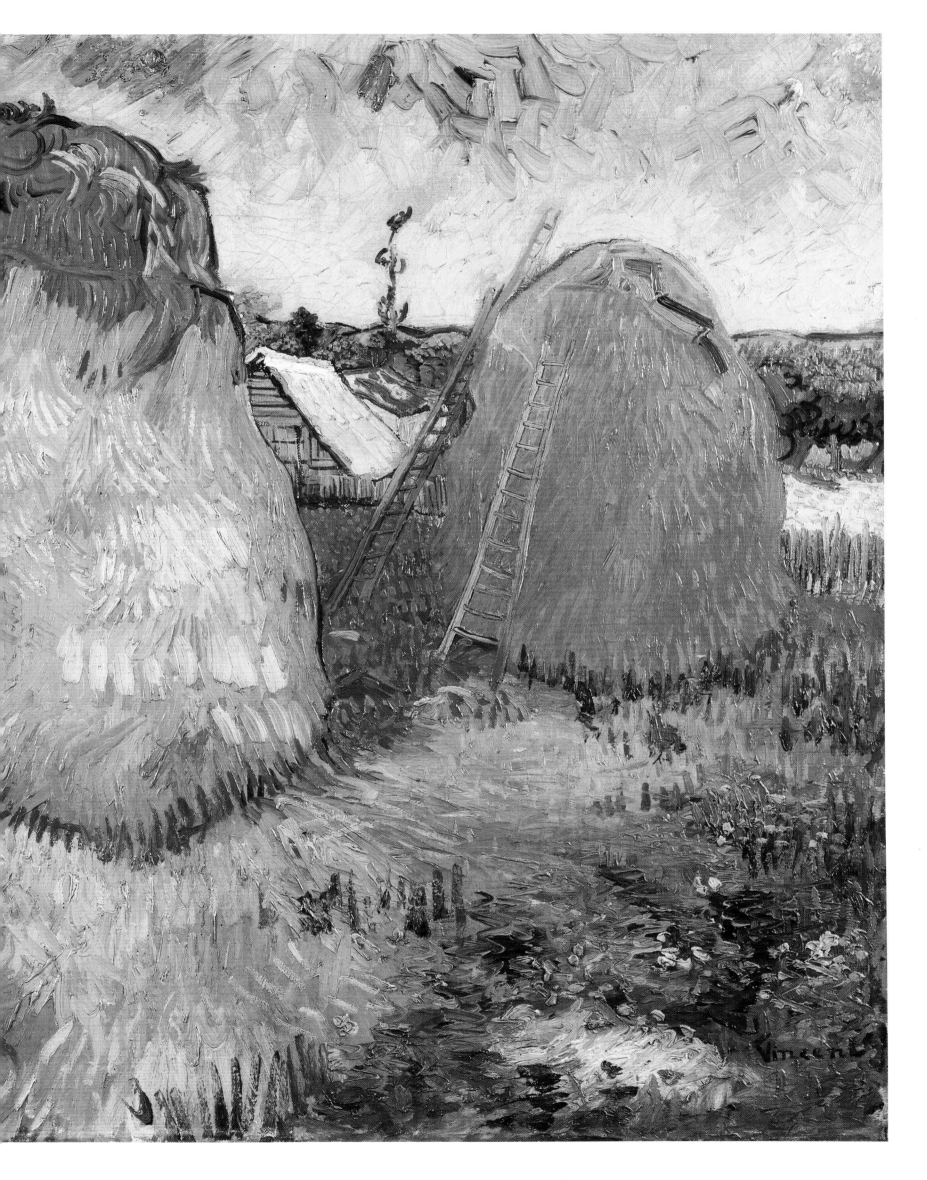

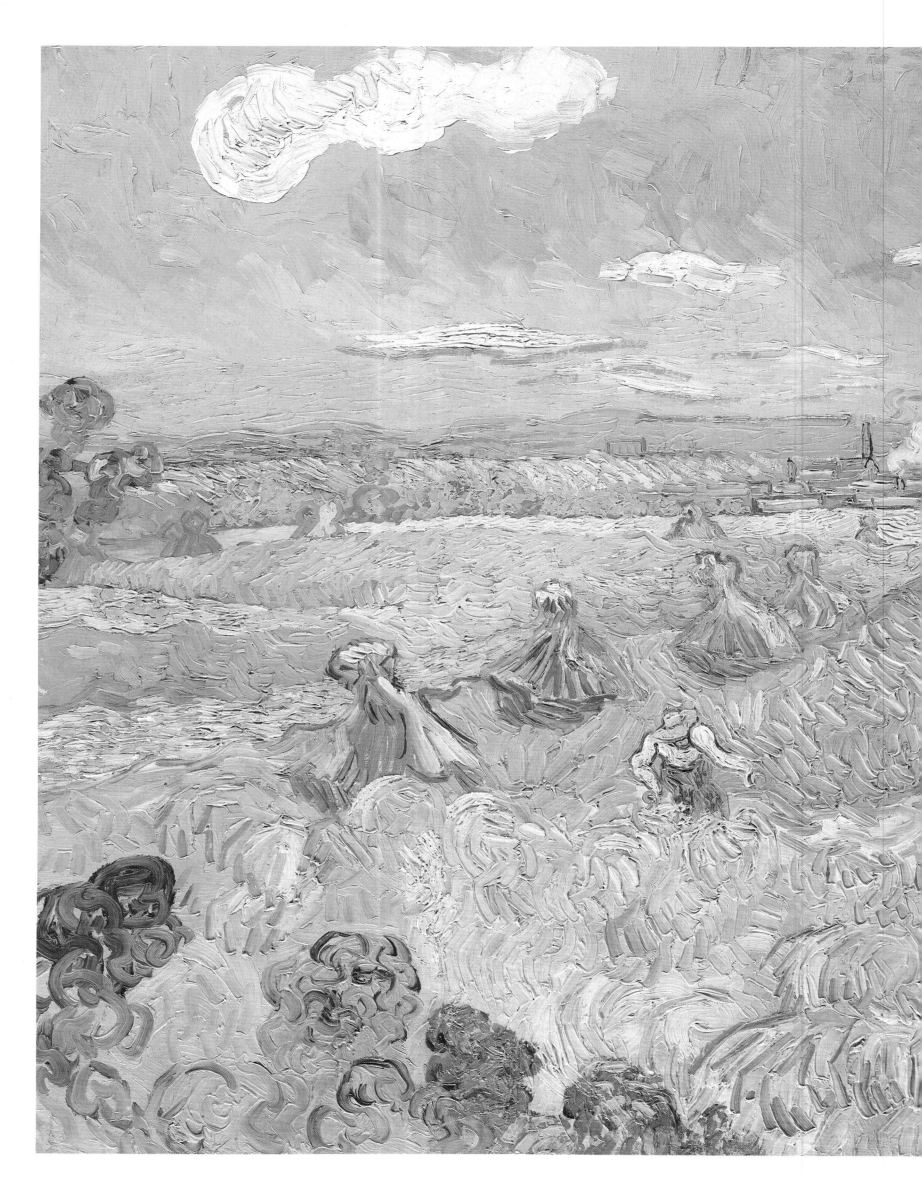

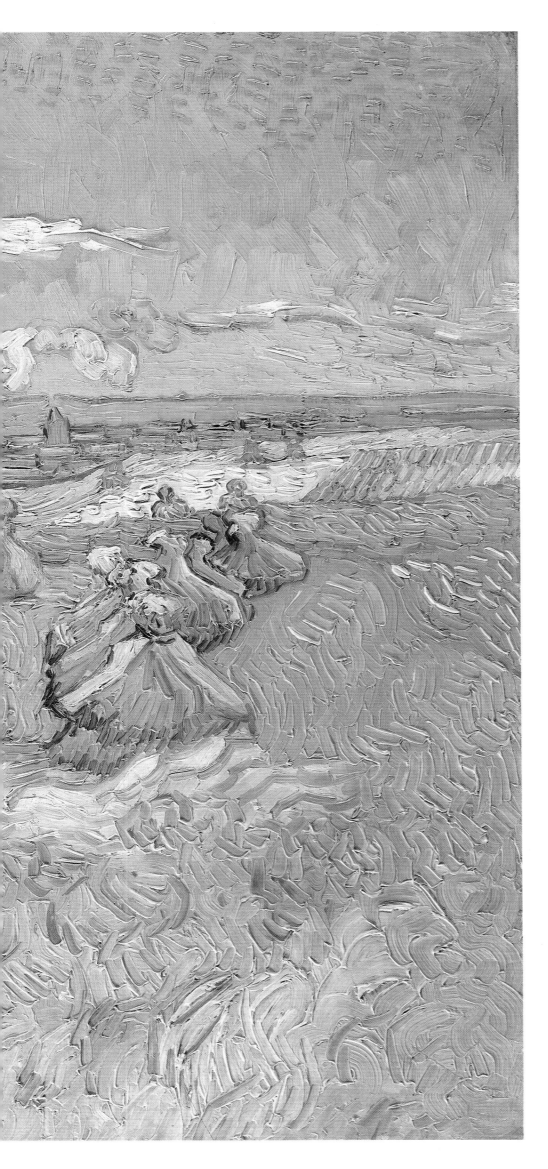

Wheatfields Summer 1888
Oil on canvas
28¾×36½in (73×93cm)
Toledo Museum of Art, Toledo, Ohio

The Sower June 1888
Oil on canvas
21¼×31¾in (64×80.5cm)
Rijksmuseum Kröller-Müller, Otterlo

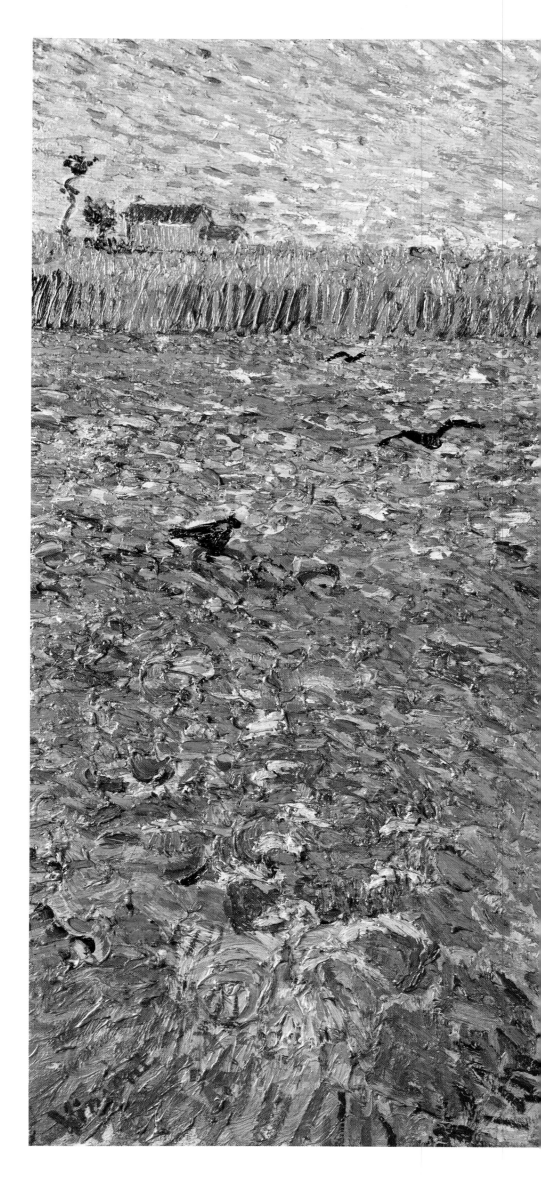

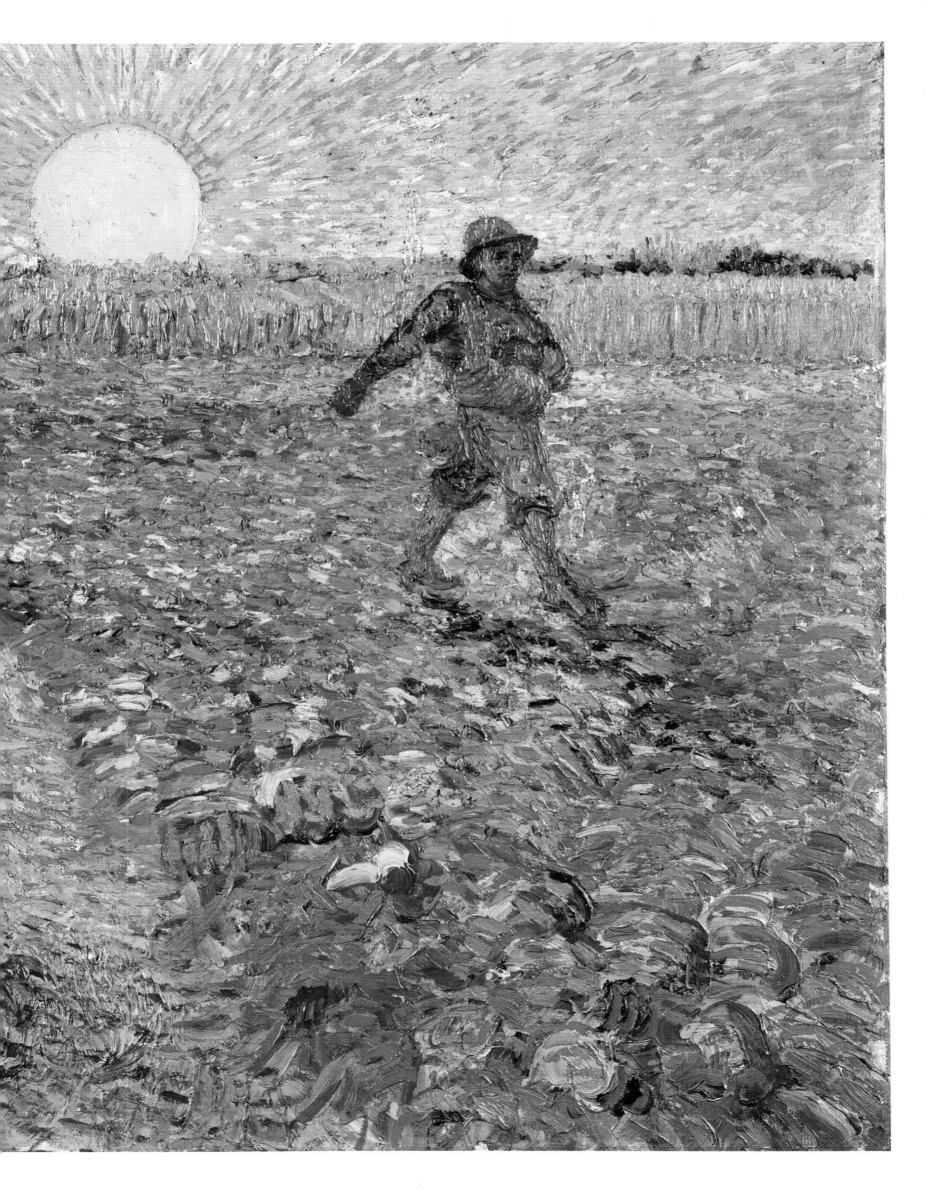

Landscape with the Plains of the Crau June 1888
Oil on canvas
28½×32¼in (72.5×92cm)
Rijksmuseum Vincent van Gogh, Amsterdam

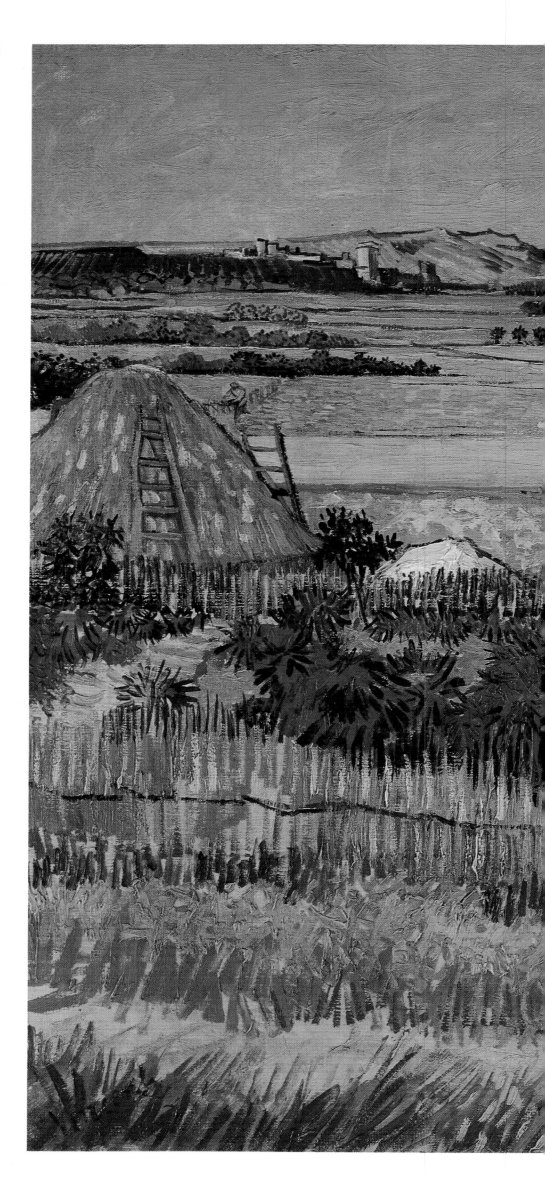

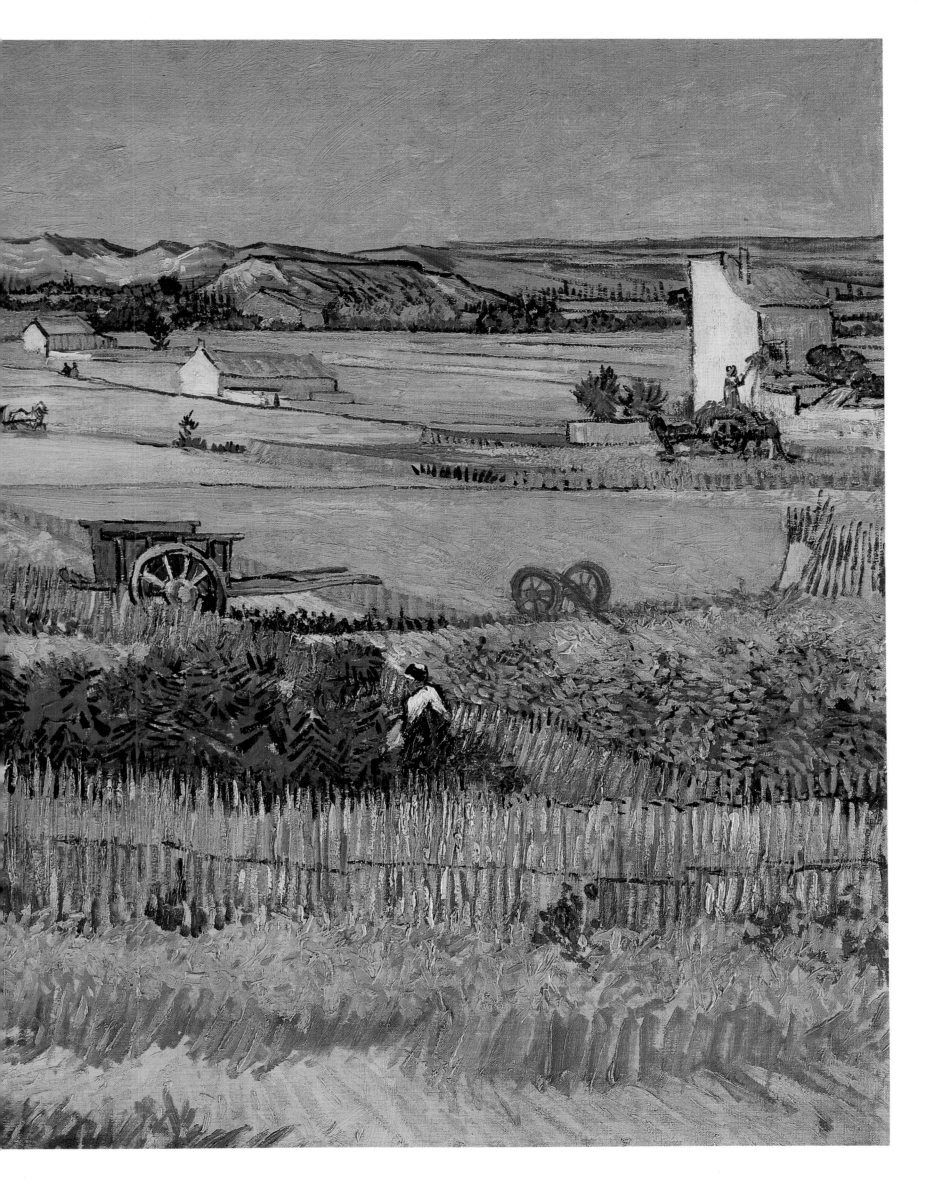

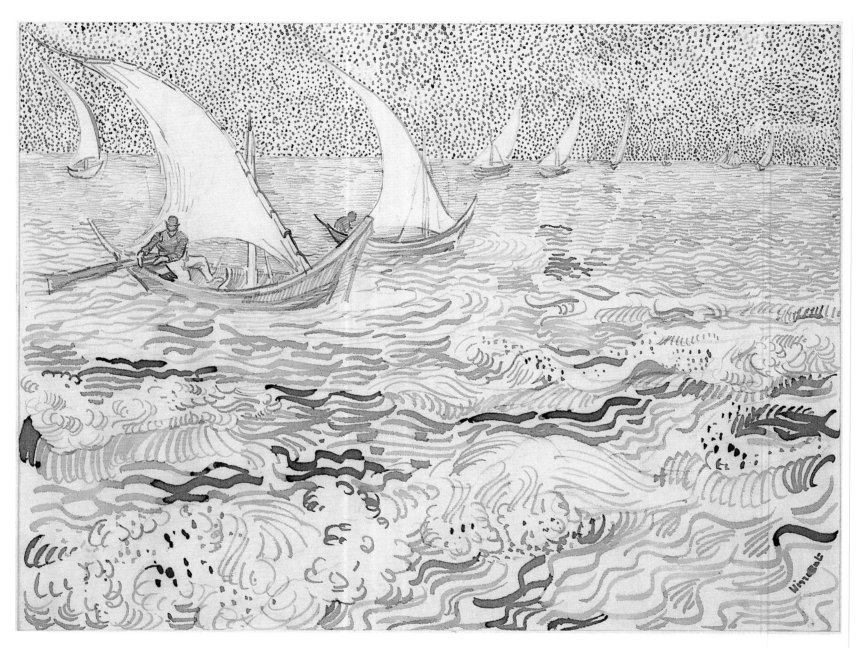

Seascape, Boats at Sea June 1888
Reed pen and ink on paper
9½×12½in (24×31.5cm)
Musée d'Art Moderne, Brussels

Boats on the Beach at Saintes-Maries
June 1888
Oil on canvas
25½×31¾in (64.5×81cm)
Rijksmuseum Vincent van Gogh, Amsterdam

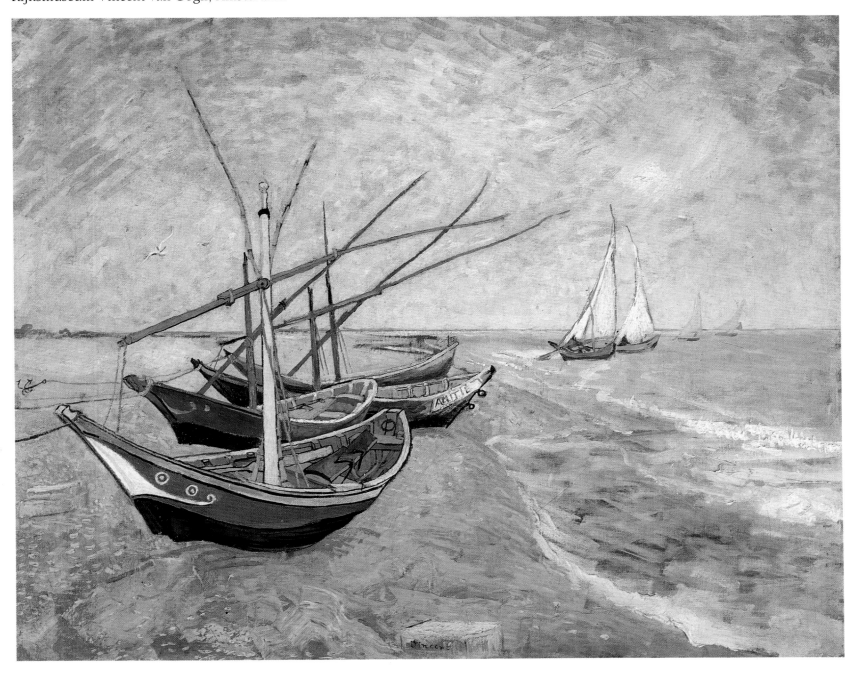

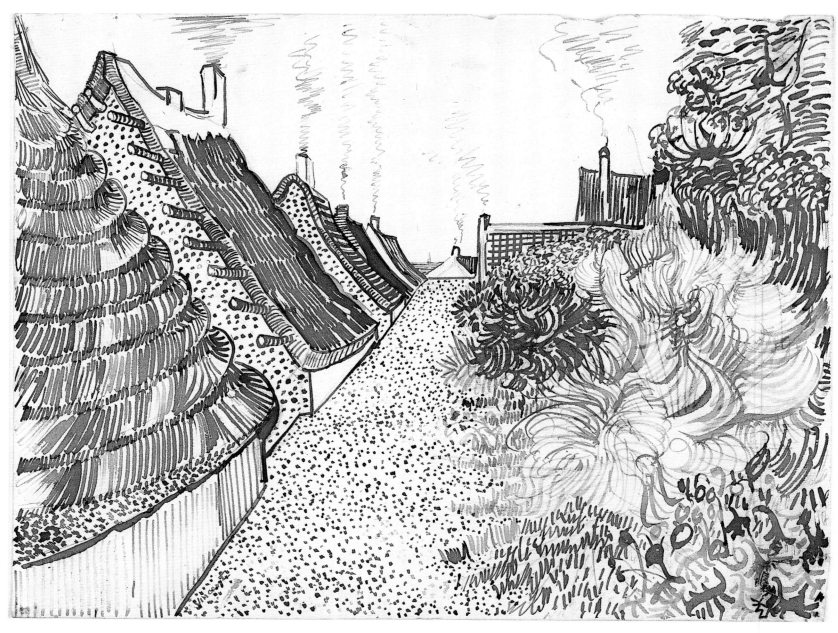

Street at Saintes-Maries June 1888
Reed pen and ink on paper
9½×12¼in (24×31cm)
The collection of the Museum of Modern Art, New York

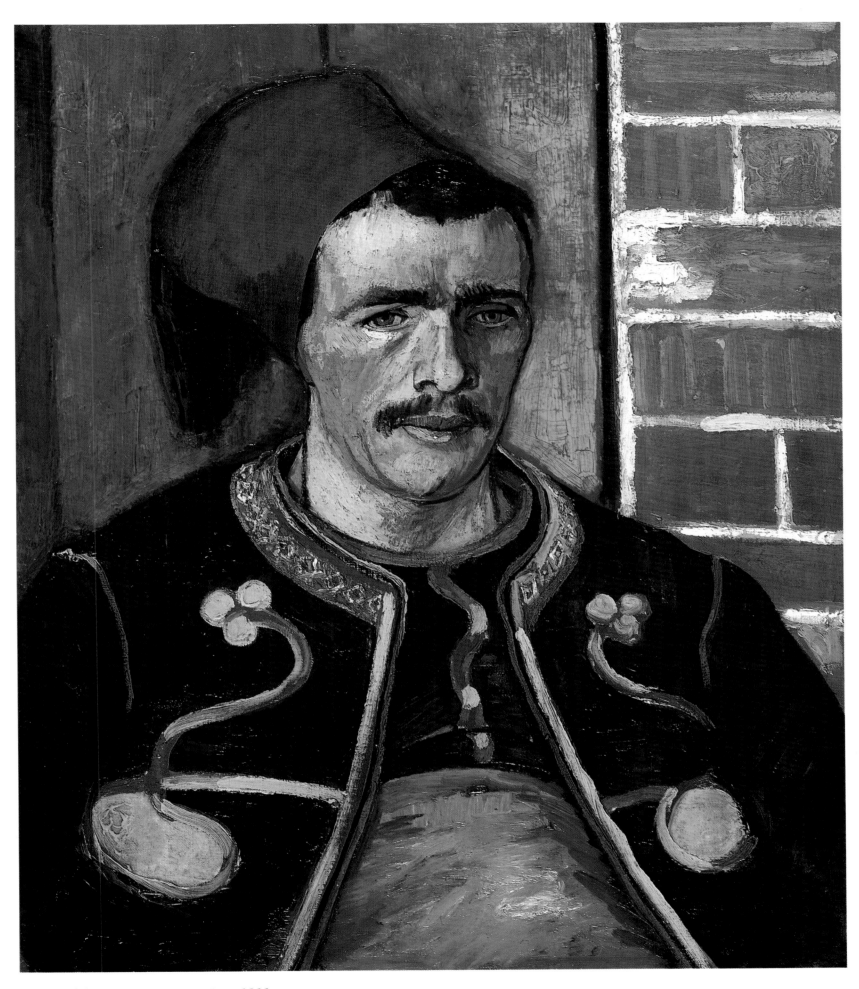

Bugler of the Zouave Regiment June 1888
Oil on canvas
25½×21¼in (65×54cm)
Rijksmuseum Vincent van Gogh, Amsterdam

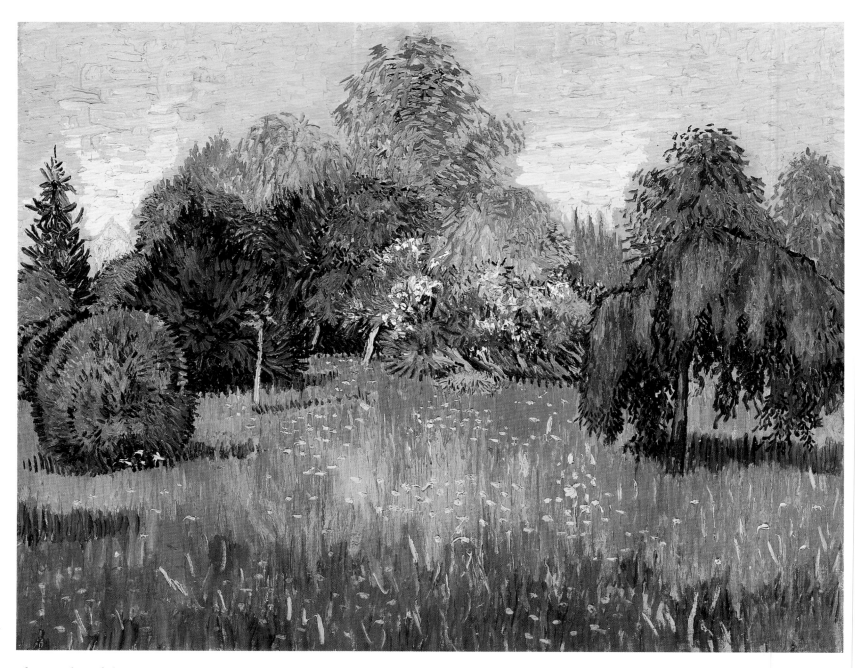

The Garden of the Poets
August-September 1888
Oil on canvas
28¾×36¼in (73×92.1cm)
The Art Institute of Chicago, Chicago

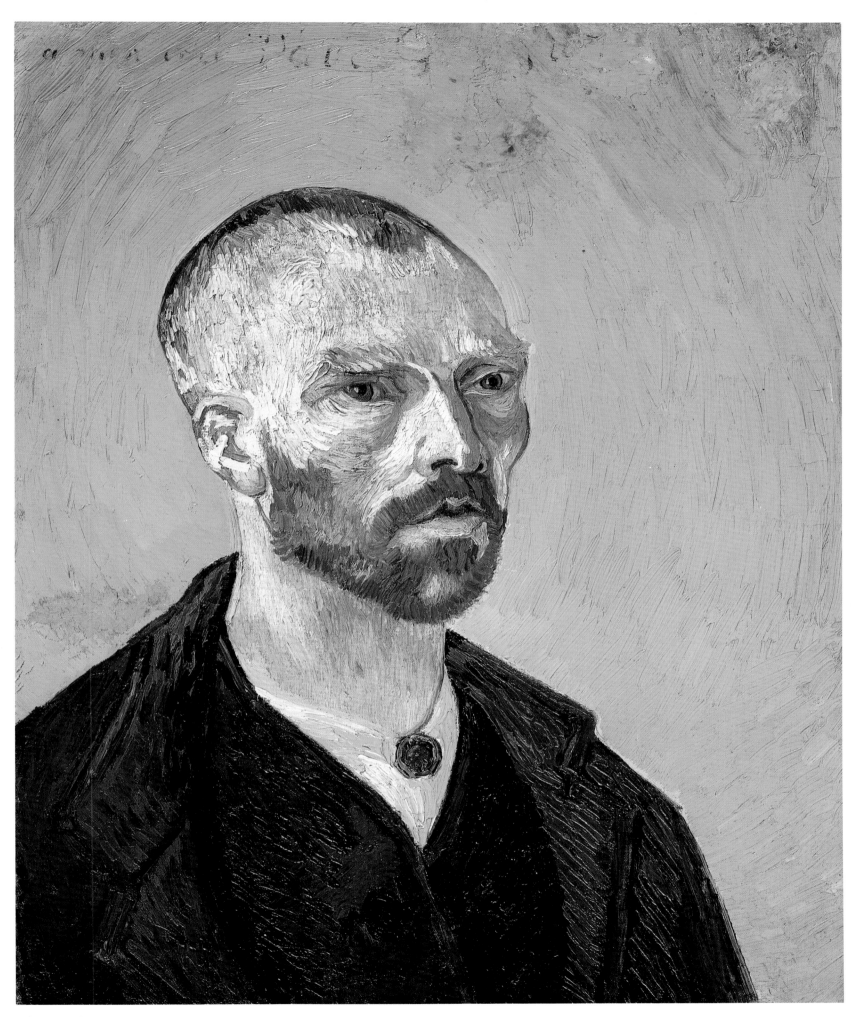

Self-Portrait dedicated to Paul Gauguin 1888
Oil on canvas
23¾×19½in (60.5×49.4cm)
Fogg Art Museum, Harvard University,
Cambridge, Massachusetts

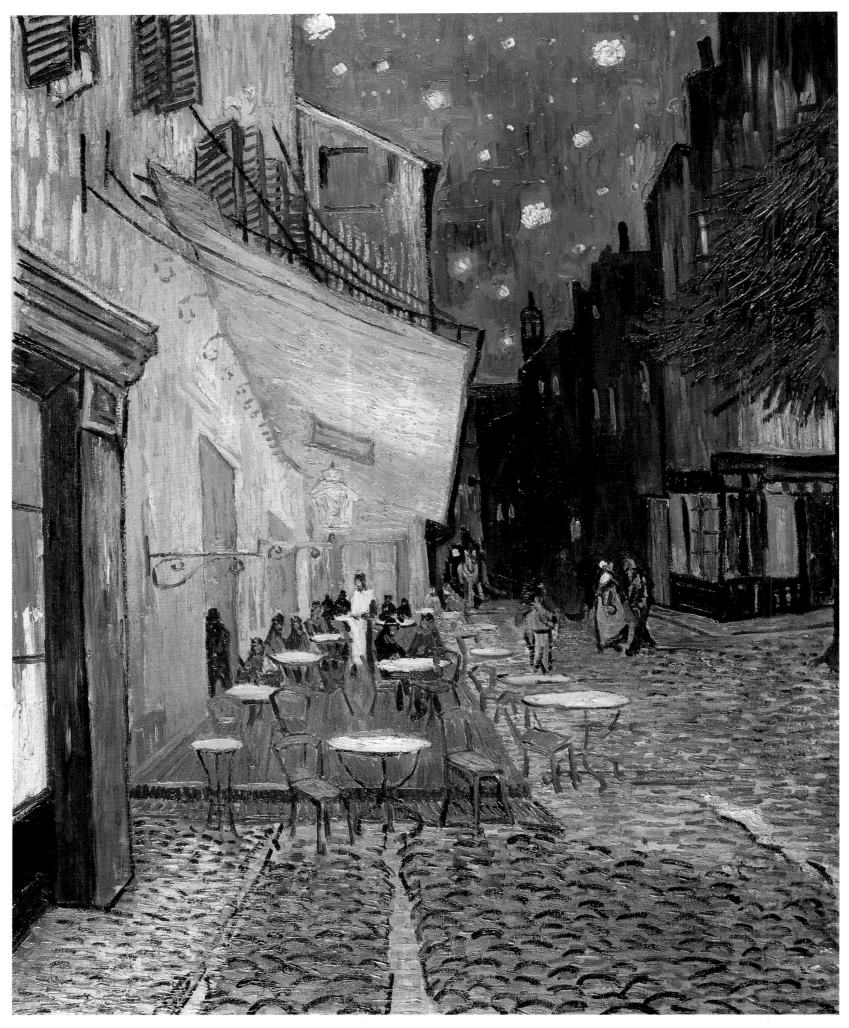

Above:
The Café Terrace, Arles at Night September 1888
Oil on canvas
32×25¾in (81×65.5cm)
Rijksmuseum Kröller-Müller, Otterlo

The Poet, Eugène Boch September 1888
Oil on canvas
23½×17¾in (60×45cm)
Musée d'Orsay, Paris

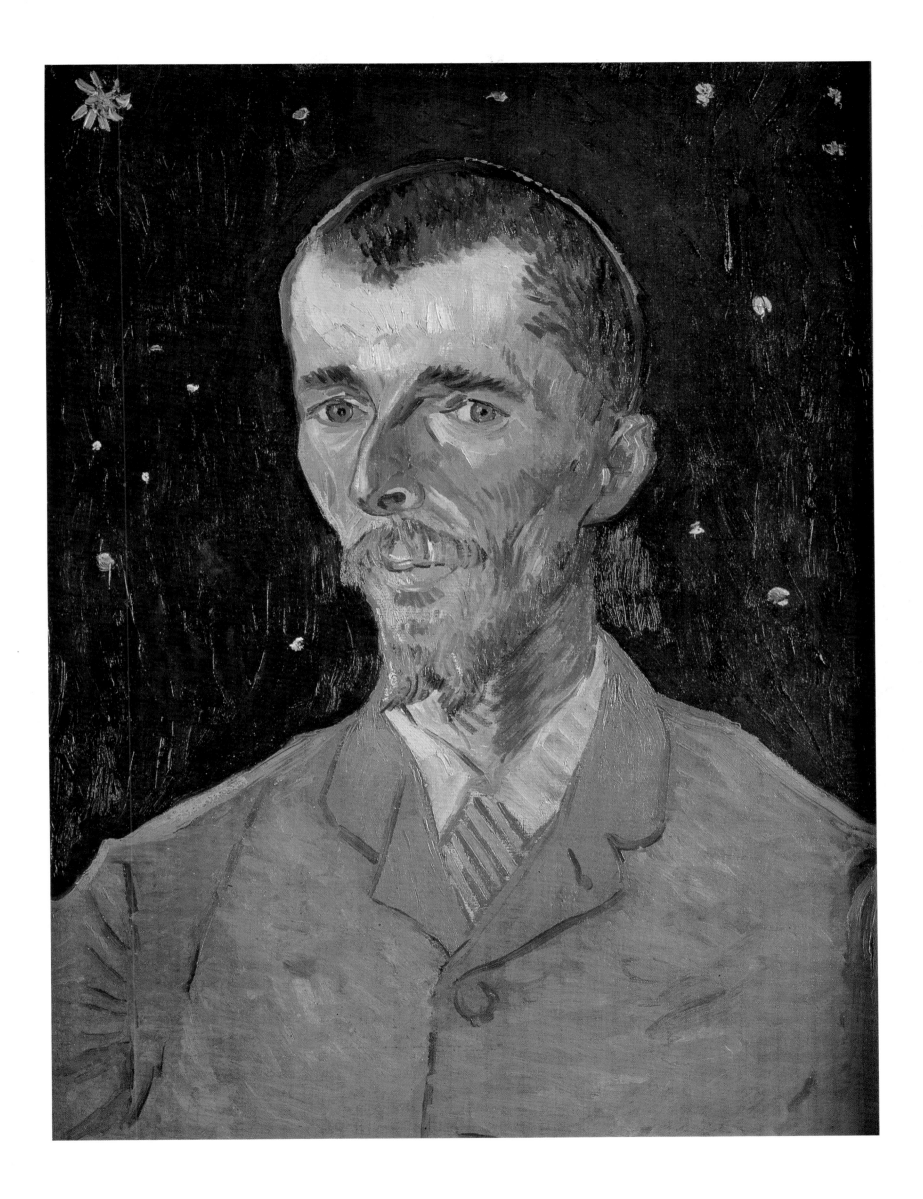

The Night Café September 1888
Oil on canvas
27½×35in (70×89cm)
Yale University Art Gallery, New Haven, Connecticut

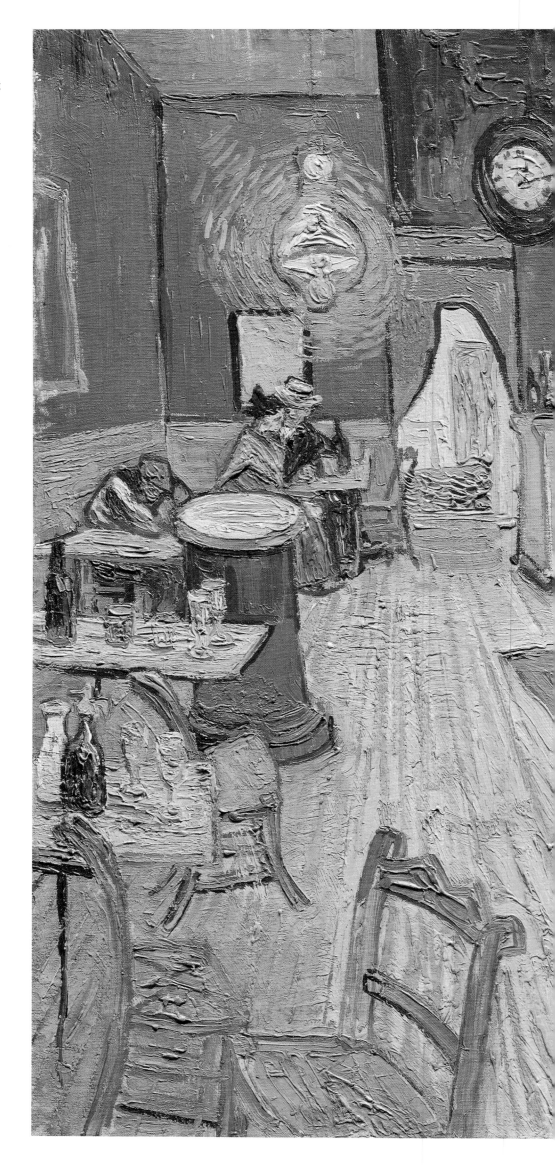

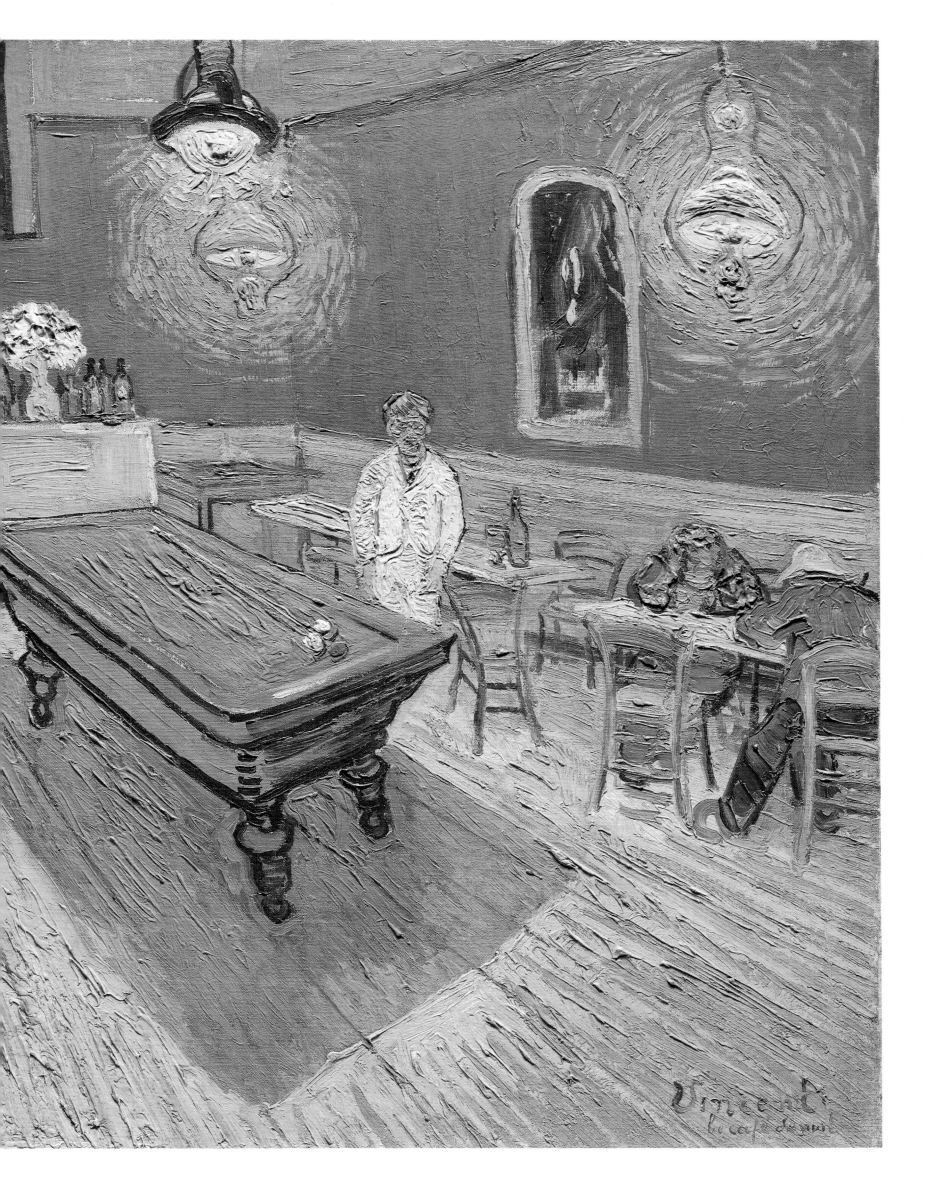

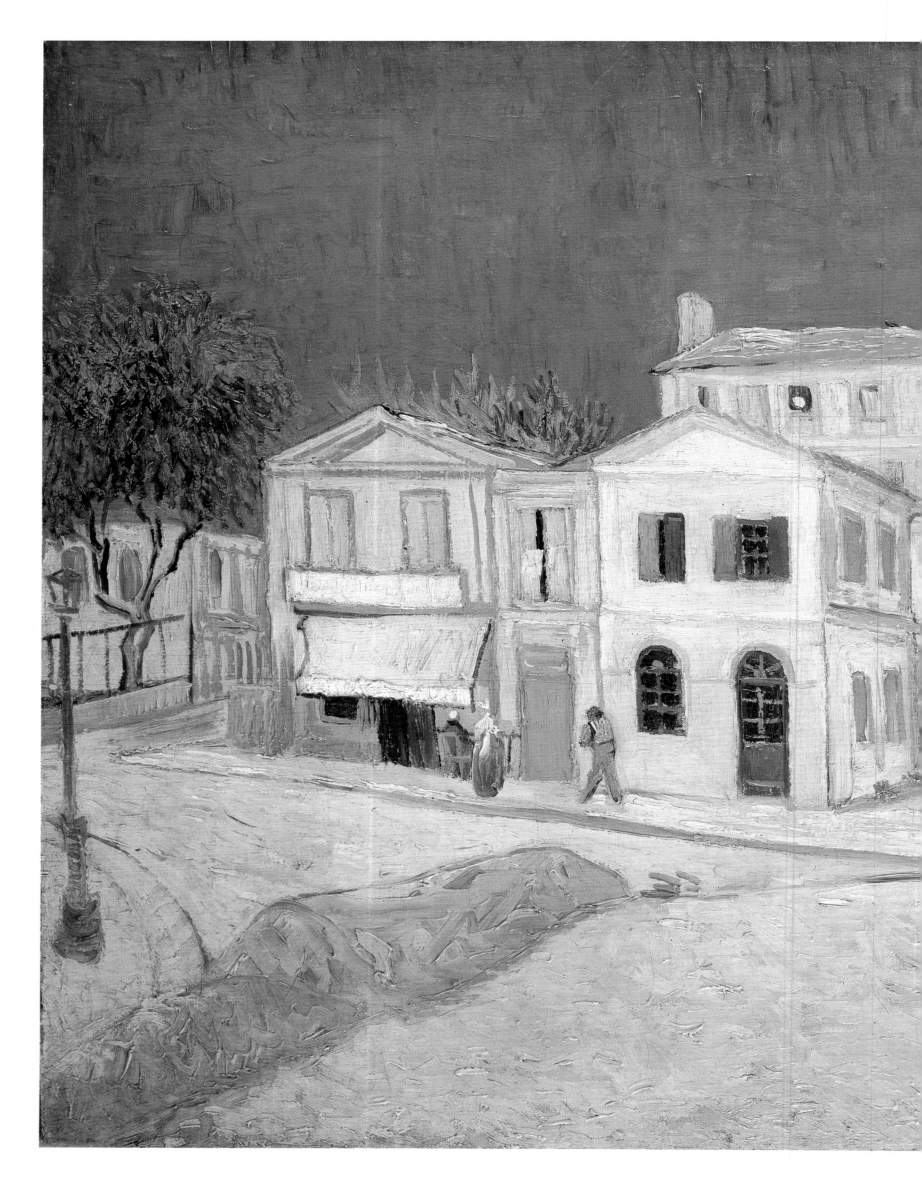

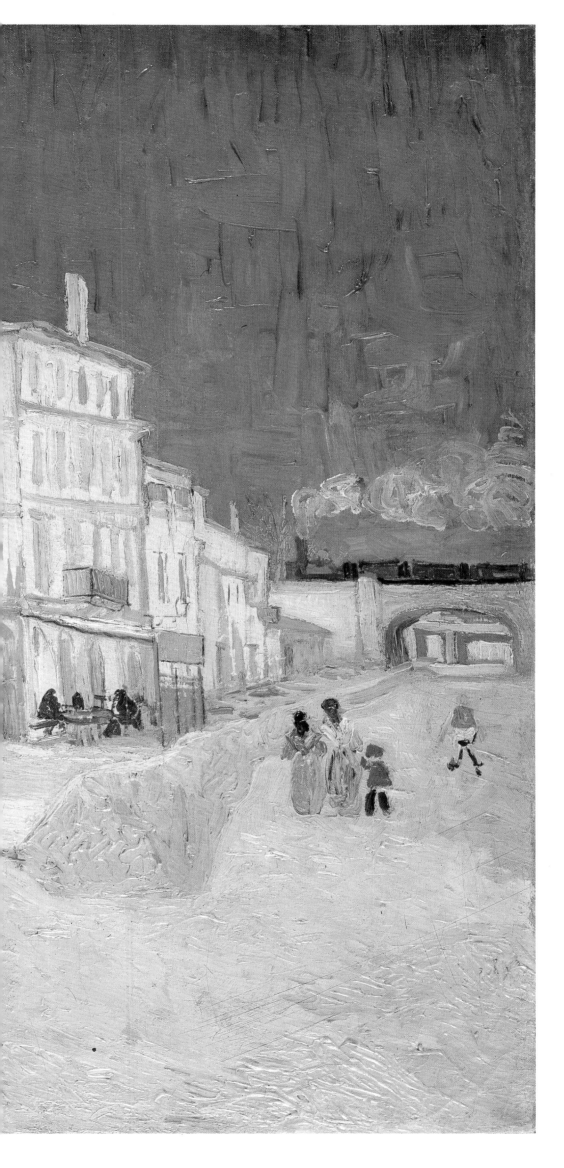

The Yellow House in Arles
Late September 1888
Oil on canvas
30×37in (76×94cm)
Rijksmuseum Vincent van Gogh,
Amsterdam

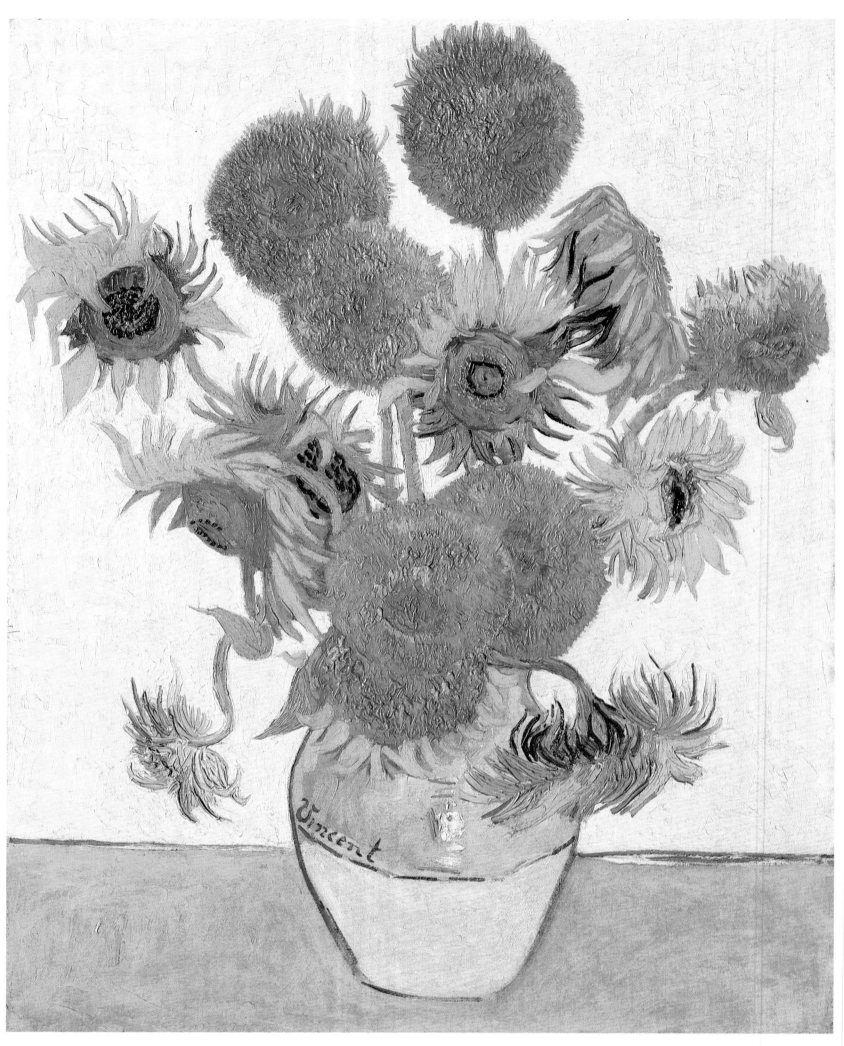

Fourteen Sunflowers August 1888
Oil on canvas
36½×28¾in (93×73cm)
The National Gallery, London

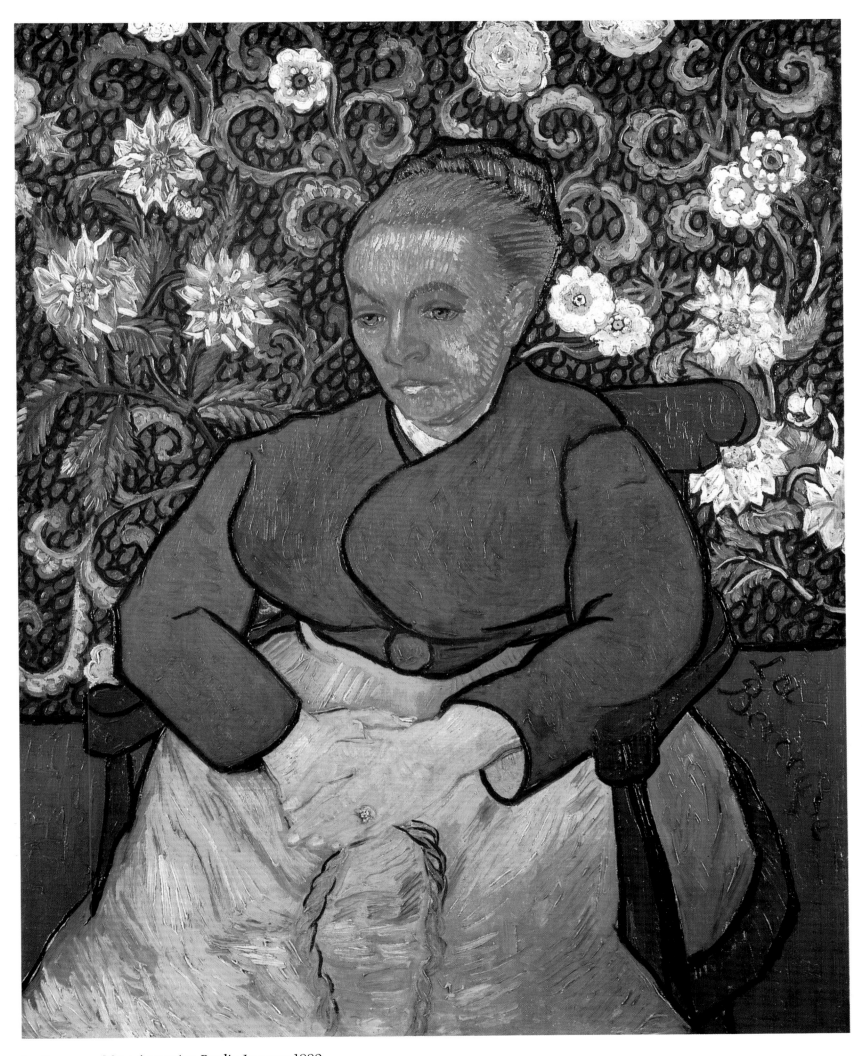

La Berceuse: Mme Augustine Roulin January 1889
Oil on canvas
36¼×28¾in (92×73cm)
Rijksmuseum Kröller-Müller, Otterlo

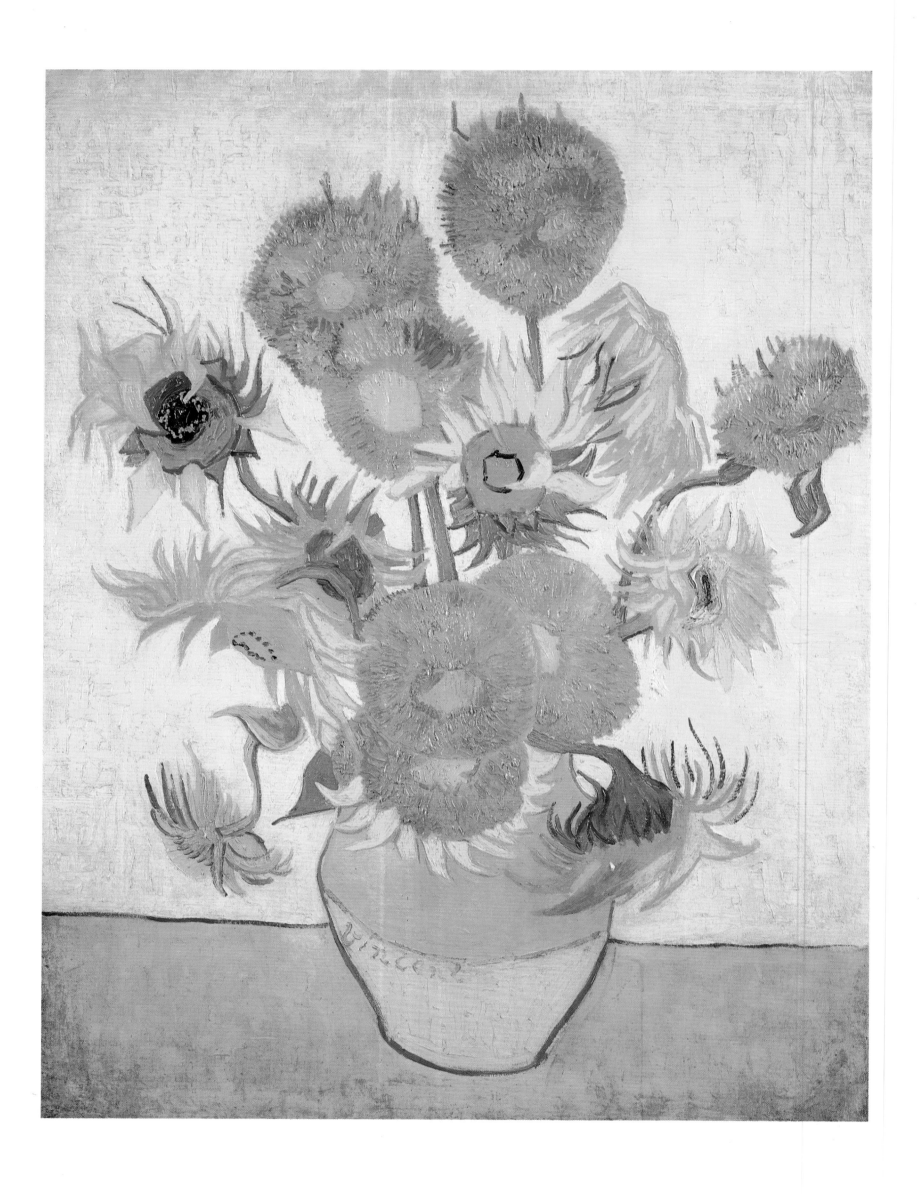

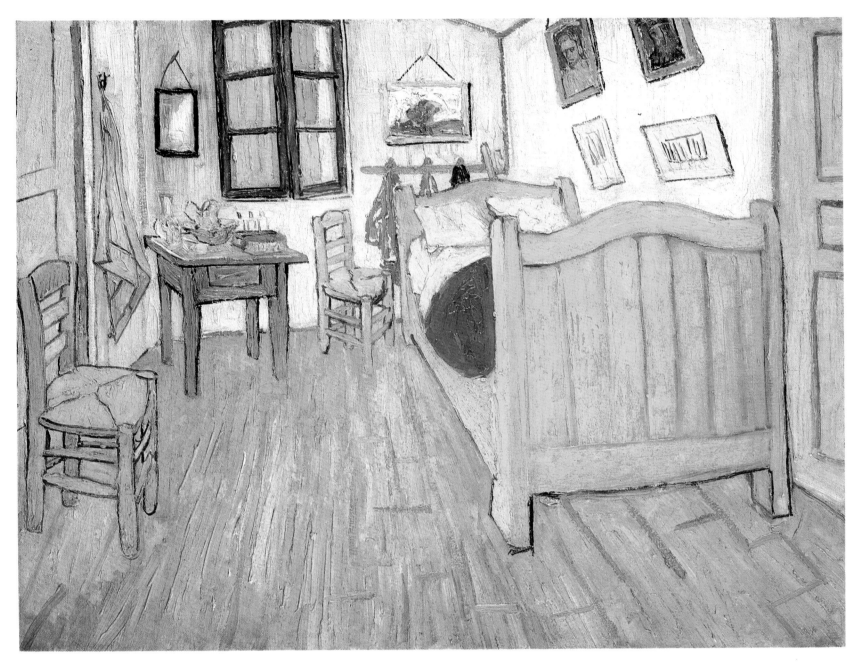

Above:
Van Gogh's Bedroom, Maison Jaune
October 1888
Oil on canvas
28¼×35½in (72×90cm)
Rijksmuseum Vincent van Gogh, Amsterdam

Left:
Still Life: *Vase with Fourteen Sunflowers* January 1889
Oil on canvas
37½×28¾in (95×73cm)
Rijksmuseum Vincent van Gogh, Amsterdam

The Railway Viaduct, Avenue Montmajour
October 1888
Oil on canvas
28×36¼in (71×92cm)
Kunsthaus, Zurich

Promenade at Arles: Memory of the Garden at Etten
November 1888
Oil on canvas
29×36½in (73.5×92.5cm)
The Hermitage Museum, Leningrad

125

Les Alyscamps November 1888
Oil on canvas
28¾×36¼in (73×92cm)
Rijksmuseum Kröller-Müller, Otterlo

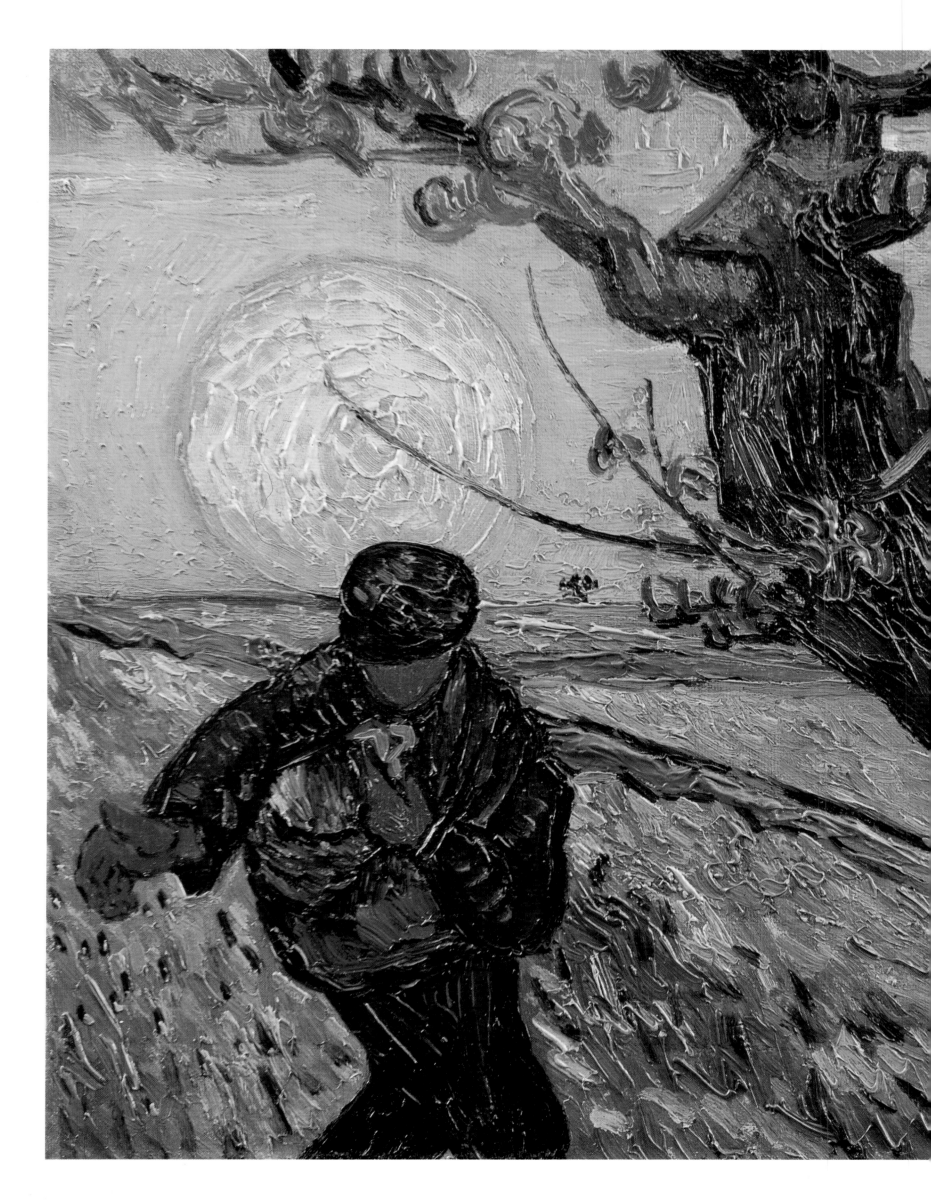

The Sower Late November 1888
Oil on canvas
12½×15¾in (32×40cm)
Rijksmuseum Vincent van Gogh, Amsterdam

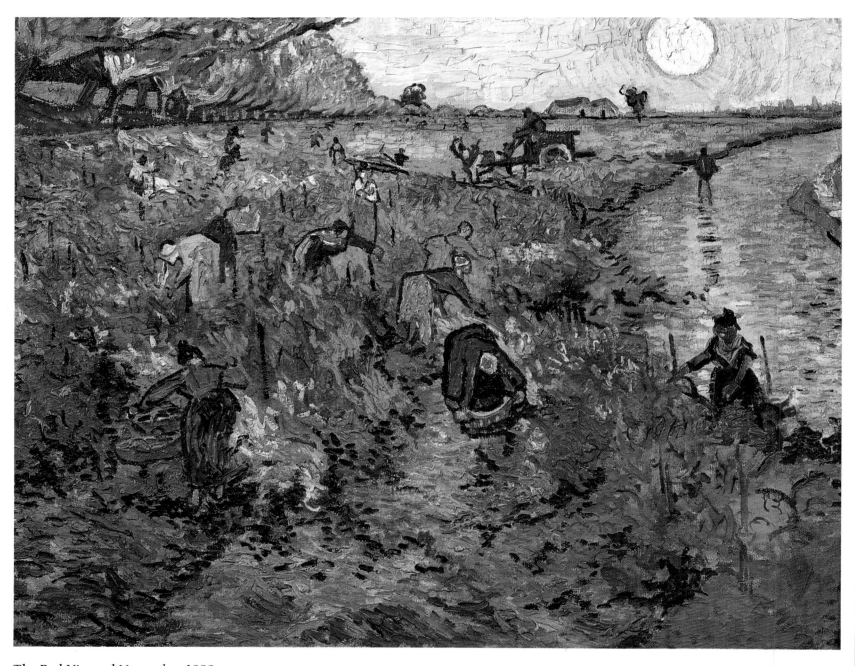

The Red Vinyard November 1888
Oil on canvas
29½×36½in (75×93cm)
Pushkin Museum, Moscow

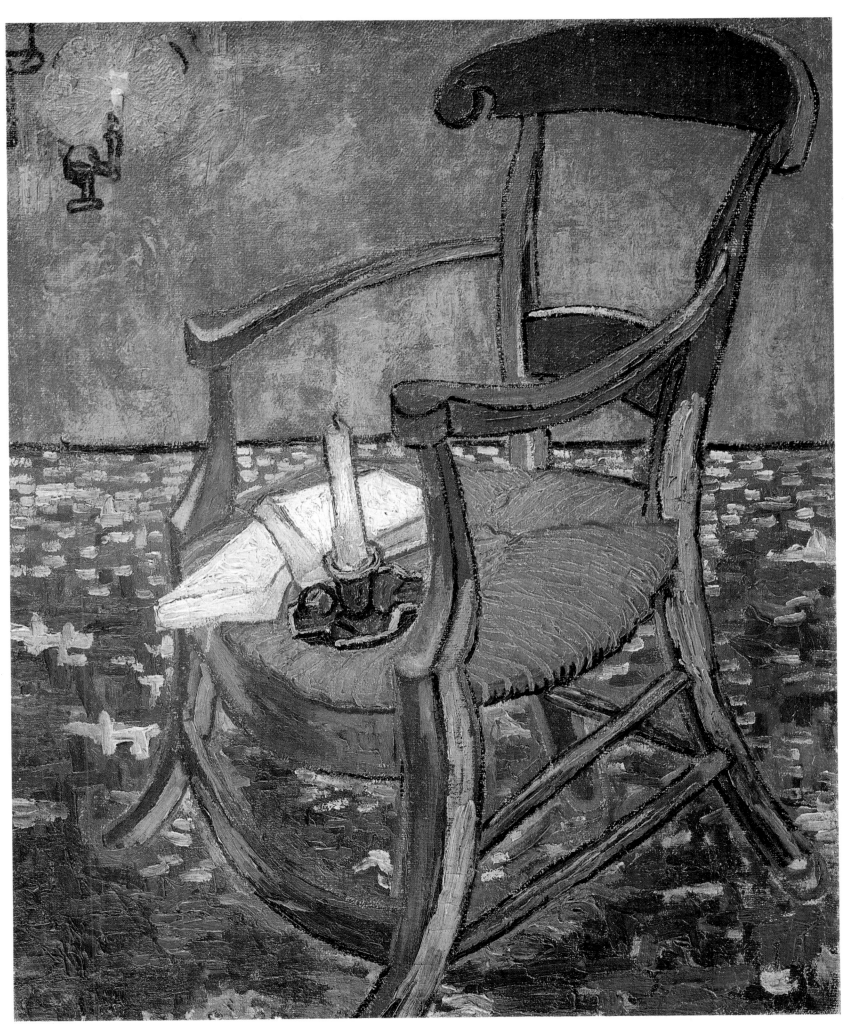

Gauguin's Chair December 1888
Oil on canvas
36½×28¼in (90.5×72cm)
Rijksmuseum Vincent van Gogh, Amsterdam

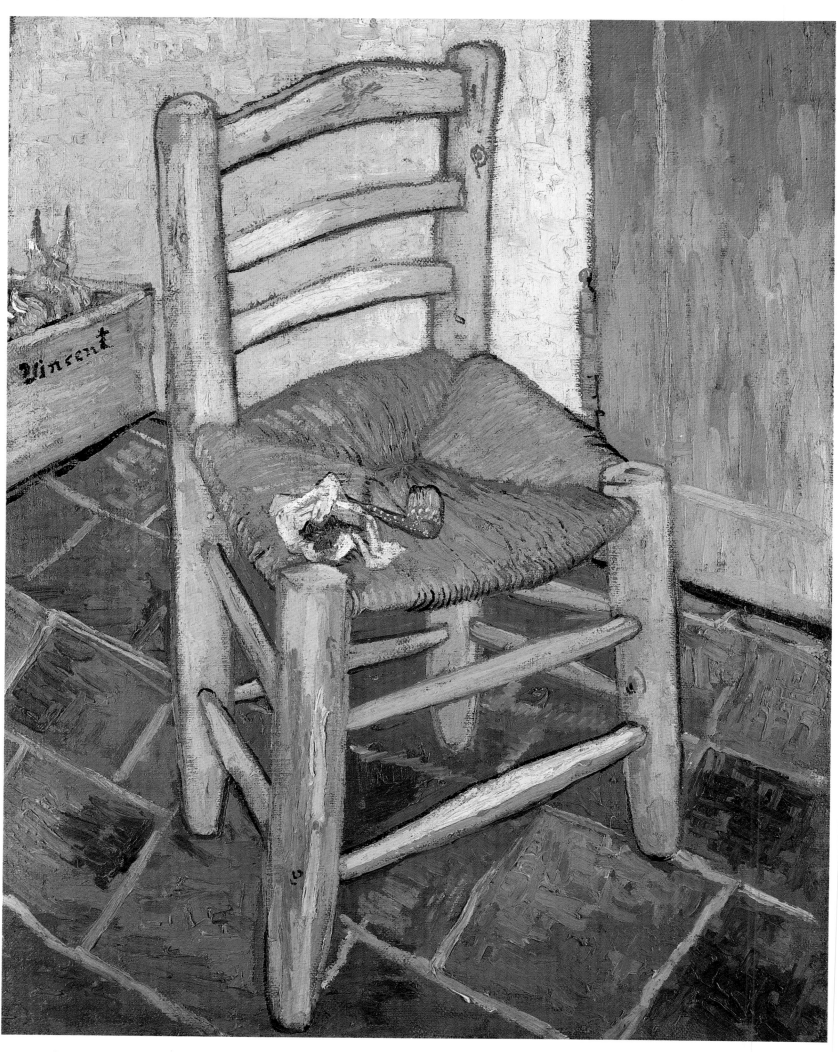

Van Gogh's Chair December 1888
Oil on canvas
36½×29in (93×73.5cm)
The National Gallery, London

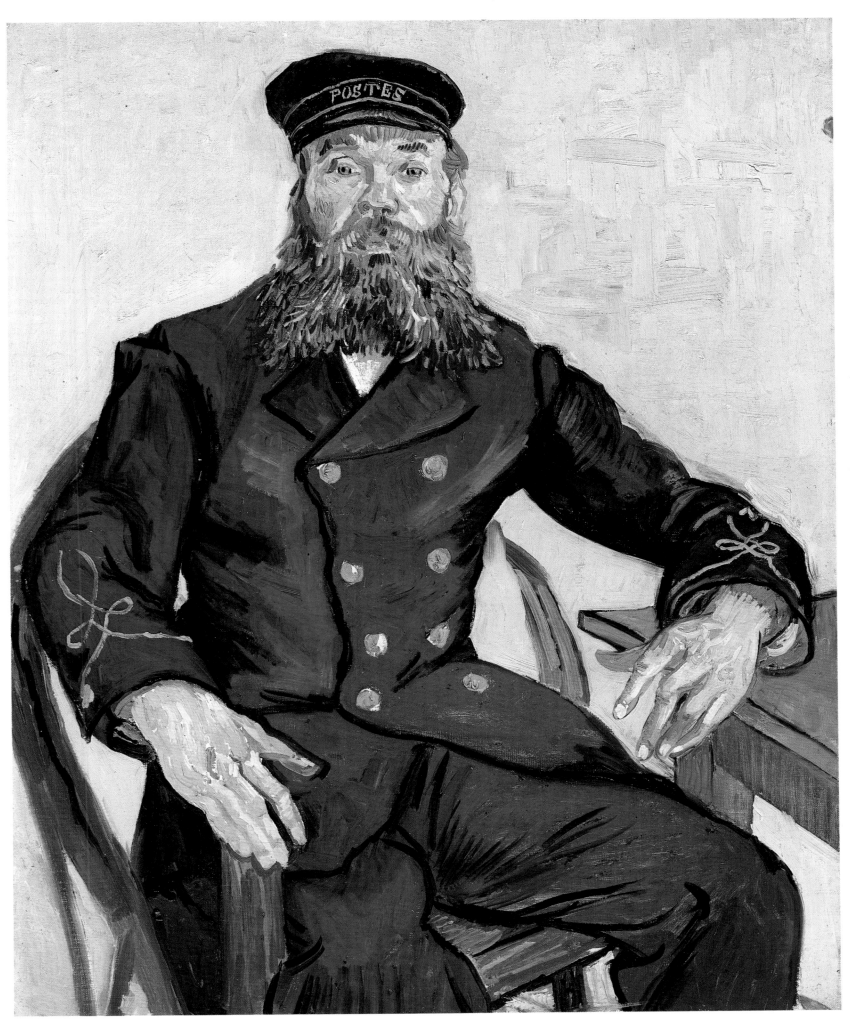

Postman Joseph Roulin July 1888
Oil on canvas
32×25¾in (81.2×65.3cm)
Museum of Fine Arts, Boston

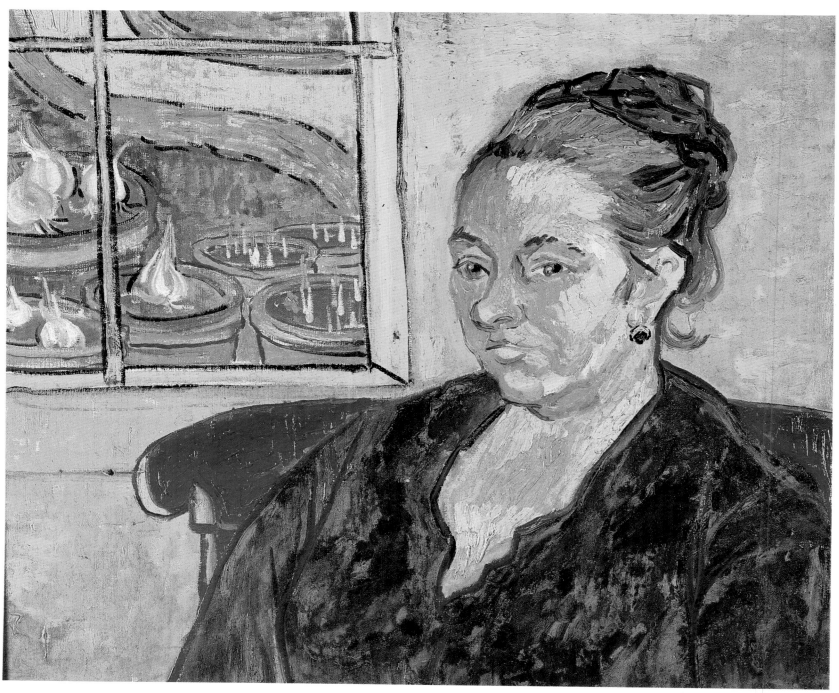

Portrait of Augustine Roulin
December 1888
Oil on canvas
21¾×25½in (55×65cm)
Sammlung Oskar Reinhart 'am
Römerholz,' Winterthur

Right:
Lullaby 1889
Oil on canvas
36½×29¾in (92.7×72.8cm)
Museum of Fine Arts, Boston

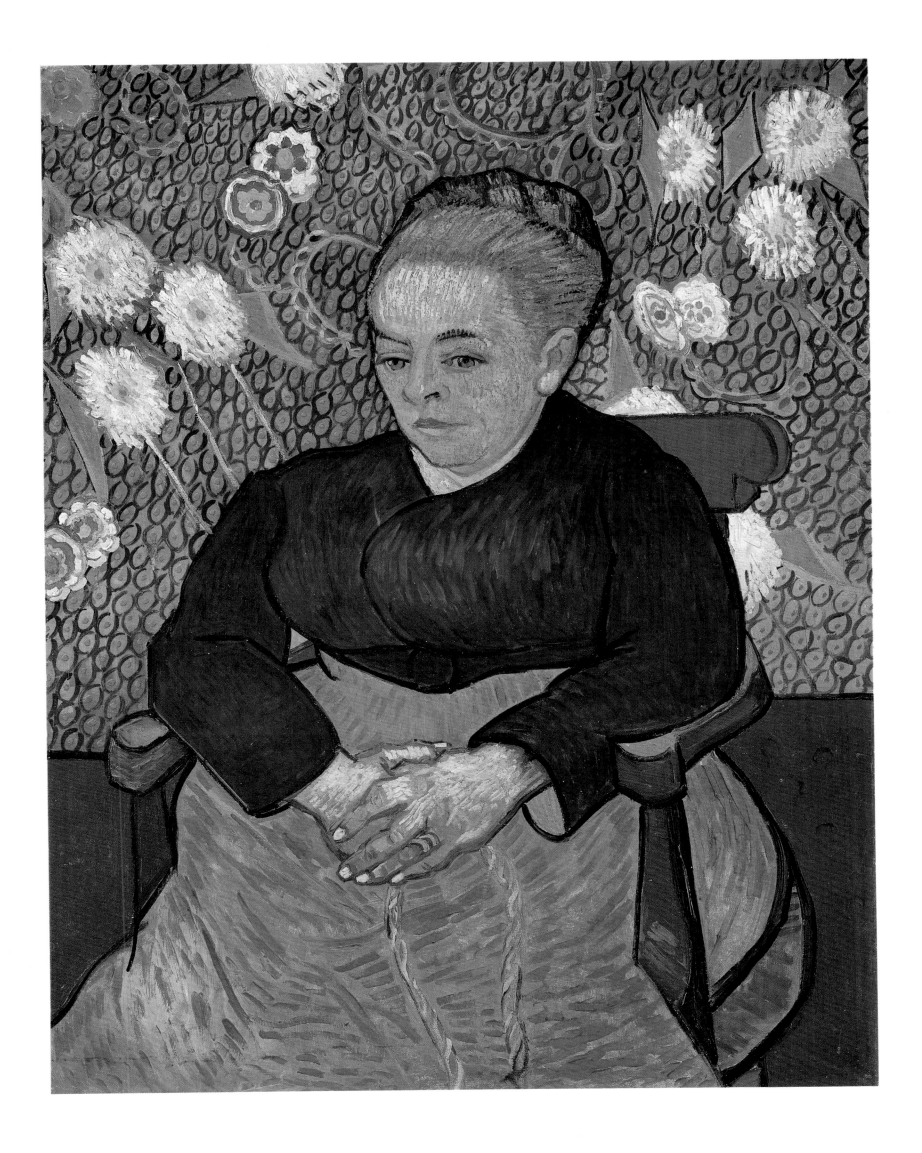

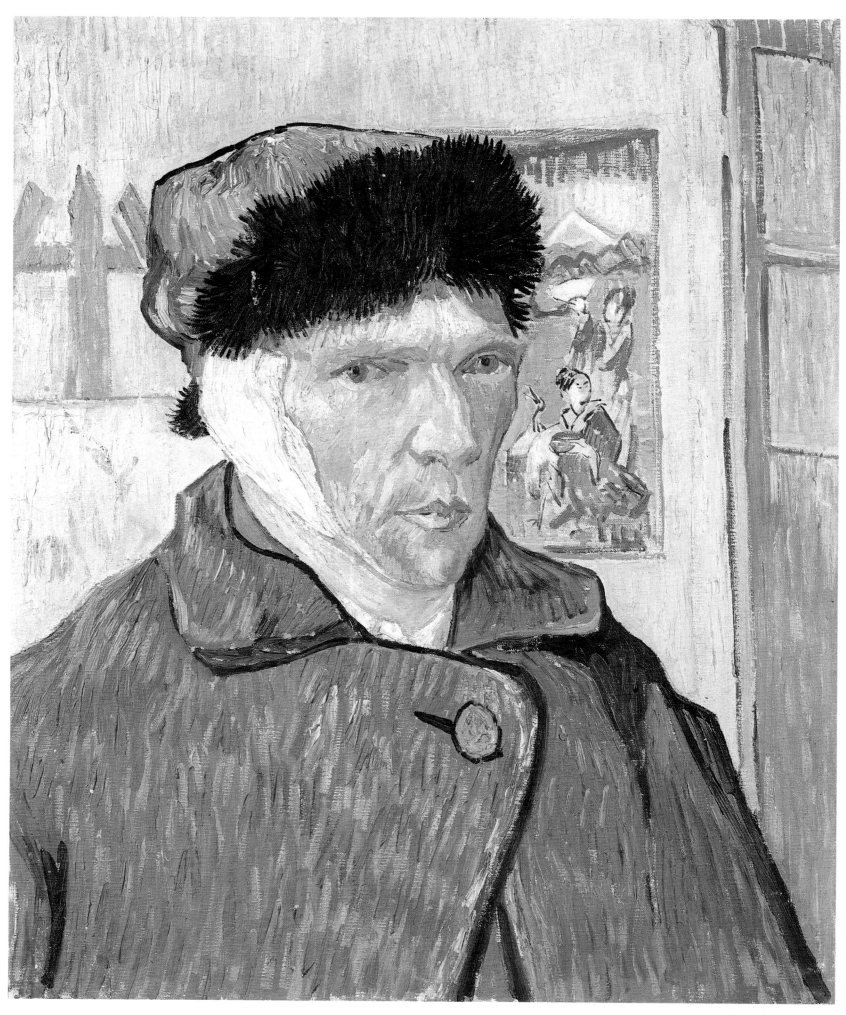

Self Portrait with Bandaged Ear
January 1889
Oil on canvas
23½×19¼in (60×49cm)
Courtauld Institute Galleries, London

*Still Life: Plate with Onions, Annuaire de
la Santé, Candle, Letter, and Pipe*
January 1889
Oil on canvas
19¾×25¼in (50×64cm)
Rijksmuseum Kröller-Müller, Otterlo

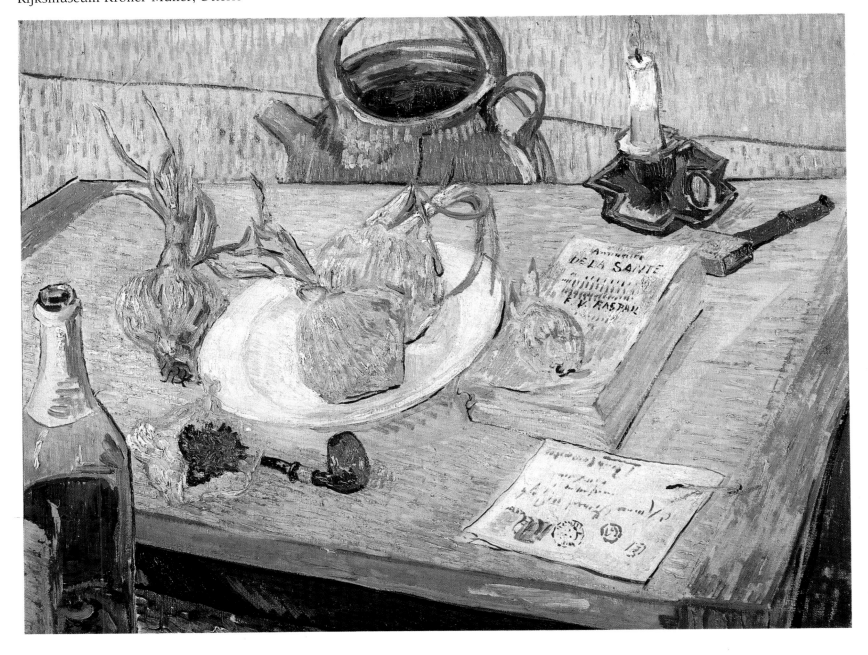

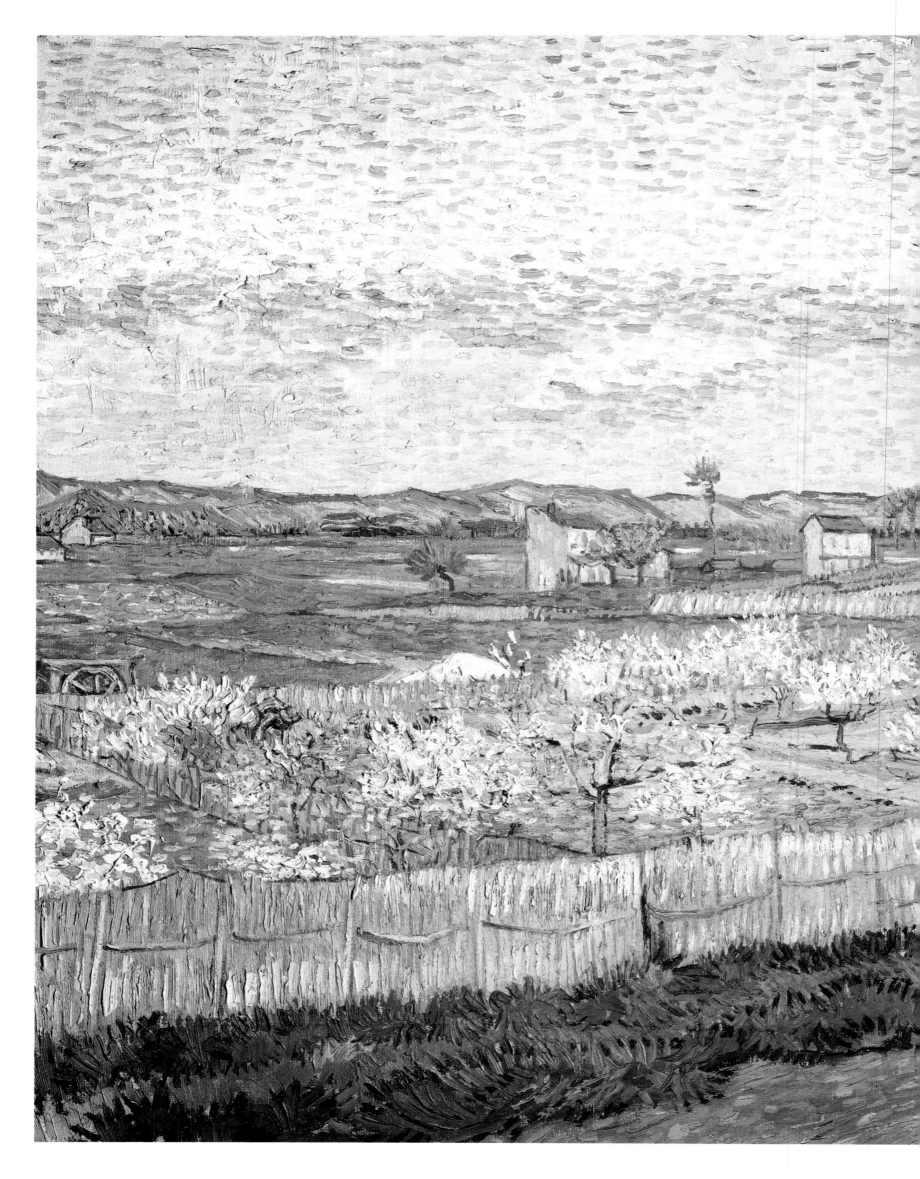

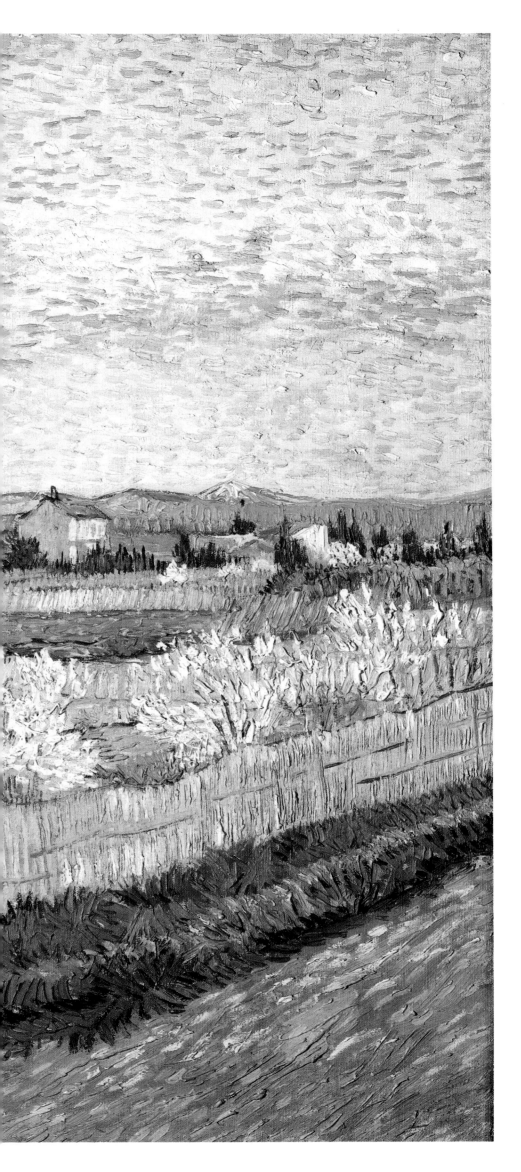

The Crau with Peach Trees in Blossom
April 1889
Oil on canvas
25¾×32in (65.5×81.5cm)
Courtauld Institute Galleries, London

Saint-Rémy and Auvers

When Van Gogh entered the asylum of Saint-Paul-de Mausole in Saint-Rémy in May 1889 he had already had to abandon the 'artist-bonze' persona that he had constructed in the summer of the pre-ceeding year. He was still the artist, he needed to assert this, but he was also the isolated madman. In the *Self-Portrait with Bandaged Ear* of January 1889 the abandonment of the dream and the persona are clearly stated as the haggard artist turns his back on the Japanese print and confronts a blank canvas. In one of two self-portraits done in the summer of 1889, the *Self-Portrait* painted in September (the other represents him as an artist), he represents himself in a swirling picture space which allows of no tangible con-text. The significance of the swirling forms changes from picture to picture, but in this case the contrast between the massive and force-fully modeled head and the swirling patterns invading his clothes and the background is meant to represent his instability in the world. Here the artist-madman persona characterized by hyper-sensitivity and isolation from the material world and society, has replaced the wise sage living in nature. This new construction of the artist was developed by the first critic to write about Van Gogh's work, G Albert Aurier. Albert Aurier wrote *Le Isolé: Vincent van Gogh* for the January 1890 edition of *Le Mercure de France*, soon to become one of the leading symbolist journals in Paris, without the artist's knowledge, but later obtained his general approval for the article. He presents the artist as a figure whose extreme sensitivity is the product of decadence, but which at the same time provides access to otherwise hidden qualities in nature and the means of expression:

Finally, and above all, he is a hyper aesthete with clear symptoms, perceiving with abnormal intensity, perhaps even painfully, the imper-ceptible and secret character of lines and forms but, even more, colors, lights, nuances invisible to healthy eyes, the magic iridescences of shadows.

This strong and true artist, a real thoroughbred, with the brutal hands of a giant, with the neuroses of a hysterical woman, with the soul of a visionary.

Close attention to the smallest details of nature continued to play a significant, if reduced, role in Van Gogh's work in St-Rémy. In pictures like *Death's Head Moth* of late May 1887 and *Long Grass and Butterflies: The Asylum Garden* of late April 1890, one done at the beginning of his stay at the asylum the other at the end, he is at the first point of the Japanese artist's understanding of the world. In the *Death's Head Moth*, attention to insects and plants is clearly an attempt to keep hold of the world; in the *Long Grass and Butterflies: The Asylum Garden*, the last picture he painted of the garden, the artist is reasserting his lucidity and capacity for work after a long period of serious illness.

The earlier picture also functioned as a symbol of death under-mining its 'Japanese' quality. In the periods of despair at St-Rémy, images of death and suffering are a leitmotiv occurring in widely differing subjects. The presence of death was not always seen as threatening. In *The Reaper* of June 1889, Van Gogh produced the first of several versions of a theme he associated with death, the reaper having traditionally been a symbol of death. He draws on his observation of the seasonal work in surrounding fields, and de-velops the symbol as something modern and timeless in his terms. The cypress trees in the *Starry Night* of June 1889 and *Wheatfield and Cypress* of September of the same year also carried traditional connotations of death being graveyard trees, although Van Gogh's initial attraction to this motif was the challenge to his pictorial means depicting the deep black and bottle green color harmonies he found in their leaves. This suggests that the formal act of paint-ing was, at least in part, an act of displacement. The related theme of heroic suffering is to be found most consistently in his repre-sentations of the pine trees in the asylum garden, painted in late October/early November of 1889. In *The Hospital Garden at Saint-Rémy* painted in the few days around the 22nd of November, Van Gogh depicted a shattered tree, having been caught by lightning, sending out new shoots from a side branch. In a letter to Emile Bernard he makes the function of this symbol explicit:

This somber giant – like a defeated proud man – contrasts, when con-sidered in the nature of a living creature, with the pale smile of a last rose on the fading bush in front of him.

It was with pictorial devices like that outlined above that Van Gogh hoped to persuade Bernard of the futility of painting his 'artificial' and archaizing pictures after Biblical subjects.

The deliberate reduction of the scale of the figures in this picture is a factor common to other pictures of this period like *The Ravine (Les Peyroulets)* where the two women are almost completely dis-solved in the clashing of the flame-like markings of his brushwork in the hills and lava-like flow of the water in the stream which destabilizes the picture space by appearing to pour out of the front of the picture. This was an alchemical world in which nothing re-mained as base substance. Albert Aurier created an astonishing ver-bal equivalent of these pictures when he wrote:

there is the universal and mad and blinding coruscation of things; it is matter, it is nature frantically twisted, in paroxysm, raised to the extreme of exacerbation; it is form becoming a nightmare, color becoming flames, lavas and precious stones, light setting fire to itself, life a burning fever.

The proliferation of metaphor in both the visual and the written texts, stresses the 'instability of the world' in which the guarantee of stability and particularity of form is constantly undergoing trans-formation. This, in spite of the fact that the great swirling forces in Van Gogh's work at this period were seen by the artist in the formal terms of attempting 'to express the interlocking of the masses.'

The dynamic principles which underlay many of the artist's works in the latter part of 1889 were also echoed in his process of cognition. Current reality was constantly informed by memory. *Starry Night* combines specifically Provençal motifs with the church spire which has some specifically northern connotations. It

anticipates the major elements of his 'memories of the North' series, produced after a major period of illness in March-April 1890. The major example of these series is *Landscape with Cottages and Two Figures: Souvenir du Nord*, where aspects of his current experience and isolation were fused with memories of his past in Holland which fulfilled his longing to feel part of a tradition, a race, and a group. Memories by definition are different from immediate experience and yet inform it. They also have an element of the dream about them, restructuring 'reality.' This process had been a major element in works done from 'imagination' during his period of collaboration with Gauguin in the Autumn of 1888 at Arles. *The Promenade at Arles – Memory of the Garden at Etten* was not antipathetic to his means of cognition, but Gauguin's means of representing it were.

When he did return to the land of his memories, not quite Holland, but Auvers, he continued to long for a closer sense of bonding with his native culture. In *Thatched Cottages at Auvers* of July 1890, he stressed the link between the roofing material of human habitation and the earth, the thatch being the subject of the picture. It clearly has parallels with and reminiscences of his representations of peasant cottages on the heath around Nuenen. Both construct a metaphor of a humble and ordered society close to the earth, something 'eternal' and resisting change which at the same time constantly renews itself in the cycle of 'naturally' harmonious labor.

The problems of combining the 'modern' and the 'eternal' and its concomitant concern with the nature of time that had so preoccupied Van Gogh since his Nuenen period and which had most recently been manifested in the memory-dream pictures of the North at St-Rémy, were to re-emerge with new vigor at Auvers. To be modern was, for Van Gogh, a combination of the most innovative formal and expressive devices of avant-garde painting as he understood it, especially color, in order to represent the artist's perception of the character of things and the symbolic use of everyday objects and scenes taken from the modern world, even if they were themes without specifically 'modern' connotations like wheatfields, which would establish a link between present reality and more generalized and timeless abstractions. It is in this context that paintings like *Village Street and Stairs with Figures* of May 1890 and *Landscape with Cart and Train* of June 1890 function, utilizing symbolic and expressive languages already seen in the landscapes produced in Arles and St-Rémy.

The works of Puvis de Chavannes had a major impact on his formulation of a pictorial language which was appropriate to the expression of such aims when Van Gogh was working at Auvers. He had been greatly impressed by the older artist's *Inter Artes et Naturam* when he had seen it exhibited at the Salon de Champs de Mars in Paris in May 1890. He admired the grace and beauty of the figures and the sense of uncertainty of period created in the picture, neither resorting to archaism nor denying allusions to modes of representation which constructed a vocabulary of timelessness. His own pictures of peasant women in the wheatfields of Auvers, like *Peasant Women Standing in the Wheat* of June 1890, attempt to create similar qualities by presenting the modern dress image in the context of the 'cyclic' timeless qualities he associated with the theme of a peasant in the fields. This peasant is entirely different from those earthy lumpen figures of the Nuenen period, being both naive and genteel. She participates in the world of 'instinctive'

women close to the earth – a type of earth-mother without the child-bearing hips – and cycles of life that dominated many symbolist representations of the female at this time.

The construction of instinctive and intuitive qualities in women is further stressed in his portrait of *Marguerite Gachet at the Piano* of June 1890 which acknowledges a debt to artists as diverse as Caillebotte, Morisot, Renoir, and Toulouse-Lautrec in terms of its theme and pictorial conventions. On the one hand the young woman is associated with music, a medium redolent of spiritual and instinctive qualities in Symbolist terms and on the other she is the medium through which the consoling qualities of music are manifested. Furthermore as music, consolation, and love were closely associated in Van Gogh's mind, the image of a young girl would also stimulate the possibility of projections of romantic love in the artist-viewer. The girl is also the model for the artist himself evoking feelings of consolation through her art. It is worth remembering in this context that Albert Aurier had characterized the painter in terms of male, female, and visionary qualities. It was this combination that allowed the artist to see more clearly into things and their relations.

This concern with epistemology was clearly in his mind when he painted Mlle Gachet. In a letter to Theo of the 26/27th of June he writes that the picture went well with an earlier painting of a wheatfield, in terms of color harmonies, complementary vertical and horizontal formats, and, most important of all, because in some mysterious way they illuminate and give meaning to each other. The process of understanding by analogy, perceiving the relation between things, essentially the Symbolist nation of synthetic cognition, was so far the domain of those with special powers of perception, the 'artists' in the broadest sense: 'We are still far from the time when people will understand the curious relation between one fragment of nature and another, which at the same time explain each other and enhance each other.'

In one sense cyclic metaphors for understanding the whole of nature, which dominated the projects of the Arles years, had been replaced by analogies created by the juxtaposition of disparate fragments and with meaning emerging in the space between. Profundity was no longer exclusively to be found in symphonic structure but in its combination with miniatures of salon piano music, to create a 'concert' of meaning.

Van Gogh hoped that these modes of understanding and types of perception would bring consolation when the character of the bourgeois modern world (he was still an enthusiastic socialist) created a sense of pessimism and melancholy in those who were capable of seeing 'deeper' and more 'permanent' values in things. It is this spirit that characterizes the pictorial tensions in *The Church at Auvers* of the first week of June 1890. Van Gogh alluded to what he called 'the heartbroken persona' – the doctor is shown in the pose of melancholia, the familiar symbols of the modern novel – in this case the de Goncourts' *Manette Salomon* and *Germinie Lacerteux*, and the symbol of the foxglove. The doctor's melancholy is a product of heart sickness, but like the artist his understanding of nature's secrets offers a potential cure. It was two consequences of 'seeing' alienation and disillusionment on the other hand and a broader understanding that claimed to transcend the limits of logic on the other, that characterized Van Gogh's last works. The pessimism and alienation eventually destroyed him.

Irises 1889
Oil on canvas
28×37in (71×94cm)
Sotheby's, New York

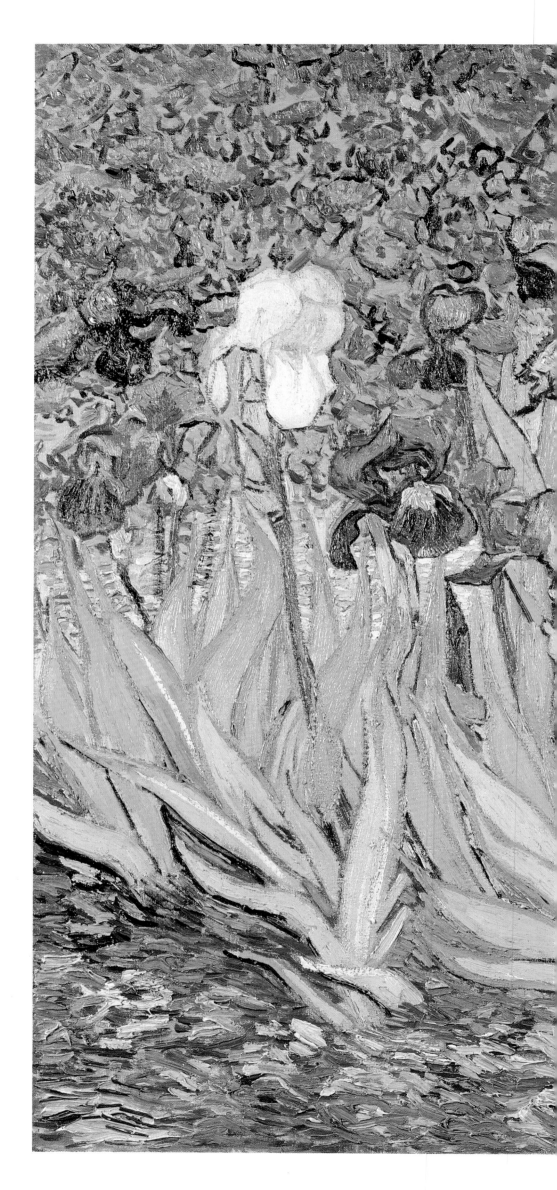

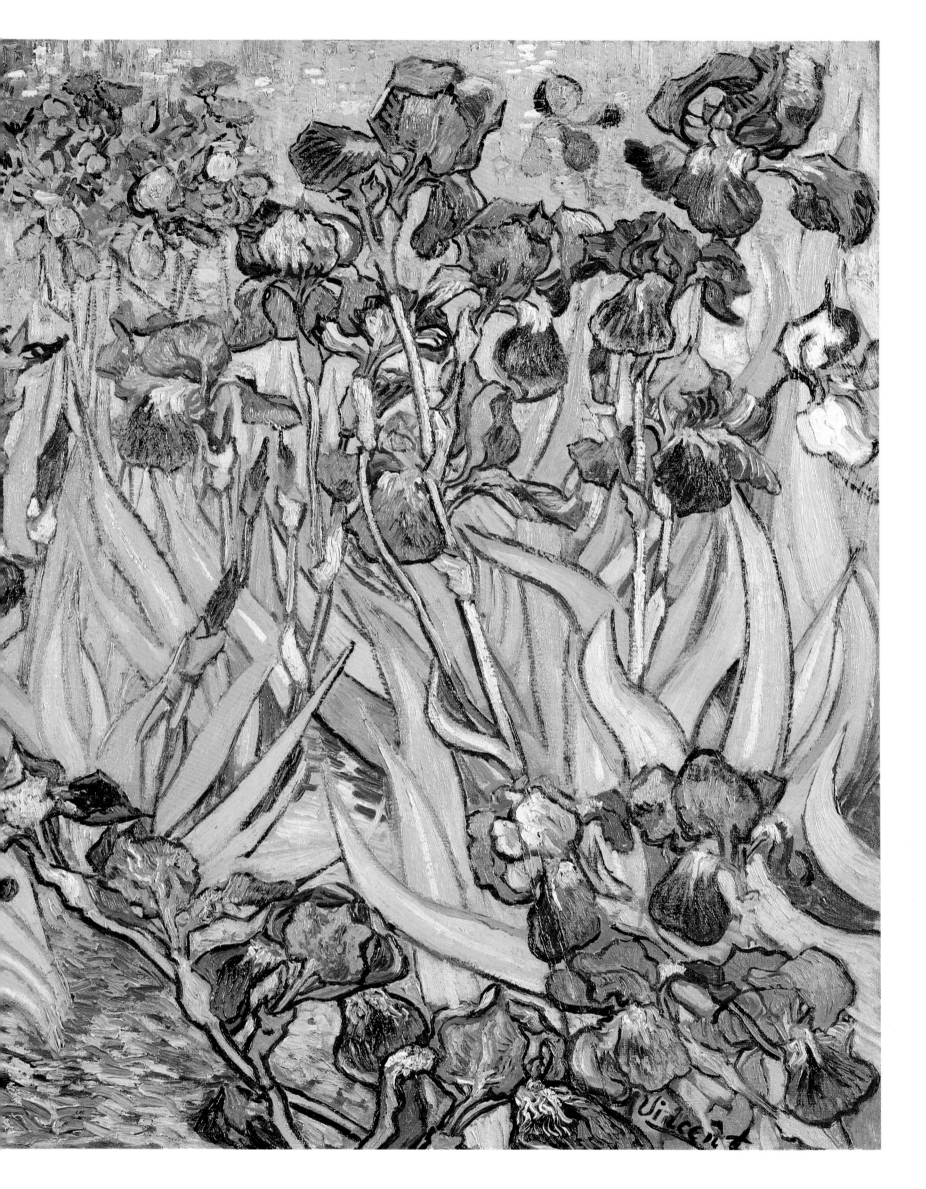

The Starry Night June 1889
Oil on canvas
29×36¼in (73.7×92.1cm)
The collection of the Museum of Modern Art, New York

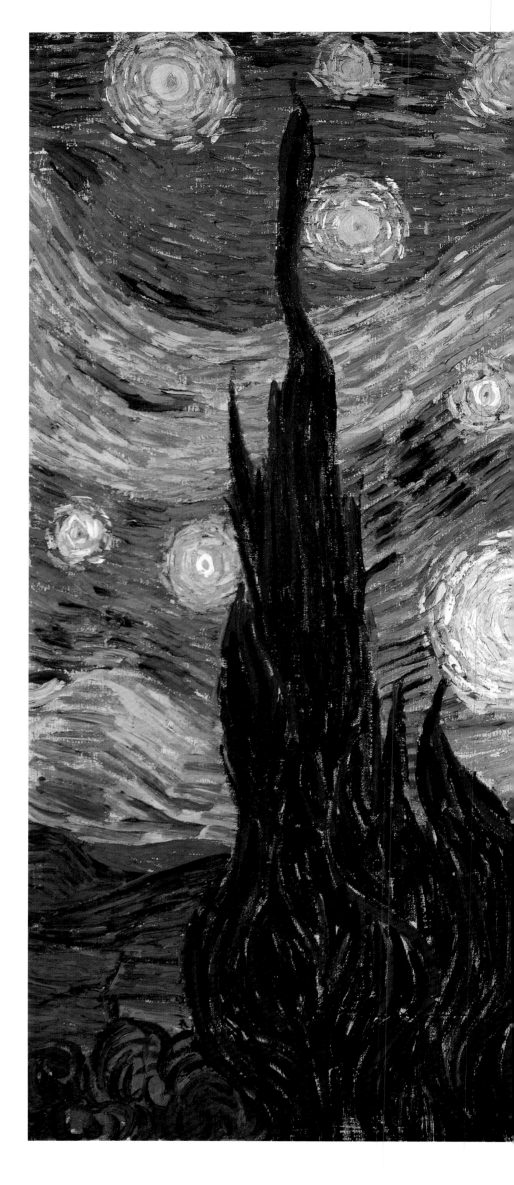

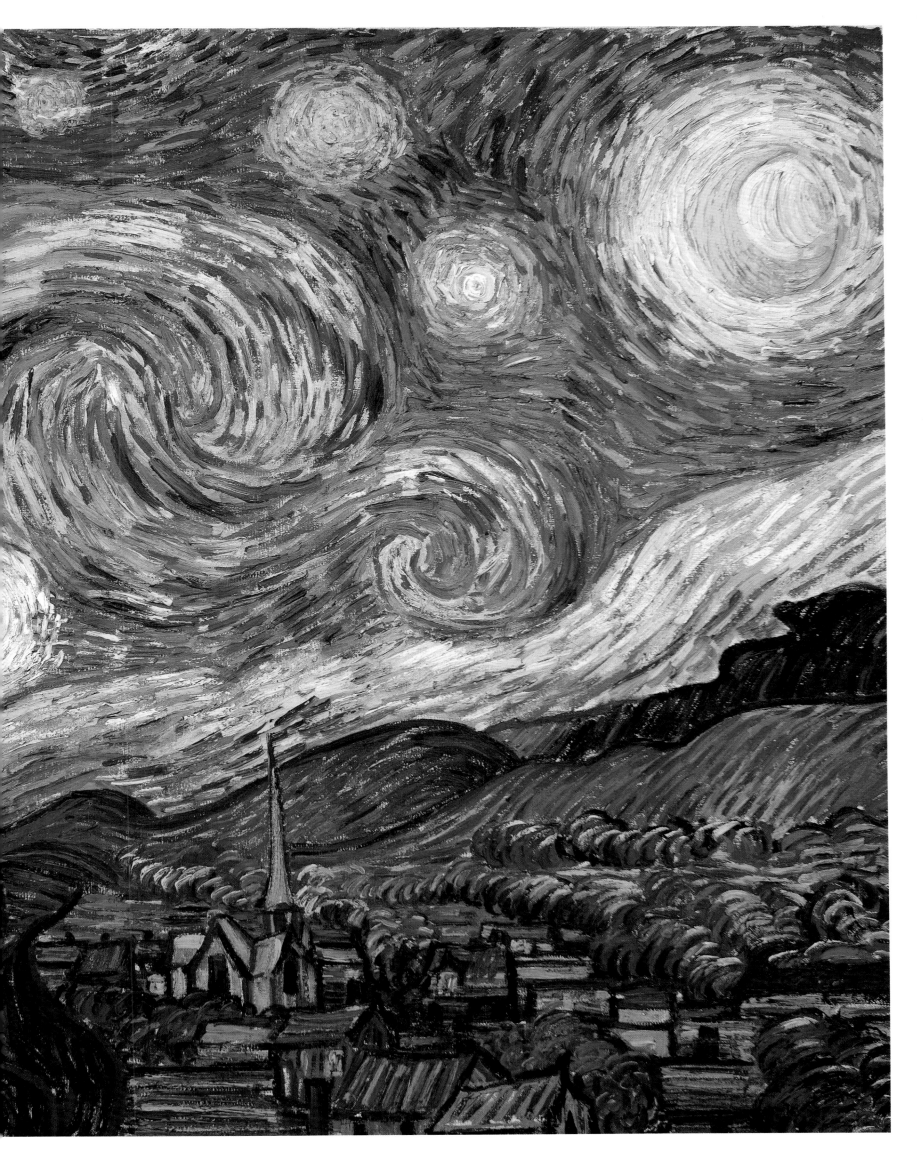

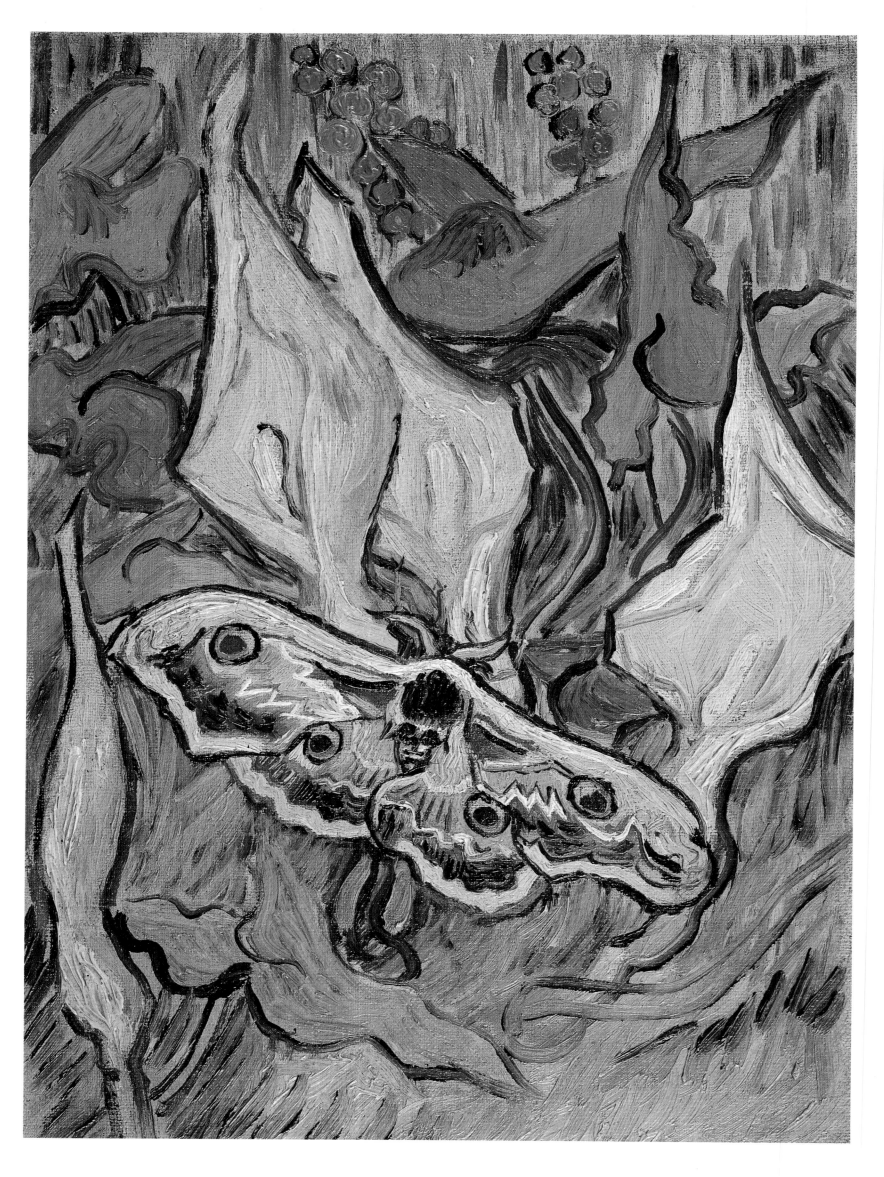

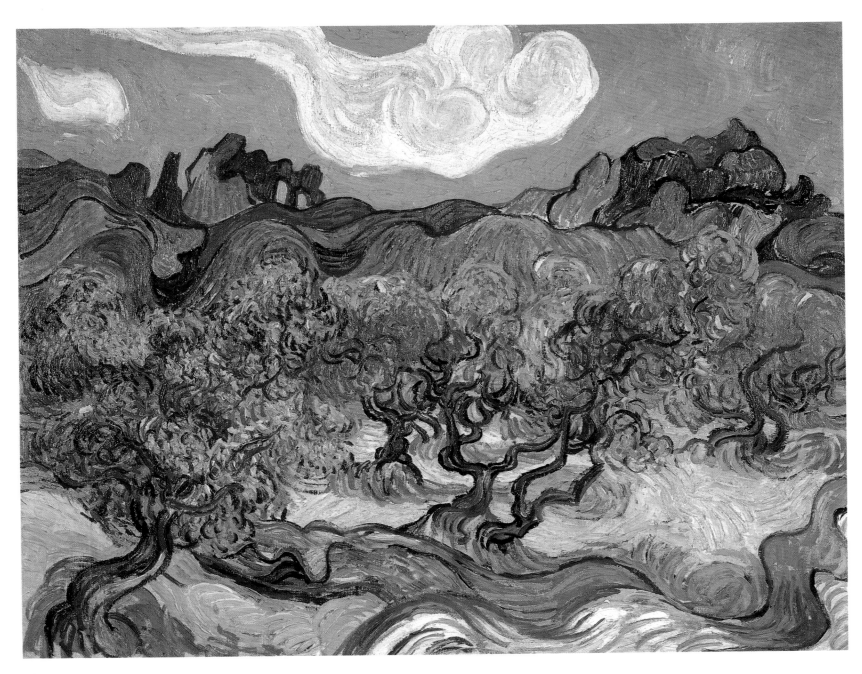

Above:
Olive Trees with the Alpilles in the Background
June 1889
Oil on canvas
28½×36¼in (72.5×92cm)
Collection of Mr and Mrs John Hay Whitney,
New York

Left:
Death's Head Moth Late May 1889
Oil on canvas
13×9½in (33×24cm)
Rijksmuseum Vincent van Gogh, Amsterdam

A Cornfield with Cypresses Summer 1889
Oil on canvas
28½×36¾in (72.1×90.9cm)
The National Gallery, London

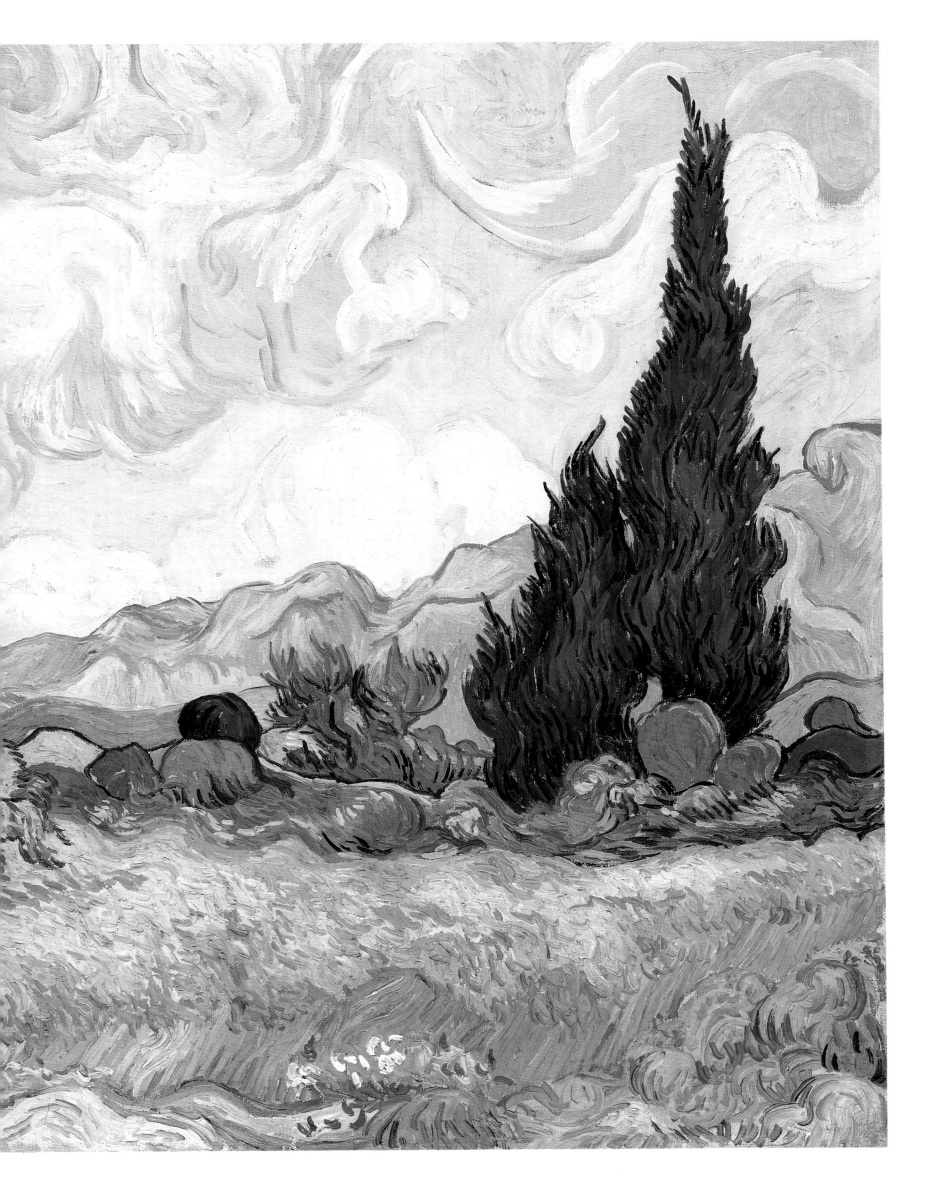

The Garden of the Hospital at Saint-Rémy
Late October 1889
Oil on canvas
29×36¼in (73.5×92cm)
Folkwang Museum, Essen

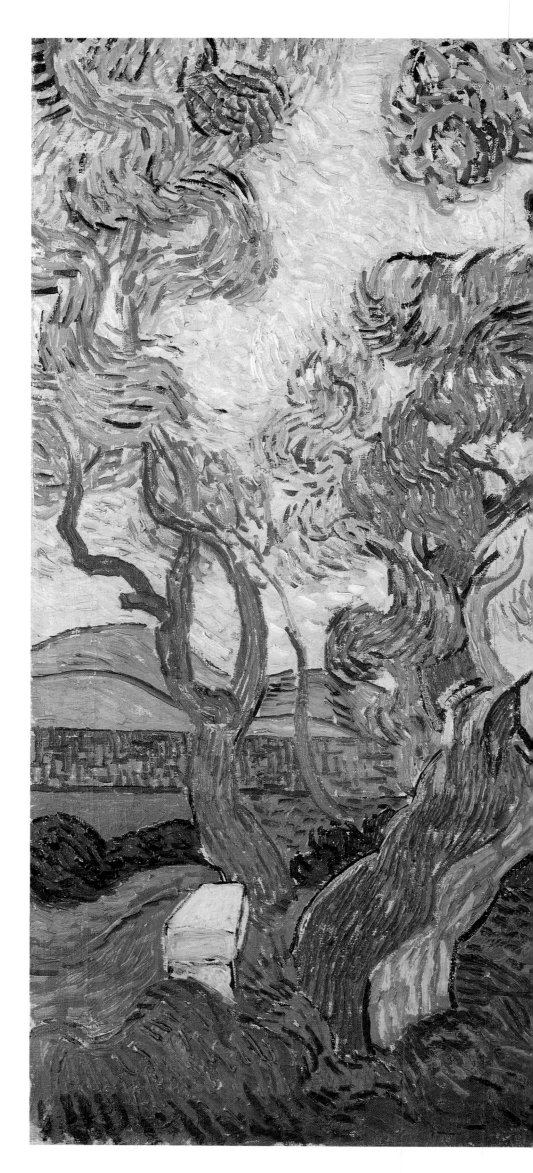

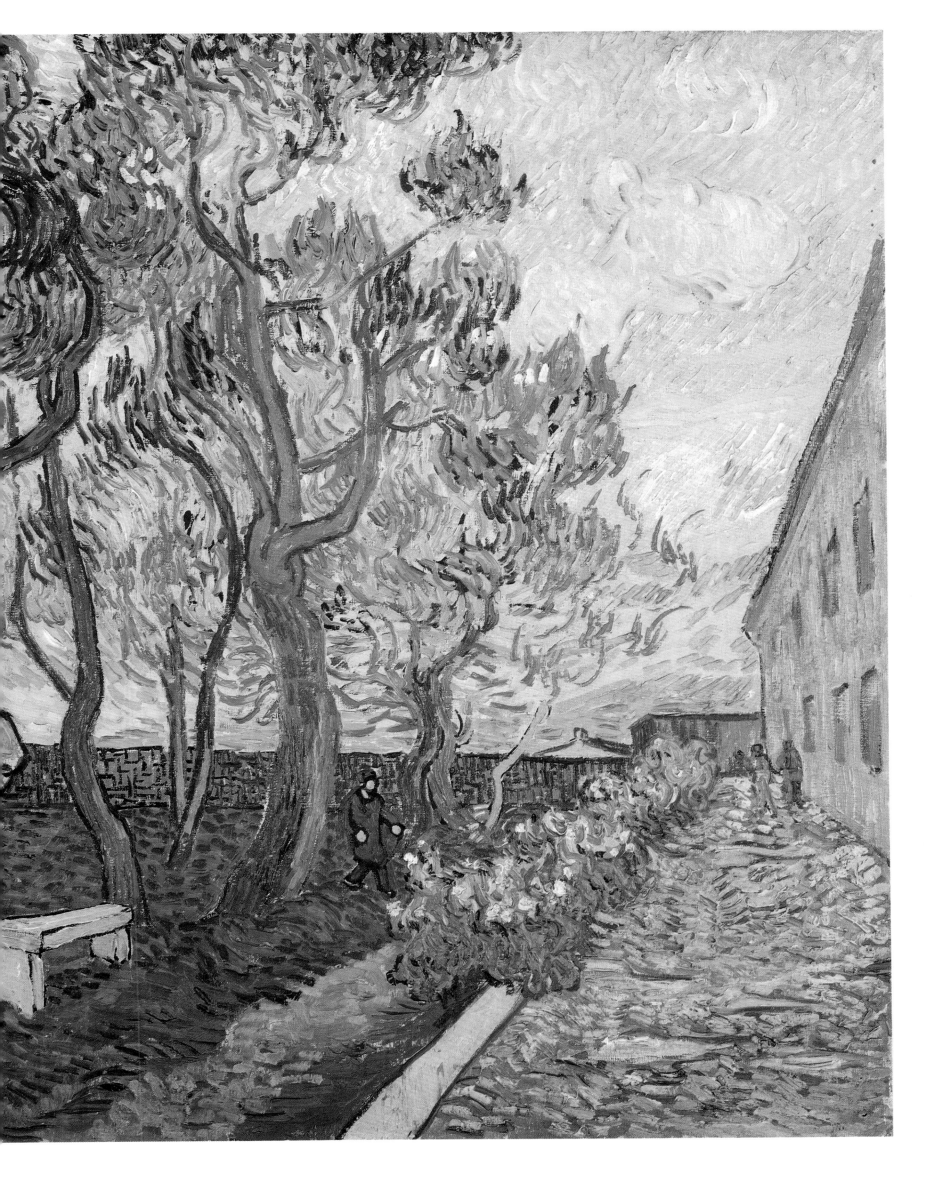

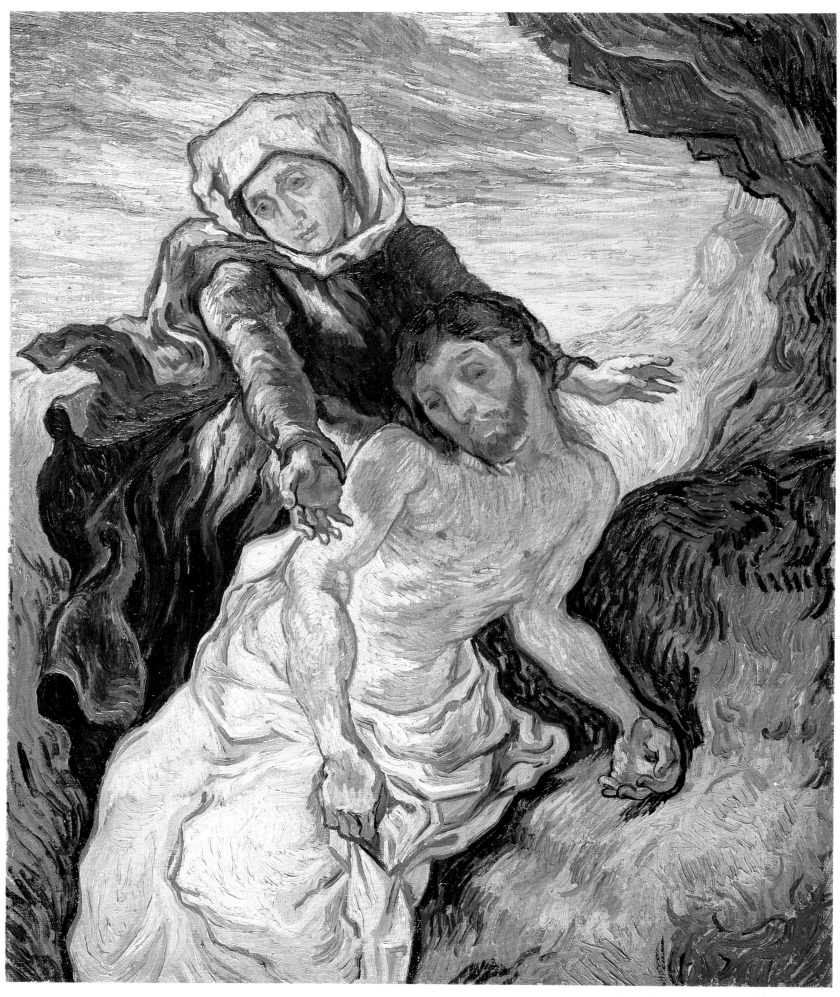

Pietà (after Delacroix) September 1889
Oil on canvas
28¾×23¾in (73×60.5cm)
Rijksmuseum Vincent van Gogh, Amsterdam

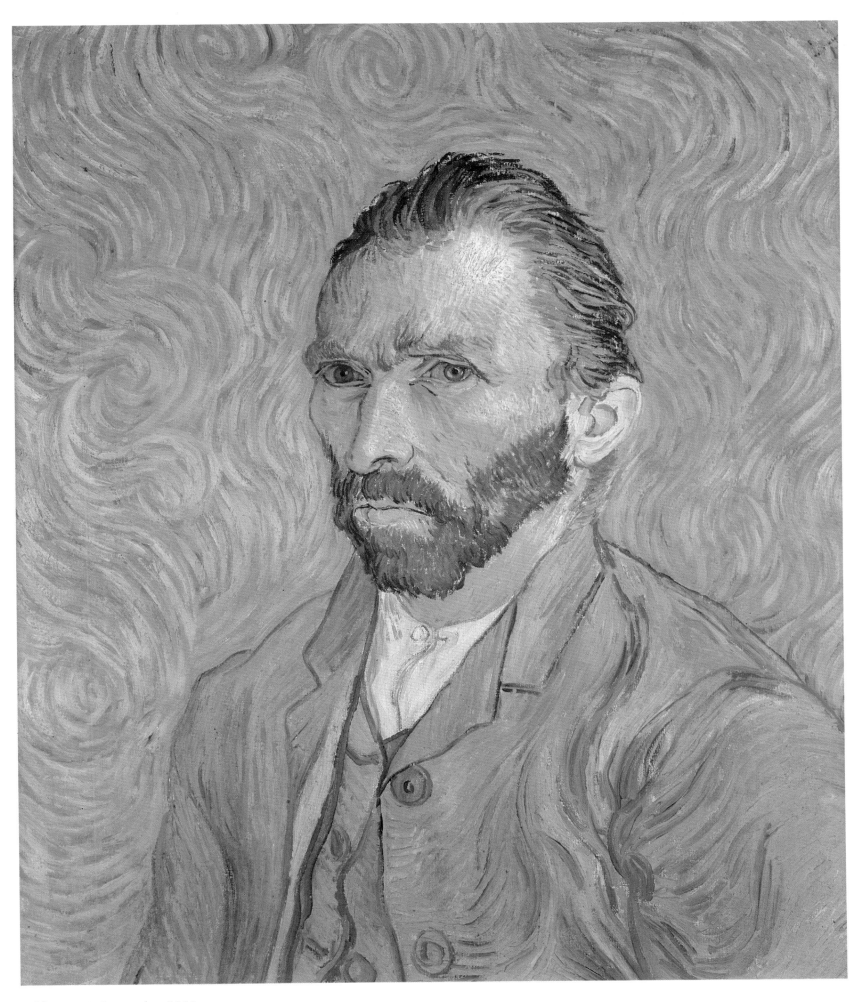

Self-Portrait September 1889
Oil on canvas
25½×21¼in (65×54cm)
Musée d'Orsay, Paris

The Ravine (Les Peyroulets)
November or December 1889
Oil on canvas
28¼×36¼in (72×92cm)
Rijksmuseum Kröller-Müller, Otterlo

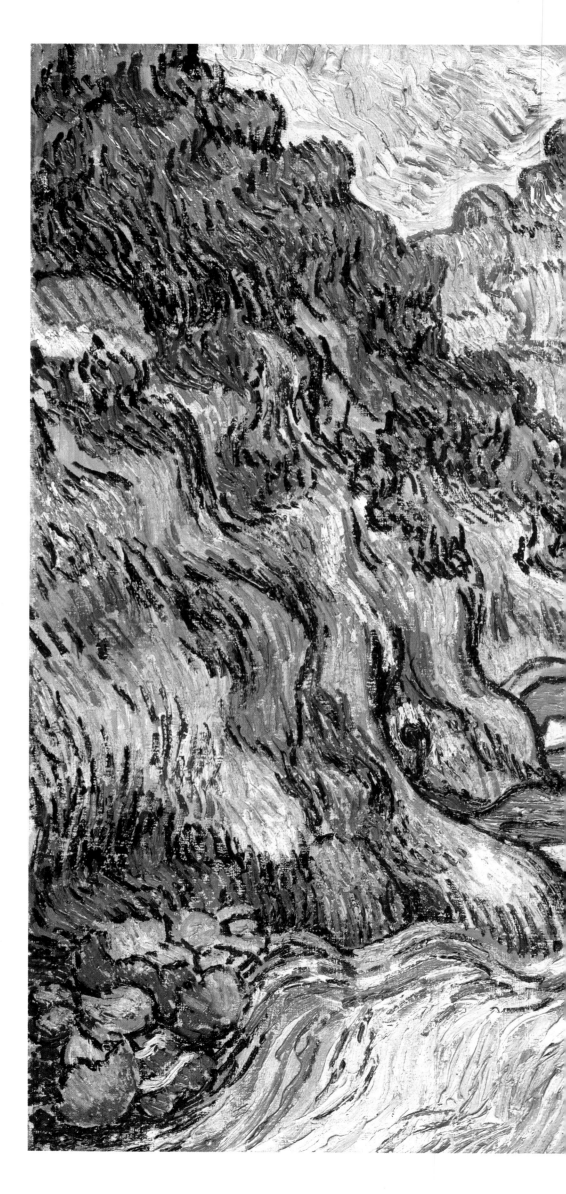

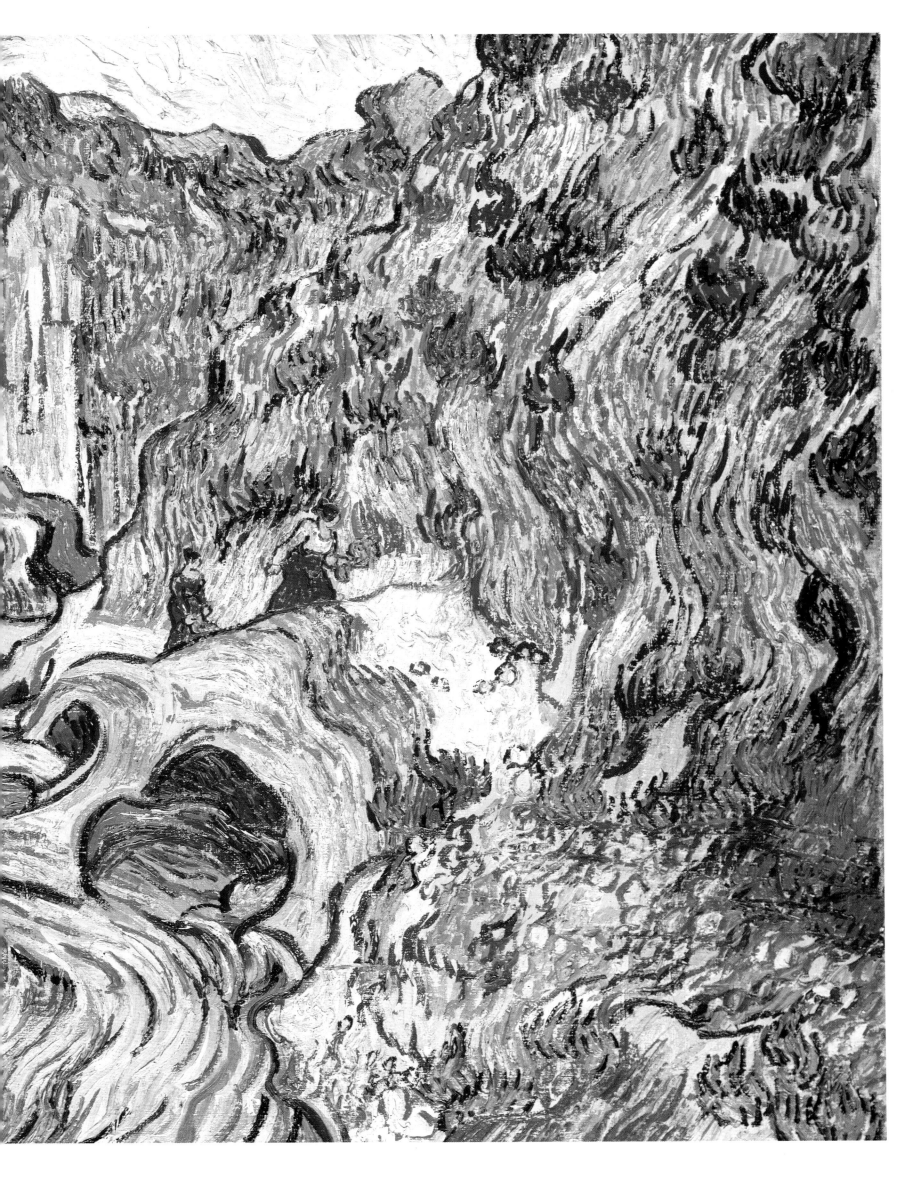

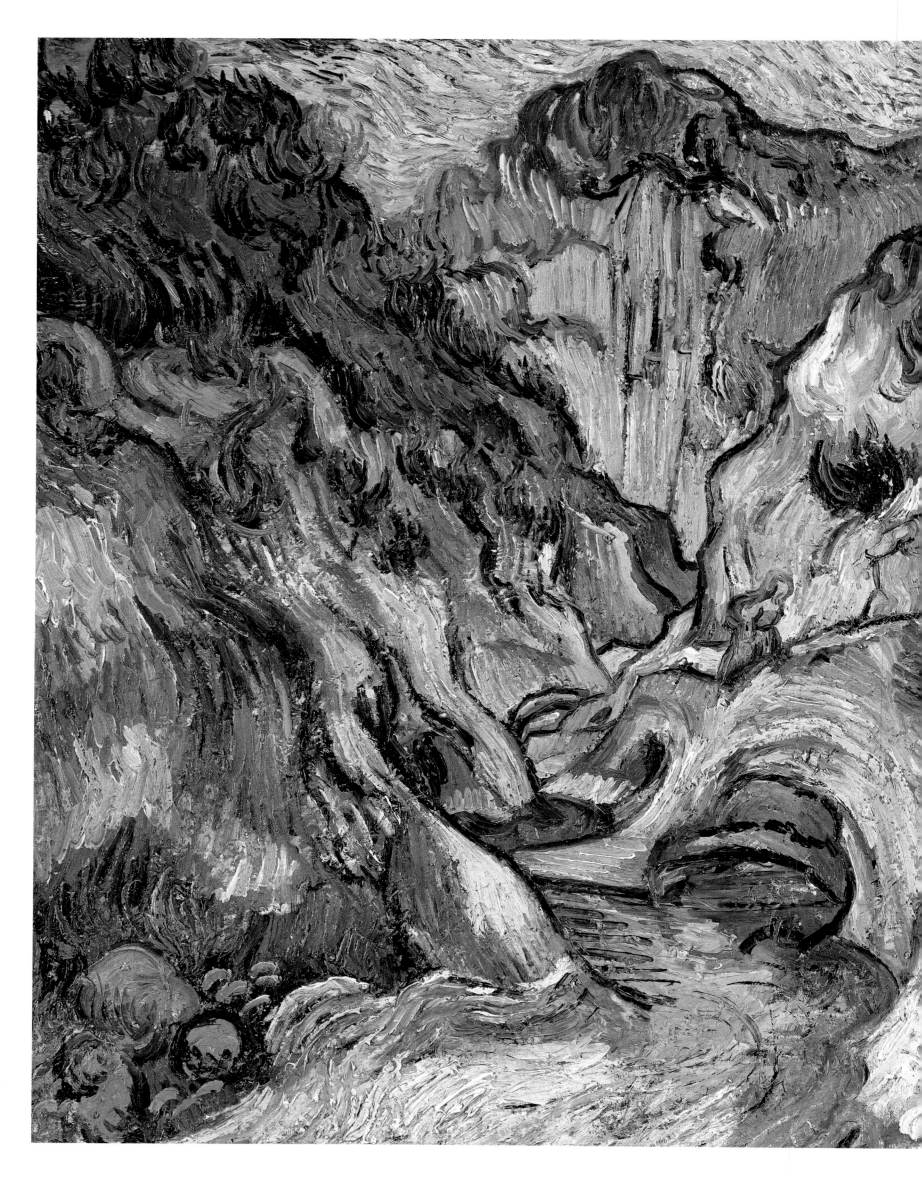

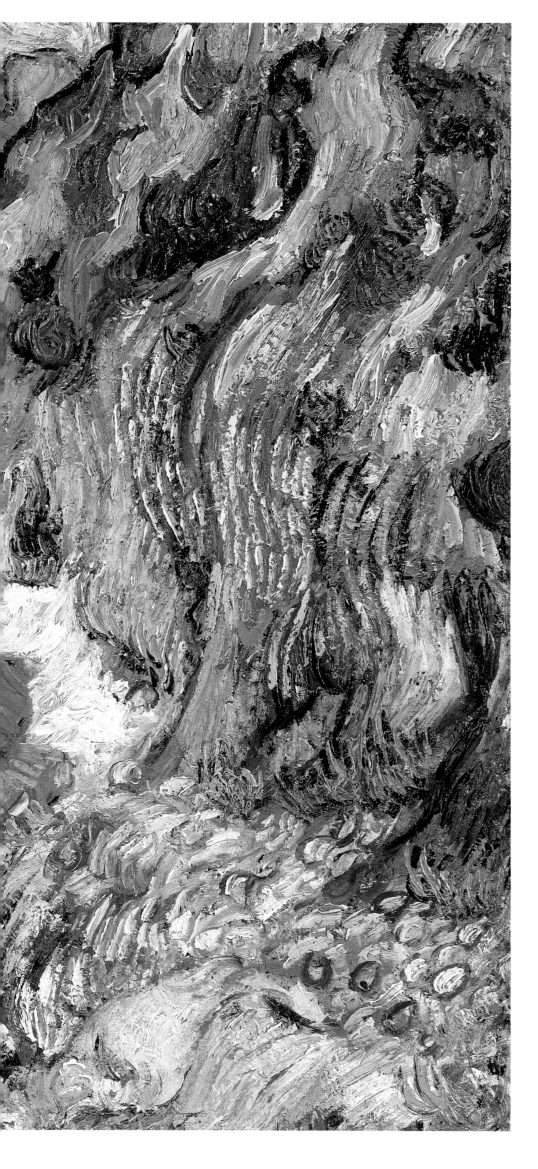

Ravine 1889
Oil on canvas
23¾×36⅛in (73×91.7cm)
Museum of Fine Arts, Boston

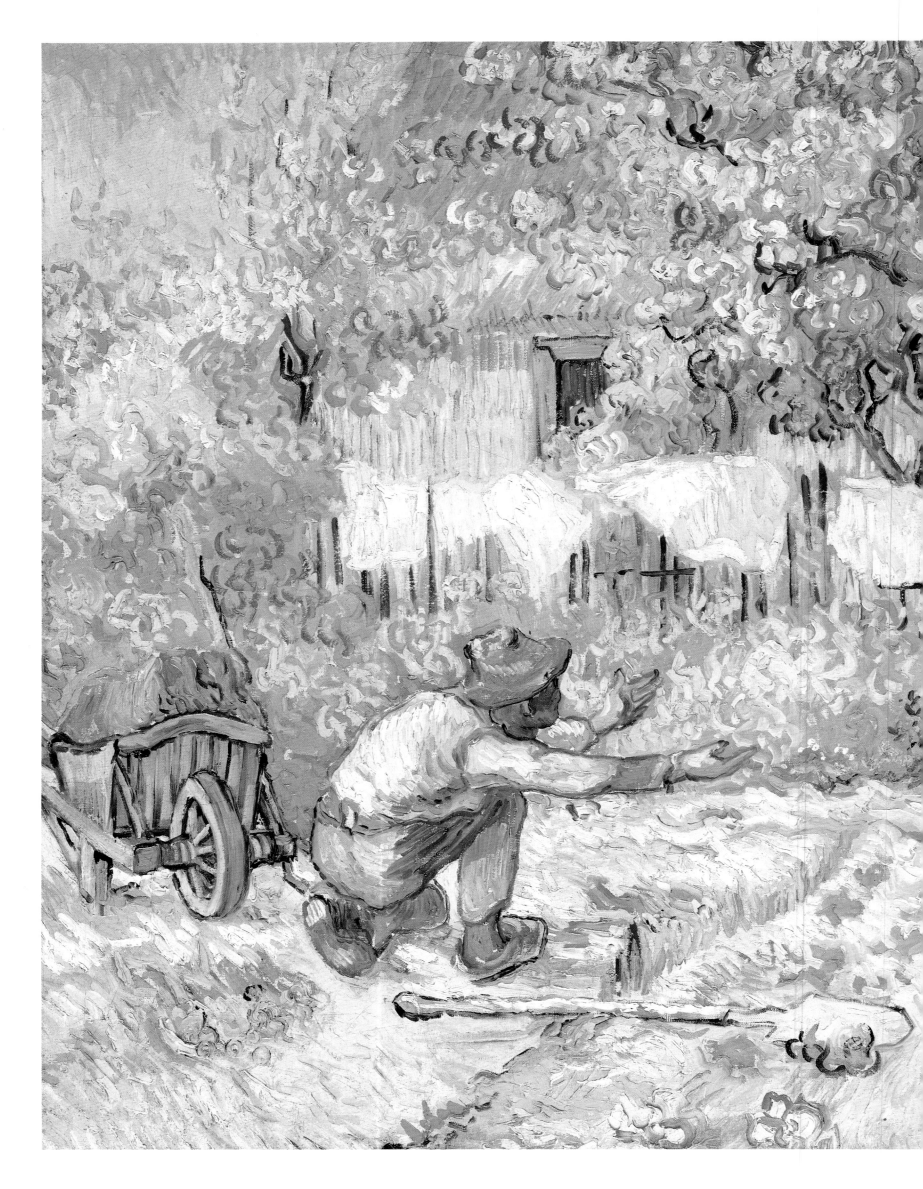

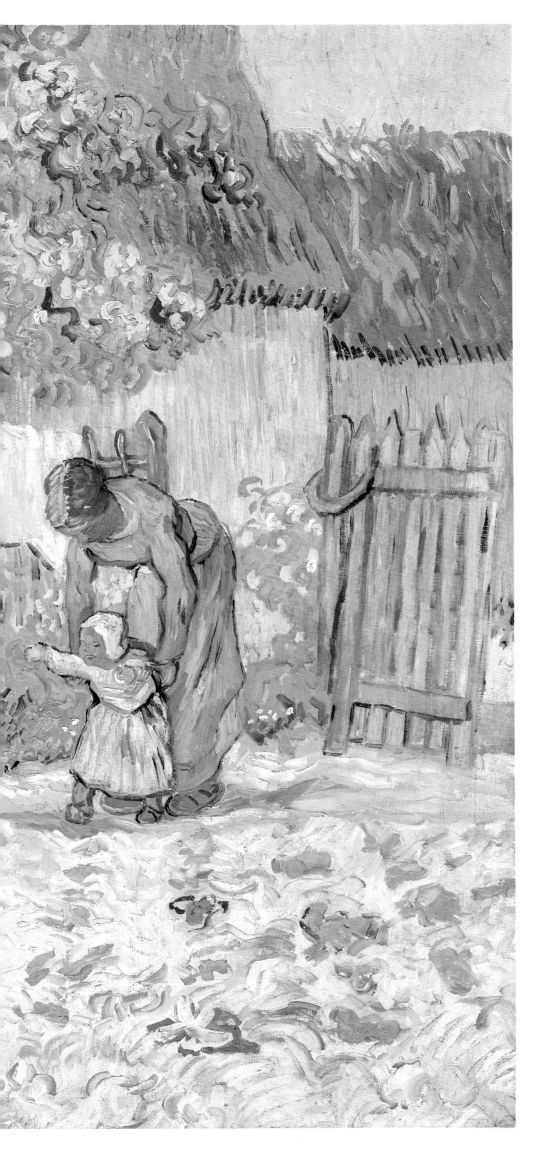

Two Peasants and a Child after Millet's
'Les Premiers Pas' January 1890
Oil on canvas
28½×36in (72.4×91.2cm)
The Metropolitan Museum of Art, New York

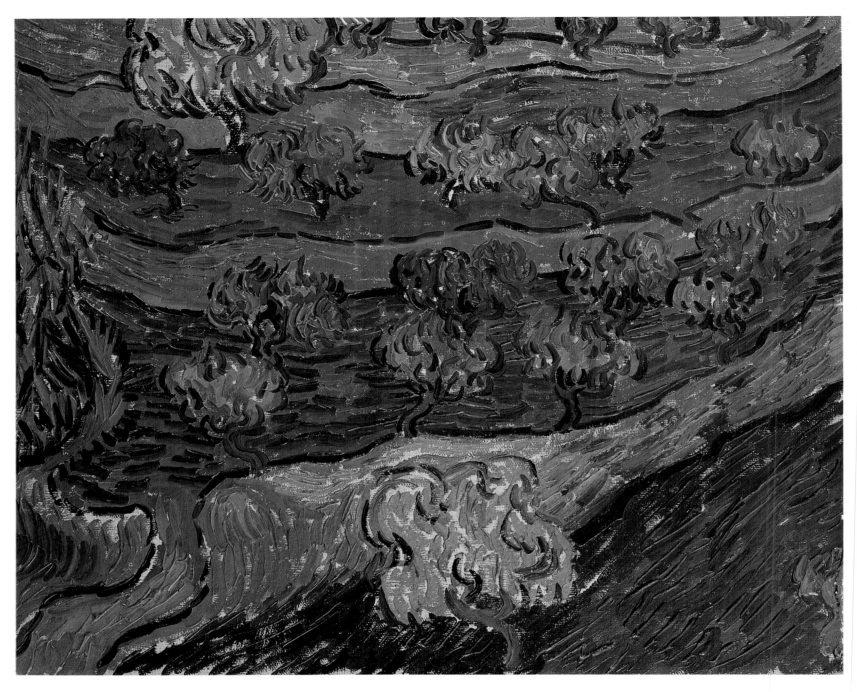

Above:
Olive Trees September-November 1889
Oil on canvas
13×15¾in (33×40cm)
Rijksmuseum Vincent van Gogh, Amsterdam

Right:
L'Arlésienne: Mme Ginoux
January-February 1890
Oil on canvas
25½×19¼in (65×49cm)
Rijksmuseum Kröller-Müller, Otterlo

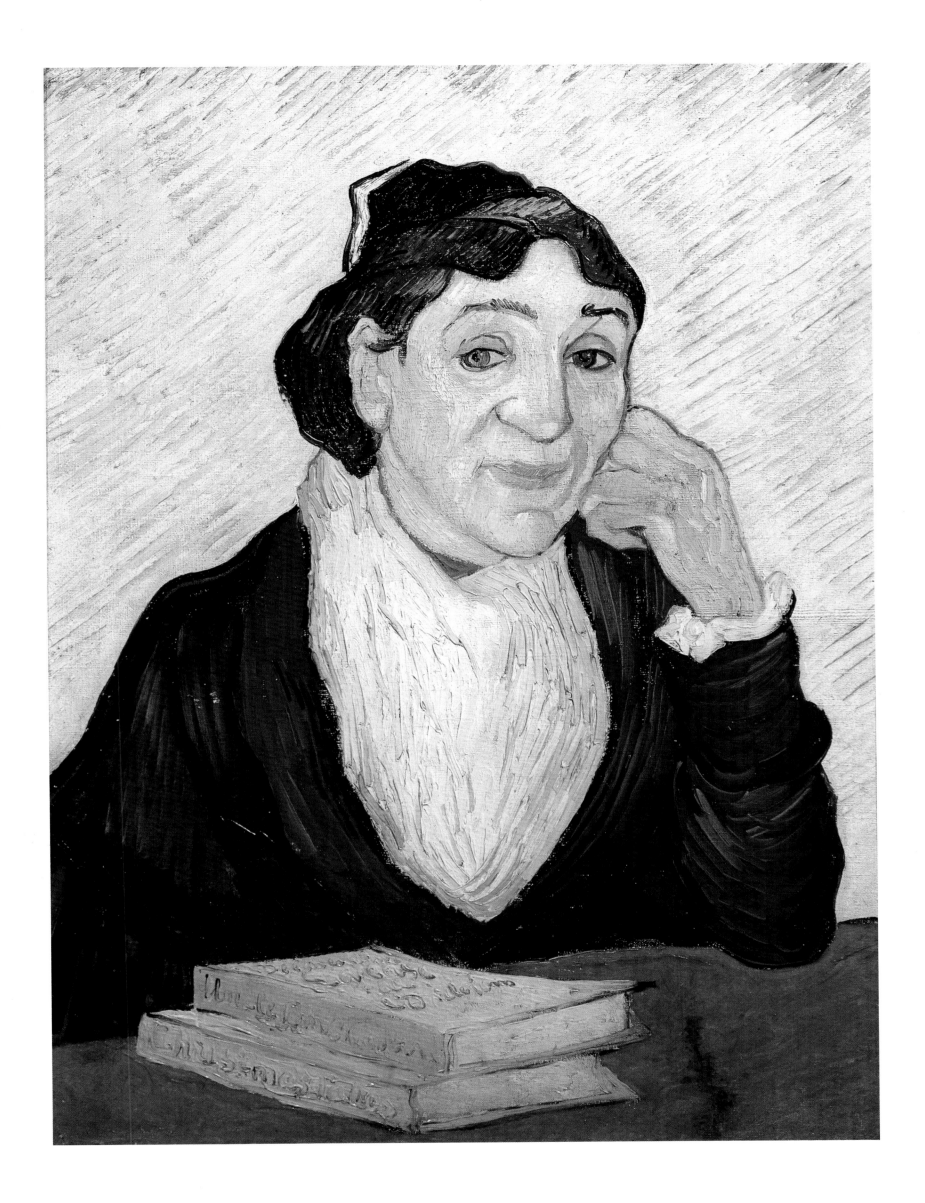

Souvenir du Nord March-April 1890
Oil on canvas
11½×14¼in (29×36.5cm)
Rijksmuseum Vincent van Gogh,
Amsterdam

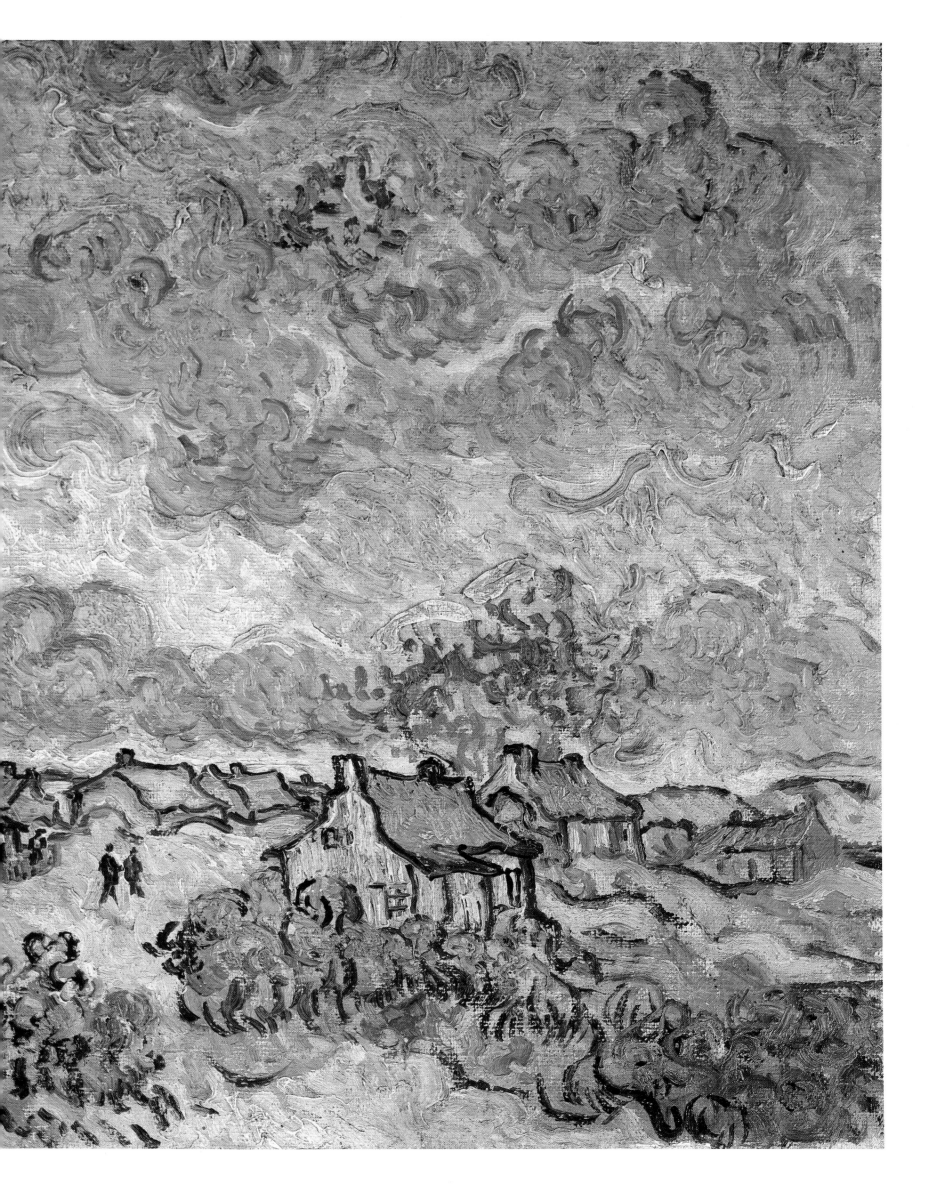

Sower in the Rain March-April 1890
Pencil and chalk on paper
9¼×12½in (23.5×31.5cm)
Folkwang Museum, Essen

House behind the Trees June-July 1890
Black crayon, violet ink, and blue crayon
9½×12¼in (24×31cm)
Rijksmuseum Vincent van Gogh, Amsterdam

Long Grass with Butterflies c. 1890
Oil on canvas
25⅜×31¾in (64.5×80.7cm)
The National Gallery, London

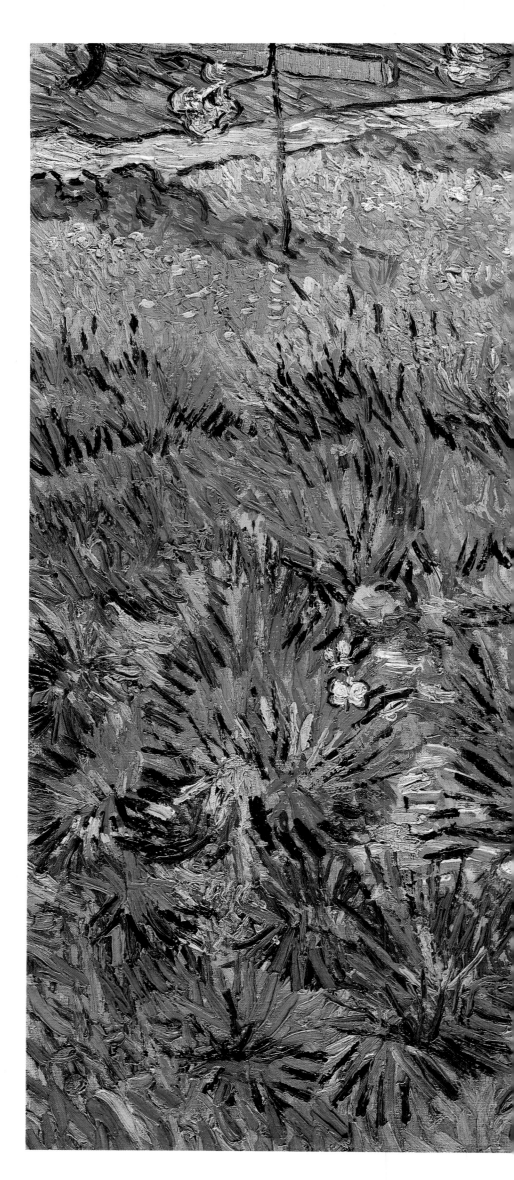

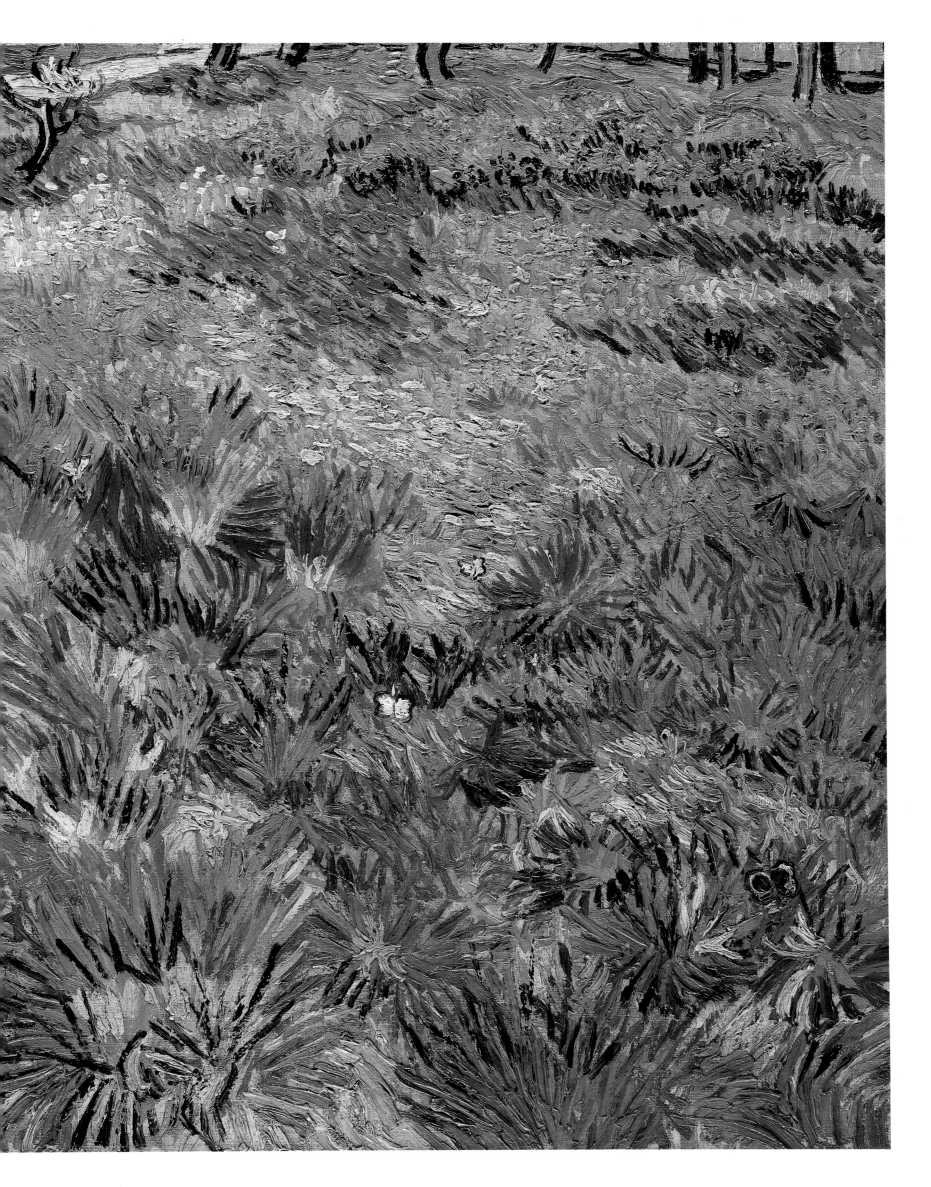

Village Street and Stairs with Figures
May 1890
Oil on canvas
19½×27½in (49.8×70.1cm)
The Saint Louis Art Museum,
Saint Louis, Missouri

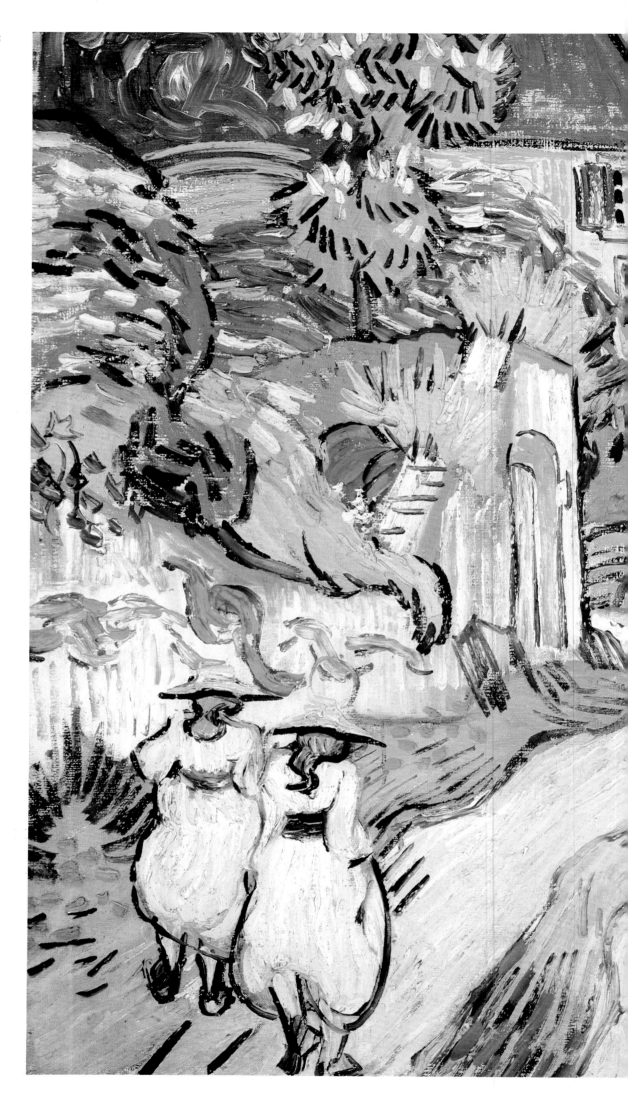

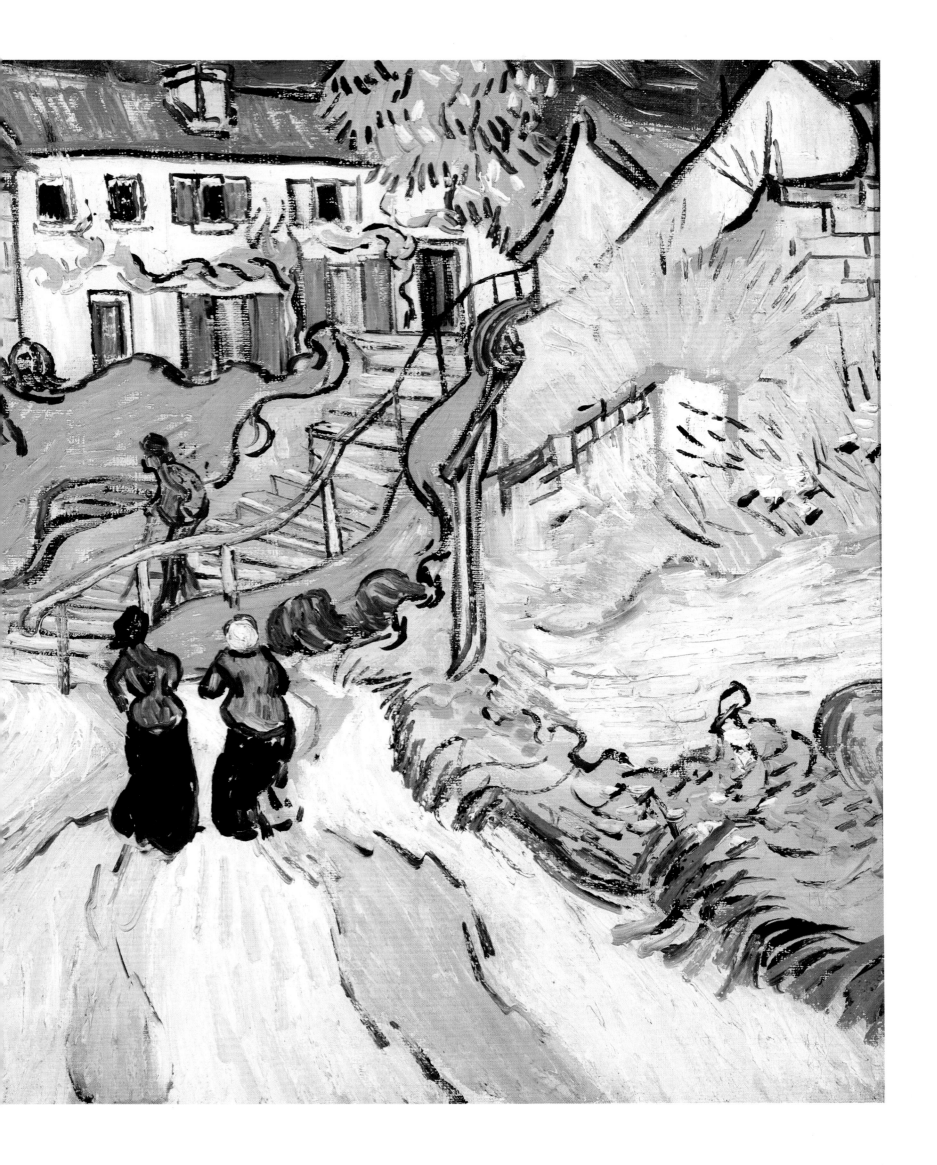

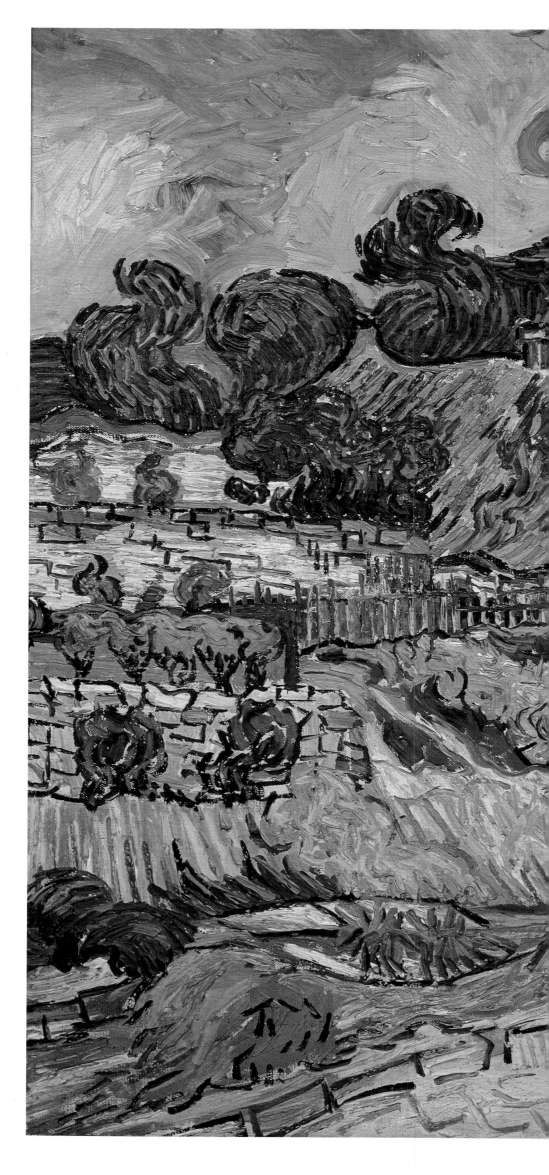

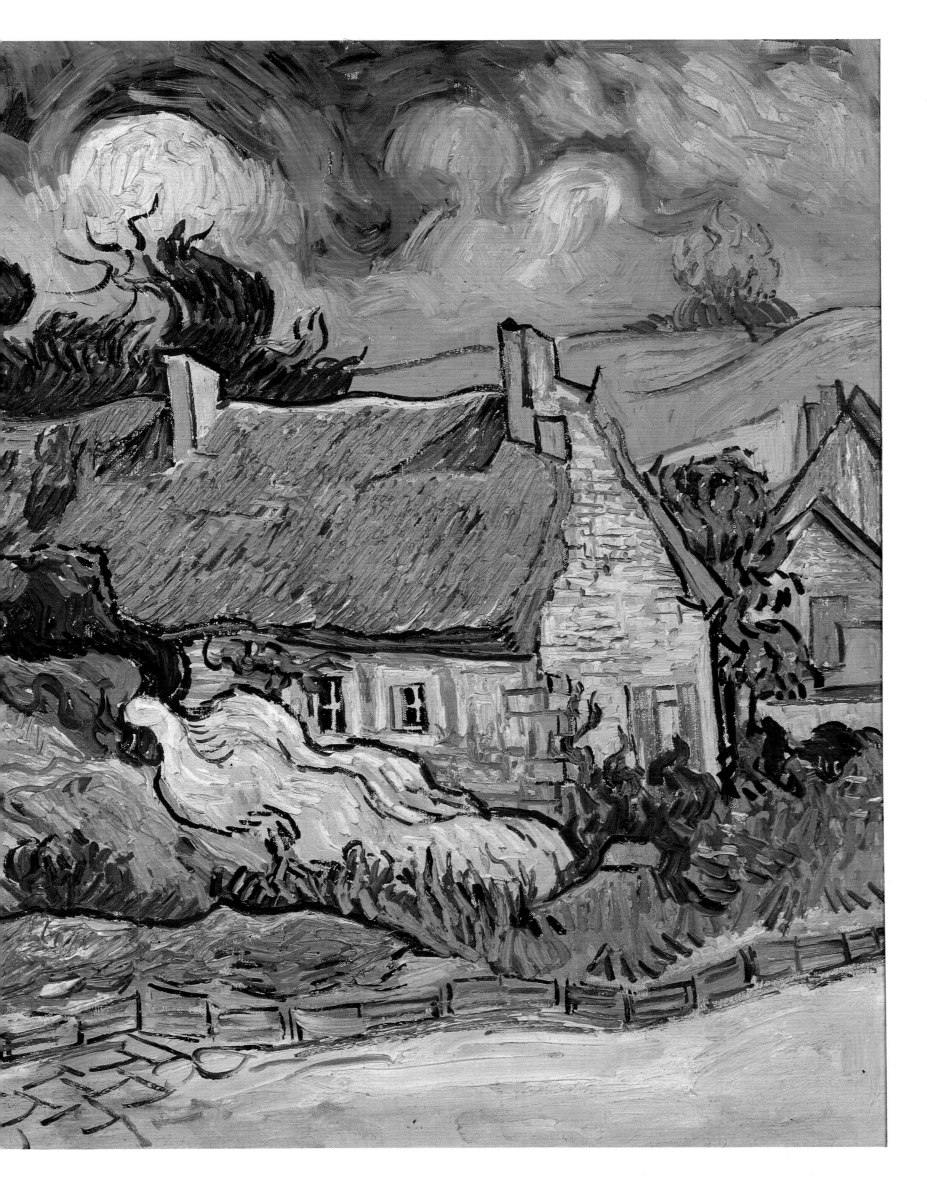

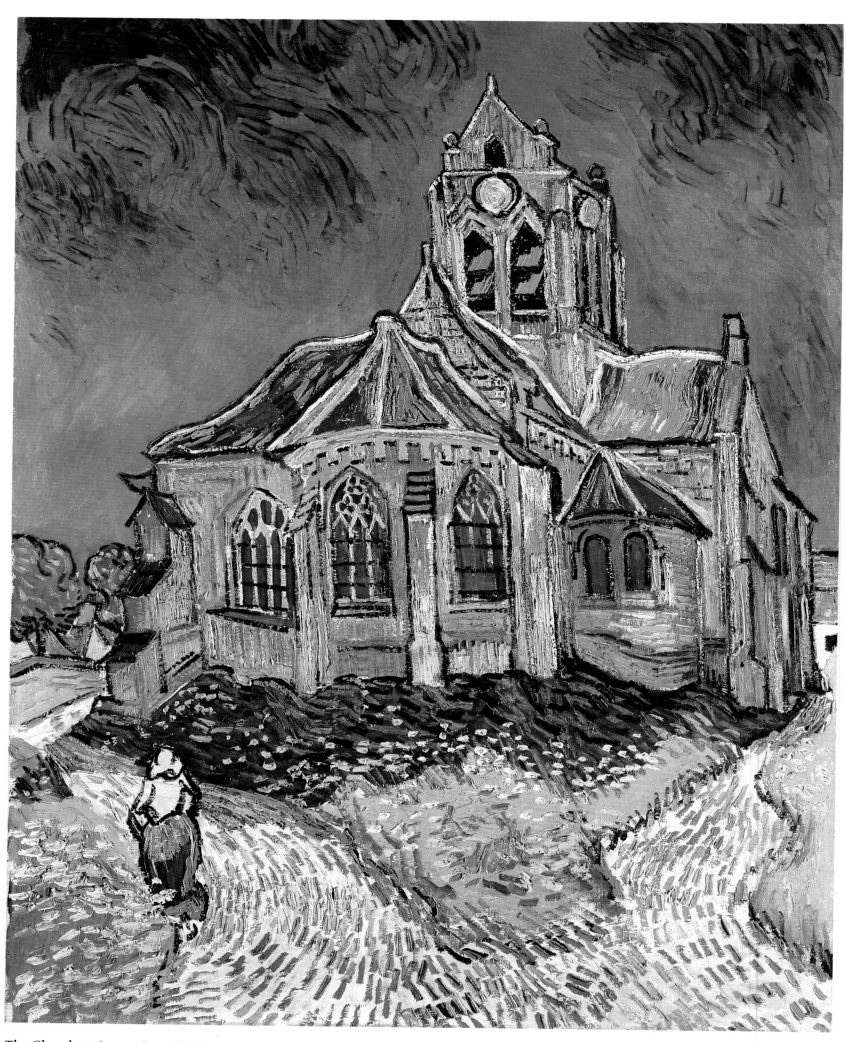

The Church at Auvers June 1890
Oil on canvas
37×29¾in (94×75.4cm)
Musée d'Orsay, Paris

Marguerite Gachet at the Piano
June 1890
Oil on canvas
40½×19¾in (102.6×50cm)
Kunstmuseum, Basel

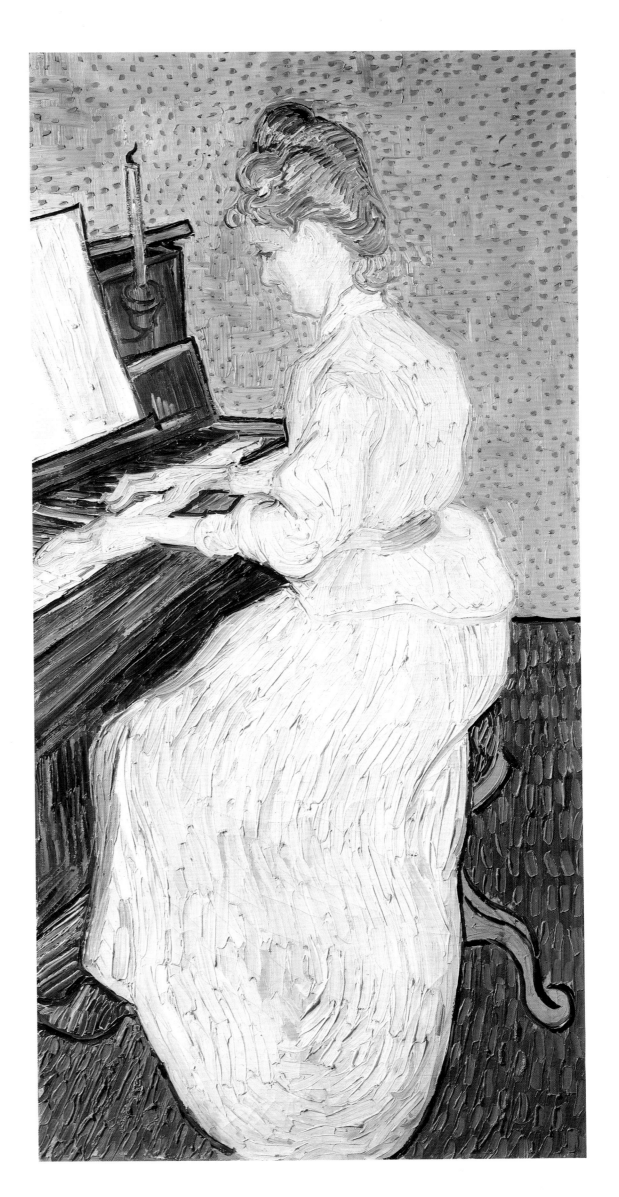

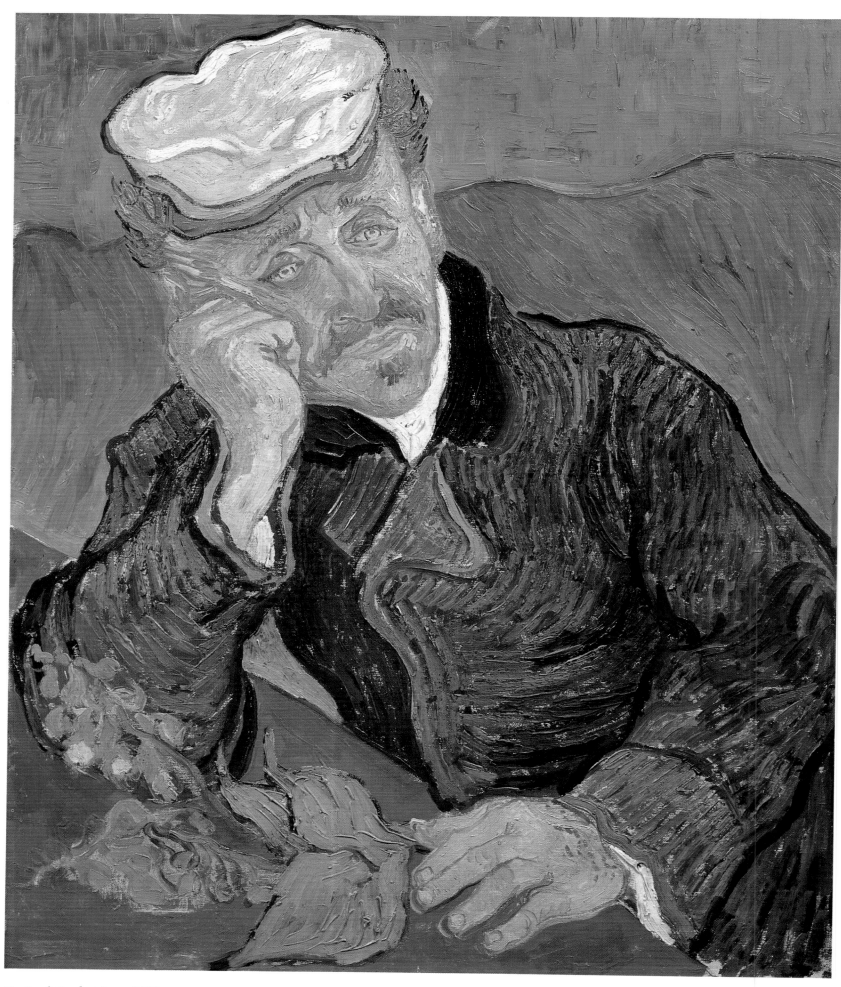

Dr Paul Gachet June 1890
Oil on canvas
26¾×22½in (68×57cm)
Musée d'Orsay, Paris

Rain at Auvers 1890
Oil on canvas
19×39in (48.3×99cm)
National Museum of Wales, Cardiff

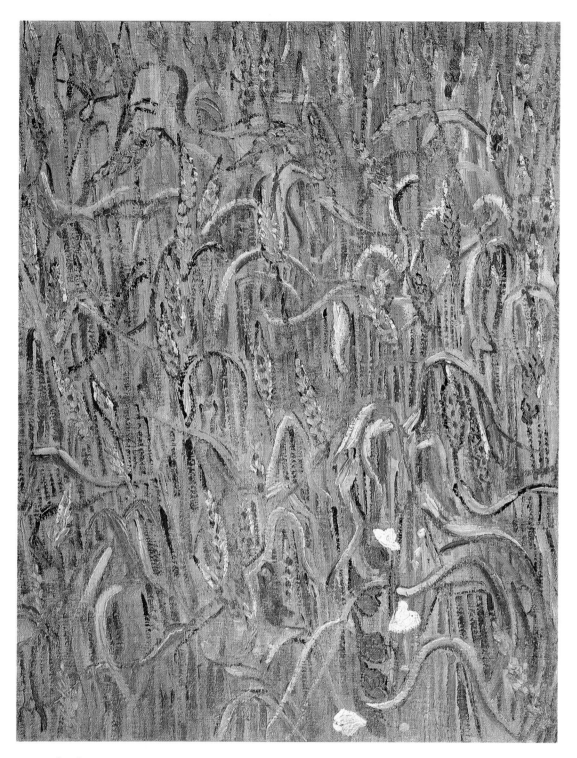

Ears of Wheat June 1890
Oil on canvas
25½×18½in (64.5×47cm)
Rijksmuseum Vincent van Gogh, Amsterdam

Right:
Girl in White June 1890
Oil on canvas
26⅛×17⅞in (66.3×45.3cm)
National Gallery of Art, Washington

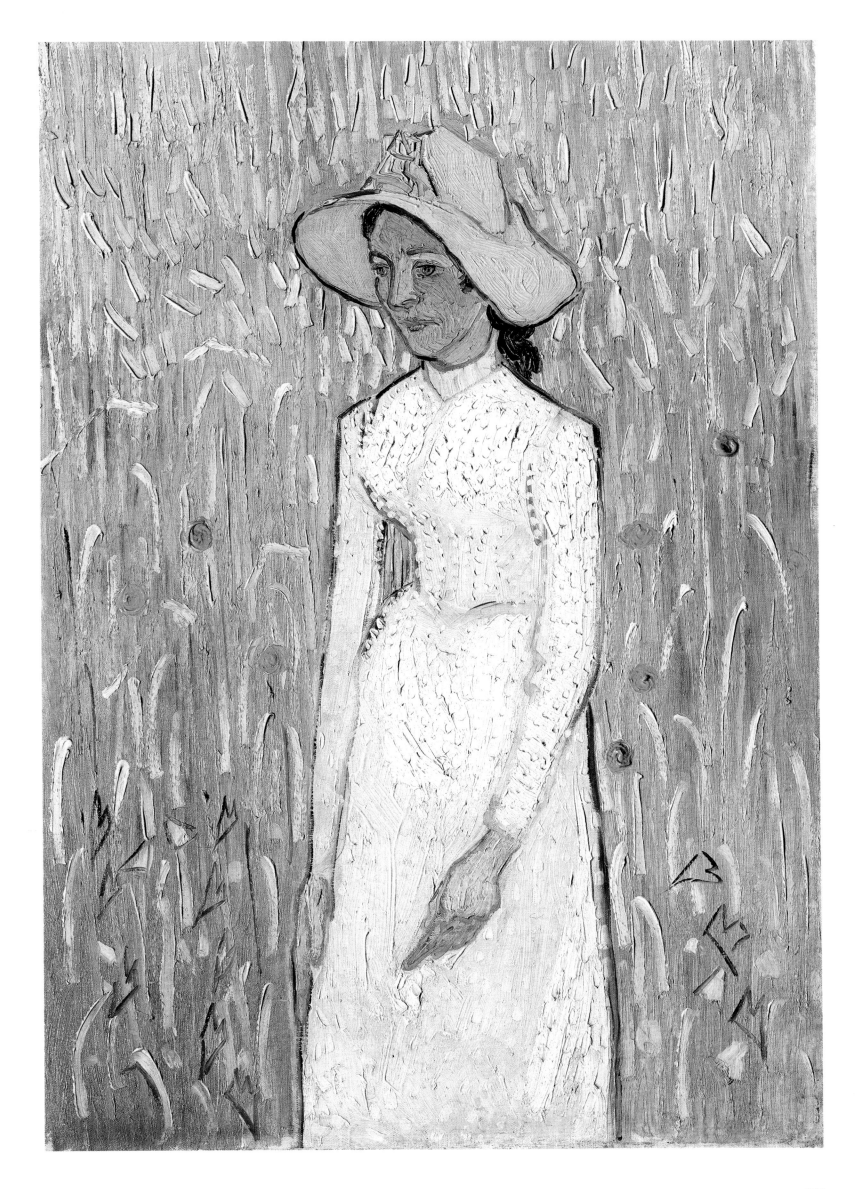

Landscape with Cart and Train June 1890
Oil on canvas
28¼×35½in (72×90cm)
Pushkin Museum, Moscow

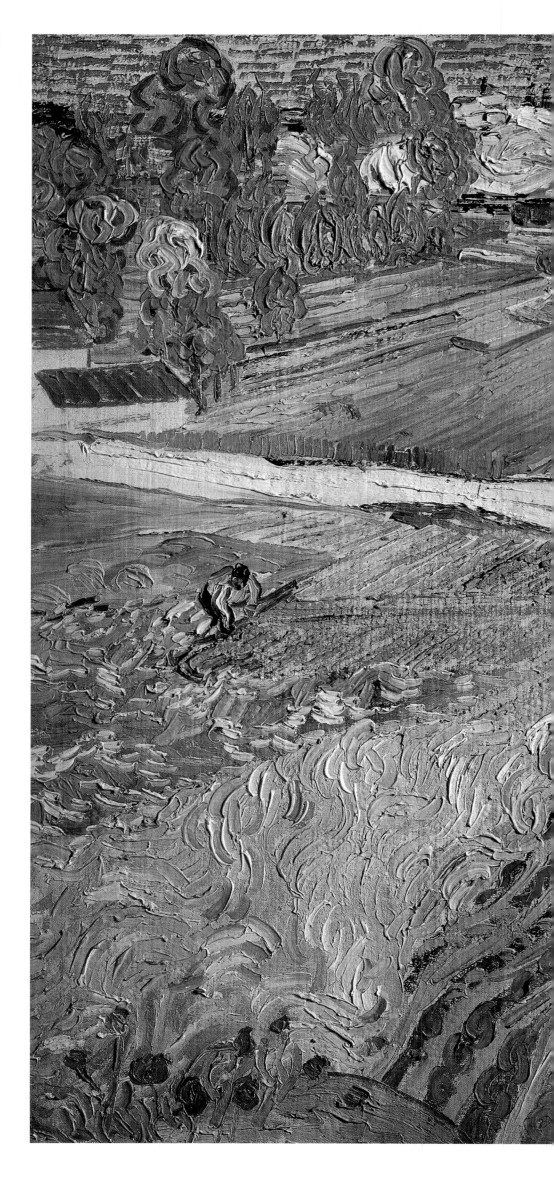

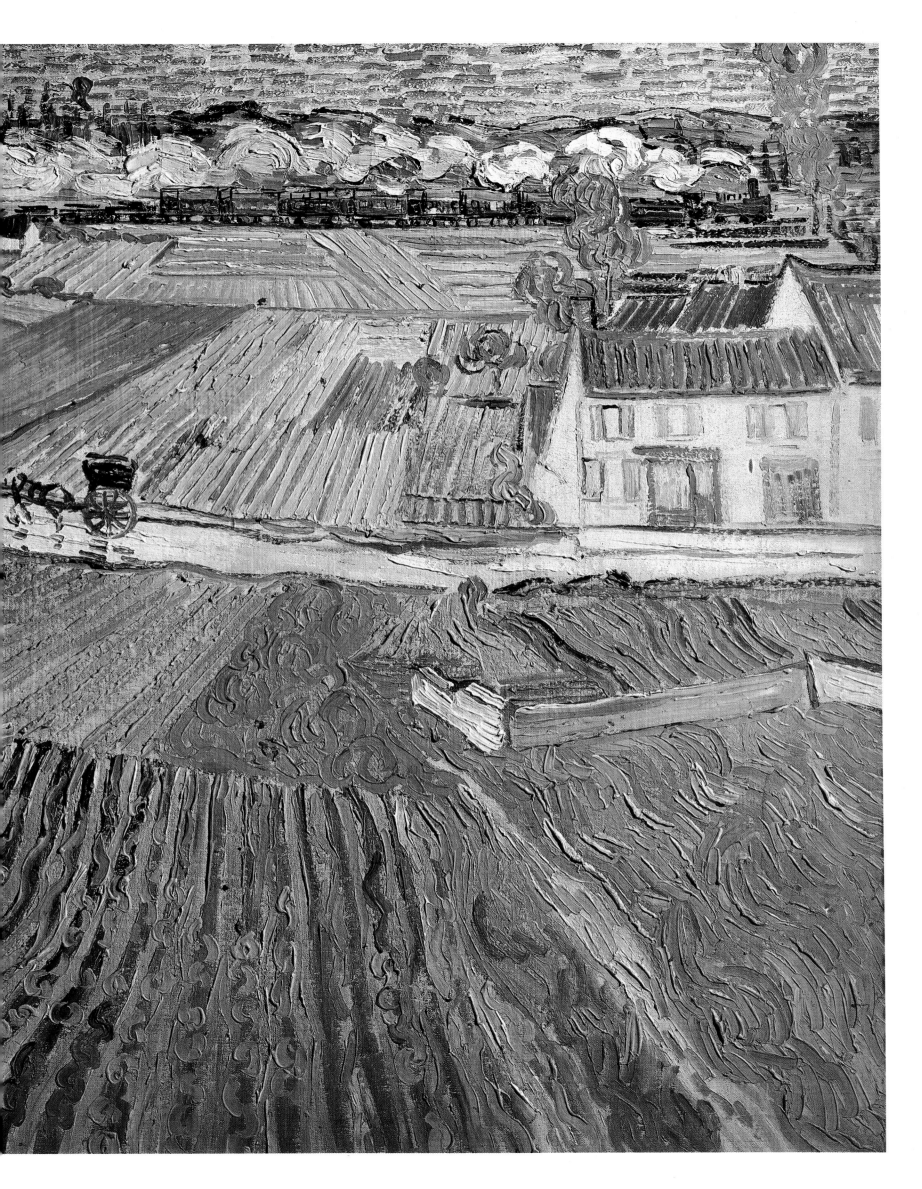

The Oise at Auvers 1890
Oil on canvas
18⅝×24¾in (47.3×62.9cm)
The Tate Gallery, London

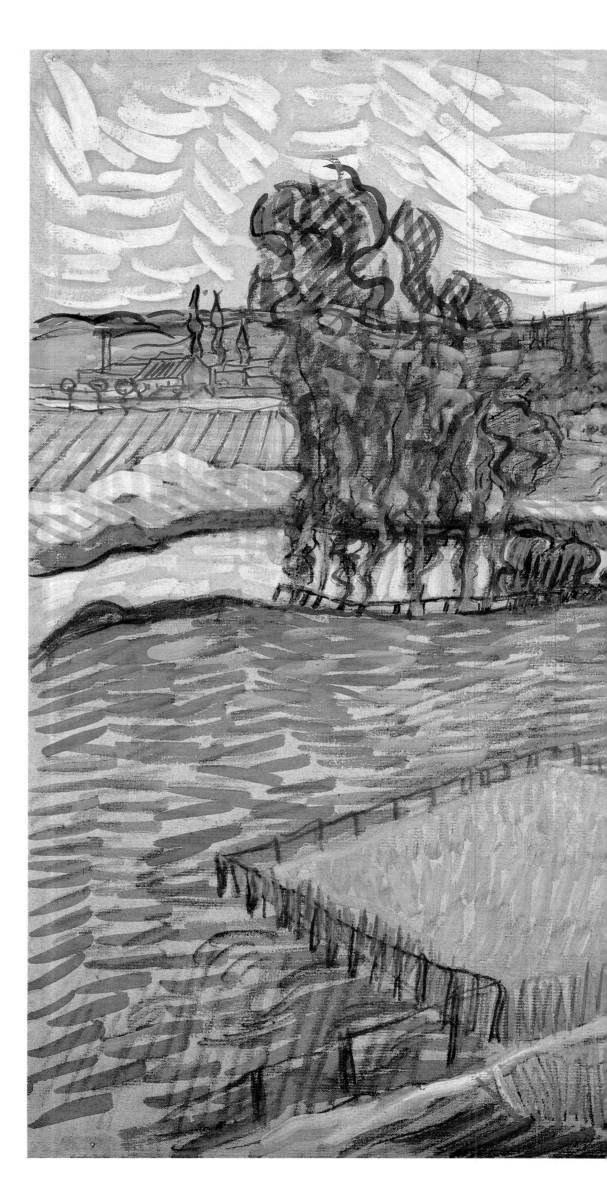

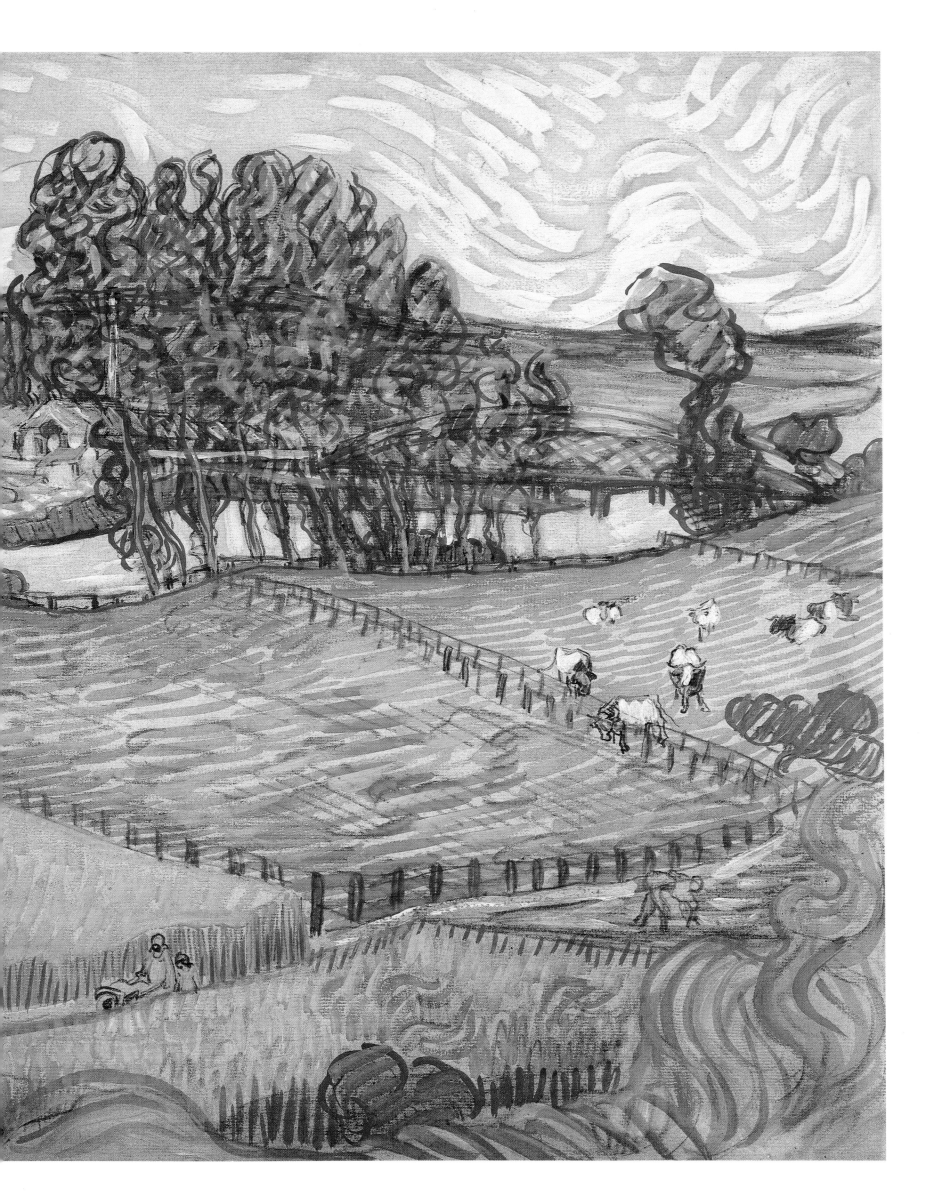

Thatched Cottages near Auvers July 1890
Oil on canvas
25½×32in (65×81cm)
Kunsthaus, Zurich

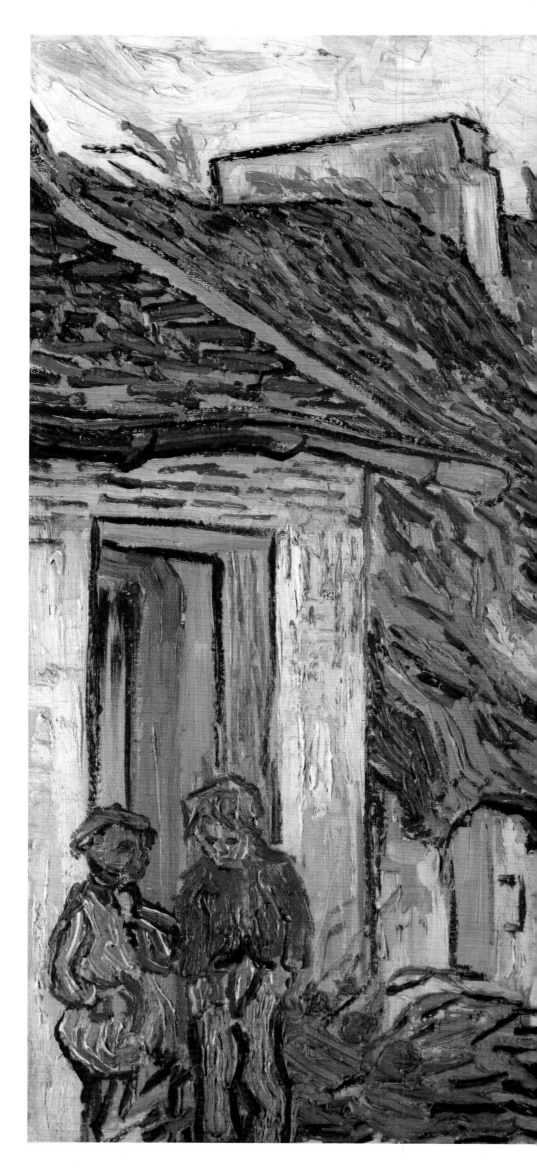

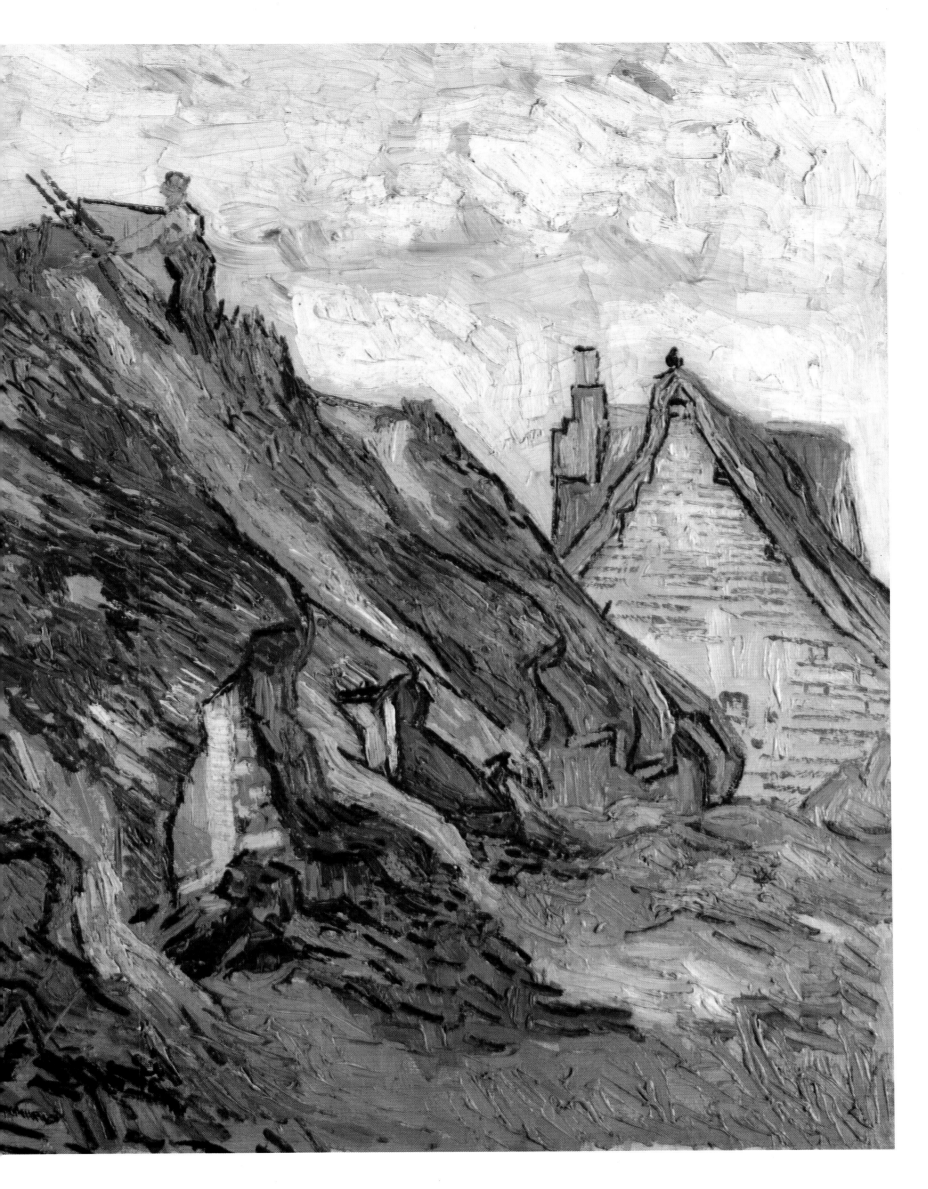

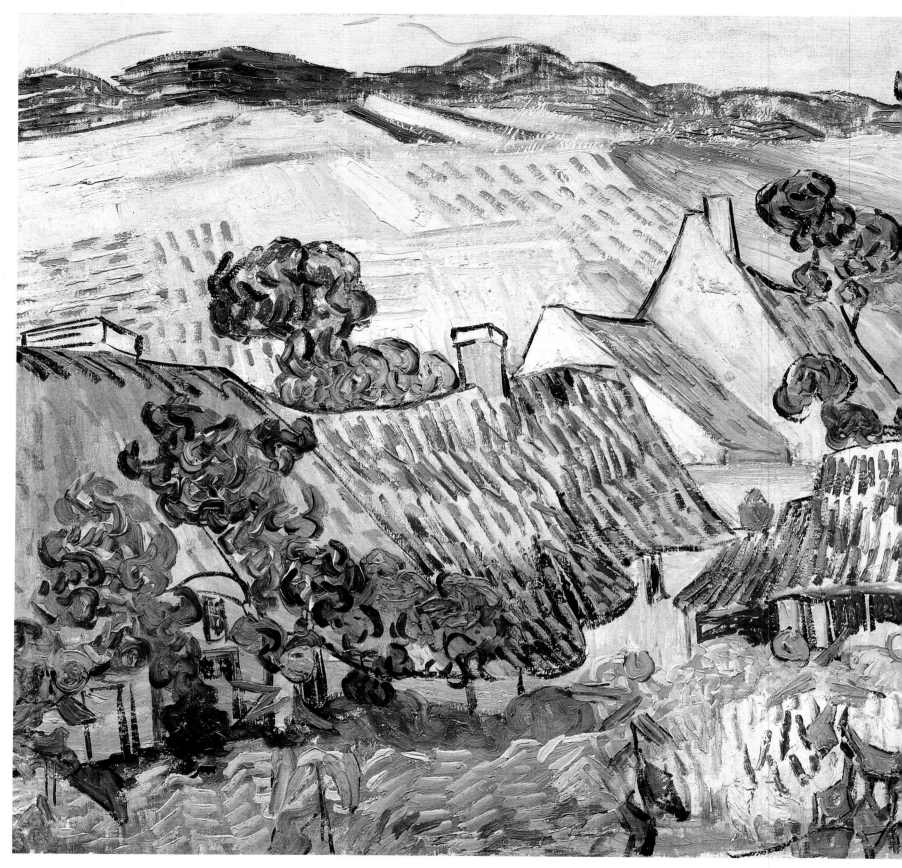

Farms near Auvers 1890
Oil on canvas
19¾×39½in (50.2×100.3cm)
The Tate Gallery, London

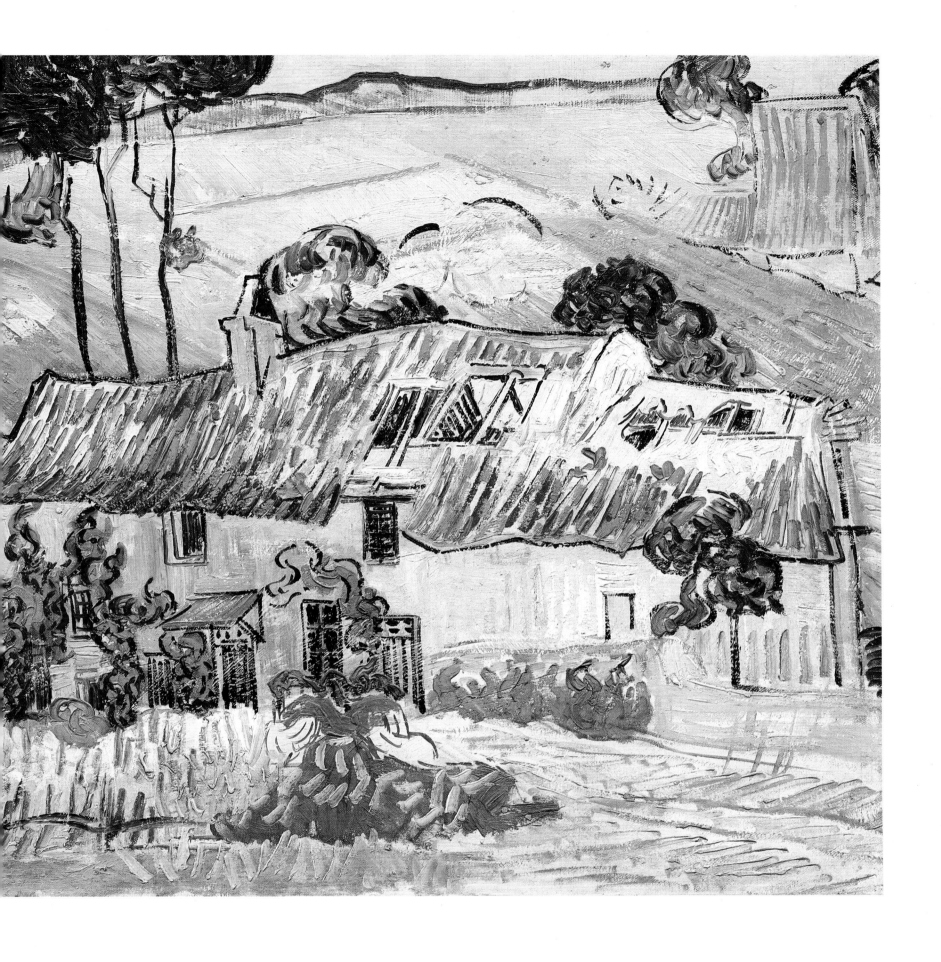

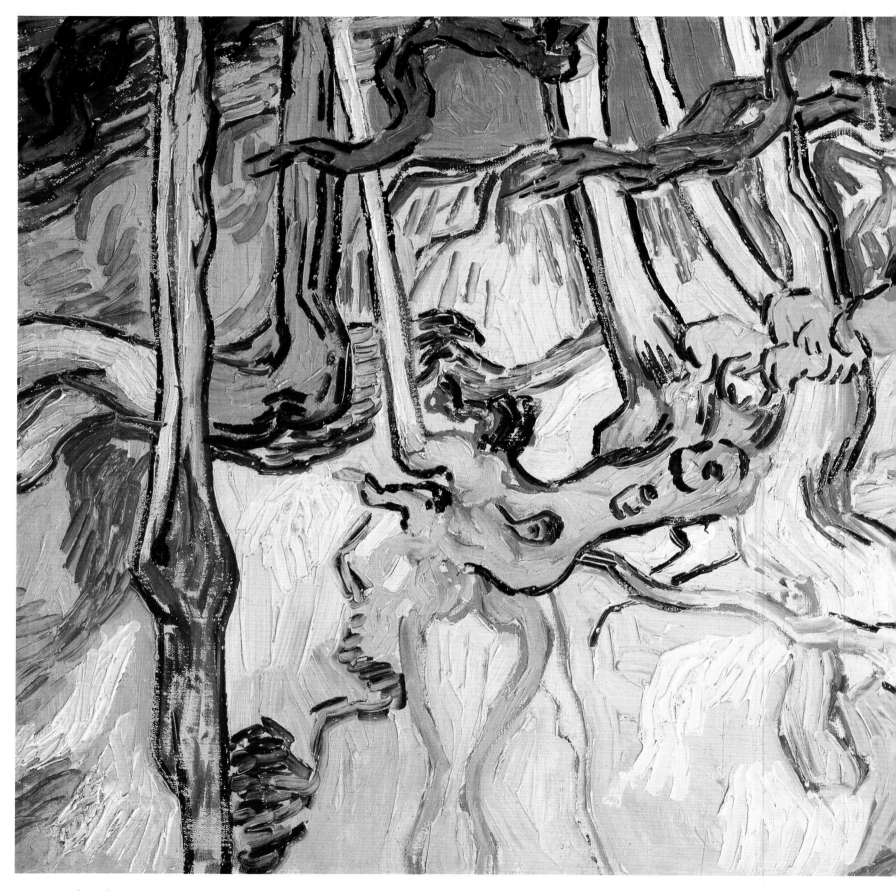

Tree Trunks July 1890
Oil on canvas
19¾×39½in (50.5×100.5cm)
Rijksmuseum Vincent van Gogh, Amsterdam

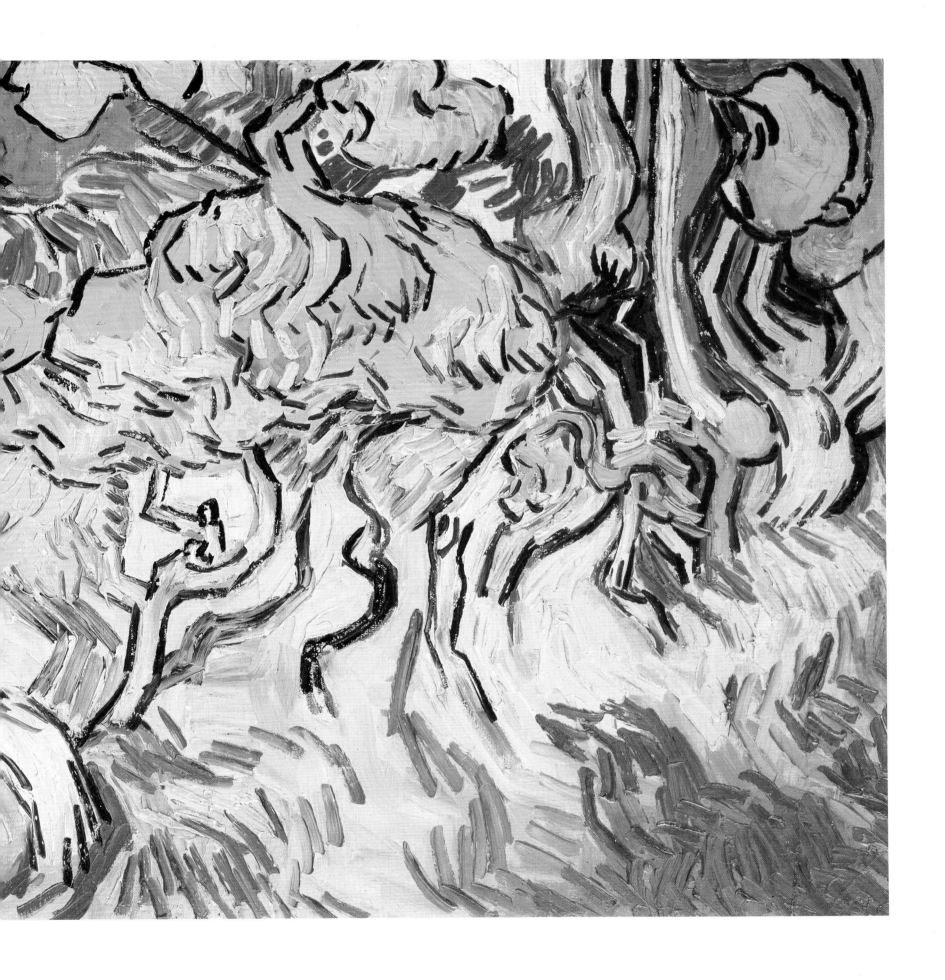

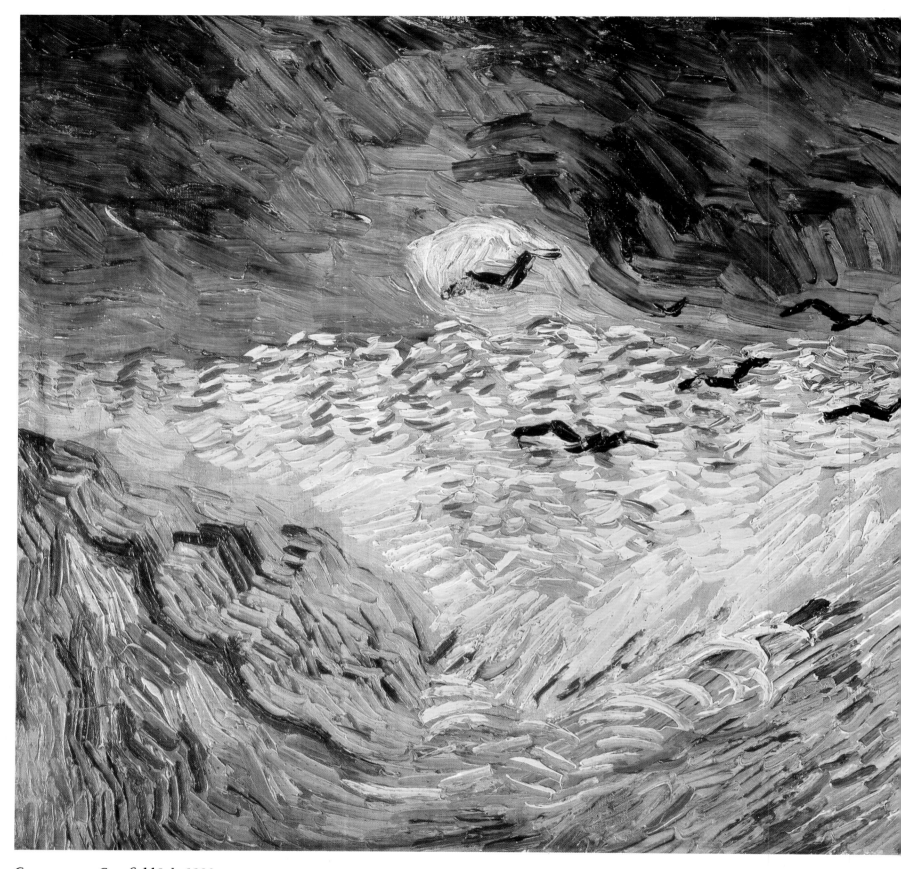

Crows over a Cornfield July 1890
Oil on canvas
19¾×39½in (50.5×100.5cm)
Rijksmuseum Vincent van Gogh, Amsterdam

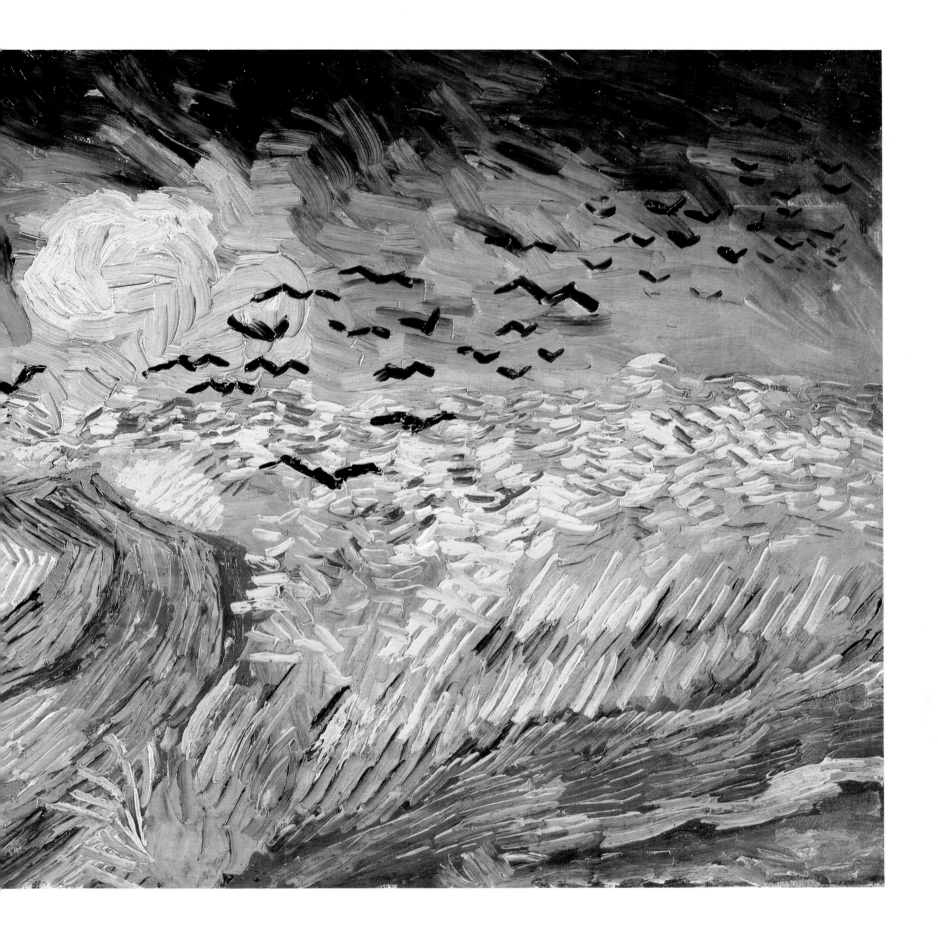

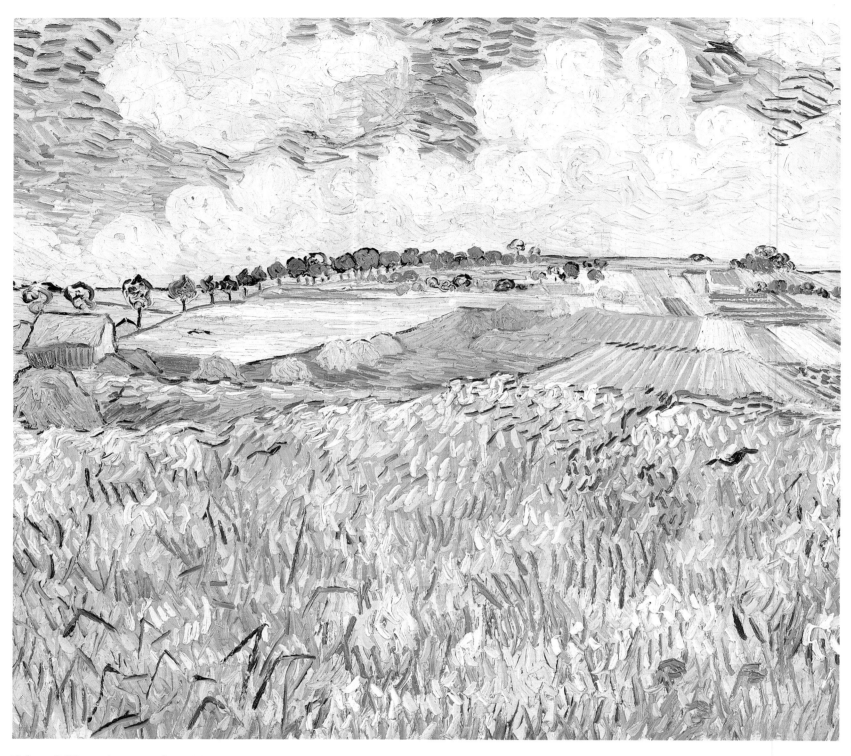

Wheatfields at Auvers July 1890
Oil on canvas
29×36¼in (73.5×92cm)
Neue Pinakothek, Munich

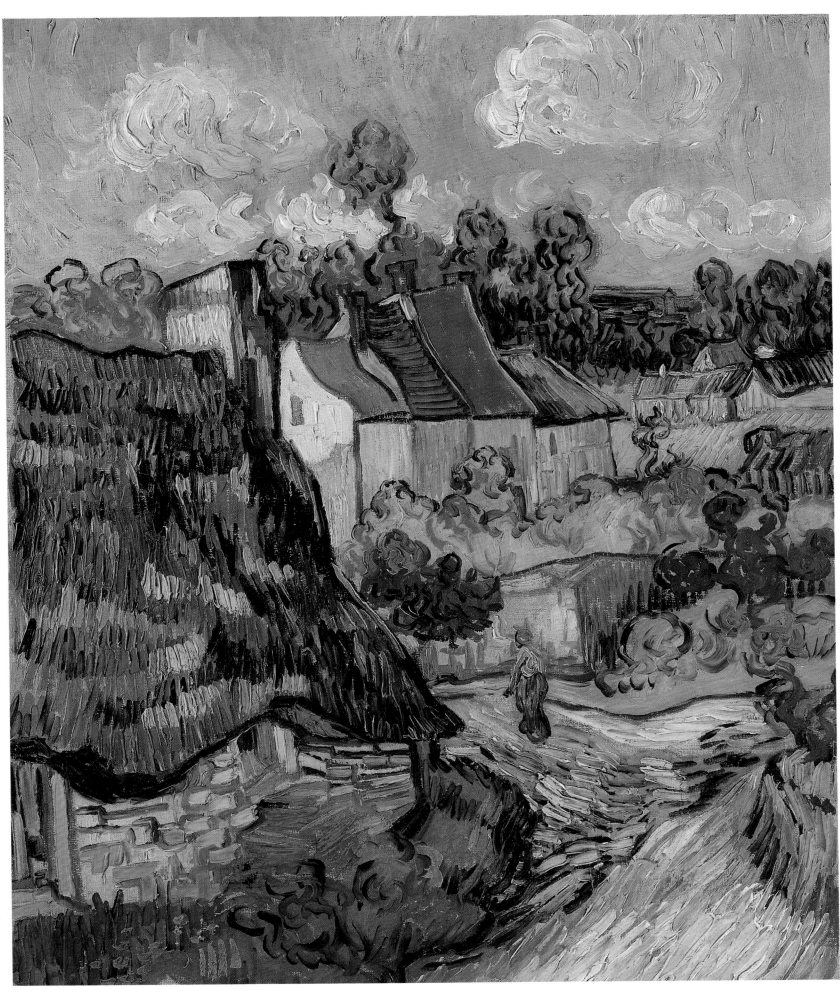

Houses at Auvers 1890
Oil on canvas
29¾×24⅜in (75.5×61.9cm)
Museum of Fine Arts, Boston

Acknowledgments

The publisher would like to thank Martin Bristow who designed the book; Maria Costantino, the picture researcher; and Aileen Reid, the editor. We would also like to thank the following institutions, agencies, and individuals for permission to reproduce the illustrations:

The Art Institute of Chicago: page 110 (Mr and Mrs Lewis Larned Coburn Memorial Collection)
Baltimore Museum of Art: page 63 (The Cone Collection formed by Dr Claribel Cone and Miss Etta Cone of Baltimore, Maryland)
Collection of Mr and Mrs Paul Mellon, Upperville, Virginia: page 28
Collection of Mrs John Hay Whitney: page 147
Courtauld Institute Galleries (Courtauld Collection): pages 136, 138-39
Dallas Museum of Art: page 77 (The Eugene and Margaret McDermott Fund in memory of Arthur Berger)
Folkwang Museum, Essen: pages 150-51, 164
Foundation E G Buhrle Collection, Zurich: page 74-75
Groninger Museum, Groningen: page 42
Harvard University Art Museums: page 111 (Bequest Collection of Maurice Wertheim, Class of 1906)
Hermitage Museum, Leningrad/SCALA, Florence: page 124-25
Kunsthaus, Zürich: page 182-83
The Metropolitan Museum of Art, New York: page 158-59 (Gift of George N and Helen M Richard)
Musée du Louvre, Paris/Photo: Réunion des Musées Nationaux: page 15 (below)

Musée d'Orsay, Paris/Photo: Réunion des Musées Nationaux: pages 11, 89, 113, 153, 170-71, 172, 174
Musée Rodin, Paris/Photo: ADAGP, Paris/DACS, London 1989: pages 84, 97
Musées Royaux des Beaux-Arts de Belgique: pages 51, 106
Museum Boymans van Beuningen, Rotterdam: page 62
Museum of Fine Arts, Boston: pages 156-57 (Bequest of Keith McLeod); pages 135 and 191 (Bequest of John T Spalding); page 133 (Gift of Robert Treat Paine II); page 44 (Tompkins Collection)
The Museum of Modern Art, New York: page 108 (The Abby Aldrich Rockefeller Bequest); page 144-45 (Acquired through the Lillie P Bliss Bequest)
Reproduced by Courtesy of the Trustees of The National Gallery, London: pages 118, 132, 148-49, 166-67
The National Gallery of Art, Washington: page 177 (The Chester Dale Collection)
The National Gallery of Victoria, Melbourne: page 17 (Felton Bequest, 1948)
The National Museum of Wales, Cardiff: page 175
Neue Pinakothek, Munich/ARTOTHEK: page 45, 190
Offentliche Kunstsammlung Basel, Kunstmuseum/Colorphoto Hinz, Allschwill, Basel: page 173
Oskar Reinhart Collection 'Am Romerholz,' Winterthur: page 134
Private Collection, USA/Sotheby's New York: page 142-43

Private Collection, Zürich: page 122-23
Pushkin Museum, Moscow/SCALA Florence: pages 26, 130, 178-79
Rijksmuseum Kröller-Müller, Otterlo: pages 2, 10, 27, 37, 54, 55, 80, 93, 98-99, 102-03, 112, 119, 126-27, 137, 154-55, 161
Saint Louis Art Museum: pages 168-69; page 73 (Gift of Mrs Mark C Steinberg)
Stedelijk Museum, Amsterdam: page 79
Tate Gallery, London: pages 8, 180-81, 184-85
Toledo Museum of Art: page 100-01 (Gift of Edward Drummond Libbey)
Vincent Van Gogh Foundation/National Museum Vincent Van Gogh, Amsterdam: pages 1, 6(both), 7(both), 9, 12, 13(both), 16, 18, 20, 21, 22, 23, 25, 32, 33, 35, 36, 38-39, 43, 46, 47, 48, 49, 50, 52-53, 56, 58-59, 66, 67, 69, 70-71, 72, 76, 78, 81, 82, 83, 86-87, 88, 92, 94, 95, 96, 104-05, 107, 109, 116-17, 120, 121, 128-29, 131, 146, 152, 160, 162-63, 165, 176, 186-87, 188-89, /The Weidenfeld Library: 14(top), 15(top), 19, 24, 29, 34
Von der Heydt Museum, Wuppertal: page 68
Wadsworth Atheneum, Hartford, Connecticut: page 14(below) (The Ella Gallup Sumner and Mary Catlin Sumner Collection)
Yale University Art Gallery, New Haven: page 114-15 (Bequest of Stephen Carlton Clark, BA 1907)